THE APPEARANCE OF WITCHCRAFT

For centuries the witch has been a powerful figure in the European imagination; but the creation of this figure has been hidden from our view. Charles Zika's groundbreaking study investigates how the visual image of the witch was created in late fifteenth- and sixteenth-century Europe. He charts the development of the witch as a new visual subject, showing how the traditional imagery of magic and sorcery of medieval Europe was transformed into the sensationalist depictions of witches in the pamphlets and prints of the sixteenth century.

This book shows how artists and printers across the period developed key visual codes for witchcraft, such as the cauldron and the riding of animals. It demonstrates how influential these were in creating a new iconography for representing witchcraft, incorporating themes such as the power of female sexuality, male fantasy, moral reform, divine providence and punishment, the superstitions of non-Christian peoples and the cannibalism of the New World.

Lavishly illustrated and encompassing in its approach, *The Appearance of Witchcraft* is the first systematic study of the visual representation of witchcraft in the later fifteenth and sixteenth centuries. It will give the reader a unique insight into how the image of the witch evolved in the early modern world.

Charles Zika is Professor of History at the University of Melbourne. He researches the cultural and religious history of late medieval and early modern Europe. Among his publications are *Exorcising our Demons: magic, witchcraft and visual culture in early modern Europe* (2003).

THE APPEARANCE OF WITCHCRAFT

Print and visual culture in sixteenth-century Europe

Charles Zika

Routledge
Taylor & Francis Group

LONDON AND NEW YORK

First published 2007
by Routledge
2 Park Square, Milton Park, Abingdon, Oxon OX14 4RN

Simultaneously published in the USA and Canada
by Routledge
270 Madison Ave, New York, NY 10016

Reprinted 2008, 2009

Routledge is an imprint of the Taylor & Francis Group, an informa business

Publication of this work was asssisted by grants from the University of
Melbourne Publication Sub-Committee, Arts Research and School of Historical
Studies; and from the Australian Academy of the Humanities.

Typeset in Galliard by Bookcraft Ltd, Stroud, Gloucestershire

Printed and bound in Great Britain by TJ International Ltd, Padstow, Cornwall

British Library Cataloguing in Publication Data
A catalogue record for this book is available from the British Library

Library of Congress Cataloging in Publication Data
The appearance of witchcraft : print and visual culture in sixteenth-century
Europe / by Charles Zika.
p. cm.
Includes bibliographical references.
1. Witchcraft in art. 2. Art, European—16th century. 3. Witchcraft—Europe—
History—16th century. I. Title.
N8262.7.Z55 2008
704.9'4913343—dc22 2007019086

ISBN13: 978–0–415–56355–0 (pbk)
ISBN13: 978–0–415–08242–6 (hbk)

CONTENTS

ILLUSTRATIONS

ILLUSTRATIONS

PREFACE

I began researching this book a long time ago and many people and institutions have helped me to complete it. Grants from the Australian Research Council enabled me to research and write a number of related articles and to draft some of the early chapters. The research environment and facilities of the Herzog August Bibliothek, Wolfenbüttel, the Centre for the Advanced Study in the Visual Arts, National Gallery of Art, Washington, and the Humanities Research Centre, Australian National University, Canberra, helped me conceive and shape the original project and to collect some of the most important research materials. My own Department of History and Faculty of Arts have been generous with support, study leave and also funding over many years. Publication costs were helped by grants from the University of Melbourne's Publication Sub-Committee, Arts Research and the Department of History, as well as from the Australian Academy of the Humanities.

Many libraries and art museums have also been generous with their support and advice. I have to single out the University of Melbourne Library, and especially its Inter-Library Loans unit, for providing a wonderful service that keeps scholars in the Antipodes in touch with international research. The many art museums and libraries that provided the numerous illustrations and reproduction permissions are credited in the captions. But I would especially like to mention the Cornell University Library, where this project effectively began many years ago with the help of staff in the Department of Rare Books; and also the Herzog August Library in Wolfenbüttel, where I have been able to advance the project periodically.

Many of the responses to papers given at conferences and symposia, to lectures and talks in classrooms, to casual conversations with colleagues and students, have found their way into this book. For such exchanges, some possibly long forgotten, I would especially like to thank Jaynie Anderson, Christiane Andersson, Wolfgang Behringer, Michael Bennett, Jill Bepler, Robin Briggs, Vivien Brodsky, Sue Broomhall, John Cashmere, Megan Cassidy-Welch, Stuart Clark, Conal Condren, Patricia Crawford, Pia Cuneo, Joy Damousi, Greg Dening, Heidi Dienst, Nick Eckstein, Sarah Ferber, David Garrioch, Bob Gaston, Andrew Gow, Klaus Graf, John Gregory, Pat Grimshaw, Valentin Groebner, Katie Holmes, Peter Howard, Ronnie Po-chia Hsia, Linda Hults, Keith Hutchinson, Rhys Isaac, Jens Christian Johansen, Susan Karant-Nunn, Bill Kent, Elizabeth Kent, Catherine Kovesi, Peter Lang, Claudia Lazzaro, Brian Levack, Machteld Löwensteyn, Grantley Macdonald, Martha Macintyre, Phyllis Mack, Ian Maclean, Pam Maclean, Philippa Maddern, Pat Mainardi, Louise Marshall, Lynn Martin, Peter Matheson, Peter McPhee, Donna Merwick, Erik Midelfort, Lotte Mulligan, Klaus

Neumann, the late Heiko Oberman, Marian Quartley, Judith Richards, Sue Reed, Sheryl Reiss, the late Ian Robertson, Hedwig Röckelein, David Rollison, Ulinka Rublack, the late Diane Russell, David Sabean, Rainer Schoch, Tom Scott, Peter Sherlock, Larry Silver, Pat Simons, Sabine Solf, Chips Sowerwine, Walter Sühlberg, Claudia Swan, the late Richard Trexler, Stephanie Trigg, John O. Ward, Karl Vocelka, Alex Walsham, Hans de Waardt, Andrea Wicke, Merry Wiesner-Hanks, Patrick Wolfe, Irena Zdanowicz, and Heidi Zogbaum.

I have had the support of some excellent research assistants working on different sections of this project over the years: Nick Baker, Adrienne Cameron, Kate Challis, the late Murray Creswell, Julie Davies, Elizabeth Kent, Mindy Macleod, Katie Oppel, Helen Penrose, Charlotte Smith, Katharina Weiss and Heidi Zogbaum. They not only helped with many of the tiresome and time-consuming tasks such research involves; they also contributed many creative ideas, more than they are probably aware of. Sarah Ferber offered invaluable assistance and keen critique in the early years of the project, and Jenny Spinks in the later stages. And there were those who made periodic research trips to Europe seem like visits to another home: Walter Sülberg and Sylvie Buxmann, Paul and Gisela Münch, Peter and Margot Lang, Elizabeth and Gert Keller, Dagmar and Jürgen Eichberger, Nick Stargardt and Lyndal Roper.

I also thank the editorial team at Routledge and Bookcraft: Ginny Gilmore and Matthew Brown for their care and consideration in editing and formatting; Geraldine Martin, Eve Setch and Emma Langley for their general editorial assistance; and especially Vicky Peters, for her belief in the project, her encouragement and patience.

There are a few people to whom I owe a special debt. It was the late Bob Scribner, a wonderful colleague, mentor and friend, who first encouraged me to write a book on the visual in history and to send a proposal to Routledge. Trish Crawford has listened and commented on much of it over many years, broadened my vision and given me much encouragement. Dagmar Eichberger has been a generous and enthusiastic sharer of ideas, and has frequently helped dispel the uncertainties of a novice unsure of his steps in a foreign discipline. Paul Münch always buoys up one's spirits with his wonderful mix of intellectual curiosity, humanity and irreverent humour, as well as his deep knowledge of early modern Europe. Lyndal Roper inspires with her intellectual breadth and has been extremely generous with her knowledge and advice; and it is also fun to see our intellectual paths cross so often. Lyndal generously read an earlier draft of my manuscript, as did Sarah Ferber and also Stuart Clark. I thank them deeply for their corrections and advice, even if they were not always accepted.

Kaya often kept me company during many of the early morning hours, snuggled against the laptop and warmed by the heat of the desk lamp. My deepest gratitude is to Stasia, for her love, her support, her engagement with the book and its underlying concerns. She has had to live with it for far too long, and I dedicate it to her.

A NOTE ON NAMES, SPELLING AND CITATION

The titles of early printed works cited in this study generally follow the wording and spelling of the particular editions used, and this often varies from one edition to the other. Full references are given in the list of works cited. The names of artists, authors and printers have been standardized and follow the most widely accepted form. Guides for this standardization have been VD16 and Golden, *Encyclopedia of Witchcraft*. Place names are given their modern spelling, and when common English versions exist, these are then used. The names of publishers or printers are included only for works published before 1800. An exception is in the captions when the publisher is acknowledged.

ABBREVIATIONS

BL	British Library, London.
BN	Bibliothèque nationale de France, Paris.
BSB	Bayerische Staatsbibliothek.
Geisberg/Strauss	Max Geisberg, *The German Single-leaf Woodcut: 1500–1550*, edited and revised by Walter Strauss, 4 vols, New York, 1974.
GNM	Germanisches Nationalmuseum, Nuremberg.
HAB	Herzog August Bibliothek, Wolfenbüttel.
HDA	Eduard Hoffmann-Krayer with Hanns Bächtold-Stäubli (eds), *Handwörterbuch des deutschen Aberglaubens*, 10 vols, Berlin and Leipzig, 1927–42.
Hollstein	F.W.H. Hollstein, *German Engravings, Etchings and Woodcuts c. 1400–1700*, Amsterdam, 1954–.
LCI	Engelbert Kirschbaum with Günter Bandmann et al. (eds), *Lexikon der christlichen Ikonographie*, 8 vols, Rome, 1968–76.
Schramm	Albert Schramm, *Der Bilderschmuck der Frühdrucke*, 23 vols, Leipzig, 1920–43.
Strauss	Walter L. Strauss, *The German Single-leaf Woodcut: 1550–1600*, 3 vols, New York, 1975.
TIB	Walter L. Strauss (ed.), *The Illustrated Bartsch*, New York, 1978–.
VD 16	Bayerische Staatsbibliothek, Munich and Herzog August Bibliothek, Wolfenbüttel, *Verzeichnis der im deutschen Sprachbereich erschienenen Drucke des XVI. Jahrhunderts*, ed. Irmgard Bezzel, 25 vols, Stuttgart, 1983–2000.
Wickiana	Johann Jakob Wick, *Sammlung von Nachrichten zur Zeitgeschichte*, 1560–87, F. 12–35 (24 vols) in Zentralbibliotek, Zurich.

1

INTRODUCTION

In the first half of the fifteenth century the witch appeared as a newly defined figure on the cultural landscape of Europe. While belief in the power of certain men and women to do harm had been firmly entrenched in European societies since ancient times, it was not until the fifteenth century that theologians, preachers, lawyers, judges and physicians began to elaborate a set of beliefs about the practices and potency of people called witches. These were said to be evil-doers, those who inflict malefice (*maleficium*), and they rapidly became the object of intense religious, political and judicial scrutiny. Men and women who had traditionally specialized in a range of magical practices – love and fertility magic, fortune telling, treasure seeking and healing – as well as those who had a reputation for harmful sorcery directed against fertility, bodily health or community well-being, now stood accused of witchcraft. They were transformed into performers of blasphemous rituals that denied God's omnipotence, and practitioners of an invocatory magic that called on the assistance of demonic agents. Fundamental to this new model of witchcraft, which was propagated through an increasing number of specialized pamphlets and treatises, was the key notion that witches acted as a group. They engaged collectively in a broad and dangerous conspiracy orchestrated by the devil and directed ultimately against the institutions of church and state. Belief in this new diabolical conspiracy, however it might have been shaped and for whatever reasons it was deployed, resulted over the next three centuries and more in the deaths of approximately 50,000 victims, a large percentage of them women, and in the persecution, imprisonment and abuse of many more.[1]

I first confronted European witchcraft in 1972, when as a young postgraduate studying in Tübingen I visited the Städel Museum in Frankfurt. It was here that I saw the wonderful small panel painting, *The Weather Witches*, by Hans Baldung Grien. What should I make of these two naked and beautiful women, with their powerful and seductive bodies statuesque against the sulphurous oranges and yellows of the turbulent sky? Why was one of them staring out coquettishly from the canvas, transfixing me with her gaze? Were these women really witches? They appeared nothing like the witches I'd seen. What made them witches? Why was I so shocked? What in fact was witchcraft? My interest at the time was in Renaissance Neoplatonism and Kabbalah, and the way Renaissance thinkers championed philosophical magic to breathe new life into learning and knowledge. I knew little of witchcraft except that some of my philosopher magicians were quite desperate to distance themselves from it. I had read Hugh Trevor-Roper's small booklet on the European witchcraze and was just starting to read Keith Thomas. But Erik Midelfort's ground-breaking regional study had not yet appeared; and the

studies of William Monter, Norman Cohn, Richard Kieckhefer and Ed Peters, which established a vibrant new field of study over the next half dozen years, were still to be written.[2] As I read this exciting new witchcraft historiography over the coming two decades, Baldung Grien's two women remained etched in my brain and my thoughts kept returning to the questions they had first raised for me. This book has been my attempt to provide some answers.

This book is about the appearance of witchcraft in a double sense. It concentrates on the period when notions of witchcraft were systematically elaborated and first appeared within European societies. More importantly, it focuses on how witchcraft appeared visually, how artists and printers gave it particular visual shape, and how they and their audiences may have viewed and understood it. The book endeavours to plot the development of this new visual subject and to explore the different social and cultural meanings communicated to its viewers. To understand witchcraft images, I contend, one needs to locate them within their broader visual culture. Just as they cannot be read as simple reflections of social reality, as direct evidence of witchcraft practices and demonological beliefs, they cannot be understood simply in relationship to the texts they illustrate. While the function of many witchcraft images was certainly to illustrate – whether scenes described in demonological treatises, in classical works, in pamphlets or broadsheets reporting terrible crimes or sensational trials – it was also to represent and interpret. Artists played a critical role in selecting, interpreting and reconfiguring visual elements and thereby created particular cultural readings of witchcraft. They did this especially by relating their representations of witchcraft to other visual motifs and themes within contemporary visual culture. An aim of this book is to uncover these linkages and associations, in order both to discover the cultural significance and emotional power of particular visual images and to articulate the range of broader cultural meanings that the new visual subject of witchcraft generated in the sixteenth century.

Another aim of this book is to begin to assess the role visual images played in the development of a newly imagined witch figure in the fifteenth and sixteenth centuries. Visual images were employed to illustrate the powers of witchcraft and to record and document its incidence and punishment. The intention of some images was certainly to question its physical reality and effects; but most helped give it widespread currency and underpinned belief in its potency. Most especially visual images provided the means for Europeans to imagine the nature and behaviour of witches and witchcraft; they provided them with visual images that distinguished this figure from the magicians and sorcerers of past centuries. Visual images helped embody the witch; they helped make her more immediate, recognisable and credible. Through visual images the witch could more easily become universal and also stereotypical. Together with theological and legal tracts, popular pamphlets, political decrees, judicial testimony and court practice, visual images helped give vital shape to the figure of the witch in fifteenth- and sixteenth-century Europe.

The relationship between visual imagery and literary or documentary sources is never simple. Whereas visual and literary discourses often overlap and interact, they also develop separately and remain quite distinct. Visual images and literary tropes have their own independent histories and are shaped by their media and language. One aim of this book is to discern whether a visual history of witchcraft in the sixteenth century differs from its literary or legal history. What does a history of witchcraft look like, if based primarily on visual sources? Does it tell us a different and distinctive story? This book

suggests that for various social and cultural groups, such as visual artists, there may well have been significant variants. Recent studies of witchcraft, for instance, have claimed that by the late fifteenth century a 'cumulative concept of witchcraft' had become well established.[3] The fundamental elements of this concept were that witches made a pact with the devil, which they sealed with sexual intercourse; they then worshipped the devil as a group, renounced God, and engaged in rituals of cannibalism, dancing and sex at a regular group assembly called a Sabbath.[4] This notion of a Sabbath seems to have been limited to written sources, however; for it is virtually absent from visual documentation for a century and more. It is imperative that historians explore such historical phenomena and the processes by which images articulate and communicate meanings quite independently of literary texts. In pre-modern societies, in which modes of communication were predominantly oral, visual objects exercised significant social and cultural power. This books aims to join a growing number of historical studies exploring the impact of the visual in the past; and by encouraging historians to redress their past bias, to help release, as Barbara Stafford has put it, Plato's images from the cave.[5]

Only in the past two to three decades have witchcraft images been considered a topic worthy of serious scholarly study. Historians have generally regarded witchcraft images as little more than illustrations to be used to enliven their texts; or as evidence of the demonological beliefs and social practices provided in their accounts. Art historians have considered these images primarily with reference to the work of well-known artists: how they sit within their artists' oeuvres and the contributions they make to the general art history of a particular period. The German art historian, Sigrid Schade, was the first to provide a major synthesis of early sixteenth-century witchcraft imagery in her Tübingen dissertation published in 1983.[6] Schade focused on the early witchcraft images of Baldung Grien and his German contemporaries, and argued that these artists transformed traditional notions of magic by locating its source in the eroticism of the female body. Schade's broad framework is heavily predicated on notions of societal transformation drawn from social theorists such as Habermas, Elias and Foucault; but her iconographical analyses are rich and detailed, and draw for support on a wealth of anonymous and aesthetically crude images, literary and documentary texts, as well as the works of established artists. Schade has also published a lengthy survey of witchcraft images through to the twentieth century, which remains after 20 years the most coherent and stimulating overview of its kind.[7] Baldung's witchcraft images have also received much attention from the American art historians, Linda Hults and Joseph Koerner.[8] Both have added immensely to our understanding of Baldung's iconographical content, technique and style, and how his images relate to the work of other contemporary artists, their patrons and their audiences, and to contemporary ideas of artistic invention and imagination.[9]

This book is the first study that attempts to explain the appearance of witchcraft images in the later fifteenth century and their development as a visual subject through to the late sixteenth century. Not least it includes the period from the 1540s, which is largely neglected in the historiography. Linda Hults' recent book, for instance, leaps from the work of Baldung Grien in the early sixteenth century to that of Frans Francken II and Jacques de Gheyn II in the early seventeenth; while the fascinating recent study of de Gheyn by Claudia Swan simply underscores the very different political, religious and cultural context for the production of witchcraft images a century apart.[10] Jane Davidson, who has written the only book-length survey of witchcraft images to be published in English, also pays only limited attention to the second half of the sixteenth century.[11]

The Bielefeld legal historian, Wolfgang Schild, one of the few scholars to have written on witchcraft images who is not an art historian, also largely ignores these broad historical developments.[12] Schild has been more interested in grouping images according to their particular function in legitimating or weakening witchcraft beliefs and prosecution. My aim in this book, on the other hand, is to understand witchcraft images in terms of cultural communication and meaning. I consider both the consciously and aesthetically crafted works of established artists as well as those more crude and artistically unsophisticated images, often by unknown artists. I aim to uncover how these witchcraft images create links with other visual and literary discourses, how they succeed in making their content intelligible and recognisable by the use of visual cues and visual codes, how they establish and continue to reproduce these visual codes – in other words, how they succeed in communicating cultural meaning.

The visual images of witchcraft that this book traces and endeavours to explain were mediated predominantly through print. The increase in the number of images of witchcraft from the 1490s related as much to the developing print industry as to the increasing incidence of witch trials through Europe. Print only began to be firmly established as a new medium for cultural communication from the 1470s, and it was over the next two decades that printers and artists began to experiment with book illustration and forge a powerful new cultural alliance. The invention of moveable type resulted not only in previously unimaginable levels of circulation of such images, it also created new opportunities for cultural experimentation and exchange. The print workshop, as a new space for the interaction of intellectuals and moralists, theologians and preachers, lawyers and civic officials, publishers and booksellers, financiers, artists and patrons, as well as for all those directly involved in technical production – proof-readers, letter-setters, designers, cutters and colourers – constitutes the key social and cultural environment for the visual imaging of witchcraft.[13] Over the next century and more, most images of witches and witchcraft were created in this environment, through the new collaboration between the technologies of print and printmaking. It was the print – whether woodcut, metal engraving, or less often etching, produced either as a single leaf woodcut or illustrated broadsheet, as titlepage, frontispiece or other form of book illustration – which became by far the most popular medium for the representation of witchcraft until the last decade of the sixteenth century.[14] A very small proportion of the witchcraft images produced in the fifteenth and sixteenth centuries were drawings; paintings of witchcraft were even more rare.

The critical role of print in the imaging of witchcraft serves as a clear reminder that the historical phenomenon of the witch-hunt needs to be situated within the political, social and cultural changes of early modern European societies. In much of western Europe the most intense legal prosecution of witchcraft occurred between 1590 and 1630, carried out by rulers we identify with Renaissance culture and supported by some of the leading intellectuals of Europe. Demonological literature and the prosecution of witchcraft were inextricably bound up with the restructuring of early modern political institutions and the refashioning of its cultures and societies. They were not anachronistic throwbacks to a superstitious past, as some historians once thought. The recent historiography of the witch-hunt focuses on how these beliefs constituted a resource to be used by rulers, courts, churches, local communities and powerful families. The conclusions of this study also reinforce the notion of witchcraft as a cultural resource; in the hands of fifteenth- and sixteenth-century artists, witchcraft could give expression to a variety of contemporary concerns. As the following chapters will show, representations of witchcraft could

support calls for reform of the moral order, stimulate anxieties over female sexuality, support the articulation of male fantasies, forefront the moral lessons of classical literature, reinforce the power of Scriptural precedents, strengthen secular authorities in the disciplining of their states, interpret social crimes as signs of divine displeasure, and help incorporate the New World into the cultural frameworks of the old.

The images of witchcraft and sorcery explored in this book range across a little more than a century, from about 1480 to 1590. In the 1480s and 1490s such images first appeared in significant numbers as illustrations in printed books and manuscripts. Then, in the first two decades of the sixteenth century, established artists such as Albrecht Altdorfer, Albrecht Dürer, Hans Schäufelein, Niklaus Manuel Deutsch and especially Hans Baldung Grien, created a new and distinctive iconography of witchcraft. Through the circulation and copying of drawings and woodcuts, a number of fundamental visual codes for witchcraft were quickly developed. These survived, albeit with variations in style and meaning, through to the work of the brilliant Dutch artist, Jacques de Gheyn II, in the early seventeenth century. The early sixteenth-century images emphasized female lust as a basis for witchcraft, and linked witchcraft's dangers to notions of societal inversion and moral disorder. This new iconography of witchcraft developed for the most part in southern Germany, and especially in Baldung's adopted city of Strasbourg and the region of the upper Rhine. Yet a more traditional iconography that identified witchcraft with the harm and moral evil of individual sorcerers continued to be represented in Augsburg by artists such as Hans Burgkmair and Jörg Breu the Elder, and by the printer Heinrich Steiner.

The production of early witchcraft imagery in south German cities, with their well-established printing presses, print shops and traditions of artistic collaboration and patronage, soon spread out to other cultural centres in central and western Europe. From the middle of the sixteenth century printers in Frankfurt, Cologne, Basel, Berne, Zurich and Wittenberg, as well as in Rome, Paris, Antwerp, Lyon and London, began to include images of witchcraft in their books, pamphlets and broadsheets. The great majority of these images continued to be produced in the German-speaking territories of the Holy Roman Empire and Switzerland, where 60 to 75 per cent of European witch trials took place. Very few were produced in England, Scotland, Spain and Italy before the seventeenth century; and while a significant number are found in France, their numbers do not compare with those produced in German-speaking lands. The only other significant centre of interest is Flanders, where Pieter Bruegel the Elder and Martin de Vos introduced significant and influential witchcraft images into their oeuvres. In Bruegel's case, the iconographical and compositional features he developed continued to influence artists well into the seventeenth century. Interest in the subject of witchcraft also meant that figures from Europe's classical, biblical and Christian past were drawn into the iconography; and as the number of witch trials in Europe increased from the 1560s, the horrible crimes of witches were more frequently depicted, as were the punishments meted out to them by the authorities. The figure of the witch also began to be universalised, a figure who could be identified in the distant past as well as the present, active in the heart of Christian Europe as well as on its fringes.

The end point of this study of witchcraft images is the early 1590s. Artists continued to develop and exploit the subject well beyond that date of course – right through the seventeenth, eighteenth and nineteenth centuries. But the 1590s mark a significant change in the number, iconography and themes of these images. From this decade a new

level of political and cultural interest in the subject becomes quite evident. In the late 1580s witchcraft trials reached their peak in a number of European regions, such as in France and in England; whereas in Scotland, the Spanish Netherlands, the duchies of Lorraine and Luxembourg, the archbishoprics of Trier and Augsburg, Burgundy and the Pays de Vaud – to name but a few prominent territories – large-scale persecution was just beginning. And an epidemic of witch trials was to cut a swathe through large parts of southern Germany – Mainz, Ellwangen, Bamberg and Würzburg – in the first three decades of the seventeenth century. With the ever-increasing numbers of trials of the 1580s, there also came a rash of new demonologies. These included treatises by the French lawyer and political theorist, Jean Bodin; the suffragan Bishop of Trier, Peter Binsfeld; the Lorraine judge, Nicholas Rémy; the Spanish-Belgian Jesuit, Martin Delrio; the Burgundian judge, Henri Boguet; and the King of Scotland, James VI. Possibly in response to this expanding witch-hunt, as well as to the discourse of diabolical threat articulated in the new demonologies, a new generation of artists sought to give expression to this changing political and cultural environment. Jacques de Gheyn II, Frans Francken II, Jan Ziarnko, David Teniers, Matthaeus Merian the Elder and Salvator Rosa, were just a few who gave much more emphasis than previous artists to the cruelties of witchcraft, to its mass societal character and its potential social threat. And in contrast to the witchcraft iconography of the sixteenth century, such themes often found expression through images of witches' assemblies and Sabbaths. Moreover, the greater number of drawings and paintings of witchcraft scenes produced in the seventeenth century testify to a very different artistic, cultural and intellectual environment, in which images of witchcraft were more commonly linked to artistic invention and reflected the concerns of the very different social groups that constituted its audience and patrons. But that is the story of the seventeenth century, not the story of this book.[15]

The chapters of this book attempt to mirror what I understand to be the processes by which artists and printers constructed a new iconography for witchcraft in the sixteenth century. I begin each of the chapters with a detailed examination of a particular witchcraft image, in order to highlight discursive links, the visual and literary associations between witchcraft and other contemporary cultural discourses and themes that artists created or adapted, or even simply alluded to, in order to create particular and distinctive meanings for their images. These allusions and associations, these links to other discourses and conflations of different meanings, were not only critical for the development of a witchcraft iconography by artists. They also served to make these images more intelligible to viewers, helped create new audiences, and forged a broader social interest in the witchcraft beliefs on which the images were based. The development of a witchcraft iconography from the late fifteenth century was certainly not a methodical and uniform chronological process; it was irregular, gradual, partial. As a result, the book's structure must be primarily thematic in its divisions. Yet since there is a rough congruence between iconographical emphases and time periods, the chapters do trace out the broad and jagged lines of a chronological development.

In the first chapter I show how a group of south German artists in the first decade of the sixteenth century wholly transformed the traditional visual language of magic and sorcery and created distinctive visual codes for witchcraft. The most creative of these artists was Hans Baldung Grien, who drew on the work of his elder colleagues, Albrecht Dürer and Albrecht Altdorfer, and established the visual cues and codes through which witchcraft imagery would be read for much of the next century. From this time

witchcraft could be imagined as a group of women gathered around a cauldron or as women riding goats or various implements through the air. The sources for these two readily identifiable visual codes were the illustrations that accompanied the 20 or so editions of Ulrich Molitor's *On Female Witches and Seers*, published in the two decades after the work's original appearance in 1489. Exploitation of the new technology of print facilitated this development. The widespread distribution of illustrations, their frequent recycling through new editions, the creation of new markets for both books and single-leaf woodcuts, the cultural and intellectual interaction facilitated by the print shops with which key artists such as Baldung Grien had a close working relationship – all played a critical role in the speedy development of this new visual language.

Chapter 2 moves back to the period before 1490 and surveys the visual resources and models available to artists for their representations of popular magic, sorcery and witch-craft. A substantial part of the chapter focuses on the set of woodcuts in Hans Vintler's *Book of Virtues*, a work published in Augsburg in 1486 that depicts a magical world largely untouched by the contemporary discourse on witchcraft. The critical shift in the move to witchcraft imagery was the demonization of various forms of magic and sorcery. Limited evidence of such a shift is discernible in the Vintler woodcuts; but in a number of other fifteenth-century images – of necromancy, invocatory magic and Waldensian heresy – one can also discern a subtle yet gradually increasing emphasis on demonic pres-ence and agency. These demonic 'black arts' were ultimately combined with images of village sorcery to create the new crime and heresy of witchcraft.

The third and fourth chapters consider the links between witchcraft and discourses of female sexuality and gender disorder in the first half of the sixteenth century. Since the images created by Dürer and Baldung Grien in the first decade of the sixteenth century, witchcraft was consistently represented in highly gendered terms, as an inversion of the gender order or as a threat to masculine sexuality and power. The choice of the cauldron and the female rider as central motifs in the two key visual codes deployed to represent witchcraft rested on their capacity to link physical harm and social malfunction with sexual licentiousness and moral disorder. These two chapters explore how artists drew on visual images representing the powers of female bodies and sexuality, female sociability and popular tales of the Furious Horde and the Wild Ride, to stimulate complex allu-sions and associations for their viewers. In this way attacks on witchcraft were integrated with calls for moral reform on the part of social critics and civic authorities in the turbu-lent years just prior to the Reformation, and witchcraft was used to underpin fears of sexual emasculation and moral disorder. Yet, as we shall see in Lucas Cranach's allusions to the Venusberg in his Melancholy paintings, witchcraft images could also help artists explore fantasies of sexual seduction and sensual pleasure.

Chapter 5 examines sixteenth-century images of witchcraft that were drawn from or based on classical literature. It shows how such images helped expand the range of models available to artists and also provided witchcraft with a longer and more complex history. As the sixteenth century progressed, various figures from classical mythography such as the Three Fates and Artemis/Diana were drawn into the web of witchcraft imagery, while figures such as Saturn were deployed to emphasize its savagery. Represen-tations of classical witches also helped give currency to particular views of witchcraft. Circe, Palaestra, Meroe, Pamphile and Medea – figures who increasingly became well known to literate readers with the publication of new translations and new editions of classical texts – were especially distinguished by their capacity to cross borders, between

the animal and the human world, and between the world of the living and the world of the dead. Their behaviour was frequently characterized by extreme violence and all were driven by sexual desire. They clearly underpinned some of the key attributes of witchcraft created by artists in the early sixteenth century: that witchcraft was primarily identified with women, and was rooted in their sexual desire.

The depiction by artists of three different stories of demonic magic drawn from Christian tradition constitutes the subject of Chapter 6. The first is the biblical story of the witch of Endor who performed an act of necromancy for King Saul (1 Sam. 28.3–20); the second is the legendary account of the apostle James in his struggle against the pagan magician Hermogenes; and the third is the dramatic contest waged by the apostle Peter and the magician Simon Magus before the Roman Emperor Nero on the Field of Mars. Sixteenth-century artists embellished these stories with allusions to witchcraft in order to give them added contemporary relevance. But in so doing they also underlined the critical role of the devil and diabolical illusion in enabling witches to deploy their claims to supernatural power; and more importantly perhaps, they located the phenomenon of witchcraft within the history of Christian salvation, the long history of struggle by Christians against the power of the devil.

The last two chapters of the book explore the relationship of witchcraft images to the representation of the sensational and exotic in the later sixteenth century. In Chapter 7 I trace the manner in which witchcraft and printing came together in a significantly new way through the pamphlet and the broadsheet. Witchcraft was a subject that readily accommodated the new sixteenth-century market for news reports, a market stimulated by the sense of a world gone astray, racked by every evil and in dire need of the guiding hand of God's providence. Terrible crimes, natural disasters and war, the wondrous births of malformed animals, or the customs of exotic cultures on the fringes of Europe, all fed this appetite for reportage and news. Publishers and printers quickly inserted witchcraft into the news-sheet; and the graphic images that accompanied the enticing headlines attempted to reach an audience beyond the literate. These news reports helped 'naturalise' witchcraft, making it one more crime to beset human society in an age of crisis, even if a truly exceptional crime dependent on the intervention of the devil. They also demonstrated that the impact of witchcraft was common to Christian Europe as a whole; it was not simply a threat of local or regional significance.

The news reporting of distant events throughout Europe seems to have stimulated the association between witchcraft and the exotic peoples of far-off lands. In Chapter 8 I examine how artists used the ancient figure of Saturn to link the activities of witches to accounts and images of New World cannibalism; and how the illustrators of the ethnological account of Scandinavian culture by the Swedish bishop, Olaus Magnus, depicted witchcraft as a demonic superstition native to pre-Christian Scandinavian societies. Visual images of witchcraft were used to define those on the geographical or imaginative margins of European society; in the process witchcraft became a more universal concept, common to pre-Christian cultures at home and indigenous cultures abroad. Association with the savagery of the Amerindians stressed its fundamentally antichristian and antisocial nature; association with the pagan Goths emphasized its demonic nature. By the late sixteenth century the witch was also figured as an accomplice of the murderous Jew, and became a living threat to the integrity, and even survival, of the Christian community.

Modern viewers are frequently surprised, even shocked, at the powerful emotional pull of witchcraft images from the sixteenth century. These images exercise their power in

spite of the crude messages they sometimes construct, the sensationalism they employ and the human fantasies to which they appeal. Indeed, the ability of these witch figures to look out at us from their frames and lock us in their gaze serves as a reminder, in a very sensual and concrete way, that witchcraft cannot simply be relegated to a distant past as a bizarre and grotesque byway of history. The history of the European witch-hunt, these living relics tell us, is also our history, a history which only took its last victims a little more than two centuries ago, a history from which we can and need to learn. And not least so in the early twenty-first century, when in the shadow of the obscenities of Guantanamo, torture and 'coercion' are once again considered to be necessary weapons against those deemed enemies of our society and culture.

My hope for this book is that it provides us with a much keener, if only partial, under-standing of the ways visual images helped create demonic figures in our historical past; and that it helps us reflect on the multiple ways that that past continues to live for our present.

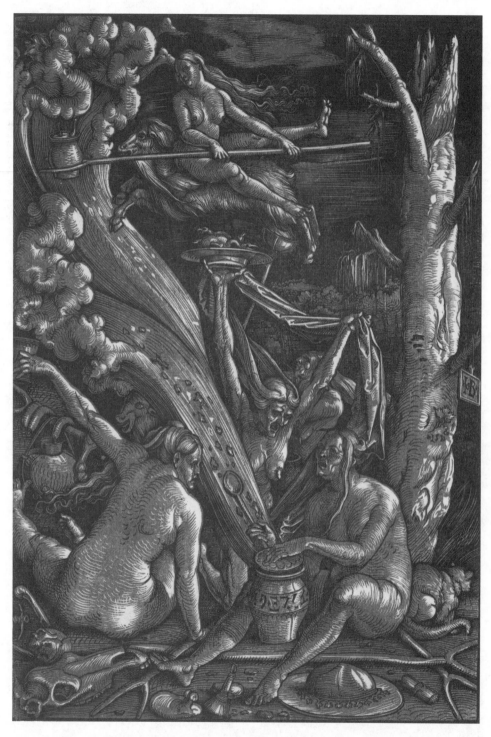

Figure 1.1 Hans Baldung Grien, *A Group of Female Witches*, 1510, chiaroscuro woodcut. Museum of Fine Arts, Boston, W.G. Russell Allen Bequest, 69.1064. Photograph © Museum of Fine Arts, Boston.

1

FASHIONING A NEW VISUAL
LANGUAGE FOR WITCHCRAFT

In the year 1510 the young south German artist Hans Baldung Grien, then in his late twenties, created an image of witchcraft that would influence visual representations of this subject for the next century and more (fig. 1.1). It was possibly the finest single-leaf woodcut of Baldung's early work and technically a cutting edge and fashionable image at the forefront of contemporary artistic experimentation. Baldung adopted the new technique of chiaroscuro – a combination of several wood blocks in different tones, pioneered just a few years earlier by the established and older Augsburg artist, Hans Burgkmair – to create an eerie, three-dimensional forest setting for his witchcraft rituals.[1] In 1510 Baldung was on the brink of his success as one of the leading German artists of the period. He had returned to Strasbourg the previous year, married, taken out his citizenship, become a master in the guild of goldsmiths, painters, printers and glaziers (*Zur Steltz*), and established his own artist's workshop. As though symbolic of his new independent status, he now introduced into the monogram he had used since 1507, the year he left Albrecht Dürer's workshop in Nuremberg, a 'G' from his cognomen (*Grien* or green) – as one can see in the monogram hanging from a tree in this woodcut.[2] The period in Dürer's workshop had been a critical one for the young Baldung, and it is likely that Dürer's earlier engraving of a witch riding a goat (fig. 1.12) became the model for one of Baldung's witches. But the topic of witchcraft was beginning to elicit interest not simply among a group of visual artists. From the turn of the century it was attracting the attention of many readers among the urban populations of southern Germany, and not least in Baldung's recently adopted city of Strasbourg. In a series of remarkable images produced between 1510 and 1515, the first of which was his chiaroscuro woodcut, Baldung would give this interest his own particular visual form, and more than any other artist contribute to the creation of the new visual subject of witchcraft.

The dominant impact of Baldung's woodcut rests on the trio of naked women grouped around a pot or cauldron, symbolically united by a triangle of forked sticks.[3] They are shown engaged in ritual activity that involves food, drink and sacrifice. They focus attention on a cauldron inscribed with pseudo-Hebraic script placed between one of the women's legs. Thick billowing vapours escape from the cauldron, and in them one discerns animal shapes such as toads. A kneeling witch, who raises a cloth and bowl containing various bird-like remains, seems especially agitated. The seated witch on the right has a ladle with which she prizes open the cauldron; while the one on the left holds up a drinking cup. The women are symbolically united by a triangle of forked sticks. These are not pitchforks, as they are often called, but cooking forks (*Ofengabeln*) –

implements used for stoking fires, turning food, and as seen in the print itself, hanging food over the fire and transporting pots.

The gestures and activity of these women, the flying hair with its traditional magical and sexual associations, the suggestions of sacrifice communicated by the plate and cup held up in offering, the employment of pseudo-Hebraic script, the uncontrollable forces that escape from the cauldron as though from Pandora's box, the triangle of forked sticks and the eerie forest setting, all provide the scene with a sense of magic and mystery. It is a mystery clearly linked to the women's gender. Their naked bodies dominate the scene, as they engage in the traditional female role of food preparation. But the cultural meaning of food as nourishment has been inverted: it is linked to images of destruction, such as the skull of a horse and of a child, the bones in the bottom left corner, and the legs shown emerging from the pot carried by the witch riding through the sky. The nature of these body remains is left unclear. Are they the result of terrible dismemberment? Or have they been brought here from graves in order to be used in necromantic rituals, one of the most common forms of late medieval magic? That Baldung might have been alluding to necromancy is supported by the parallels between the witches' sacrifice, directed towards gaining access to demonic power, and the priestly sacrifice of Christ's body in the mass, meant to provide access to the treasury of divine salvation.[4] Not only is the divine ritual inverted here, but male priestly celebrants are replaced by females, and pot, spoon and cooking fork supplant the ritual objects of a male liturgy.

Baldung's highly gendered representation of witchcraft was communicated to his viewers in other ways as well. The witches' sexuality, for instance, resonates through the whole scene. On the ground beside the skulls and bones are other instruments by which these women carry out their witchcraft. There is a convex mirror, traditionally used for entrapping demons in rituals of divination; a brush supposedly employed in the rubbing on of salves; a bundle of hair – probably from a horse or goat – used to inflict sickness; and a bone, commonly used in acts of sorcery. Together with the highlighting of the naked female bodies, with their smooth surfaces contrasted against the dense forest vegetation and billowing vapours, brush, hair and mirror also allude to the female toilette, as symbols of female vanity, sexuality and sin.

The witch riding backwards on the goat also alluded to female sexuality, by drawing on a traditional topos for the representation of sexual disorder.[5] While the figure was probably directly inspired by Dürer's engraving of a riding witch, completed when Baldung was still a journeyman in Dürer's workshop (fig. 1.12), Baldung provided his own inflection. He spread the witch's legs, so that together with the loose, flying hair, a common visual cue for illicit sexual activity in the sixteenth century, the woman became a potent figure of sexual disorder. Goats were well-established as visual symbols of lust in the iconography of the vices in the late Middle Ages;[6] and Baldung underscored this meaning by having a torch held up and lit from the sexual heat of the goat's genitals.[7] Torch and spread-eagled legs above echo the seated witch below, the cauldron between her legs and the symbols of vanity at her feet.

The sausages roasting over the fire on the left also support the link between witchcraft and female sexuality. In visual and literary images of carnival in this period the sausage represented the phallus and was frequently used to allude to the raucous sexuality of carnival time.[8] Carnival was a time of reversal when the normal order within society was temporarily upturned. The instinctive life of the lower body, symbolized by the sausage and bauble, was given free reign over the upper. It was the time when not only fools, but

also food, drink and sex, were made king. Baldung's sausages represented witchcraft as such an inversion, and more specifically an inversion of gender order. For one specific and widely acknowledged power attributed to witchcraft was the capacity to cause sexual impotence; witches were known as those who 'tie the knot'. The *Malleus Maleficarum*, for example, the contemporary witchcraft manual first published in Speyer in 1486 and then a further 12 times by 1523, described the power to inflict impotence as one of the principal evils of witchcraft, and included stories of witches collecting the penises they removed from men.[9] Baldung must have known the *Malleus* from one of the many editions published in southern Germany; and his sausages might well have been inspired by this text. But the sausages over the fire might simply have been a play on popular expressions for sexual intercourse, such as 'roasting one's sausage' (*Würste braten*).[10] Either way, Baldung seems to be claiming that witchcraft was a female grab for power, an attempt to appropriate not only the ritual power of priests, but also the sexual power of men.

Modern scholarship has commonly and misleadingly entitled Baldung's 1510 chiaroscuro woodcut as *Witches' Sabbath*, or *Witches Preparing for the Sabbath Flight*. Such titles ignore the actual dynamic and logic of the print, which makes little reference to the key elements of the Sabbath such as homage to the devil, communal dancing and feasting, and orgiastic sex. They also perpetuate the tendency to locate the subject matter of witchcraft images within a pre-ordained narrative, based on the belief that an elaborated stereotype of witchcraft was widely believed in by the end of the fifteenth century and must have been implied. Baldung and other contemporary artists were almost certainly aware of contemporary literary discussion about witchcraft and its prosecution. By 1510 seven editions of the *Malleus Maleficarum* had been published, primarily in Speyer, Nuremberg and Cologne, though not – as has been claimed – in Strasbourg.[11] Although Baldung's adopted city of Strasbourg saw very few witch-trials before the 1570s, the vibrant cultural life of one of the European centres of the printing industry promoted a lively engagement with the theological and political issues of sorcery and witchcraft. In 1499 the Franciscan moralist and later anti-Lutheran propagandist, Thomas Murner, published his *Useful Treatise concerning the Witches Pact*.[12] In 1509 Strasbourg's very popular preacher, Johann Geiler of Kaisersberg, delivered a series of Lenten sermons in the cathedral that considered different forms of witchcraft and popular sorcery; and eight years later the similarly popular Franciscan author, Johann Pauli, had those sermons published under the title of *Die Emeis* (*The Ants*).[13] But just as these works promoted very different views of witchcraft, we cannot automatically ascribe to Baldung any particular set of ideas or beliefs. The particular interest of visual artists in witchcraft and the novel perspectives they brought to its understanding need to be explained through the visual associations and links which artists create with other visual discourses, the manner in which they adopt and adapt particular iconographical elements to their subject.

In the development of a visual iconography of witchcraft, however, there is little doubt that the work of Baldung holds a pre-eminent position. His 1510 woodcut, in particular, helped fashion two of the dominant visual codes for the representation of witchcraft in the sixteenth century: first, as women engaged in practices around a cauldron – a code closely linked to contemporary discourse about the female body and sexuality; and second, as women riding animals or domestic implements through the sky – a code which drew on the popularity of the Wild Ride of Germanic folklore as a threat to moral order. Both codes emphasized the group nature of witchcraft and its identity as

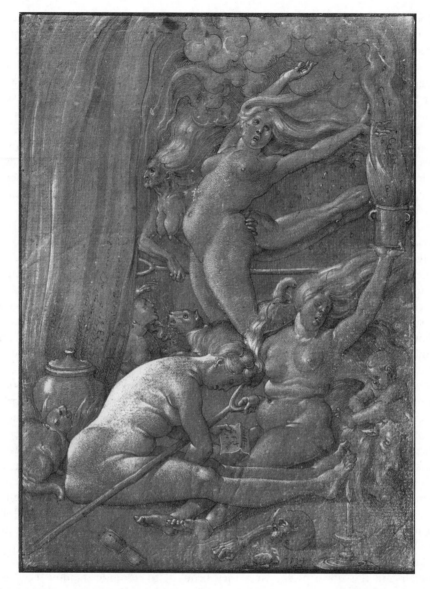

Figure 1.2 Hans Baldung Grien, *A Group of Witches, c.* 1514, pen and ink, heightened with white on red-brown tinted paper. Albertina, Vienna.

essentially female. Baldung began to disseminate these views of witchcraft from 1510, first in his chiaroscuro woodcut and then in the drawings he completed in 1514–15, while working in Freiburg on the high altar for the cathedral. At least three of these drawings survive in their original form and one as a very close copy, and the likely existence of others can be deduced from various copies. All were done in chiaroscuro technique (white ink on tinted paper), all provided testimony to the close links Baldung created between witchcraft and female sexuality, and all but one depicted witchcraft as involving groups of women. Two of the extant drawings, moreover, were strongly

influenced by the iconography and composition of the 1510 woodcut and provide graphic evidence of Baldung's interest in developing his particular views of witchcraft through the second decade of the sixteenth century. Indeed, the drawings gave added emphasis to particular aspects of the earlier woodcut and were critical in fashioning a new language for witchcraft that focused on the cauldron and the power of female bodies.[14]

In both these drawings a trio of witches takes centre stage, just as in the 1510 woodcut. In the drawing now held by the Albertina (fig. 1.2), the smoke from the cauldron, the flames and vapours belching from a vessel held up by a seated woman, and the wild hair of the witches, all serve to create a sense of turbulent energy. The cauldron of the 1510 woodcut has been moved to the perimeter of the image and transformed into a wine canteen. As a result the viewer's attention becomes even more clearly fixed on the bodies of the women. Their relationship is very physical, while the cooking forks again create symbolic links – connecting hand with thigh in the case of the two women seated on the ground, or enabling a crone to carry a younger witch through the air. The whole scene is suffused with erotic intensity. The witch seated on the left is rubbing salve onto her genitals while reading a magical script, and her crouching gesture is clearly suggestive of masturbation; the trance-like state of the woman on her right resembles orgasm, as do the bodily gestures of raised arms, protruding abdomen and rolling eyes of the young witch behind her. As in the woodcut of 1510, the presence of animals defines the women's activities as bestial – a goat mounted by a small child (possibly a reference to beastly union between goat and witch), and two cats, one in front of the cauldron and another between the legs of the younger witch. The objects on the ground – a human arm and skull and a bundle of hair – denote the destructive nature of witchcraft; while the lighted candle conveys the notion that some kind of ritual is being enacted.

While the Albertina drawing makes a link between witches' trances and sexual pleasure, the Louvre drawing (fig. 1.3) emphasizes the threat of witches' bodies for a male gender order. Developing a motif from the 1510 woodcut, it depicts a trio of witches making a sacrificial offering of a human skull and bones.[15] This is clearly a parody of the priestly offering of the mass, the prayer beads held up by two of the witches a testimony to an act of Catholic devotion. By the second decade of the sixteenth century, as contemporary broadsheets and Reformation propaganda remind us, prayer beads had become one of the most common signifiers of Catholic religious practice.[16] The dice, small bells, a rabbit's foot and a skull included as prayer beads locate the scene in the inverted world of carnival; while the sausages of the 1510 woodcut have been brought to centre stage. Here the sausages are brought into direct contact with the witches – as they hang from a cooking fork that passes between the legs of two of them, and are stroked by a third kneeling crone – and become potent statements of contemporary fantasies about the power of witches to castrate. But as in the earlier woodcut, Baldung's representation of witchcraft is not simply a fantasy of emasculation. It is the control exercised by the women that is most striking, the way they appropriate and manipulate phallic objects for their own pleasure.[17] The inversions of witchcraft have as their aim the collapse of the gender order upon which the powers of church and society rest.

The sexual powers of witchcraft are clearly embodied in the actions of the witch seated on the ground. Like the old witch in the 1510 woodcut who lights her torch from the genitals of a goat, she reaches between her legs to light a taper from the gas of her lower body.[18] The gas is the heat of her lust, a product of Venus's 'straw arse', as Sebastian Brant puts it in *The Ship of Fools*, a work and image probably well known to Baldung

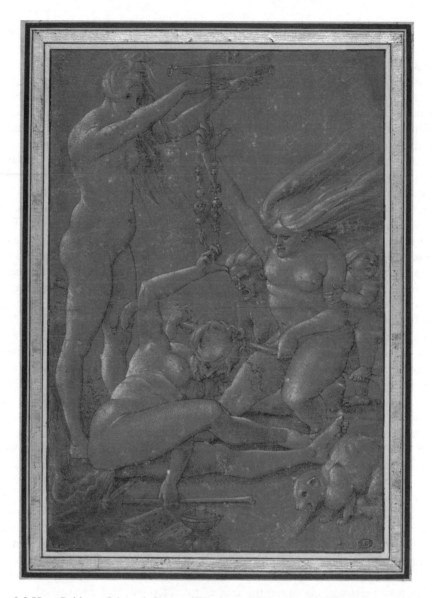

Figure 1.3 Hans Baldung Grien, *A Group of Witches, c.* 1514, pen and ink, heightened with white on green-tinted paper. Départment des Arts Graphiques, Musée du Louvre, Paris, RF 1088. © Photo RMN.

through the Strasbourg print shops.[19] The hot gas spurting from the witch's lower body has displaced the vapours billowing from the cauldron in the 1510 woodcut. The cauldron as a metonym for the witch's body is an important theme to be explored below in Chapter 3. It suffices to indicate at this point that it was Baldung who largely established its use, and that in his work it gives expression to an understanding of female sexuality as closely linked to female seduction. The contrast between the seething turbulence of the internal body and the smooth sensuality of its surfaces represents for Baldung the contradictions of sexual desire. This is analogous to the tensions he establishes compositionally,

in his juxtaposition of the older bodies of crones with the desirable bodies of his younger witches. The crones refer the viewer to the procuress figure in contemporary images of sexual liaison, giving voice to contemporary fears about the breakdown of moral and social order, and serving to identify sensual attraction as a form of seduction.[20]

These two drawings open up and develop the themes that Baldung enunciated in his woodcut of 1510. They exemplify his keen and continuing interest in the subject of witchcraft, just as the copies of his works by other artists demonstrate a wider interest. Baldung's drawings – exquisitely executed, and by virtue of their one-off production created for a limited audience – could afford to be artistically and thematically daring. It was only indirectly, through the copies made by other artists, that they could influence a broader public's understanding of witchcraft. The shaping of particular ideas of witchcraft were more likely to be achieved through woodcuts, either in the single-leaf format, or as part of a broadsheet, pamphlet or book. The woodcut of 1510, for instance, must have brought Baldung far greater exposure than any of his drawings. Three chiaroscuro versions of the original survive, as well as one black and white print made from the outline block. We also know of four different copies of the woodcut by other artists.[21] On the basis of general estimations of print runs of a thousand copies for such single-leaf woodcuts,[22] it seems justified to assume a fairly high level of circulation. But, as I shall argue below in Chapter 3, a 1516 woodcut (fig. 3.1), itself modelled on the 1510 woodcut and probably produced by Baldung's workshop, was the most important instrument for the dissemination of Baldung's new iconography throughout the sixteenth century. The grouping of female witches around the cauldron, and the riding of animals or implements through the sky, would become two of the most common ways to depict witches in the sixteenth century. As much as a century later Jacques de Gheyn II would still draw on Baldung's compositional model of a group of women gathered around a cauldron under a gnarled tree in the countryside with witches riding through the sky above. It was only the work of de Gheyn's contemporaries, such as Frans Francken II and Jan Ziarnko, that made a decisive break with this iconography and established quite different patterns and emphases in the seventeenth century.

Claims for the formative character of Baldung's 1510 woodcut should not be understood as a total break with past traditions. While Baldung's work represented witchcraft in a visual language that was intelligible and significant to the literate viewers of Strasbourg and south-west Germany, the success of his imagery was also related to his capacity to draw on and adapt images of witchcraft developed in the previous generation. This only became possible through the new technology of print. Print gave Baldung access to the range of image-making created over the previous two decades, and also to those persons engaged in fashioning and shaping the broader cultural discourse of witchcraft, whether as authors, editors, printers or patrons. For printing created new environments for artists, new cultural spaces in which artists could make contact with a range of cultural producers and audiences. Print also made the work of artists more affordable, more widely circulated, and by virtue of that, more accessible.

The images which played the most significant role in shaping Baldung's iconography of witchcraft in the second decade of the sixteenth century – as women gathered around a cauldron or riding through the sky – was a series of six woodcuts that appeared in more than 20 illustrated editions of Ulrich Molitor's *On Female Witches and Seers* between 1490 and 1510. It would be difficult to exaggerate the impact that the Molitor images

had on contemporary representations and perceptions of witchcraft. Of the 16 Latin and three German editions published before 1500, no less than 11 different printers were employed from nine different cities: Reutlingen, Strasbourg, Ulm, Cologne, Basel, Speyer, Hagenau, Erfurt and Leipzig.[23] And in the first decade of the sixteenth century, illustrated editions of the the work were again published in Augsburg (1508) and in Basel (1510).[24] By the turn of the sixteenth century, therefore, Molitor's work had become extremely popular, or was at least regarded by printers as very marketable. There seems little doubt that this marketability had much to do with the accompanying illustrations. The same scenes were recycled again and again with only slight stylistic and iconographical changes. The woodblocks were clearly sold to a number of printers, as in some cases the images were simply reversed or slight changes made to their accompanying frames. In some editions particular woodcuts were repeated, their order altered as they were attached to different chapters, or they were used as titlepages or conclusions to the text.

Ulrich Molitor, a doctor of laws and procurator of the episcopal curia in Constance, had been commissioned to write his work by Archduke Sigismund of Austria.[25] The commission was probably the result of regional tensions created in Innsbruck in 1485 by the Dominican inquisitor and author of the *Malleus Maleficarum*, Heinrich Kramer, which led to strong opposition from Bishop Georg Golser of Brixen, and to Kramer's eventual expulsion from Golser's diocese in early 1486.[26] Molitor's work took the form of a discussion of nine questions by three participants: the Archduke Sigismund, Konrad Schatz, the mayor of Constance, and Molitor himself. Partly because of its dialogue form Molitor was able to express a range of viewpoints and considerable skepticism concerning various claims made for the powers and behaviour of witches. The text denied the witches' Sabbath and night riding, for instance, just as it refuted the claim that witches could cause impotence or transform humans into animal shapes. These apparent effects were imaginary, it argued, the result of diabolically induced fantasy and illusion. The woodcuts were something of a fourth voice within this meandering colloquy and communicated views which differed from those found in the literary text: they represented the powers of witchcraft not as diabolical illusion but as producing real effects in the everyday world. For that reason they could be understood and digested independently of the text. It must have been this independent status, together with the capacity for continual recycling as a series, which enabled them to achieve their pre-eminent role in establishing a visual language for witchcraft in the later fifteenth century, and for the adoption and transformation of some of their key iconographical elements by artists such as Baldung early in the next century.

The woodcut that occurs most frequently in the various editions of Molitor's work, and achieves considerable prominence through its reproduction as a titlepage in at least seven cases, depicts two witches putting a cock and a snake into a belching cauldron and causing a hailstorm (fig. 1.4).[27] In most editions it accompanies the section headed 'Whether the devil can make hail or thunder'. While the text is concerned to stress that weather sorcery can be performed only by the power of the devil and not by witches' rituals, the woodcut ignores this issue of the devil's agency. The artist depicts weather sorcery as the result of rituals performed around a cauldron, and the agency of the women remains unquestioned. In this way the woodcut transmits quite traditional beliefs about the magical powers women were believed to have in causing bad weather.

So why did the cauldron achieve such wide circulation in the 1490s through the many editions of Molitor's work? From as early as the sixth century there had been an association

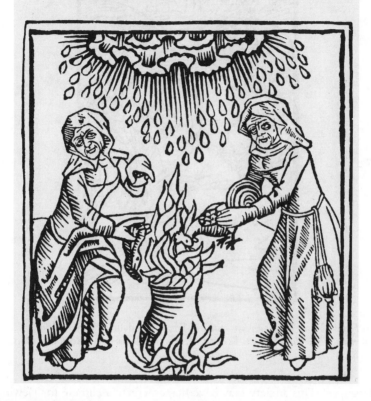

Figure 1.4 Two Witches Cooking up a Storm, titlepage woodcut, in Ulrich Molitor, *De laniis et phitonicis mulieribus*, Cologne: Cornelius von Ziericksee, *c.* 1496–1500. From Schramm, vol. 8, fig. 928.

between witchcraft and cauldrons, as the receptacles in which it was believed witches brewed their potions.[28] But cooking up dead animals in cauldrons did not seem to be a common technique for performing weather sorcery. The only visual depictions of weather sorcery we have prior to Molitor involve conjuring with an animal's jawbone, while almost all literary descriptions involve water. However, one of the most common literary and theological sources for the development of fifteenth-century witchcraft theories, the work called *Formicarius* (*The Ant Colony*) by the Dominican Johann Nider, describes how a witch named Stadlin from the Swiss town of Boltingen would stir up hailstorms by sacrificing a black chicken at a crossroad and then throwing it up in the air for the 'prince of demons' to catch. This story would have become widely known in the late 1480s and 1490s by its inclusion in the *Malleus Maleficarum* and, in this way, may have become the source for the Molitor woodcut.[29] While weather sorcery was a relatively infrequent charge in fifteenth-century witchcraft trials, it was most commonly found in south German and Swiss territories, where there was also considerable concern about ecclesiastical

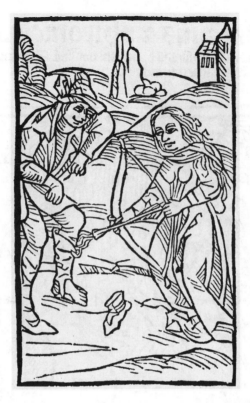

Figure 1.5 A Female Witch Lames a Man with an Arrow, woodcut, in Ulrich Molitor, *De lanijs et phithonicis mulieribus*, Speyer: Konrad Hist, *c.* 1494, fol. a4ᵛ. From Schramm, vol. 16, fig. 615.

weather blessings.[30] This anxiety may have helped create a climate for viewing weather sorcery, a form of magic with communal rather than merely individual consequences, as an especially destructive and therefore evil form of magic. And storm-making may have therefore emerged as an iconic image for the new social crime and heresy of witchcraft.

An image depicting women performing weather sorcery around a cauldron must have also been considered very apt to head a work that closely identified women and witchcraft. First, weather sorcery was generally associated with women.[31] Second and most importantly, both the Latin and German titles of Molitor's work specified that it concerned *female* witches and seers. While the *laniae* and *pythonicae* of the Latin title are rather abstruse terms, the critical descriptor is *mulieres* (women).[32] It is a treatise about witches and diviners who are women. The subtitle in the German editions is very direct: *A treatise concerning evil women called witches* (*Tractatus von den bosen wyber die man nennet die hexen*). The most common title-page woodcut for early editions of Molitor's work depicted sorcery as a social threat which stemmed from groups of female practitioners.

Another Molitor woodcut to draw on traditional malefic sorcery to represent the power of witchcraft is that of a woman laming a man by shooting him in the foot with a reversed, and possibly charmed or poisoned, arrow (fig. 1.5). In most editions the woodcut accompanies the chapter of Molitor's text headed, 'On the harm and illness done to children and adults', and leaves little doubt about the effectiveness of this act of

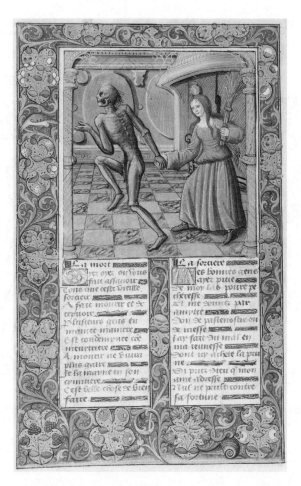

Figure 1.6 The Witch and Death, manuscript illumination, in *Danse Macabre des Femmes, c.* 1500. Paris, Bibliothèque nationale de France, MS fr. 995, fol. 39ᵛ.

malefice, represented symbolically by the loss of the peasant's boot. In most versions the female witch is shown bareheaded, displaying her flowing hair. Her unkempt hair signifies her wild and dishevelled nature, a common visual cue increasingly employed in the sixteenth century.[33] There may also be suggestions of uncontrolled sexuality here, given that the witch is depicted as an aggressive virago, transgressing her proper female role. An almost contemporary representation from a Parisian *Women's Dance of Death* of *c.* 1500 also depicts the witch with long and dishevelled hair (fig. 1.6), a characteristic which distinguishes her from the other female characters in the dance; while in the earlier 1491 printed version, on which this later manuscript was modelled, the witch was represented as a traditional sorcerer, with a head covering and exclusive attention given to her gesture of conjuration.[34] It seems as though the loose unbridled hair of the sexually dissolute had begun to be considered an appropriate visual cue for identifying the social and moral threat of witchcraft in the last decade of the fifteenth century.

This woodcut of a laming witch primarily gives expression to the most common charge of malefic sorcery in later medieval Europe: the inflicting of physical harm, injury

Figure 1.7 Witch and Devil Embracing, wood-cut, in Ulrich Molitor, *Von den Unholden oder Hexen*, Ulm: Johann Zainer, 1490?, fol. B5ᵛ. From Schramm, vol. 5, fig. 419.

Figure 1.8 Witch and Devil Embracing, wood-cut, in Ulrich Molitor, *De lamiis et pythonicis mulieribus*, Basel: Johann Amerbach, *c.* 1495, fol. 1ᵛ. From Schramm, vol. 22, fig.1278.

or sickness. Although the shooting of an arrow would not normally involve magic, the reversed arrow suggests it is not the weapon itself which will bring harm to the victim, but the poison or charm for which the arrow has become the means of contact. The woodcut in the Speyer edition (fig. 1.5) displays very clearly the reversal of the arrow and includes something attached to the shaft.[35] The shooting of bristles and other substances into an animal or human by means of an arrow was a common form of malefice in the fifteenth century and was also cited in the sixteenth century as the work of the devil.[36] Smearing with unguents and hurling powders, offering poisoned food or drink, placing charms in a person's proximity such as under a pillow or above a lintel, were all ways of doing harm to an enemy. The arrow sorcery represented here is a particular variant of bringing magical substances in contact with the bodies of those to be harmed.

While Molitor's text did not deny the physical threat of witchcraft, as expressed most graphically in the woodcut of the laming witch, it tended to emphasize the diabolical source of such action and the divine permission needed to carry it out successfully. The woodcut series reflects this diabolical emphasis in one particular image – a devil and witch shown embracing in a country setting. The embrace clearly signifies sexual liaison and would therefore seem to be a very early visual representation of the diabolical pact.

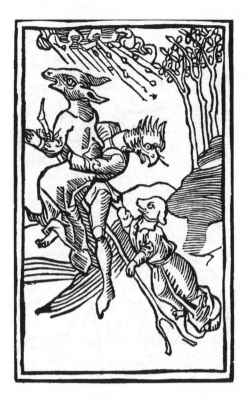

Figure 1.9 Transformed Witches Ride a Forked Stick through the Sky, woodcsut, in Ulrich Molitor, *Von den Unholden oder Hexen*, Strasbourg: Johann Prüss, *c.*1493, fol. B3ʳ. From Schramm, vol. 16, fig. 618.

In the Zainer edition from Ulm (fig. 1.7) the devil sports a hunting hat, but his true nature is betrayed by the tail emerging from beneath his short, slit-style tunic, by his donkey ears and his hoofed feet; in most other editions, such as the Amerbach edition from Basel (fig. 1.8), the devil has been given clawed feet and also fang-like teeth, which give him an especially lecherous appearance. These are common visual characteristics of the devil in the later fifteenth century and emphasize his beastly and sensual nature. Here they are particularly apt as the devil draws the witch towards him and – in the Zainer edition – rests his right hand on her breast. The woman's headdress indicates she is married, and so we have a scene not only of diabolical seduction, but also of adultery. This woodcut was usually located in one of two chapters that raised key demonological questions of the period: 'Whether the devil can appear in human shape and sleep with women' and 'Whether children can be born of the sexual intercourse of the evil spirit [with women]'. While Molitor's textual discussion of these questions was complex, the woodcut simply affirmed the sexual liaison between witch and devil as fundamental to witchcraft belief.

The diabolical nature of witchcraft also features in the Molitor woodcut depicting three witches with animal heads, about to ride a forked stick through the sky (fig. 1.9). The image represents the witches' powers of metamorphosis and their capacity to traverse vast distances. The assumption of animal form is analogous to the devil's

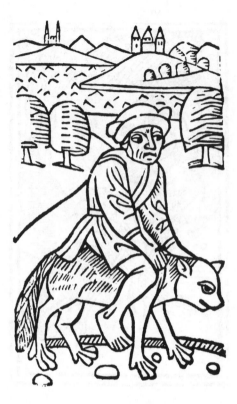

Figure 1.10 Male Witch Riding a Wolf, woodcut, in Ulrich Molitor, *De lamiis et pythonicis mulieribus*,
Basel: Johann Amerbach, *c*. 1495, fol. 8ᵛ. From Schramm, vol. 21, fig. 713.

assumption of human form. Molitor's accompanying chapter is headed, 'Whether they
themselves can be transformed into another shape or whether they can transform
others'. The riding of the cooking fork, seemingly the first instance of this implement to
appear in scenes of witchcraft, makes it fairly clear that these are transformed witches
rather than bewitched victims. Transformation was seldom a concern in late medieval
sorcery or witch trials, but it did constitute an important theme in late medieval
discourse. The *Malleus*, for instance, discussed it at considerable length in a number of its
chapters, and it was also frequently represented in visual form.[37] The late medieval
viewer, on the other hand, may well have related this image to the animal-masking tradi-
tions of carnival, for the ass was a figure resonant with folly, while the rooster and its bris-
tling comb was employed to represent the exhibitionism, transgression and sexual
masquerading of carnival time.[38] In this way witchcraft would allude to issues of moral
order, the subject of the pre-Reformation folly literature of moralists such as Sebastian
Brant and Thomas Murner, and a theme developed further by Dürer and Baldung a
decade later: in the inversions of the riding witch (fig. 1.12), or the inclusion of bells and
fools' caps into Baldung's witchcraft scenes (fig. 1.3). By the time of the Molitor editions
of 1544 and 1545, the female witch riding a cooking fork through the sky is depicted
caught in the devil's lusty embrace (fig. 4.17).

The riding motif appeared in another Molitor woodcut and in somewhat surprising
form: a witch is depicted riding a wolf through the countryside, and in all editions other

24

than the Zainer, the witch is depicted as male (fig. 1.10).[39] The woodcut is clearly an illustration of a particular story in Molitor's text that told of a peasant from the territorial court of Constance and how he was bewitched and struck lame by a male witch riding a wolf. In the Zainer edition, where the riding witch is depicted as female, it would appear that the artist was illustrating the subject of the chapter as a whole, 'Whether witches can ride to their feast on an oiled stick or on a wolf', rather than the particular story from Constance. Indeed, in the summary of chapters found at the beginning of the Latin edition of Molitor's work, the chapter heading was expanded to read 'or on some other animal'; while in the German edition it became 'or on wild animals'. In other words the riding motif would have been critical, rather than a particular narrative or even the gender of the witch.

Any who read Molitor's accompanying text were also quite likely to have linked the woodcut to a whole genre of medieval stories about the Wild Ride. For the text specifically compares the ride of these witches out to their feast – or 'to their pleasure' ('wollust'), as Molitor calls it – and the fantasies of women in medieval penitential literature who claimed to ride out on animals in the company of pagan goddesses such as Diana and Herodia.[40] Why the artist did not attempt to portray a group of wild female riders for this chapter remains a little puzzling. But perhaps in the last decade of the fifteenth century witchcraft was still generally perceived in terms of traditional malefic sorcery, rather than as the behaviour of a diabolically linked and mainly female group. It was not until the first decade of the sixteenth century that Albrecht Dürer and Albrecht Altdorfer developed these early tentative images into the disturbing visual code of the riding witch (figs 1.12 and 1.13). And the extent to which this influenced the visual tradition, and even later illustrations of Molitor's work itself, can be clearly seen from the 1544 and 1545 editions, where the artist has used inversion to clearly identify the witch's ride as wild and disorderly (fig. 4.16).

The sixth Molitor woodcut (fig. 1.11) marks a significant point of transformation in the representation of sorcery in the later fifteenth century. It emphasizes witchcraft as a group female activity rather than the action of a solitary male or female sorcerer. The scene of three women engaged in a meal and conversation under a tree clearly links witchcraft to contemporary fascination with female sociability and independence. The differing dress and ages of the three women serve to emphasize the bond between them, a bond of conviviality created both through the consumption of the food and drink on the table and through the conversation represented by their gestures. The pointing gesture of the senior figure has been adapted from the declamatory gesture of the rhetor and is commonly used in the later fifteenth and sixteenth centuries to represent female prattle or gossip.[41] It is also used to designate the uttering of sibylline prophecy and the casting of spells. The 1473 edition of Boccaccio's *On Famous Women*, for instance, printed in Ulm by Zainer, included many woodcuts of the sibyls and of sorcerers such as Mantho and Circe, with very similar hand gestures (fig. 5.5).

It seems likely that these apparently innocent scenes of female conviviality were meant to convey stern warnings concerning the powerful tongue of witchcraft. The Cologne editions in particular, with the heavily underlined eyes of the female participants (fig. 1.11), convey a strong sense of evil.[42] A sausage held up by a woman with a knife may also allude to the attested power of witches to castrate. For the scene is of the women's 'pleasure' – a site of unlicensed, sensual gratification out in the countryside, beyond the supervision of legitimate authority and outside the mastery of men. These intimations of

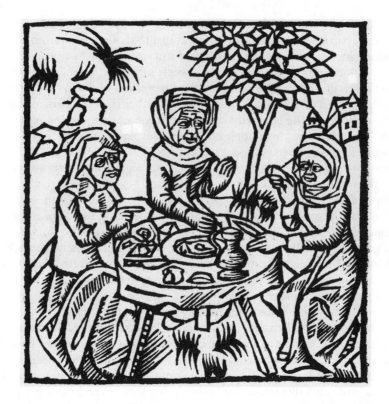

Figure 1.11 Female Witches Eating Together, woodcut, in Ulrich Molitor, *De laniis et phitonicis mulieribus*, Cologne: Cornelius von Ziericksee, *c.* 1496–1500, fol. d2ʳ. From Schramm, vol. 8, fig. 935.

female desire, in a context of food, drink and conviviality, may well have been the stimulus for the far more explicit sexualized images of groups of witches created by artists such as Baldung and Altdorfer in the following decade (figs 1.1, 1.13).

The notion of witchcraft as a female group activity is fundamental to its visual representation in the sixteenth century and to the transformation of older ideas of malefic sorcery. Examples of such group representation, in some cases quite dramatic examples, are certainly found in the fifteenth century and are based on the conceptual elisions which transform malefic sorcery into diabolical heresy and witchcraft. These will be the subject of examination in Chapter 2. Yet such cases are very much in the minority. The clear majority of images represent sorcery as an individual act usually directed towards bringing about some outcome unattainable by other means, and often involving harm to a known or unknown victim. But from the late fifteenth century the group and female character of witchcraft, as well as its exclusively harmful purposes, becomes far more pronounced.

The Molitor images were critical to the development of a new visual language of witchcraft. In them we can see older images of sorcery as an individual act gradually being transformed into the group and female behavior of witchcraft. This new emphasis occurred through the adoption and constant reiteration of visual cues, such as the cauldron, the hailstorm, the riding of animals, the cooking fork and wild hair. Their critical influence lay as much in their capacity as woodcuts to be constantly reproduced. It is

commonplace in fifteenth-century scholarship to argue that one of the most significant aspects of the new craft and technology of print and printmaking was the ability to create exactly repeatable images. The significance of the Molitor woodcuts reproduced over two decades in over 20 editions was precisely that: they allowed a limited number of images to be repeated and recycled, both in the one work and also in numerous editions published by different printers in a range of different cultural centres. The introduction of only minor variations to a fairly standard set of images and recurring iconographical motifs helped consolidate the more general patterns of meaning on which later artists could build. Through such repetition and recycling the range of visual possibilities for sorcery and magic could first of all be dramatically narrowed and limited, to particular acts of malefice such as weather sorcery, and then a far more focused and controlled iconography for the identification of witchcraft could be developed. The Molitor woodcuts were critical for achieving the first of these ends; artists of the following decades, such as Baldung Grien, Dürer, Altdorfer, Urs Graf, Hans Schäufelein and Lucas Cranach, were responsible for the second. But it was print and printmaking which provided the appropriate material and cultural conditions for the serious consideration of the theme of witchcraft by visual artists in the sixteenth century.

We have already seen how Baldung Grien's 1510 woodcut and later drawings developed a range of meanings and associations through their depiction of witchcraft as a group of female witches gathered around a cauldron. It was a visual code that Baldung may well have adapted from the Molitor woodcuts and combined with his fascination for sexuality, death and disorder, themes already evident in his earliest work. A second visual code for witchcraft that he also developed in these years was the figure of the riding witch. Also prominent in Baldung's 1510 woodcut, it was developed by his two older contemporaries: by Dürer in his engraving, *Witch Riding Backwards on a Goat*, completed some time after 1500 (fig. 1.12); and by Albrecht Altdorfer in a chiaroscuro drawing of a *Witches' Scene* of 1506 (fig. 1.13). Given the widespread circulation of the Molitor woodcuts, it would seem likely that the riding theme depicted in two of them played a significant role in this iconographical development. But there is no clear evidence. We can be fairly confident, however, that Baldung was at least familiar with Dürer's engraving. After early training in Strasbourg and probably somewhere in Swabia, Baldung came to Nuremberg as an 18 year old in 1503 to join Dürer's workshop and its young apprentices, Hans Süss von Kulmbach, Hans Schäufelein and Wolf Traut. He remained in the workshop till 1507 and was likely to have been there at the very time Dürer executed the engraving of the witch, or at least a short time after.

Dürer's engraving of the *Witch Riding Backwards on a Goat* is characterized by an overwhelming sense of wild energy and replete with allusions to sexual disorder.[43] The concentrated gaze, the open mouth, the flying hair, the unusually muscular torso, the tension in the woman's left arm as it holds fast the horn of the goat, the somewhat awkward grip of the distaff between her fourth and fifth fingers, all in the face of the elemental disruption of a storm, serve to communicate extraordinary power. The image is a far cry from the sorcerer riding on the wolf in the Molitor series (fig. 1.10), although it has incorporated the visual cue of the storm from that series, to help identify the figure of the witch – possibly an indication of Dürer's familiarity with these woodcuts, and in particular the image of transformed witches riding a cooking stick through the sky (fig. 1.9). The nature of this witch's power is primarily defined by allusions to inversion. Her hair flies out unnaturally, for instance, in a direction contrary to the hair of the goat on

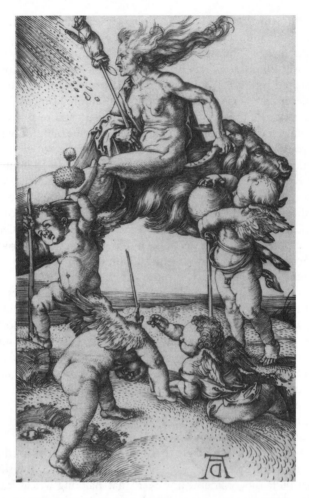

Figure 1.12 Albrecht Dürer, *Witch Riding Backwards on a Goat*, *c.* 1500, engraving. National
Gallery of Victoria, Melbourne, Felton Bequest, 1956.

which she rides. It is a backward ride, and the inversion is further emphasized through
the back-to-front rendition of the Dürer monogram.

For sixteenth-century viewers, a backward ride would have immediately established
the allusion to sexual inversion. Riding backwards on an animal, often on an ass, was a
frequent form of humiliation in the late Middle Ages, used to punish those who had not
maintained the honour considered appropriate to their gender. These were symbolic
performances, which represented control of the local community over the sexual
economy. Those who were paraded backwards had threatened the sexual balance and
order of the community, had confused roles, had failed to maintain the gender identity
and honour necessary for moral order. The sexual disorder of the witch was also encoded
in the goat which, as we have already noted, was strongly linked to the sin of lust in the
late Middle Ages through the iconography of the seven vices. The most common mode
of representing the vices in the fifteenth century was to depict them as women riding
animals, and the rider delegated to the goat was always the figure of lust.

Dürer's witch riding backwards emphasizes the transgressive lust of his female rider by having her hold the goat's horn with her left hand and the distaff with her right. The horn of the he-goat refers to practices similar to the backward ride in the culture of pre-modern European societies.[44] A cuckolded husband was made to wear the phallic horns of the goat, marking him as a fool who had failed to maintain his male virility and honour. The horn sign was consequently associated with fools in the popular broadsheets of the sixteenth century, a visual variant of allusions to cuckoldry and gender inversion in contemporary proverbs. The cuckold, who allowed his wife to commit adultery and escape control, also allowed the proper gender and moral order to be reversed. He had acted like a goat, in so far as he had abrogated his masculine authority and allowed another male access to his mate. His action brought about his sexual and social emasculation, and consequent exposure to public ridicule. His wife had effectively become master, the woman on top. This appropriated sexual power of the witch is further underlined by the distaff that rises from the crotch of the riding woman as an appropriated phallus. Whether the contrast between the rather awkward and tenuous grasp of the distaff and the firm grasp of the horn would have been read as significant by the sixteenth-century viewer is difficult to gauge. But the combination of distaff and horn would certainly have been clearly understood. Spinning was traditionally regarded as women's work, and so distaff and spindle were frequently used as visual codes of the female, whenever gender relations were the subject at issue. Here then was a wild and powerful woman, not only associated with the lasciviousness of the goat and the vice of lust, but one who had inverted the gender order by appropriating male power and sexuality for herself.

Dürer's allusions to two classical figures and their associated iconographical traditions in his woodcut would have helped underpin these ideas and give them a broader currency and credibility. First, there is the reference to Aphrodite Pandemos, the earthly Venus, goddess of lust and of the night, on whom, as Charmian Mesenzeva has argued, Dürer modelled his figure of a witch.[45] The winged *putti*, similar to those associated with the Priapus and Dionysius cults in fifteenth-century Italian representation, become her attendants; they are acolytes of a goddess of lust who through their somersaults define that lust as inversion. Second, there is the allusion to the god Saturn, through the depiction of a Capricornian goat with the tail of a fish or serpent. Saturn is the god who achieved power by castrating his father and eating his children, the patron of agricultural labourers and the poor, of the aged and crippled, of dishonourable trades, criminals, Jews, cannibals and also of magicians and witches. Dürer's riding witch becomes a 'child' of Saturn, who unmans through sexual violence and appropriates power in the manner of her 'father'.[46]

Contemporary interest in Dürer's engraving is demonstrated by woodcut copies made within a short time by Benedetto Montagna and two unknown artists, and by a small bronze created by an unknown southern German artist, probably also inspired by Dürer's work.[47] Dürer's engraving also seems to have been the source for Baldung's riding witch in his 1510 chiaroscuro woodcut, in which Baldung adapted Dürer's figure to fit within his group cooking scene, replacing the distaff with cooking fork and pot. In this way Baldung created a model for the riding witch that would link it more effectively to the female tasks associated with the cauldron. Baldung may have been more generally influenced by the Dürer image, in his emphasis on the erotically charged witches' bodies as a source of their power, and the threat this represented to a male gender order.

However, as I argue below in Chapter 4, the resilience of the image of the riding witch and its broad acceptance as a visual code for witchcraft could not simply depend on the iconographic models of Dürer and Baldung. It was also linked to the Wild Ride and Furious Horde of Germanic folklore. And it is in forging this link that Altdorfer's chiaroscuro drawing of a witch scene (fig. 1.13) seems to have played a critical role. Although we know little of Altdorfer's movements prior to his taking up citizenship in Regensburg in 1505, his early work does indicate the influence of Dürer. It is reasonable to suggest that the two artists were known to each other and that in this way Baldung became familiar with Altdorfer's work. Sigrid Schade even claims that it was in Dürer's workshop that Baldung must have seen Altdorfer's drawing of the witch scene shortly after its completion in 1506.[48] Although we have no clear evidence that Baldung knew Altdorfer's drawing, the fact that this is the first representation of witchcraft to combine one or more riding witches with a female group engaged in rituals in a forest suggests that he did.

Altdorfer has used the chiaroscuro effects of a white gouache on brown tinted paper to create an eerie forest setting quite typical of his early drawings.[49] Four women, three of them largely naked, are engaged in some form of ceremony. The seated woman has no more than a piece of cloth slung over her shoulders, her naked breasts, legs, stomach and arms highlighted with the white gouache; the standing woman with the pitch fork wears a mantle fastened at the neck as though by a necklace, while an elaborate purse and knife hang from a waistband; a third has a long piece of material wound around the waist, falling down and only partly covering her buttocks. All have prominently highlighted hair which links their bodies with the frizzy shrubbery of the forest; and the very masculine stance of the central woman, a pitch-fork positioned between her legs, adorned with an elaborate purse and several necklaces, recalls contemporary images of prostitutes. The animal skull on the ground, on the other hand, alludes to necromantic rituals, while the vessel and large circular dish at their feet probably refer to the salves and oils which witches rubbed on their bodies in preparation for the wild animal ride to which they direct the viewer with raised arms.

The significance of these riders is that they form a group, moving through what looks like a trail of fog or smoke. At least some of them are witches, for one in the leading group carries a forked stick, relying on a visual cue popularized through the Molitor series for her identity; while another is depicted with streaming hair, a distaff in one hand and the horn of the goat in the other, similar to Dürer's riding witch. This is not a backward ride, however. Altdorfer depicts her in the more common female mode of riding side-saddle – but her nakedness and open legs suggest a state of sexual abandon.

If Baldung had known Altdorfer's drawing, why did he choose not to incorporate such a group ride in his woodcut of 1510? The group ride of witchcraft was a theme which continued to stimulate interest among Baldung's fellow artists, especially among those intellectually well-connected, as we shall see in Chapter 4, and at least one artist made a copy of Altdorfer's drawing.[50] One answer is stylistic: the inclusion of so many figures would threaten to disrupt the compositional unity of Baldung's scene. Just as importantly, however, Baldung's inclusion of a cauldron and emphasis on the preparation and consumption of food and drink privileged an understanding of witchcraft that gave primacy to the witch's female body. This would militate against the inclusion of a Wild Ride, with its participation of demonic spirits and restless dead and its clearer association with violence and destruction. Baldung opted to include a single backward-riding figure, adapted from Dürer, through which a well-established association with the traditional

Figure 1.13 Albrecht Altdorfer, *Witches' Scene,* 1506, pen and ink, heightened with white gouache on brown-tinted paper. Départment des Arts Graphiques, Musée du Louvre, Paris, Inv. 18867. © Photo RMN/ © Jean-Gilles Berizzi.

medieval iconography of the vices would link riding more effectively with the themes of gender inversion below. In the religious and intellectual environment of Strasbourg, where in 1509 the most famous city preacher, Johann Geiler of Kaysersberg, had delivered a Lenten sermon in the city cathedral on the popular understanding of the Furious Horde and Wild Ride ('Von dem wütischen Heer') – a sermon Baldung himself might have heard[51] – Baldung would have been well aware of these popular beliefs. But his particular engagement with witchcraft focused more on how ideas of the Wild Ride could give expression to the themes of death and sexuality that preoccupied him as an artist throughout his career.

These themes come to the fore in the one other witchcraft image produced by Baldung during his long artistic career: a woodcut entitled *Bewitched Groom*, created in 1544, one year before his death (fig. 1.14).[52] This woodcut represents witchcraft in quite different ways to the sexually charged bodies of his earlier works; and despite its much later date, consideration of it is very relevant to the emerging visual language of witchcraft. It provides a graphic example of another, older, visual code for representing witchcraft – the witch figured as an individual malefic sorcerer with the capacity to inflict physical harm on her victims. While more traditional than the new iconography of cauldrons and riding, it was not simply tradition-bound, as exemplified by Baldung's print. By means of sometimes quite small visual cues – a demon, wild hair, a cooking fork or a thunder storm – such more traditional ways of depicting sorcery could be transformed into images of diabolical witchcraft.

In this 1544 woodcut Baldung succeeds in linking the individual witch-sorcerer and the harm she inflicts to the power, seduction and fear of sexuality. The sexuality of the witch is clearly alluded to by the breast which hangs free from her clothing and by the flaming torch which she brandishes above her head. The coat of arms hanging on the wall, dislodged and left askew, signifies its impact. Indeed, the witch is hardly the focal point of the woodcut. Her attention, just as the viewer's, is focused on the victim of her bewitchment – the apparently lifeless body of a groom lying on the floor, his left hand positioned next to a currycomb, his right loosely holding a forked stick. Though one would expect this to be a pitchfork with three prongs, the use of a two-pronged cooking fork immediately associates the figure with acts of witchcraft.[53] And what is critical in this highly charged and carefully elaborated, though somewhat mysterious, scene is the manner in which the groom's body is displayed to the viewer. The line of vision, from the feet up along the legs to the crutch, makes the codpiece the focal point. The groom's upper body and head is clearly of secondary importance, and is further eclipsed by the turned horse, standing in the doorway of its stall and positioned just above the groom's head. It casts a piercing look out at the viewer, while the swish of its tail uncovers its genital area. Sexuality is clearly the subject of the image, and not simply witchcraft.[54]

The *Bewitched Groom* has stimulated a range of quite different readings. Gustav Radbruch has read it as an allegory of anger, which the witch has incited in the horse in order to cause fatal injury.[55] Gabriel von Térey, Maxime Préaud and Dale Hoak have related it to an Alsatian legend, in which a female sorcerer takes on the shape of a black horse.[56] Dale Hoak has combined this shape-shifting legend with the harm carried out by the evil eye of the hag in the window and with the moral wounds of sexual seduction. Charmian Mesenzeva has linked the woodcut to a number of closely related medieval folktales concerning a Squire Rechenberger who was abducted by the devil on a Wild Ride.[57] The stories told of a robber-knight, who led a lawless and sinful life until he experienced a

Figure 1.14 Hans Baldung Grien, *Bewitched Groom*, *c.* 1544, woodcut. National Gallery of Art, Washington D.C., Gift of W.G. Russell Allen. Image © Board of Trustees, National Gallery of Art, Washington D.C.

vision of a Wild Ride with a riderless old horse. He was told the horse was the devil's and would be ready for him in a year. In fear and repentance the squire retired to a monastery where he worked in the stable. Exactly a year later fate caught up with him and the squire was killed, in some versions by the very same horse he saw one year earlier. His grave was later visited by that horse; it was saddled, and the squire's gloves hung from the saddle. The squire rose from his grave, mounted the horse and disappeared, taken off by the devil.

Other scholars have taken a psychological approach to the subject matter of the print and understood it as a reflective statement by Baldung concerning his inner self and sensuality. This interpretation rests on a reading of the coat of arms with the unicorn as the Baldung family coat of arms – which was modelled on that of their city of origin, Schwäbisch Gmünd.[58] G.F. Hartlaub, for instance, who argues that Baldung must have intentionally left open the question of the groom's identity by giving him an appearance similar to his own, interprets the scene as Baldung's dream concerning his own death and the spiritual dangers that await those who fail to bridle their sensual passions. The unsaddled horse symbolizes those passions, argues Hartlaub, drawing on its use in contemporary *emblemata* and also in Baldung's famous wild horses series which he completed 10 years earlier. Baldung's woodcuts, also reflexive in nature with references to himself, give graphic expression to male sexual instincts – as in the rare depiction of an ejaculating stallion confronted with the hind quarters of a mare.[59]

Linda Hults has developed Hartlaub's understanding of the groom as alter ego. She argues that it represents Baldung's self-consciousness; and by drawing on the Renaissance concept of artistic melancholy, she identifies this self-consciousness with that of the melancholic artist. By reference to a preparatory drawing for the print, she has shown that the groom is not in fact dead, but is either unconscious, sleeping or dreaming. The horse and witch then become figments of the artist's imagination or fantasy. Like Hartlaub, she uses Baldung's wild horse series to argue that the horse in this print represents the artist's sexual instincts. So too does the partly naked witch with the torch. The subject of the print, then, is a commentary on the consequences of failing to bridle one's sexual appetites, a meaning supported by other contemporary depictions of dream fantasies and the use of the dropped currycomb – the German *striegeln*, 'to curry', also means 'to dominate by beating' – to allude to lack of sexual control. The only significant reservations I have with Hults' insightful reading of the print is that she understands the moral statement it contains to refer specifically to 'the special vulnerability afforded by his [Baldung's] profession and temperament'.[60] I find no real grounds to connect the subject of this woodcut to Renaissance notions of the artistic temperament, let alone to the (indisputable) links between witchcraft and melancholy. The critical importance of such analyses, in my view, is the recognition that the print's primary concern is with sexual fantasies. But as with Baldung's wild horse series, this seems to have less to do with the sexual fantasies of artists than with the sexual fantasies of males. The unusual foreshortening of the groom's body screams out to the viewer that the subject is male sexual desire; so does the piercing look of the horse, its anus uncovered by the swish of its tail. Witch and horse together emphasize the destructive consequences of uncontrolled sexual desire.

The creative power of this print rests on the very denial of a single reading. It suggests numerous readings and refuses to be limited to any one. The depicted coat of arms approximates that of Baldung's family, but is not an exact replica; the groom may well be Baldung, but it could also be someone such as Rechenberger; the figure may well be dead, but he may also be simply asleep or dreaming; the witch may be about to torch the

barn in an act of malefic sorcery, but her torch may simply represent the flaming vessels held by witches in Baldung's other images. By alluding to the Squire Rechenberger legends, similar to those other medieval tales of the devil who comes on his horse to collect the bodies or souls of those pledged to him, Baldung locates his exploration of sexual desire within a traditional moral context. And by intimating that he himself is the victim, he emphasizes the relevance of sexual fantasy to his viewers. The witch and victim suggest that the scene be read according to traditional visual codes of malefic sorcery; but the carefully orchestrated composition and iconography invite the viewer to look beyond these appearances and explore how uncontrolled sexual desire is itself a form of destructive bewitchment.

Hans Baldung Grien was without doubt the most creative artist to deal with the subject of witchcraft in the early sixteenth century. This is clear from an analysis of the two woodcuts which frame his interest in the subject throughout much of his life as an artist. It becomes even clearer if one explores the rich iconography of his so-called Freiburg drawings, which I have only begun to do in this chapter. Consideration of these few images by Baldung and his fellow artists Dürer and Altdorfer, has demonstrated how profoundly the visual language of magic and sorcery was transformed in the first two decades of the sixteenth century after the gropings towards a new iconography through the Molitor woodcut series of the 1490s. In order to depict this new subject these artists developed a new visual vocabulary through the employment of a range of visual cues – wild hair, cauldrons, cooking sticks, smoke, animals and storms – and then fashioned these elements into the three dominant visual codes through which the key meanings associated with witchcraft would be communicated to a Europe-wide audience over the next century. But it was especially the woodcut – in the form of a single leaf, a broadsheet or a book illustration – that created the conditions conducive for the growth of interest in this new subject by visual artists; just as it was the woodcut that was primarily responsible for disseminating these images to the broader society. In the following chapter I move back in time to the visual resources and models available to artists to portray sorcery and witchcraft in the fifteenth century, so as to understand and appreciate more clearly the profound transformation that occurred at the turn of the sixteenth.

2

THE TRANSFORMATION OF SORCERY AND MAGIC IN THE FIFTEENTH CENTURY

In the city of Augsburg in 1511, a year after Hans Baldung Grien had created the basis for a new visual language of witchcraft in his chiaroscuro woodcut, another woodcut was published which exemplified the dramatic transformation in contemporary understandings of magic and sorcery over the previous decade (fig. 2.1). A depiction of magical and sorcery practices as forms of diabolical witchcraft, it was created by a Swabian artist, Hans Schäufelein. Schäufelein had been an apprentice in Dürer's Nuremberg workshop during 1503–7 – the same years as Baldung – and had cooperated with Baldung on a number of large woodcut projects. He left Nuremberg in 1507 and worked for a time in Hans Holbein's workshop in Augsburg. He moved to south Tyrol between 1508 and 1510 and then returned to Augsburg in 1511. Schäufelein's depiction of magic, sorcery and witchcraft appeared in a German law manual, *Der neü Layenspiegel* (*The New Layman's Guide*), written by Ulrich Tengler and published by the Augsburg printer Hans Otmar. The history of this work's publication, together with the inclusion of Schäufelein's woodcut, tells us a good deal about changes in the perception of witchcraft at the turn of the sixteenth century.

Ulrich Tengler had served as *Stadtschreiber* (city secretary) in the imperial city of Nördlingen, and from the 1480s as *Landvogt* (an administrative official representing the territory) in the Bavarian town of Höchstädt.[1] *Der neü Layenspiegel* was a revised edition of his *Layenspiegel* (*The Layman's Guide*), published two years earlier in 1509 by Hans Otmar, with introductory prefaces by two well-known humanists, Jacob Locher and Sebastian Brant. *The Layman's Guide* proved to be a good seller – the printer Matthias Hupfuff published a second version in Strasbourg in 1510. But in 1511 the Augsburg publisher Johann Rynman von Öringen commissioned the author's son Christoff Tengler to revise the work. As part of this revision Christoff, who was professor of canon law at the University of Ingolstadt, added material on the punishment of the magical arts. Influenced by the new theological understanding of witchcraft as heresy, a view prominent in recent works such as the *Malleus Maleficarum*, Christoff included a new section entitled 'On heresy, divining, black magic, sorcery and witches'.[2] Accompanying this new section was a new woodcut, a full-page composite image by Hans Schäufelein depicting the evil practices of witchcraft.[3]

The composite format of this woodcut helps link a range of different actions that we associate with the categories of magic, sorcery and witchcraft. Magical practices such as stealing milk from a tree trunk (right centre) are linked, first, to weather sorcery (left centre) and laming by poisoned arrows (lower left and right). These practices were already well established within the literary catalogues of late medieval sorcery and, as we

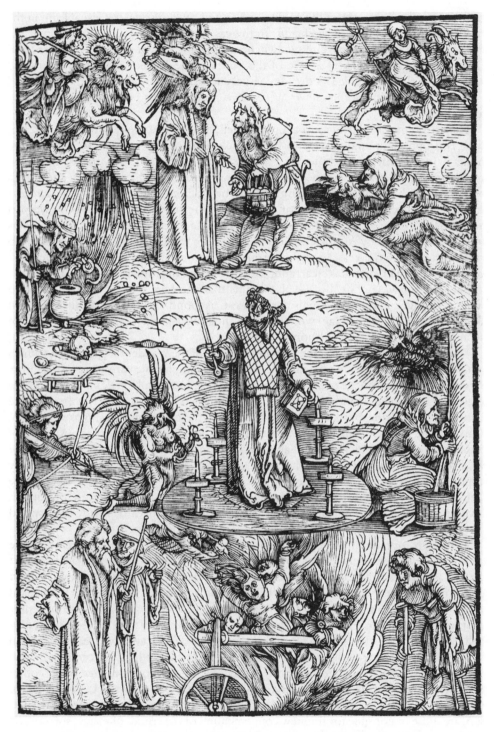

Figure 2.1 Hans Schäufelein, *Magical and Sorcery Practices as Crimes of Diabolical Witchcraft*, woodcut, in Ulrich Tengler, *Der neü Layenspiegel*, Augsburg, 1511, fol. 190ʳ. HAB, Wolfenbüttel [Ra 4° 11].

have seen in the discussion of the Molitor series, they were also taking visual form in the more recent iconography of witchcraft. In this case they were also linked to the image of a witch coupling with a devil and two witches riding goats through the sky (top left and right), so that the diabolical source of the power to steal milk, lame or to create bad weather was clearly specified. A defining visual cue was a demon, hovering above several of the women; and they themselves were more closely related by their similar clothing and appearance.

The artist employed other visual cues as well. The woman bent over the cauldron, who is dropping animal parts into her brew as part of her weather sorcery rituals, holds a forked stick, an implement well established by 1511 as one of the most common identifiers of a witch. On the ground before her she has skulls and bones which, through the work of Baldung and Altdorfer, link her behaviour to the destructiveness and necromantic nature of witchcraft. The side-saddle ride of the woman above her, on a goat whose horns are framed by a kind of diabolical aureole, was possibly influenced by Altdorfer's drawing of 1506; while the riding witch in the top right corner, with the vessel dangling from her cooking stick, has drawn on the work of Baldung. Schäufelein has clearly adopted the riding of animals through the sky as a visual code for witchcraft. But he also claims that witchcraft is not limited to naked women engaged in esoteric rituals in the forest, as found in the work of Altdorfer and Baldung; it includes village women with their well-known magical practices of stealing milk from their neighbours' cows.

The element that helps bind the individual scenes of the woodcut together, and which would have created an immediate framework of meaning for the early sixteenth-century viewer, is the central image of the traditional male magician invoking demons. The figure is clothed in ritual garb and displays the paraphernalia of invocatory or ritual magic: the sword and book, the burning candles, the protective circle and the invoked demon. Ritual magic is given centre stage as a black and demonic art; while various forms of popular sorcery are depicted round about and damned by association. The scene of the wealthy man and peasant above the ritual magician is puzzling, however. It probably depicts the practice of chiromancy by a learned magician assisted by the devil, since Tengler's text condemns this as a divining technique.[4] The demonic nature of learned, invocatory magic is given centre stage; while the local practices of village sorcery and recent witchcraft theory are presented as allied arts around the perimeter.

As though to underline the sinful and criminal nature of all these kindred arts, the scene at the bottom depicts the consequences for their practitioners: they are to be treated as heretics and punished by fire in an image that combines the flames of earthly punishment with the eternal fires of hell. The cart in which they are depicted is one used for transporting criminals to the place of execution and, as in a number of early sixteenth-century woodcuts, for transporting the dead to their eternal resting place in heaven or hell.[5] A devil transports a soul to be punished, while two men stand by, clearly identified by their staff of justice as members of the judiciary. The elder figure is certainly Ulrich Tengler himself, the compiler of the original *Layenspiegel*, who is depicted in two other Schäufelein woodcuts in this work. His companion is probably his son, Christoff, editor of the revised version, dressed in clerical garb and doctor's hat.[6] The Tenglers, father and son, are those responsible for this new condemnation of the crimes of magic, sorcery and witchcraft; but layman and cleric alike nicely illustrate the call for both clerical and secular authorities to address the threat of these new crimes.

Schäufelein's 1511 woodcut represents in simple, visual form the processes of fundamental cultural transformation by which theories of diabolical witchcraft became more widely accepted and acted upon in the fifteenth and sixteenth centuries, displacing more generalized and less precisely formulated beliefs in the power of popular magic and sorcery.[7] This involved a gradual abandonment by a theologically informed clergy and laity of a belief in the capacity of most people to take advantage of, or to deflect, the power of natural and demonic forces in the world. It also helped weaken the general belief that particular individuals in the community – magicians, sorcerers, cunning men and women, healers or diviners – possessed specialized skills and knowledge that enabled them to exploit these magical forces more effectively. Such powers were increasingly thought to owe their success to direct or indirect collaboration between practitioner and devil.

The nature and trajectory of this transformation over the fifteenth century, by which the reality of witchcraft came to be more firmly rooted in the psyche of an increasing number of Europeans, has been illuminated by important studies over recent years. We now recognize the very considerable influence of Jean Gerson, chancellor of the University of Paris. In 1398 Gerson was an important player in the formulation of the 28 propositions of the Paris theological faculty which condemned all magicians as guilty of idolatry. And in a work of 1402, Gerson equated the village magic and sorcery of old women with the idolatry and apostasy of witchcraft.[8] We also have a clearer understanding of early witch trials in Switzerland in the 1420s and 1430s and how they gradually conflated various sorcery practices with the Waldensian heresy through much of the region of the western Alps, from Piedmont and Savoy to western Switzerland and the Dauphiné.[9] And we have begun to recognize the significance of the inquisitorial activity of Heinrich Kramer in Innsbruck in 1485 and his subsequent composition of the *Malleus Maleficarum* as a manual to guide those prosecuting witchcraft.[10] The articulation of the concept of a diabolically-based witchcraft was a very gradual and irregular process, dependent to a large extent on the zeal of individual theologians, inquisitors, judicial officials and secular authorities, as well as on particular local and regional circumstances.

This chapter focuses on the visual imagery of magic and sorcery during this period of critical transformation in the fifteenth century. As we have already seen in Chapter 1, it was only around the turn of the sixteenth century that a visual language of witchcraft began to take shape, stimulated in particular by the high levels of circulation between 1489 and 1508 of the woodcut series published in the many editions of Ulrich Molitor's treatise. But the unknown creator of the Molitor images, as well as the later artists who adapted them, are likely to have drawn on conceptions of popular magic and sorcery produced prior to the 1490s. But as we shall see in this chapter, visual artists were slow to transform images of magic and sorcery into the diabolical practices of witchcraft – as Hans Schäufelein was able to do so effectively in 1511. With few exceptions, the transformation in the visual arts followed that in theology and law. Prior to the intensified literary discussions concerning witchcraft by inquisitors, social commentators and legal theorists in the later fifteenth century, artists seem to have taken little direct interest in the subject of witchcraft.

One substantial set of images of popular magic and sorcery published prior to the first printing of the Molitor treatise in 1489 provides us with the clearest example of how artists seemed to view such concepts in the fifteenth century. These images demonstrate how popular magic and sorcery at this time could still be imagined quite independently of the dualistic schema which would soon link their practice to diabolical witchcraft. The

Figure 2.2 A Woman Blesses Cattle to Protect them from Wolves, woodcut, detail, in Hans Vintler, *Buch der Tugend*, Augsburg: Johann Blaubirer, 1486, fol. 159ʳ. From Schramm, vol. 23, fig. 650.

images I am referring to are those in Hans Vintler's *Buch der Tugend*, a book of virtues and vices, published in Augsburg in 1486 by the printer Johann Heidegker of Blaubeuren, more generally called Johann Blaubirer. The *Buch der Tugend* was a long didactic poem originally written in 1411 by Vintler, a Tyrolean legal official and member of a leading Tyrolean noble family.[11] Much of the work was modelled on a widely disseminated Italian treatise of *c.* 1300, the *Fiori di virtù*; and a substantial section devoted to the vice of superstition drew on a late fourteenth-century Latin confessional translated by Martin von Amberg.[12] This section complained about the widespread contemporary belief in magic and sorcery, including the credence given to propitious times and signs of misfortune, healing and protective magic, sorcery practices concerned with bad weather, invisibility, milk stealing and impotence, as well as more learned forms of magic such as divination and necromancy. The attention given to magic and sorcery in Vintler's text was strongly emphasized in the printed version of 1486 by 52 woodcuts.[13] Most of these seem to have been based on a lost manuscript, since they are similar to the illuminations in a richly illustrated Gotha manuscript of *c.* 1500, which seems also to have used this common model.[14] The significance of this unusually large and varied visual compendium, much of it reliant on earlier traditional works, clearly suggests that in the 1480s printers such as Blaubirer believed that images of popular magic would sell among the literate population of southern German cities like Augsburg.[15]

The most striking characteristic of these woodcuts is that they show few signs of the contemporary demonization of magical and sorcery practices – possibly because they are copies of images that originated one or two decades earlier in the 1460s or 1470s. They present a society in which popular magic and sorcery is very much part of the elemental world of nature.[16] Animals, for instance, occur frequently throughout the woodcuts:

Figure 2.3 *Castration Sorcery; A Spell against an Earwig; The Use of Axe Magic to Steal Wine*, woodcut, in Hans Vintler, *Buch der Tugend*, Augsburg: Johann Blaubirer, 1486, fol. 161ᵛ. From Schramm, vol. 23, fig. 655.

wolves and rabbits are displayed as portents of fortune and misfortune; birds feature in augury and fortune telling; cattle and horses become the objects of special blessing; while chickens and cows represent village inequity and strife as objects which are stolen and need to be protected (fig. 2.2).[17] The astrological powers of the heavens also play an important part: sun, moon and stars designate fortuitous and portentous times for performing love magic, or ensuring one's future wealth.[18] Herbs and plants also frequently appear, as they are harvested or dug up in order to be used in protective and healing magic; and so too are the elements of earth, water and fire.[19] This elemental world, teeming with magical forces, is also a rural village world, quite different to the urban society of Vintler's readers.

Another fundamental characteristic of these woodcuts, which clearly differentiates them from Vintler's text, is the manner in which magical beliefs and practices are gendered. While the text provides very little information about the gender of the magical practitioners, the accompanying woodcuts depict 55 per cent as female, a figure that rises to 83 per cent of images involving specifically maleficent sorcery.[20] The gender division generally conforms to our scant knowledge of the division of labour within the magical economy, as derived from the work of social historians.[21] Women, for instance, are shown as those who primarily deal in magic associated with the use of body parts and with the healing of common illness. So in one scene (left of fig. 2.3) a woman steals the penis of a sleeping young man – clearly a case of serial castration, given the container that already holds two penises.[22] In another (centre fig. 2.3), a woman recites a spell as she strikes a patient suffering from the earwig on the temple, threatening the earwig with the

Figure 2.4 *Taking Body Parts from a Hanged Thief*, woodcut, in Hans Vintler, *Buch der Tugend*, Augsburg: Johann Blaubirer, 1486, fol. 162ʳ. From Schramm, vol. 23, fig. 656.

corner of the pillow.[23] In another (fig. 2.4), a woman approaches a dead man hanging from the gallows, whom the text identifies as a thief. Vintler's text refers to her 'doing injury' ('laben') to the dead thief's body,[24] leaving it unclear whether she is after various body parts, blood or semen, all of which were known to have been widely used for curing illnesses such as epilepsy, or for invisibility or other forms of magic, well into the eighteenth century.[25] Care of the sick and the dead were largely the business of women in late medieval rural society; and it is therefore not surprising that the artist depicted associated magical practices as female.[26]

The removal of an arrow from a man's knee with a magical charm, however, was shown as a specifically male practice (left of fig. 2.5). The sorcerer touches the end of the arrow with his right hand while the gesture of his left may refer to the charm or spell he is reciting. Arrow charming was a male form of magic related to the activity of surgeons, healers largely concerned with injuries sustained in war or other acts of violence. Likewise ritual conjuration (right of fig. 2.5), in which – the text tells us – the devil is conjured to gain access to material wealth, makes use of the magical paraphernalia of sword and circle, traditionally associated with learned male magic.[27] Similarly, healing by means of coal dug up at the sight of the first swallow is depicted as male magic, presumably because of the associations between digging and males.[28] While women's use of magic to steal a neighbour's chickens or protect cattle from wolves reflects their primary responsibility for domestic animals, the blessing of a horse, an animal more closely associated with the knightly class and the fulfillment of servile dues, is performed by a male.[29] Most intriguing is the woodcut positioned first in the series, of a monk teaching another man how to steal water by means of the well-known technique of an axe wedged in a post

Figure 2.5 *Charming an Arrow from a Man's Knee*, woodcut, in Hans Vintler, *Buch der Tugend*, Augsburg: Johann Blaubirer, 1486, fol. 151ʳ. From Schramm, vol. 23, fig. 629.

Figure 2.6 *Axe Magic Taught by a Monk*, woodcut, in Hans Vintler, *Buch der Tugend*, Augsburg: Johann Blaubirer, 1486, fol. 150ʳ. From Schramm, vol. 23, fig. 628.

Figure 2.7 *A Female Witch Stealing Wine; A Male Transformed into a Wild Cat*, woodcut, in Hans
Vintler, *Buch der Tugend*, Augsburg: Johann Blaubirer, 1486, fol. 160ᵛ. From
Schramm, vol. 23, fig. 653.

(fig. 2.6; also right of fig. 2.3). This illustrates a report found in Vintler's text that 'some
people' claim that magic cannot be evil since it has been taught them by clerics. In order
to make the point quite clear, the printer has inserted a caption above the woodcut:
'Superstition which the learned teach'; and the artist has also followed suit with a visual
message – a pair of horns protruding through the thief's hat.[30]
 Vintler's text also includes a reference to a particular group of sorcerers called witches
('unhollen'), who are specifically described as impure ('unreyn'). They are female
sorcerers who drink wine from people's cellars, clearly a reference to late medieval stories
of the Wild Ride and Furious Horde.[31] Yet the accompanying woodcut (fig. 2.7) makes
no attempt to link them to the devil. Perhaps the depiction of shape-shifting in the same
woodcut, the transformation of a male figure into an aggressive feline form, was meant to
encourage the viewer to draw a mental association with the devil. The more explicit
depiction of shape-shifting in the Vienna manuscript (fig. 2.8) suggests that such
diabolic intentions may well have been intended in the printed work also. The capacity to
change humans into animal shape, or at least to create the illusion of transformation
through the agency of the devil, was emphasized as a strong characteristic of witchcraft in
the *Malleus Maleficarum*.[32] It also featured prominently in one of the Molitor woodcuts
(fig. 1.9), as we have seen, and was represented in images of the classical sorcerer Circe
and of the golden ass from the fifteenth century (figs 5.5, 5.12). It remains striking,
however, that this seems to be the only direct allusion to contemporary views of witch-
craft in this late fifteenth-century compendium of superstitions. We do not know
whether Blaubirer's edition of Vintler sold as well as he must have expected it would. But

Figure 2.8 A Woman Undergoing Transformation into a Wild Cat, marginal pen drawing, in Hans Vintler, *Buch der Tugend*, 1400–50. Austrian National Library, Vienna, picture archives, MS Cod. 13.567, fol. 143[v].

the work does not seem to have been reprinted, nor were its woodcuts recycled.[33] In the very year in which Vintler's work was published, 1486, the *Malleus Maleficarum* would also be published, running into 13 editions by 1523; and three years later the first of the many editions of Molitor's work would come off the presses and circulate through the cities of southern Germany and along the Rhine.

The change in attitude to popular magical and sorcery practices, at least among the reading public of German cities around the turn of the sixteenth century, is clearly registered in images of milk stealing by magic or sorcery. Milk stealing features in one of the Vintler woodcuts (fig. 2.9), although the focus is the protection of sorcery victims rather than the act of sorcery itself. The pentagram is the magical instrument used to hinder the theft of the cow's milk in this scene. Pentagrams and hexagrams were widely used in early modern Germany – on house walls, castle gates, church entrances, cradles, bedsteads and cowshed doors – as a protection against evil in general and against witches in particular.[34] Here it is meant to protect the cow from the intruder kneeling on it; and the milk maid's gesture towards the cow's udder may be intended to ensure the viewer identifies the object of the intruder's interest. In the illustration in the Gotha manuscript, milk is visible in the milk maid's pail, while the pail of the intruder remains empty.[35]

The stealing of milk by sorcery is also depicted in Hans Schäufelein's 1511 collage of magic, sorcery and witchcraft practices (fig. 2.1), as we have already seen. But here Schäufelein depicts the technique of milking a post, with the woman's fingers grasping the axe-head, while the handle directs the milk into the pail below. Crucial to understanding the nature of this magical act is the demon positioned above the woman's head,

Figure 2.9 Protective Magic against the Sorcery of Milk Stealing, woodcut, in Hans Vintler, *Buch der Tugend*, Augsburg: Johann Blaubirer, 1486, fol. 156ʳ. From Schramm, vol. 23, fig. 644.

clearly identifying it as diabolical. The same sorcery technique is depicted in at least two other images: in a wall painting from the years 1440–80 in the parish church of Eppingen in northern Baden; and in a woodcut illustrating a 1509 sermon of Johann Geiler of Kaysersberg, 'How witches milk axe handles to obtain milk', published in Strasbourg in 1516 and 1517 as part of his sermon collection, *The Ants* (fig. 2.10).[36] In both cases an old woman has an axe firmly wedged into a post and milk pours out through the end of the axe handle into a pail below. In the wall painting a devil approaches the milking woman, a large container in one hand and a large sheet of paper in the other. The conversation recorded in the inscription is barely legible, but the document held by the devil clearly alludes to a demonic pact. In *The Ants* woodcut, on the other hand, the background provides the clue to the foreground action: a skinny cow in a neighbour's stall, clearly depleted of its milk, has been milked by magical remote control as it were. And the artist has added visual cues from the recent iconography of witchcraft in order to make his meaning unmistakable: a pot or cauldron is shown on a smoking fire behind the house post, and a storm is visible above. Even the depiction of a group of women is possibly meant to conform to the increasingly dominant visual code of witchcraft as group activity.[37] This would have been confirmed for any who read further in Geiler's text, by the claim that such sorcery could only succeed through the deceptions of the devil.

Belief in the power of sorcerers and witches to steal milk was widespread through the societies of Europe in the late Middle Ages. A work written between 1445 and 1450 by an Oxfordshire bailiff, Peter Idley, in the form of advice from a father to a son, included in its consideration of the first commandment a long story about a witch who stole milk

Figure 2.10 A Witch Stealing Milk from a Neighbour's Cow by Axe Magic, woodcut, from Johann Geiler of Kaysersberg, *Die Emeis*, Strasbourg: Johann Grüninger, 1517, fol. 54ᵛ. HAB, Wolfenbüttel [457.2 Theol. 2° (5)].

from her neighbours' cows by means of a magical bag or sack.[38] The witch bewitched this bag and on her command it went out and sucked cows dry. Idley had taken the story from a work of Robert Manning of Brunne written more than a century before.[39] But as Jan Wall has shown, such popular ideas about magical milk stealing were found in the decrees of church councils from as early as the ninth century and continued well into the seventeenth.[40] The milk-stealing bag in the story of Manning and Idley was closely related to the milk-stealing beasts of Scandinavian folklore. These beasts and their exploits began to take on a demonic shape and meaning in church wall paintings that have survived in northern Germany and Scandinavia from the fifteenth century. Jan Wall has identified 63 churches with wall paintings that show how witches either steal milk or churn butter fat from previously stolen milk. In 14 the thief is an animal similar to a hare. The majority of these paintings were executed either by Peter the Painter, an artist active in the mid-fifteenth century, or by the workshop of his pupil, Albert the Painter, in the later decades of the century.

In the church of Söderby-Karl in the Uppland region of Sweden, a wall painting by the workshop of Albert the Painter, dated *c.* 1490–1500, depicts a so-called troll-hare sucking milk from a cow while overseen by a devil (fig. 2.11).[41] In the next segment of the story the troll-hare vomits this milk into a pail; and a witch with a small devil on her shoulder, assisted by another to her left, churns it into butter. Drops of butter drip from the vat and are licked by the headed tail of the standing devil. In the third segment the witch shapes a huge butter pat with the help of a devil, while on the pat sits a large, reddish-black, two-faced devil with two cudgels, a large penis or tail, and wearing what

Figure 2.11 Albertus Pictor, A (above): *Troll-hare Stealing Milk from a Cow*; B (below): *Witch Churns Butter with the Assistance of Devils; Witch and Devil Shape a Butter Pat, c.* 1490–1500, wall painting in a parish church, Söderby-Karl, Uppland, Sweden. Antikvarisk-topografiska arkivet, the National Heritage Board, Stockholm. Photo: C. Wilhelm Pettersson.

appears to be a papal tiara. This general narrative is repeated again and again with only slight variations. In one painting a witch herself milks a cow, watched by the milk-hare; in another a devil shits into a butter churn in order to replace the butter balls removed by a second devil; in a third, rows of completed butter pats are displayed on a shelf.[42] And when the witches are delivered by devils into the jaws of hell, they remain easily identified by their butter churns.[43] What is critical in all these images is the presence of devils. They represent the demonization of widely held magical beliefs about milk-stealing through large areas of northern Europe in the second half of the fifteenth century.[44]

A traditional and alternative technique to including devils in scenes of popular magic was to use text to establish the meaning of the particular visual representations. In a broadsheet of 1487, for instance, scriptural precepts together with references to legal and ecclesiastical authorities, underpin warnings about the demonic nature of sorcery (fig. 2.12).[45] These combine with figures in roundels surrounding the witch and her demons and representing the teaching authority of the church. From the text we know that the trimmed figure at the top of the woodcut is God Almighty,[46] and in what seems to be a reference to Leviticus 20.6, God states he shall put to death and turn his face from anyone who visits a sorcerer, citing his punishment of King Saul for consulting the witch of Endor in 1 Chron. 10 as confirmation. The figure with the sword in the top right roundel is St Paul, the one in the top left with the sprig is Isaiah. The text refers to Paul's exhortation in 1 Corinthians 10.20 that Christians not become partners with the devil, and to Isaiah's warning in Is. 47.11–12 that unforeseen ruin will be visited on those who stand fast in their enchantments and sorceries. At the middle level, the two roundels are of Pope John XXII with his papal tiara and of an emperor, either Theodosius or Justinian, holding an orb. Pope John is presented as the author of the decretal *Super illius specula* of 1326, which banned sorcery as idolatry and superstition,[47] the emperor as one who prohibited the practice of *maleficium*.[48] The lower pair of roundels are labeled and given considerable weight in the text. On the right with his bishop's crozier and mitre is St Augustine, who, the commentary tells us, called believers in sorcery heathens and apostates of the Christian faith. On the left are the theologians of the University of Paris, who in 1398, the text reads, decreed that to enter into a tacit or explicit pact with the devil is idolatry, and that a pact with the devil occurs in every act of sorcery. And finally in the bottom roundel, as adversary to the Almighty above, is the figure of the devil with his book of magic.[49]

The visual representation of the figure of sorcery in this broadsheet matches the theological premise that underlies her condemnation in the roundels and their accompanying texts. Wearing a conical hat similar to many contemporary illustrations such as those of the Vintler series, the sorceress seems to be riding a dragon and offering it a drink from her flask. Two demons behind seem to be spurring her on, as does a horned demon to the left. A drinking vessel or flask frequently features in scenes of witchcraft, as we have already seen, and would have helped identify the woman as a sorcerer in league with the devil. Moreover, by depicting her riding a dragon and holding a flask, the artist may have been alluding to the biblical Whore of Babylon from Revelations, seated on the seven-headed beast with her cup of abominations.[50] The woman in this print is labeled a *phitonissa*, the term used for the biblical necromancer whom King Saul asked to divine the future and who summoned the ghost of Samuel (1 Sam. 28), a story referred to in the text below. This woman was described in the Vulgate as having 'the divinatory powers of the python' ('mulier pythonem habens'), a reference to the demonic prophecy of the

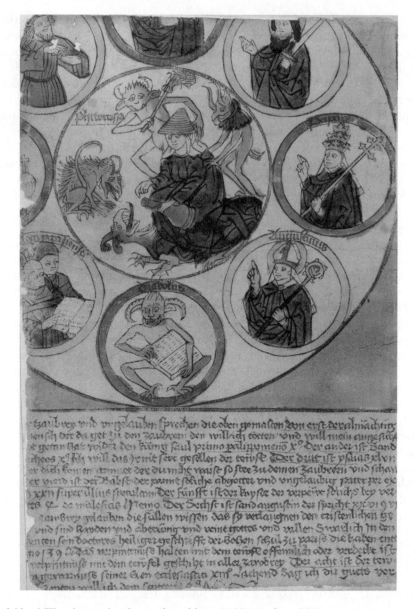

Figure 2.12 A Warning against Sorcery, broadsheet, 1487. Kupferstichkabinett, Berlin. © Bildarchiv
Preussischer Kulturbesitz, Berlin, 2007.

Delphic Oracle. For the educated viewer then, the sorcerer in the broadsheet would have
been associated with the diabolical necromancy of the biblical witch of Endor and Whore
of Babylon. But even for those unfamiliar with such biblical references, the woman
mounted on a dragon and surrounded by demons would have been readily identified
with demonic and malefic sorcery.

A critical feature of this broadsheet by an author and artist well versed in the late medi-
eval literature on magic and sorcery is the emphasis it gives to the 1398 decree by the

theological faculty of Paris. It would seem that a treatise of 1402, the *De erroribus circa artem magicam* (*On Errors concerning the Art of Magic*) written by the famous theologian Jean Gerson, Chancellor of the University of Paris at this time and an important figure in the drafting of the 1398 decree, was the source of this interest. The reference to Augustine does not seem to have been drawn from Augustine's own writings, nor even from the quoted source in Gratian's *Decretals* ('xxvi q. vii').[51] It is based rather on a passage from Augustine quoted in the *Decretals* and then reproduced in the 1398 *Conclusio*, as well as in the copy of the *Conclusio* found in Gerson's work.[52] That the author had access to this text in Gerson's work is strongly suggested by the fact that it appears there immediately before a reference to the third article of the *Conclusio*, which of all 28 articles, is the only one to be quoted in the 1487 broadsheet. More than a century ago Wilhelm Ludwig Schreiber claimed on stylistic grounds that this broadsheet was a copy of a much earlier model.[53] This analysis supports such a claim. We seem to have here a simplified and pictorial version of the programme set in train by Gerson and the Paris theologians at the turn of the century to homogenize the two medieval traditions of magic: the learned tradition of ritual magic on the one hand, and the more 'popular superstition' of urban and village sorcery on the other.[54] The 1487 broadsheet also represents an earlier and more learned version of the attempt to homogenize sorcery, ritual magic and witchcraft by Hans Schäufelein in 1511 (fig. 2.1). And it suggests that at least one source for the emerging visual code of the riding witch may have been the whore of the Book of Revelations.

A quite different attempt to demonize sorcery in the fifteenth century, by linking it – as in Vintler's treatise – to 'superstition' and the broader concept of vice, is found in the very popular late medieval allegory of Christian life, Guillaume de Deguileville's *Pilgrimage of the Life of Man*.[55] The first version of Deguileville's work appeared in 1331. It is instructive for an appreciation of the increasing attention given to magic and sorcery in the later Middle Ages, that in addition to the seven deadly sins and other vices which obstructed the pilgrim's quest to reach the heavenly city in the first recension, a number of new vices – including Heresy, Necromancy and Sorcery – found their way into the second recension of 1355. At least three surviving French manuscripts of this second recension, which date from the end of the fourteenth and beginning of the fifteenth centuries, provide illustrations of these newly added vices, as does an English verse translation of 1426 by John Lydgate, which was probably based on another, now lost, French manuscript.[56]

The figure of Sorcery in these four manuscripts is depicted as an old woman catching a pilgrim with her crook (fig. 2.13). Sorcery's visual attributes, the basket on her head and the big cut-off hand which she holds, allude to the various practices she employs to enchant and harm her victims. The hand, as confirmed by the text, refers to the art of chiromancy by which Sorcery tells people's fortunes; and the basket contains the numerous objects necessary for her malefice: knives, hoods, written spells and images, ointments, herbs, drinks and a whole face called 'physionomy'.[57] It is by the name of Malefice that she should be called, Sorcery claims in the text, because of the many different evils she brings; for she is a vice that operates with a wide variety of techniques, all learnt in 'the school of Satan.' It is curious that in the only woodcut version of this image, found in the 1511 edition of the second recension published by Antoine Vérard in Paris, the woodcutter has chosen to remove the visual association between sorcery and chiromancy (fig. 2.14). The reference in the text to the chiromantic hand carried by

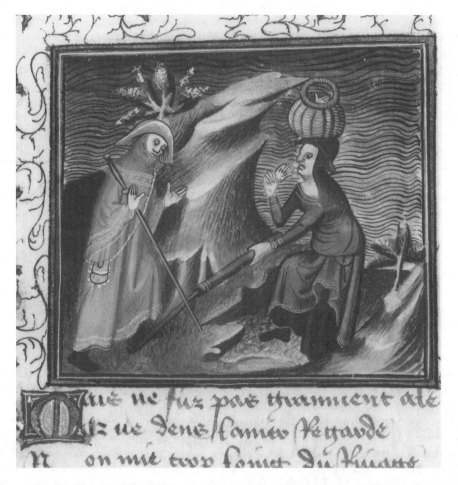

Figure 2.13 Boethius Master, *The Pilgrim Caught by Sorcery*, manuscript illumination in bright colour and gold, in Guillaume de Deguileville, *Pèlerinage de vie humaine*, second recension (1355). Paris, Bibliothèque nationale de France, MS fr. 825, fol. 124ʳ.

Sorcery is ignored and the basket that she now carries is conspicuous for its herbs. In this way the association with everyday sorcery is stressed; and the physical harm linked to such sorcery is represented by the hazards of the sea into which the pilgrim might be dragged, the text tells the reader.[58] It would seem that as late as 1511 the artist has been little touched by attempts to link sorcery practices to more learned forms of magic such as chiromancy, or indeed to witchcraft. This is despite the fact that Deguileville's text in this printed version would certainly suggest such associations. Indeed, at the point where Sorcery claims she should be named Malefice, the marginal gloss is Exodus 22.17, 'You shall not allow sorcerers (*maleficos*) to live'. There is no knowing whether the artist rejected this increasingly common application of the biblical text; but he certainly did not attempt to give visual expression to the broad range of associations malefice and sorcery suggested.

This modification in the representation of sorcery in Vérard's early sixteenth-century edition may well have been a response to a need to distinguish Sorcery from two other

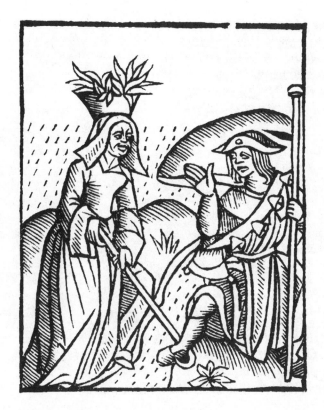

Figure 2.14 *The Pilgrim Caught by Sorcery*, woodcut, in Guillaume de Deguileville, *Le pèlerinage de l'homme*, Paris: A. Vérard, 1511, fol. 75ʳ. Paris, Bibliothèque nationale de France.

characters included in Deguileville's second recension, Necromancy and Astrology, and their association with invocatory magic. While Necromancy is represented in the four manuscripts and the printed version – in most instances as a terrible winged female figure who uses a magical book as a scabbard for her sword – the Lydgate translation presents the Messenger of Necromancy engaging in invocatory magic (fig. 2.15).[59] Apparently Necromancy ran a school on how to invoke spirits and have them answer questions and obey commands for the purpose of gaining benefits for one's dignity or wealth. The illuminator therefore represents the Messenger with the traditional attribute of invocatory magic, the sword and circle embellished with 'characters and figures'. Within the circle is the amassed treasure, and at the right the devil he has invoked, laden with goods.

This representation of invocatory magic became popular throughout Europe in the fifteenth and sixteenth centuries and elements of it fused with the new iconography of witchcraft, for the first time it would seem in Hans Schäufelein's composite woodcut of 1511 (fig. 2.1). Several striking images of ritual magic from the fifteenth century are found in the so-called *Florentine Picture Chronicle*, formerly attributed to Maso Finiguerra, but more recently considered to have been the work of Baccio Baldini and his workshop during the 1470s.[60] The *Picture Chronicle* was a portrayal of the history of the world from the time of creation, broken up into the conventional division of six ages and groups of significant historical figures. One such group included ancient magicians and doctors linked to the development of Neoplatonic philosophy and magic: Orasmades,

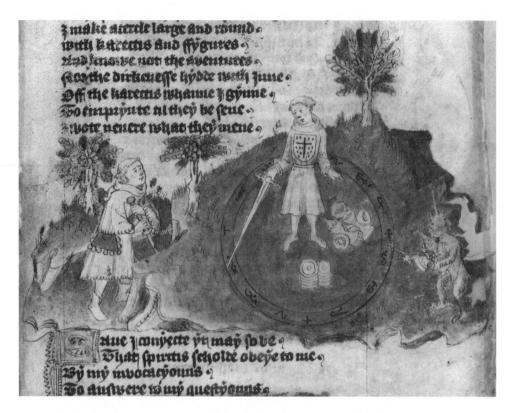

Figure 2.15 Necromancy's Messenger Shows the Pilgrim how Spirits Are Raised, pen and ink coloured drawing on vellum, in Guillaume de Deguileville, *The Pilgrimage of the Life of Man*, second recension (1355), trans. John Lydgate, 1426. London, The British Library, MS Cotton Tiberius A.vii, fol. 44ʳ. Permission The British Library, London.

Hostanes, Hermes Trismegistus, Linus and Musaeus, Apollo Medicus, Aesculapius and Machaon.[61] The drawing of Hostanes represents one of the most powerful images of invocatory magic produced in the fifteenth and sixteenth centuries (fig. 2.16).[62] A Persian magician and follower of Zoroaster, Hostanes is depicted standing in a circle, holding a book from which he is reading ritual invocations. Within the circle stand four flaming braziers and outside it lies an unsheathed ritual sword. Strange demonic monsters mass at the perimeter of the circle, and together with other demons in the air offer Hostanes an assortment of magical books and scrolls. The drawing reflects the strong interest in such classical representatives of the magical arts in the later fifteenth century not only in Florence, but throughout much of Europe. However the demons they invoke are not benign classical spirits: they appear as Christian devils and identify Hostanes' magic as the demonic art of 'nigromancy'.

Another representation of invocatory magic – employed again to find treasure – is a woodcut of the so-called Petrarca-Meister, who illustrated German translations of Petrarch's *Of Two Kinds of Fortune* in the sixteenth century (fig. 2.17). This extremely popular work was first published by Heinrich Steiner in Augsburg in 1532, but the illustrations are known to have been completed much earlier, between 1518 and 1520. Publication of the work had been planned for 1521 or 1522, but due to the death of the

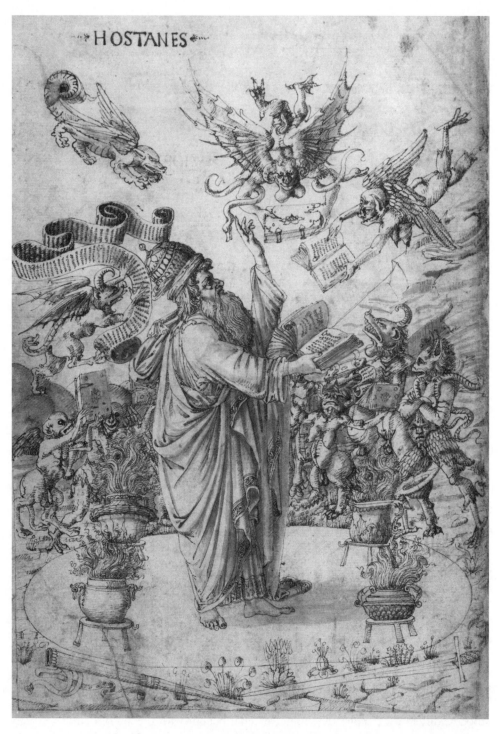

Figure 2.16 Baccio Baldini and workshop, *Hostanes Invoking Spirits by Ritual Magic*, pen drawing, brown ink and wash, in *The Florentine Picture Chronicle*, 1470s, fol. 31ᵛ. British Museum, London. Copyright the Trustees of The British Museum.

Figure 2.17 Petrarca-Meister, *Discovering Treasure through Invocatory Magic*, woodcut, in Francesco Petrarca, *Von der Artzney bayder Glück des güten und wider wertigen*, Augsburg: Heinrich Steiner, 1532, fol 71ʳ. HAB, Wolfenbüttel [H: 0 48.2° Helmst. (1)].

first translator Peter Stahel, in 1520, and continuing financial difficulties experienced by the Augsburg printshop of Marx Wirsung and Sigmund Grimm in the 1520s, the project was taken by the Steiner workshop in 1532.[63] The woodcuts must have reached a wide audience as they are found in at least seven editions through the sixteenth century.[64] Once again we see the use of a sword and book within a double circle inscribed with magical characters. Two male practitioners perform the ritual, while a third holds a lantern. Unlike the Lydgate illumination (fig. 2.15), the invoked demon at the perimeter of the circle does not himself bring the treasure, but an assistant needs to dig for it. He puts his index finger to his mouth in a plea for silence, possibly in order to hear instructions from the demon. In the right background two figures dig at a rock face with a pick, one of them gathering into his sack what may be treasure; while in the background left, a young man presents his master with what seems to be the Philosopher's Stone he has been deputed to find.[65] Verses by Johann Pinitian, first included at the beginning of this chapter in 1539 and then in subsequent editions, would suggest that these were understood as different examples of gaining material benefit with the aid of demons, which readers were admonished to reject in favour of seeking their treasure in heaven.

Invocatory magic also features in another woodcut from the same work, representing

Figure 2.18 Petrarca-Meister, *The Promises Made by all Kinds of Divination*, woodcut, in Francesco Petrarca, *Von der Artzney bayder Glück des güten und wider wertigen*, Augsburg: Heinrich Steiner, 1532, fol. 133ᵛ. HAB, Wolfenbüttel [H: 0 48. 2° Helmst. (1)].

one among many types of divinatory practice (fig. 2.18).[66] The woodcut reflects the general contemporary impulse to conflate the varieties of magical experience and theory. In the right foreground within an elaborate fourfold circle marked with various magical characters and signs, a male figure holds a skull in one hand to denote the art of invoking the dead through necromancy, and a magical sceptre in the other to refer to the so-called notarial art of demonic invocation. Another magician is removing the entrails from a sheep on a slatted trestle, in order to examine them by the art of haruspicy. In the left foreground another male figure in the robes of a physician holds up a flask, presumably containing water, and would thus refer to the practice of hydromancy; while the vessel belching fire and smoke which he holds in his other hand, refers to the art of pyromancy. And in the background a male figure in the coat of a patrician meets with a barefoot female wearing an exotic hat and coat. Her clothing and begging child identify her as a

Figure 2.19 Sorcery in the School of Satan, pen and ink coloured drawing on vellum, in Guillaume de Deguileville, *The Pilgrimage of the Life of Man*, second recension (1355), trans. John Lydgate, 1426. London, British Library, MS Cotton Tiberius A.vii, fol. 70ʳ. Permission The British Library, London.

gipsy, as she holds the hand of her client and performs the divinatory art of chiromancy.[67] Such a representation of the divinatory arts, which ignored the demons invoked by the ritual magician, was already somewhat uncommon by the early sixteenth century. Whereas some divinatory arts could be understood as operating independently of the devil's involvement, the use of a circle, sword and other paraphernalia was specifically directed at the invocation and conjuration of spirits: the circle constituted a kind of force field within which the magician could maintain control over his demonic agents yet remain protected from their terrifying power. In literary descriptions there is no more graphic account of the overwhelming terror that conjured spirits could bring to those sheltering within the confines of a magical circle than the description provided by Benvenuto Cellini in his autobiography, of his experience with a Sicilian priest-necromancer in the Roman colosseum.[68] But the Petrarca-Meister has upheld an older tradition that did not automatically identify these magical arts with the devil.

One of the most startling fifteenth-century images that did make the diabolical nature of sorcery quite explicit is a coloured pen drawing included in John Lydgate's 1426 translation of Deguileville's *Pilgrimage of the Life of Man*. The anonymous drawing depicts 'the school of Satan' where, Sorcery tells the reader in Deguileville's text, she has learnt her malefic arts together with many other scholars, and in exchange has promised to forsake godly works and give Satan her soul, 'hool and al' (fig. 2.19).[69] From the representation of Sorcery on the previous folio[70] one can surmise that Sorcery in this drawing is the older standing female figure. Her attention is caught by a horned and hoofed devil, difficult to discern clearly on account of the heavy brown wash. The infant whom Sorcery is either charming or taking from the young woman on the left is not referred to in the text, and one can only wonder if this detail refers to the early association

of witchcraft and infanticide. The two women crouched over the vessels on the right seem to be in the process of preparing the 'oynementys or herbages' that Sorcery carries in her basket.[71] The illuminator's green colouring suggests that they are the herbs seen growing along the horizon. They are being pressed through a sieve into the mortar below, where they will be pounded with the large pestle held by the woman on the right. From the perspective of later witchcraft iconography, it is not so much the manufacture of herbal charms which is so striking in this drawing. It is the message that sorcery is an art taught by the devil, exclusively to women, and to women in groups. In an uncanny resemblance to the butter sorcerers of Scandinavian wall paintings and to later witches positioned around their cauldrons, sorcery is represented not only as women's work, but as the work of groups of women.

One of the images that must have helped popularize the link between the practice of sorcery and the devil in the fifteenth century was that of the witch of Berkeley, found in the five editions of the *Nuremberg Chronicle* published between 1493 and 1500.[72] The story of the witch of Berkeley was a well-known medieval *exemplum* found in William of Malmesbury's *Chronicle of the Kings of England* of c. 1142, then picked up in Vincent of Beauvais' *Speculum Historiale* and published in at least eight printed editions by 1546. It told of a woman addicted to witchcraft and augury who sought to prevent the devil taking her body when she knew her death was near. She asked her children to sew her corpse in a stag's skin, to place it in a stone coffin and to fasten the lid with lead and iron, bound round with iron chains; she arranged to have local monks sing psalms and say masses around her body for 50 days. But despite the precautions the devils broke through the doors of the church, and the largest and most terrible of them burst the coffin's chains and stamped through its lid. He then abducted the body of the woman, riding off on a black horse, its back bristling with iron hooks, while the horrified onlookers continued to hear the woman's pitiable cries.[73]

It is rather astonishing that Hartmann Schedel, the wealthy Nuremberg landowner and humanist who was the author of the *Nuremberg Chronicle*, should have included a summary of the story of this obscure woman in his world history. It was no doubt the topicality of the theme of sorcery and witchcraft in southern German cities in the early 1490s that led him to do so. The accompanying woodcut depicts the diabolical abduction of this 'evil-spirited sorceress' ('boßgastige zawbrerin') on a horse (fig. 2.20). She is naked except for her shroud, her frizzy hair a testament to her evil, both her arms raised in horror and her mouth wide open with her terrified cries. Beneath the horse is the upturned carrying frame for the stone coffin, its lead cover mangled like a piece of cloth. As we shall see in later chapters, versions of the woodcut continued to be reproduced throughout the sixteenth century. But in the 1490s, the critical decade in the development of a new iconography of witchcraft, five editions were produced: the Latin and German editions of 1493, and the pirated German (1496, 1500) and Latin (1497) editions published by Johann Schoensperger in Augsburg.[74] Because of their sizeable runs of 1,000 copies for the 1493 Latin edition and 1,500 for the 1493 German, this image of a sorcerer or witch as a naked female with loose morals who would ride through the sky as the devil's associate was likely to have exercised considerable influence on witchcraft iconography.

Some of the most powerful images of the diabolical nature of witchcraft produced in the fifteenth century depicted witches as part of a group, and were shaped by contemporary notions of heresy and apostasy. The most well known of these are three

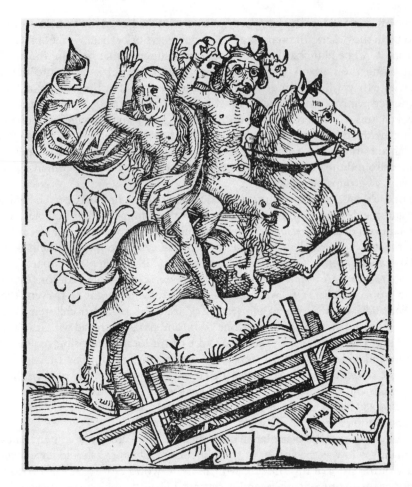

Figure 2.20 Michael Wolgemut and Wilhelm Pleydenwurff workshop, *The Devil Abducts the Witch of Berkeley*, woodcut, in Hartmann Schedel, *Liber Chronicarum*, Nuremberg: Koberger, 1493, fol. 189ᵛ. Special Collections, Information Division, The University of Melbourne.

extraordinary Flemish miniatures found in different French versions of a *Treatise against the Sect of the Waldensians*, written by the Cologne theologian Johannes Tinctor. Tinctor wrote the treatise in the wake of the *vauderie d'Arras*, prosecutions against a group of devil-worshipping witches, who were identified with the Waldensian heresy in the northern French town of Arras in 1459–60.[75] A connection between a devil-worshipping witchcraft and Waldensianism, the thirteenth-century heretical reform movement named after Peter Waldo, was possibly encouraged by the fact that the Waldensians of the alpine regions generally held their meetings in private houses at night.[76] From the late fourteenth century, especially in the general region of the western Alps, the two terms began to be conflated. Waldensians were increasingly described as members of a sect that rode through the air to their assemblies – termed 'synagogues' – where they would worship the devil in the form of a cat or other animal, abjure the Christian faith, and engage in sexual intercourse and other obscene rituals with the devil and each other.

The practices and beliefs of these devil-worshipping Waldensians were called *vauderie*. The identification was made not only in inquisitorial trials, but also by Pope Eugenius IV in a bull of 1440. And when inquisitorial activity was reorganized in much of France in 1451 under an Inquisitor General located in Toulouse, it is perhaps not surprising that the ideas of *vauderie* migrated from the south-east to the northern region of Arras.[77]

Tinctor's *Treatise* circulated widely in at least eight manuscript versions – five in Latin and three in French – and in two printed versions – a Latin edition printed together with some of Gerson's works in Brussels in 1475, and a French edition published by Collard Mansion in Bruges *c*.1477.[78] The circulation was clearly stimulated by the need to maintain the belief that the practices of the *vauderie* actually took place. For while the harsh interrogation of individuals in Arras and its region over 12 months from November 1459 led to the trials of 34 persons and the execution of 12 on the grounds of their involvement in Waldensian devil worship, appeals against the judgments of the courts were brought before the Parlement of Paris by a number of wealthy Arras citizens and a nobleman, Payen de Beaufort, from late 1460. The appeals process dragged on with claim and counter-claim for more than 30 years. Although the Parlement finally found in favour of the appellants in 1468–69, the clerical defendants refused to cooperate; under pressure of the political complexities of the broader French–Burgundian conflict, the appeals were not finally resolved until July 1491. We know that Tinctor was somehow involved in the trials, but we do not know the nature of his role.[79] A number of factors, including the claim of some Louvain theologians that the practices of the *vauderie* were nothing more than illusion, suggest that the composition of his treatise in September 1460 needs to be read as an attempt to demonstrate the reality of the *vauderie* practices. The work's frequent copying and printing through the 1460s and 1470s mirrors the continuing struggle between the clerical defenders of *vauderie* and those who had for so long appealed against their conviction.[80]

The illuminations found in three of the Tinctor manuscripts are most unusual in so far as they depict in the same scene of group worship of the devil in the form of a goat, the so-called obscene kiss in which the devil is kissed on the arse as a parody of the liturgical kiss of peace, and witch figures riding strange beasts and implements through the air. They represent the 'synagogue of the Waldensians', the first and only depictions of a scene approximating a witches' Sabbath produced before the 1570s. The miniature in a Bruges copy of the Tinctor manuscript of *c*.1470, attributed to the workshop of the Master of the Dresden Hours and now held in Paris (fig. 2.21),[81] depicts a group of one female and 11 male Waldensians kneeling around a goat, some hands joined in prayer and others holding lighted candles. A central figure is about to pay homage to the goat by kissing it on the anus, a scene repeated in the two small monochrome medallions in which the devil is presented for the kiss in the form of a monkey (below) and a dog (right). The scene is very similar to the *vauderie* described in a sermon preached by the Inquisitor of Arras, Pierre le Broussart, before the pronouncement of sentence in the first trial in May 1460:

> And they were carried to the place where they ought to make their assembly, and in this place they found one another, tables burdened with wine and food, and there they saw a devil in the form of a goat, a dog, a monkey, and sometimes as a man, and they made offerings and homages to the said devil and adored him ... then they

Figure 2.21 Workshop of the Master of the Dresden Hours(?), *Waldensians Worshipping the Devil*, illumination on vellum, in Johannes Tinctor, *Tractatus contra sectam Valdensium*, *c*. 1470. Paris, Bibliothèque nationale de France, MS fr. 961, fol. 1.

kissed the devil in the form of a goat, on the rear, that is on the tail, with burning candles in their hands … [82]

Pierre le Broussart's sermon goes on to identify Jean Lavite as 'the first conductor and master of ceremonies of those who made homage when they were newly arrived'. Lavite, an abbot of one of the *sociétés joyeuses* or Abbeys of Misrule in the area, a painter and poet of over 60 years of age, who tried to cut out his tongue to avoid incriminating himself and others after he was imprisoned, is likely to be the balding and bearded figure holding up the tail of the goat as master of ceremonies. The artist has provided him with grey hair, both in the central scene and also in the otherwise largely monochrome medallion below, in which he is shown kissing the tail of the monkey. In the smaller medallion to the right he again holds up the tail of the dog. And the portrayal of only one female Waldensian suggests that this is the other principal character in the proceedings, Deniselle Grenier from Doui, who was initially implicated in the trial of the hermit and Franciscan tertiary, Robinet de Vaux, and after torture named Lavite as attending the *vauderie* with her. Indeed, the long-haired male about to kiss the goat's posterior may well be this Robinet, clothed in a rough garment with a cord at the waist. Yet the two figures riding brooms through the sky indicate this image was not necessarily meant to be an accurate depiction of the inquisitor's account of the *vauderie*, even if the events and participants in the Arras trials had stimulated it. For while Pierre le Broussart describes the small wooden rod which Waldensians smear with ointment, put between their legs and then, carried by the devil, fly to their assemblies, the illumination depicts two figures riding brooms, one a beast and two carried by devils.

The identification of Waldensian heretics with women who were believed to ride through the sky on besoms, or brooms made of twigs, received literary and visual expression in a manuscript of Martin Le Franc's long allegorical poem, *Le Champion des Dames* (fig. 2.22).[83] Probably the best known image of witches from the fifteenth century, the two female figures are labelled 'Des Vaudoises' (Waldensians). They are found in one of the nine surviving manuscripts of the work, composed as a luxury manuscript with 66 miniatures by Jean Boignare in Arras in 1451.[84] Martin Le Franc had composed the work much earlier in 1440–41, while at the Council of Basel as apostolic pronotary and secretary to the anti-pope Felix V, and he dedicated it to Duke Philip the Good of Burgundy. This was essentially a contribution to the late medieval debate on the nature of women, the *Querelle des Femmes*: it mounted a strong attack on the overt misogyny of works such as Jean de Meun's *Roman de la Rose*, as it presented authorities in support of the greater virtues of women and formulated a defence of human love as a spiritual human experience and part of God's creation.

As part of this debate about the nature of women, a section of the work in book four (lines 17380–18148) considers the extraordinary deeds of the 'shameless women' called sorcerers.[85] One of the main protagonists to argue for the evil of women, is Lourt Entendement (Slow Understanding), called The Adversary throughout the text. He relates how these women appear as werewolves and elves, how they travel on sticks and fly through the air as birds, how they roast and eat young children, how they travel in night rides over fields, woods, rivers and seas and pass through closed doors. One of these women also confessed how she would travel out on a stick on certain nights from the valley of Valpute in the high Alps to 'the synagogue'. Thousands like her would come to see the devil in the form of a cat or goat, and they would kiss it on the backside as a sign

Figure 2.22 Waldensian Sorcerers Riding a Besom and a Stick, illumination, in Martin Le Franc, *Le Champion des Dames*, 1451. Paris, Bibliothèque nationale de France, MS fr. 12476, fol. 105ᵛ.

of obeisance, and then deny God and his power. Then some would learn perverse arts and sorceries, some would dance, some feast and drink. And they would also receive a poison ointment and powders with which they could do harm to humans, animals, the weather and crops. The champion of women, named Franc-Vouloir (Free Will), consistently denies these claims, arguing that they are nothing more than phantasms, illusions and tricks produced by the devil.

It was possibly this discussion that inspired the illustrator of the 1451 manuscript to represent female sorcery by two women, dressed in humble and possibly peasant garb, riding a besom and a stick. This association was widely held in south-eastern France by the second half of the fifteenth century; and the author of a description of the Waldensian heresy written in the late 1480s referred to the fact that in his youth – he was born about 1430 – these sorceries were called *scobaces*, a word derived from *scoba*, a besom.[86] The illustrator of Le Franc's work, however, gave these female sorcerers what was by 1451 the most common colloquial term, *vaudoises* – even if the text referred to them only as sorcerers ('sorcières' or 'faicturières').[87] A 1460 treatise on the *vauderie* in the Lyon region states that 'the sect is called *valdesia* in everyday speech, or *faicturerie* in French'.[88] In this same Lyon treatise of 1460, there is also a discussion of the name of the Waldensian assembly: 'among some it is called *le Fait* (the event) in French, among others *le Martinet*, but in everyday speech it is most commonly called *la synagogue*.'[89] While Martin Le Franc used the term *la synagogue* to refer to the sorcerers' assembly in

his text, the illustrator may have been alluding to *le Martinet* as a reference to the eve of St Martin (11 November), when he included the phrase '*passe martin*' in the margin between the two Waldensian riders. Across a large swathe of north-western Europe, stretching from the Flemish coast and Brabant to Luxembourg and the Rhine, the feast of St Martin had been a significant date within the calendar of popular celebration throughout the medieval period. On the eve of St Martin it was customary to light large bonfires, around which people danced and sang. After the fires were put out there was drinking of wine and feasting on special kinds of meats and cakes. Indulging in these festivities was called *martiner*, and was similar to the feasting of pre-Lenten carnival, since it preceded the period of Advent fasting before Christmas.[90] But such a reading, linking Waldensian diabolical rites to the carnivalesque festivities of St Martin's eve, ignores the meaning of the word '*passe*'. Martine Ostorero and Jean-Claude Schmitt have interpreted '*passe*' as the mount which Waldensian women ride; while '*martin*' refers to the rod of discipline exercised by husbands. The Waldensian women riders would then allude to the appropriation of male power, the overturning of proper societal order, by those who participate in such diabolical rites at the synagogue or *Martinet*.[91]

Waldensians riding through the sky also feature in the illuminations found in two other manuscript versions of Tinctor's attack on the Waldensians. In an image by an unknown Flemish artist from a manuscript of *c.* 1470 now held in Oxford (fig. 2.23),[92] a number of women are depicted riding on various domestic implements – on a distaff (left), a broom (centre) and a threshing flail (right). Another woman emerges from a chimney on the right. On the ground surrounding the group of Waldensians are a pair of tongs, a broom and a staff, objects which the devotees were meant to have ridden to the assembly. As in the case of the illumination from the Bruges manuscript discussed above (fig. 2.21), riding Waldensians combine with a scene of a *vauderie* in the foreground. A similar combination, featuring a single woman and a couple riding on large demonic beasts, is found in a third Tinctor manuscript, known to have been in the library of Philip the Good as early as 1467 and now held in Brussels (fig. 2.24).[93] Unlike the large number of worshippers in the Paris illumination, the two others depict only a small group of devotees grouped around a goat. And whereas the Brussels scene is set in the countryside, the Oxford *vauderie* takes place in a village street. It is unclear whether these images depict initiation rituals – of a single young man in one case, and of two young men in the other – or whether they are variations on a more general act of devil worship.[94] But the pursed and reddened lips of the kneeling woman in the right fore-ground of the Oxford image seem to allude to the ritual performance of the obscene kiss.

One iconographical detail in the Oxford illumination reminds us that devil-worshipping Waldensians were associated with contemporary anti-Jewish polemic, a polemic encoded in the common names for these meetings, the *synagoga*. The shitting goat with its raised tail must have reminded many late fifteenth-century viewers of the obscenities of the so-called *Judensau,* a large sow from whose teats Jews were believed to suck. For it was during the fifteenth century, in a cultural region which extended out from its centre in the German-speaking lands to the west of the Rhine and Meuse, that the figure of the *Judensau* was transformed from an allegorical representation of one of the vices to an instrument of religious abuse.[95] Representations of the *Judensau* began to include the figure of a Jew holding up the sow's tail while another stuck out his tongue as though to lick the sow's anus.[96] And in some cases Jews were shown eating the sow's shit. The Nuremberg *Meistersinger* Hans Folz even had the actors playing the roles of the

Figure 2.23 Waldensians Worshipping the Devil, illumination, in Johannes Tinctor, *Tractatus contra sectam Valdensium*, *c*. 1470. The Bodleian Library, University of Oxford, MS Rawl. D. 410, fol. 1ʳ.

Antichrist and the Jews in the carnival play, *The Play of the Duke of Burgundy*, lie under a sow, pretend to suck at its teats and eat its shit.[97] Excrement and defecation were widely drawn on in late medieval culture and could serve a range of cultural purposes.[98] And because of the popular associations of the devil with defecation, excrement functioned readily as an instrument of demonization. In the *Errores Gazariorum*, an anonymous Savoyard tract written in the late 1430s, the host consumed by the sorcerers was said to be made from excrement;[99] while the preacher Geiler of Kaysersberg drew a contrast between God's Sacrament and the devil's 'excrement'.[100] The shitting goat at a Waldensian *synagoga* would have strongly suggested such cultural associations in the later fifteenth century, and may have even been intended as a reference to the diabolical communion at the assembly. Similarly, the intimacy of dancing couples in the background probably referred to the sexual orgy that ensued after the drinking and eating.[101]

Images of the Waldensian heresy from the middle decades of the fifteenth century demonstrate the existence of a number of elements found in the later visual language of

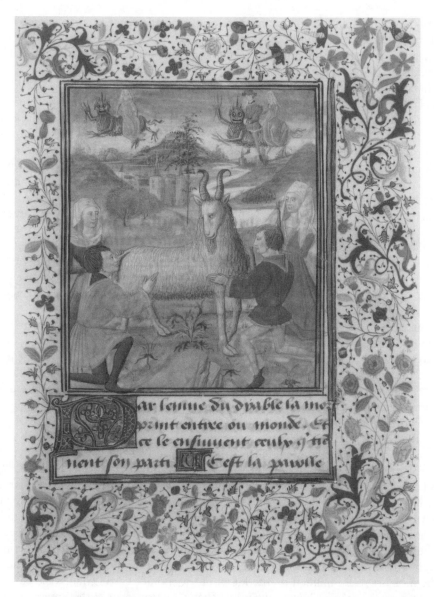

Figure 2.24 Waldensians Worshipping the Devil, illumination on vellum, in Johannes Tinctor, *Tractatus contra sectam Valdensium*, *c.* 1467. Brussels, Bibliothèque Royale de Belgique, MS 11209, fol. 3. Copyright Bibliothèque Royale de Belgique.

witchcraft. An assembly of Waldensians paying homage to the devil in the form of a goat, combined with *vaudoises* riding beasts, sticks, brooms and other implements through the air, provide a foretaste of the imagery that develops in the sixteenth century. What is puzzling is that this combination did not survive, just as the literature on the *vauderie* also disappeared. It was possibly a consequence of the victory of the appellants in the Arras trials in 1491 and the conclusion that the *synagoga* was at best illusory. For the next surviving illustration of a witches' Sabbath involving homage to the devil does not appear

for another century, in the 1570s, and the iconography does not become more common until the seventeenth century. For reasons that are unclear, sixteenth-century artists did not seem to have had a real interest in depicting the events of the witches' Sabbath, although they would have known of it from demonological accounts.

What does survive from the *vauderie* images, however, is the figure of a witch riding an animal or implement through the sky. But since they circulated only in manuscript form, it remains doubtful whether they were critical to the development of the later iconography of witchcraft. Indeed, one of the fundamental differences between the images of *vauderie* in the fifteenth century and those of witchcraft in the sixteenth is that the earlier images made no attempt to incorporate malefice or sorcery practice into their scenarios. The manner in which witchcraft impacted on the environment and society is ignored. Literary descriptions of the Waldensian *synagoga* refer to the powders received by initiates in order to exact harm on animals, humans and crops. Similar descriptions are found also in a number of other contemporary trial records and treatises.[102] But the visual depictions provide no hint of this agenda. They do not share in what Richard Kieckhefer has identified as the chief contribution of the 1430s to the development of witchcraft mythology: 'the idea of conspiratorial witchcraft, the belief that … witches are at all times already gratuitously inclined toward malicious conduct.'[103] They remain images of a devil-worshipping heretical sect.

Yet images of *vauderie* do express a growing sense of the devil's role in human affairs. A sense of increasing diabolical presence and agency is critical to the transformation of everyday magic and sorcery into diabolical 'black arts'. The devils massing at the perimeter of the necromancer's circle slowly begin to take up position on the shoulders of village women, whispering their instructions, lending their assistance, offering their power and ensuring their spiritual and physical mastery. This demonization of magic, the creation of a fundamentally dualist world view, is evident in a woodcut of *c.* 1514–16 by Hans Burgkmair (fig. 2.25). It was created for the *Weißkunig*, a large book project commissioned by Emperor Maximilian I that included 251 full-page woodcuts by four different artists, and recounted the life of Maximilian and his father Frederick III.[104] The woodcut illustrates part two, chapter 23, entitled 'How the young Weißkunig learnt the black arts'; and it contrasts an old and hunched female figure with a devil on her shoulders with a young, male figure of a monk attended by an angel, the bible in one hand and the cord of his habit as symbol of his religious vows in the other. The crone's money bag, an allusion to her avarice, is contrasted with a monk's life governed by the scripture; while her stick, possibly symbolic of a local, vernacular knowledge, is set against the vows of the monastic rule signified by the knots of the monk's cord. The choice facing the young king is represented by the two books that hang from stars in the firmament above him. This dualist world, in which diabolic and Christian faiths are directly opposed, symbolizes the demonization of everyday magic in the later fifteenth century. But it was only one image, and for the next few decades at least, not the dominant one. Far more important for the first two or three decades of the sixteenth century were the visual codes related to women and sexuality, which were developed by artists such as Hans Baldung Grien and Albrecht Dürer. It is to these that I turn in the next two chapters.

Figure 2.25 Hans Burgkmair, *The Weißkunig Learns the Black Arts*, 1514–16, woodcut, published in Marx Treitzsaurwein, *Der Weiß Kunig*, Vienna: Kurzböck, 1775. HAB, Wolfenbüttel [Lo° 26].

3

WITCHES' CAULDRONS AND
WOMEN'S BODIES

In 1516 an anonymous artist, probably from Hans Baldung's Strasbourg workshop, produced a woodcut which gave expression to that close association between witchcraft and female sexuality forged by Baldung and his fellow artists in the early years of the sixteenth century (fig. 3.1). It was an image that came to represent witchcraft to a broad public more than any other and would continue to influence artists throughout the century. This rather crude woodcut of a group of three women positioned around a belching cauldron in a site strewn with bones and overseen by a male figure in a tree was first published by the Strasbourg printer, Johann Grüninger. Grüninger used it in both editions of the 1509 sermons of the Strasbourg cathedral preacher Geiler of Kaysersberg, collected by the Franciscan Johann Pauli and published under the title *Die Emeis* (*The Ants*) in 1516 and 1517.[1] Grüninger chose the woodcut again a few years later in his 1519 edition of Hieronymus Braunschweig's *Book of Distillation*, this time to illustrate the relationship between melancholy and witchcraft.[2] And when Johann's son, Bartholomäus Grüninger, wished to illustrate a group of stories about magic and sorcery in what was to become one of the most popular German works of the sixteenth century, a collection of moral tales written by Johann Pauli and published under the title of *Schimpf und Ernst* (*Humour and Seriousness*), Bartholomäus again made use of the woodcut. He included it in both the illustrated Strasbourg editions of 1533 and 1538, even though the woodcut had no relationship to the stories in the text.[3] By the time Matthias Apiarius included it in his 1542 and 1543 Bern editions of *Humour and Seriousness*,[4] the woodcut had become one of the most widely recognized images of witchcraft among the German book-buying public.

The woodcut accompanied one of Geiler's sermons on the illusions or fantasies of witchcraft and specifically illustrated the story found immediately below the woodcut in the text. This told of a Wild Ride by the woman shown seated on the stool in the woodcut.[5] Geiler's text was actually based on a story from an earlier fifteenth-century collection, *The Ant Colony*, by the Dominican theologian Johann Nider.[6] According to both Geiler and Nider this woman was deluded and had attempted to prove to a priest that she really could travel out at night with her fellow witches. The story tells how she did this. When night came she sat astride a kneading trough which had been placed on a bench, smeared herself with oil, uttered the appropriate words and fell into a trance. Then, the text informs us, she imagined that she was travelling and felt so much pleasure that she 'thrashed around with her arms and legs'. Her actions were so violent that the trough fell off the bench, and she fell down and injured her head.

The artist has incorporated the stool found in a number of images of witchcraft and

Figure 3.1 Baldung workshop (?), *Three Female Witches on a Night Ride*, woodcut, in Johann Geiler of Kaysersberg, *Die Emeis*, Strasbourg: Johann Grüninger, 1517, fol. 37v. HAB, Wolfenbüttel [457.2 Theol. 2° (5)].

the Wild Ride in this period (figs 2.1, 3.1, 3.2, and 4.14) as the bench on which the woman rides her kneading trough. Her frenzied movements are represented by the blurred linework between thigh and arm, while the manner in which her dress is hitched up to her thighs is strongly suggestive that this is a sexual ride. The artist seems to have picked up the suggestions of masturbation in the text, which plays on sexual innuendo to describe the delusions of a woman who thinks she is night riding, but has actually fallen into a trance. The word used to communicate her imagination or illusion, *wont* (from *wähnen, Wahn*), seems also to allude to her ecstasy or pleasure (from *wohnen, Wonne*). This is supported by the description that the inner pleasure she felt ('het semliche Freud inwendig') resulted in a frenetic thrashing of her arms and legs. In Nider's original story a similar allusion is made, by claiming that the woman's trance or dream originated with the lady Venus.[7]

There is no way of knowing the basis for the particular choice of words by Johann Pauli for the activity of witches in sermons he had heard about eight years earlier. They may have been based on his notes, but they may also have been influenced by the close relationship between witchcraft and sexuality which had been so often displayed in the visual representations produced by his fellow Strasbourg resident, Hans Baldung Grien, over those years. The woodcutter, however, seems to have taken up and expanded Baldung's particular emphasis. The ride of the central woman is one in which she is physically and symbolically linked with two other women who accompany her. These women

are naked and hold up vessels that allude both to the flaming vessels of Venus and the cauldrons of witchcraft. The composition has clearly been influenced by Baldung's work, but it is now adapted to the Geiler/Pauli narrative. Even the strange banner held by the woman on the kneading trough serves to corroborate the sexual nature of her Wild Ride. A codpiece or pair of hose tied to it merge with the wings of a bird-like demon.[8] Similar banners with codpieces feature in one of Peter Flötner's satirical attacks on the Roman church's processions a few years later.[9] Both probably allude to 'the struggle over the pants' and 'the stealing of the codpiece', common metaphors in early sixteenth-century Germany for gender conflict. The theme is well illustrated in an engraving by Israhel van Meckenem, for instance, which also features a bird-demon similar to that in the 1516 woodcut.[10] A woman holding a distaff is shown preventing a man from picking up a codpiece from the ground by grasping his wrist and stepping on his foot. Her distaff is raised as though in victory and her hair streams out behind her, while the young man's skirt divides to reveal his genitals. And in a 1533 woodcut by Erhard Schön, *The Prize of the Devout Woman*, a woman is depicted driving her man forward as a beast of burden after she has robbed him of his sword, purse and codpiece – the accoutrements of his male power.[11] Just as these prints represent statements about the appropriation of sexual dominance by women, the raising of the pants provides a similar statement about the dangers of female sexuality. Witchcraft in these images represents an attempt by women to free themselves from male mastery and to appropriate the sexual power on which that mastery rests.

The main purpose of Geiler's sermon was to demonstrate that the claims of witchcraft were nothing but diabolical illusion and delusion. For this reason he added to the story of the woman's night ride the better-known story of a Wild Ride from the life of St Germain.[12] The artist incorporated the theme of diabolical illusion by creating what is almost a frame for the central composition. As I discuss in Chapter 8, the male figure up the tree with the crutch was probably an allusion to Saturn, the god-planet identified with the Saturnine or melancholic temperament and known as providing entry for diabolical fantasies into the human imagination. This Saturn figure served to present the scene as the product of diabolical fantasy. And for those who could read Geiler's text, the theme of delusion would have sounded loud and clear: after referring to diabolical delusion in the St Germain story, Geiler goes on to tell of the diabolical delusions in the transformation of the Trojan war hero Diomedes and his comrades into swans, a story taken from Augustine's *The City of God*.[13]

My interest in this chapter is not the artist's framing of the central scene, but the central scene itself. The group of three women gathered around a number of cauldrons – an image that clearly derived from Baldung but achieved widest circulation in this form – soon acquired iconic status as a visual code for witchcraft. This is clear in the adoption of key elements from the scene once the woodblock stopped being used by printers after the early 1540s. A woodcut clearly modelled on it appeared as a titlepage in three publications later in the century: in a news-sheet of 1571 written by a Catholic priest, Reinhard Lutz, from the town of Sélestat in Alsace; in a new German translation of Molitor's work by Conrad Lautenbach, published in Strasbourg in 1575; and in a short treatise by Paulus Frisius, *The Devil's Hoodwink*, published in Frankfurt in 1583 (fig. 3.2).[14] The central scene of the woodcut in Frisius' work, which features a clothed woman on a stool in a site strewn with bones, demonstrates an obvious link with the Geiler woodcut of 1516, even if one of the vessels has been brought to ground and

Deß Teuffels Nebelkappen/
Das ist:

Kurtzer Begriff/den

gantzen handel von der Zauberey
belangend/zusammen gelesen.

Durch

PAVLVM FRISIVM NAGOL.
danum, der H. Schrifft Studenten.

Gedruckt zu Franckfurt am Meyn/Anno 1 5 8 3.

Figure 3.2 *Witches around a Cauldron*, titlepage woodcut, in Paulus Frisius, *Deß Teuffels Nebelkappen*, Frankfurt a.M.: Wendel Humm, 1583. HAB, Wolfenbüttel [A: 243.9 Quod.].

operates more conventionally like a cauldron. The reptile head suggests a horrible brew is being cooked up and is to include something from the mouth of the dead child. Unlike the linked hands of the women in the 1516 woodcut, the clothed woman points to the cauldron, making it the focal point of the scene. And the bird-demon overhead has been excised, creating space for the image of a naked witch riding a goat through the sky, and holding its horn in the manner of the early images of Dürer and Altdorfer (figs 1.12 and 1.13). The figure in the tree has also lost his crutch now, suggesting that the very particular iconographical meanings of the original have been lost on this later artist.

73

A third version of the same subject, but with important iconographical variations, served as the titlepage woodcut to part one of the second German edition of Johann Weyer's *On the Tricks of Demons* (*De Praestigiis Daemonum*), published in Frankfurt in 1566 and translated by Johann Fuglinus (fig. 4.15).[15] The woodcut was then included in the German translations of 1575 and 1586. In 1582 it was again used as a titlepage, this time in a pamphlet published in Frankfurt by the Marburg lawyer Abraham Saur, which told of the execution of a woman convicted of witchcraft in Marburg in the same year (fig. 3.3).[16] In this version the belching cauldron sits on a fire, stirred by an older witch with sagging breasts. The narrative links to Geiler's story have largely disappeared, creating a more generalized image of witchcraft. The clothed night-rider has become naked, now largely indistinguishable from her companion, her banner reduced to a cooking stick. She looks out at the viewer to emphasize the print's moral and didactic purpose. Only a bonnet and scarf survive, traces of her role in the earlier narrative; even the stool has been turned at an angle, so as to lose its earlier visual prominence and connection to the night ride. The witch riding the goat has now been foregrounded and is more closely integrated into the image; while the removal of the hand gesture by the male in the tree reduces him to little more than a decorative feature, used to create compositional balance.

The various pots or vessels in the different versions and copies of this frequently reproduced image constitute the central element in one of the dominant visual codes created for witchcraft in the sixteenth century: a group of women shown gathered around a cauldron. As we have already seen in Chapter 1, the cauldron first achieved prominence in the Molitor woodcut series, which Baldung so successfully adapted in his programmatic woodcut of 1510. The question I want to pursue in this chapter is how and why the cauldron achieved such popularity and longevity in witchcraft representation through the rest of the sixteenth century. My suggestion is that, while drawing on a range of meanings from different cultural practices and discourses, the cauldron primarily served to identify the witch as female. It linked witchcraft to the female roles associated with the hearth, the preparation and distribution of food, the more general nurturing of society. And since food exchange was commonly associated with sexual exchange in visual culture, the cauldron of witchcraft could also be linked to vessels that served as symbols for the seething carnality and sexual power of women's bodies – to the flaming torches of Venus, for instance, or to the chaotic power locked in Pandora's box. Artists adopted the cauldron as a key element in the visual coding of witchcraft, I argue, both to create a link between witchcraft and female labour and to emphasize the relationship between witchcraft and the carnal lust of women's bodies. This chapter aims to explore how such associations were established through a range of images and media.

The cauldron, as a sign of the physically destructive activity of witchcraft and the morally destructive seduction of sexuality, was graphically represented by two images and their accompanying verses in *The Exorcism of Fools* (*Narrenbeschweerung*), a work of the pre-Reformation pamphleteer, Thomas Murner.[17] Murner was a Franciscan theologian and a prominent member of that group of lay and clerical reformers in Strasbourg who argued for the need of moral reform throughout German societies in the three decades before the Reformation of the 1520s. *The Exorcism of Fools* picked up on the themes of *The Ship of Fools*, a far more famous work first published in 1494 by Murner's colleague and Strasbourg secretary, Sebastian Brant. Brant had drawn notice to the fundamental moral and spiritual crisis in his society and used the traditional figure of the

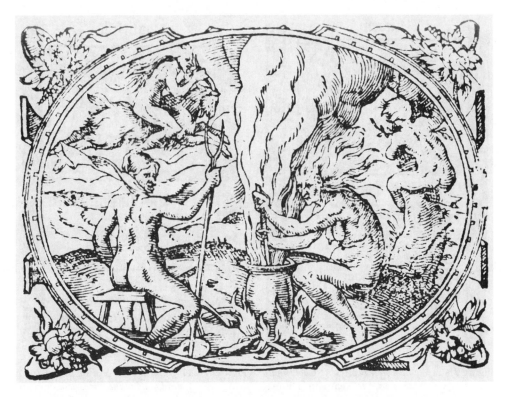

Figure 3.3 *Witches around a Cauldron*, titlepage woodcut, in Abraham Saur, *Ein kurtze treuwe Warnung Anzeige und Underricht*, Frankfurt a.M.: Christoph Rab, 1582. Courtesy of the Division of Rare and Manuscript Collections, Cornell University Library.

carnival fool to communicate the moral disorder he identified as its root cause. Murner argued in turn that the folly Brant identified was synonymous with sin and had to be consciously eradicated from his society. Many of the woodcuts from the first edition of Murner's work, published in Strasbourg in 1512, were simply reproductions of those in Brant's work of 1494.

In the second edition of *The Exorcism of Fools*, however, published in Strasbourg in 1518, the 1512 woodcuts for chapters 46 ('Ein hagel sieden' – 'On cooking up a hailstorm') and 47 ('Das hefelin zu setzen' – 'On putting the cauldron on the fire') – were replaced by images drawing on the new iconography of witchcraft and far more closely related to the content of Murner's text.[18] Chapter 46 now included a woodcut of an old witch in a fool's cap stirring a cauldron on a fire, the purpose of which was the hailstorm shown breaking above (fig. 3.4). The text described the revenge harboured by these women who destroy wine, corn and fruit, and their blindness to the tricks of the devil, who allows them to imagine that the destruction is the result of their own power.[19] The very next chapter, however, provided a quite different meaning for 'putting the cauldron on the fire'. The woodcut depicted a younger woman, but in similar dress and fool's cap, before a similar cauldron; and opposite her a young male fool, legs apart, arms raised and shoulders thrown back, as though to accentuate the artist's suggestion of an erection (fig. 3.5). The woodcut was clearly the artist's representation of Murner's text: 'when the

Figure 3.4 *A Woman in a Fool's Cap Cooking up a Hailstorm*, woodcut, in Thomas Murner, *Narrenbeschweerung*, Strasbourg: Johannes Knobloch, 1518, fol. M2[r]. Permission The British Library, London.

Figure 3.5 *A Woman in a Fool's Cap Setting a Cauldron on the Fire*, woodcut, in Thomas Murner, *Narrenbeschweerung*, Strasbourg: Johannes Knobloch, 1518, fol. M3[v]. Permission The British Library, London.

pot is on the fire, sleep becomes scarce; then there is no respite nor rest, and one only attends to the pot boiling on the fire.'[20] The analogies Murner was drawing on were well known from contemporary discourse: those bound and chained by the bonds of Venus are transformed into fools who become slaves to their brutish senses.[21] The cauldron alluded to the desires of sexuality, desires stimulated by women to bring about the subjection or subordination of men.

It was these two different, yet related, meanings of the cauldron, as physically destructive and sexually emasculating that many early sixteenth-century images of witchcraft drew on. While it has been commonplace for historians to associate cauldrons with the activity of the Sabbath, at which witches produced poisons to wreak destruction on their communities, such a reading restricts the cultural meanings of the cauldron to those provided by learned demonologists. Artists drew on a much broader range of symbolic meaning and association. Murner's image, for instance, probably alluded to contemporary use of the German word for pot or cauldron, *Hafen* or *Häfelin*, for the vagina. The association was not just limited to language, but also related to communal practices. On the feast of St. John in southern Germany, for instance, unmarried women would hang from the eaves of their houses small pots filled with rose petals, with a burning candle inside. The pot symbolized the vagina and so the hanging of these pots at mid-summer marked a

Figure 3.6 Sebald Beham, *Two Fools*, c. 1536–40, engraving. From TIB, vol. 15, p. 112, fig. 213–I (206).

woman's sexual fertility and availability.[22] It is not surprising, therefore, that the pot, vase or vessel was frequently used pictorially to represent female sexuality, most graphically and obviously so in a small engraving of *Two Fools* by Sebald Beham, in which a phallic stick held by the male fool is matched by the vessel held by the female (fig. 3.6).[23]

Murner's cauldron might also have been read as an allusion to Pandora's box, a vessel which, when opened, revealed the evil lusts of women – a theme revived with the publication of Erasmus' *Adages* in 1508 and then widely used by Murner's fellow moralists and playwrights in the early sixteenth century.[24] Until the powerful rendition of the story in a drawing of *c.* 1536 by Giovanni Battista di Jacopo, better known as Rosso Fiorentino, the 'box' was usually represented as a vase or jar. In Rosso Fiorentino's drawing, the evils released from the box held by the elegant and half naked figure of the goddess Pandora, represented the seven deadly sins in graphic human form.[25] But by the 1540s, amongst German writers such as Leonard Culman, Philipp Melanchthon and Hans Sachs, the evils released upon humanity from the box or 'vessel' were identified with the vice of lust or, even more specifically, with female lust.[26] 'Where the servants of Venus gather together', says Satan in one of Culman's plays, 'there the box is accepted'.[27] Certainly by the time that the third and fourth editions of Murner's *Exorcism of Fools* were published by Georg Wickram in Strasbourg in 1556 and 1558, with the same woodcuts accompanying chapters 46 and 47 as in 1518, the link between the belching cauldron of witchcraft and the flaming torches of Venus would have been well established. The cauldron had served to identify the witch as a figure who threatened not only human production and reproduction by unleashing destructive forces upon the world of nature; she also threatened the moral and social order by stoking the fires of lust.

Associations between the cauldron, Pandora's box, Venus' torch and the female bodies of witches were first suggested, as we have seen, by Hans Baldung Grien. In the Albertina drawing of 1514 (fig. 1.2), billows of smoke from both the cauldron and a flaming vessel work together with the movement of the witches' hair to communicate a

sense of the trance-like nature of the women's experience. In the Louvre drawing of the same year (fig. 1.3), fiery vapours of smoke escape from the lower body of one of the women; while in a copy of this drawing by Urs Graf (fig. 3.7), the vessel representing the cauldron seems to be heated by these vapours. And like the older woman in Baldung's 1510 woodcut who lights her torch from the genitals of the goat (fig. 1.1), this woman lights a taper from the gaseous fire that emanates from her own body. In this way magical powers are closely linked to the body; and widely held views concerning the power of women's wombs and genitals are given novel and graphic expression.[28]

Another representation of witches' bodies as cauldrons is found in an anonymous drawing of 1514 clearly influenced by Baldung (fig. 3.8).[29] In this witches' meeting, the fiery gas or smoke that shrouds much of the scene originates from the lower bodies of two of the witches. Together with the unruly, flying hair and the trumpet blown to warn of imminent conflict, the gas belching from the women's bodies conveys a sense of terrible power and impending destruction. The cauldron has been virtually replaced by gaseous female bodies, and the focal point has become the riding witch, borne up on the turbulent movement below. The drawing underlines the view that it was the female bodies that gave these women their power and propelled them through the air on their cooking sticks or goats. And the fact that at least three other copies of this scene have survived suggests that such ideas aroused considerable contemporary interest in the early sixteenth century.[30]

The medieval legend of Virgil, the Roman poet and also magician or necromancer who became infatuated with a Roman emperor's daughter, provides one of the most important links between depictions of witches' cauldrons and of female bodies inflamed with sexual desire.[31] The legend was well known by the late Middle Ages and was also frequently illustrated. It told how the emperor's daughter tricked and ridiculed the poet, and then how he exacted a humiliating revenge. First the woman agreed that Virgil could visit her and at night she pulled him up to her window in a basket; but then she left him suspended half way up the wall, where he became an object of public ridicule for the people below. This scene was frequently depicted from the fourteenth century, and came to be linked with other images illustrating 'the power of women' – as seen in the left hand border of the title-page woodcut of a 1531 edition of Boccaccio's *Genealogy of the Gods* (fig. 3.9).[32] From the late fifteenth century, artists also began to focus on the woman's duplicity and the revenge Virgil exacted as punishment for her deceit. By virtue of his legendary magical powers Virgil had all the fires in the city of Rome extinguished, except the fire in the young woman's vagina. She was consequently forced to expose herself in the marketplace, so that all the inhabitants of Rome could come to her and light their individual torches, for the torches could not be lit from each other. This terrible event was usually depicted as an experience of deep shame for the woman.[33] But when Urs Graf illustrated the scene in 1519, he established a new interpretation for sixteenth-century artists: the woman now became a prostitute, her sexual lust signified by her loose flying hair and the fiery smoke belching from her lower body, as she bared her genitals to the crowds below. And the scene became immensely popular. Graf's version featured in six different printed editions over a dozen years; and a copy of it, as represented in the 1531 Bocaccio titlepage (fig. 3.9), appeared at least 10 times in the same period.[34] For Virgil's story represented the powers women were understood to have over men by virtue of their sexual seduction; and it offered a perfect analogue to contemporary images of witches as women driven by the flames of their lust. Graf had of course learnt to depict witches in this way when he copied

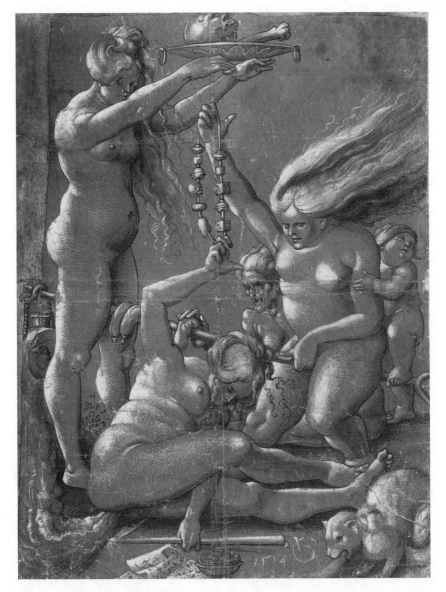

Figure 3.7 Urs Graf, copy of Hans Baldung Grien, *A Group of Witches*, *c.* 1514, pen and ink, heightened with white on green-tinted paper. Albertina, Vienna

Baldung's Louvre drawing in 1514 (fig. 3.7). He embraced Baldung's meaning that witchcraft was not limited to physical destruction and spiritual apostasy; at its core was the sexual seduction of women's bodies.

The sexual power latent within the body of the witch was given extraordinary expression in the most sexually explicit of Baldung's works: a chiaroscuro drawing of 1515 usually entitled *Witch and Dragon* (fig. 3.10).[35] Although the precise details of intercourse between witch and dragon remain unclear, there is little doubt Baldung is alluding to cunnilingus. It has been claimed that the dragon is releasing a fiery jet into

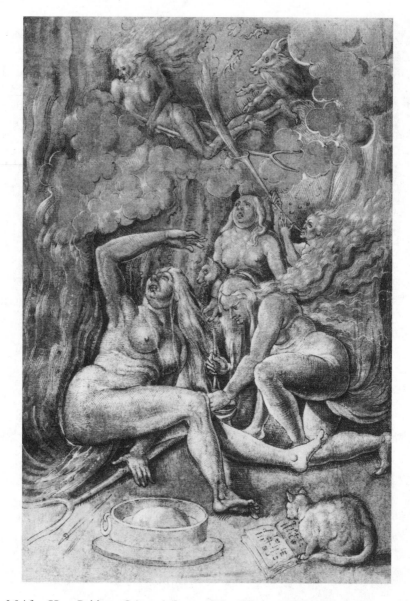

Figure 3.8 After Hans Baldung Grien, *A Group of Five Witches and their Fiery Vapour*, 1514, pen
drawing on grey-tinted paper, heightened with white. Previously Comtesse Béhague,
Paris; now privately owned. From Carl Koch, *Die Zeichnungen Hans Baldung Griens*,
Berlin: Deutscher Verein für Kunstwissenschaft, 1941, fig. A17.

the woman's vagina. But the witch's pose and the action of the putto holding open the
jaws of the lolling dragon, suggest that the woman is the protagonist, firing a jet of gas
into the beast's mouth, which then billows out of its tail. She is in the dominant sexual
position, her hips swivelling in tandem with her downward thrust of a vine-like rope into
the ear-like orifice of the dragon's tail. Baldung is playing with the ambiguities of bodily
orifices and vapours. Devils were of course known to act both as male incubi and female

Figure 3.9 *The Power of Women*, titlepage woodcut, in Giovanni Boccaccio, *De la généalogie des dieux*, Paris: Philippe le Noir, 1531. The Bodleian Library, University of Oxford, Douce ss.453.

succubi, and in that way gained the capacity to sexually engage both genders. By association, witches were also sexually ambivalent. While they were female, they were also masters of their own sexuality, appropriating masculine roles and agency to themselves. Baldung's drawing is a pornographic representation of the diabolical and bestial basis of witchcraft, and his depiction of sexual intercourse and exchange underlines the centrality of the body of the witch.

Such drawings clearly need to be related to the new market for erotica in the sixteenth century.[36] As with other genre scenes such as those of the bathhouse, for instance, scenes of witchcraft responded to male fascination with female sensuality, and in particular, a

Figure 3.10 Hans Baldung Grien, *Witch and Dragon*, 1515, pen drawing on brown-tinted paper, heightened with white. Staatliche Kunsthalle Karlsruhe.

sensuality free of male authority. Baldung created such a scene in a 1514 chiaroscuro drawing of three witches, which has survived in a workshop copy (fig. 3.11).[37] The inscription indicates this was a New Year's card, although the intended recipients are unknown. Traditionally it was thought they were clerics, the 'Corcapen' a reference to canons of an ecclesiastical chapter. But the grammar of the inscription has always been puzzling, and a recent reading suggests it was more likely to be a private card, addressed to a woman with the dog-Latin nickname, 'the heart capturer'.[38] Witchcraft has been reduced here to a representation of female bodies. The wild hair of the women clearly identifies them as witches, as does the flaming vessel, which links them to the fiery lusts of Venus. There are no signs of malefice; and even Baldung's forest settings have been

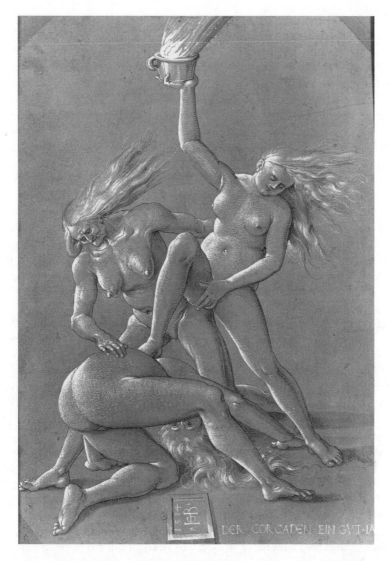

Figure 3.11 Hans Baldung Grien (copy?), *Three Witches*, 1514, pen drawing on red-brown tinted
 paper, heightened with white. Albertina, Vienna.

abandoned, with only the hint of a pitched roof. There is just an entanglement of female
bodies and limbs, a wild and erotic display. The unnaturally high angle of the right leg of
the woman holding the fiery vessel, resting on the hip of her older companion, inevitably
draws the viewer's attention to both their genitals, as does her shielding hand. She is key
player in the artist's game of hide and seek. The woman below them, crouched on hands
and legs, displays her genitals in more seductive fashion: she spreads her legs and locks
them in her upside down gaze, drawing in the viewer's gaze with hers. If Baldung's
figure was meant to allude to the German proverb that when one looks through one's
legs one sees the devil, he has cleverly turned the meaning around, so as also to include
the gaze of the seduced viewer.[39]

Witchcraft as a power linked to the sexed bodies of female witches also finds expression in Baldung's only panel painting devoted to the subject, *The Weather Witches* of 1523 (fig. 3.12).[40] As in almost all of Baldung's witch images, female bodies dominate the canvas. They are identified as the source of disorder in nature by Baldung's depiction of the hair which flies out in contradictory directions, fanned by the sulphurous clouds that presumably result from the women's evil. But flying hair, as we have already seen, commonly represents the unbridled lust of women. This is reinforced by the standing woman's cross-legged stance, a common visual cue for immorality in the sixteenth century.[41] The fiery torch in this image is the cauldron. It dispels its vapours into the red and sulphur yellow of the turbulent sky, held up by a putto who possibly represents a demonic offspring. Baldung uses this cupid-like figure to uncover the seated woman's genitals, at the same moment as she uncovers, ever so furtively, the presence of the goat.[42] Again sexuality and the devil are identified as the sources of these women's power. But the devil is largely a shrouded presence, as the partially revealed goat and also as a small demon held captive in the flask held up by the seated woman.[43] It is the strong and assertive poses of these women, the eroticism of their bodies, directed out to the viewer, which convey the centrality of sexual desire and seduction in Baldung's perception of witchcraft. And this is echoed by the flaming torch and the wild environment of billowing sulphurous clouds.

Flaming vessels and bodies are also prominent in other drawings clearly influenced by Baldung. There is a pen and ink sketch from the early 1520s, in which an older naked witch, identifiable by her wild hair, cooking stick and flaming vessel, approaches a young and beautiful woman reclining on a couch in the manner of a Venus or one of Cranach's reclining nymphs (fig. 3.13).[44] The reclining woman may be a witch, but she may also be the potential victim. In a chiaroscuro drawing by the Monogrammist HF, another contemporary artist influenced by Baldung and who is probably Hans Frank of Basel, a more unusual cauldron appears (fig. 3.14).[45] Here it is made of straw, and, as Linda Hults has suggested, looks like the end of an inverted distaff. The flames spewing from the straw cauldron could be another allusion to Venus' torch; but here they are also linked to physical death and destruction, signified by the human skull held up for display by the witch lying on the ground. The physical destruction wrought by witchcraft is graphically embodied in the emaciated figure of the standing witch with distended breasts and a child tied to her back by her hair. This figure may have been inspired by Baldung's image of Atropos, one of the three fates in his woodcut of 1513, about to cut the thread of life (fig. 5.2). She is clearly menopausal, a representation of anti-nurture, bearing what is presumably a dead child. Below her are the others who cross the borders of the living and the dead through their rituals of necromantic witchcraft, two of them already in a trance on the ground surrounded by the paraphernalia of their craft, the mirror, brush, spindle and a pan with the markings of a magic circle, all clearly coded female. They extend the image of tangled female bodies and poses, limbs, breasts and buttocks, all ungainly and contorted, with the feet wrapped awkwardly and unnaturally around the horizontal cooking stick. But it is the witches' hair with its fantastic highlights that breaks the smooth contours of these bodies and links them not only to each other, but also to the straw, flames, frizzy goat and skull, by means of endlessly gyrating curls and whirls. These are wild bodies, uncontrolled, destructive and bestial, as are the acts of witchcraft.

Some fundamental features of this new visual language of witchcraft, developed by Baldung, Altdorfer, Dürer, Graf and Hans Frank, had taken clear shape by the third

Figure 3.12 Hans Baldung Grien, *The Weather Witches*, 1523, panel painting. Städelsches Kunst-
institut, Frankfurt a.M. Photo: Ursula Edelmann.

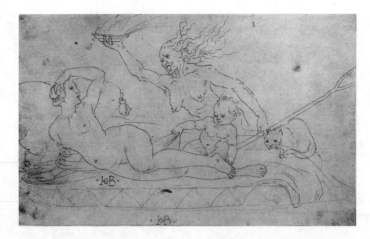

Figure 3.13 Reclining Woman Approached by an Old Witch, *c.* 1520, pen drawing. Kunstsamm-lungen der Veste Coburg.

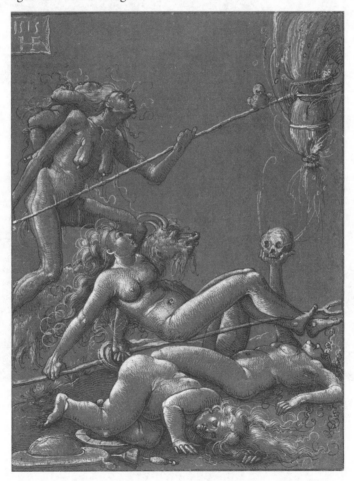

Figure 3.14 Monogrammist HF (Hans Frank?), *Four Witches*, 1515, pen drawing on grey-tinted paper, heightened with white. Kupferstichkabinett, Berlin. © Bildarchiv Preussischer Kulturbesitz, Berlin, 2007.

decade of the sixteenth century. They were established first among a narrow artistic elite who had access to the drawings discussed above; and they had also begun to circulate more widely among a book-buying and book-reading public for whom woodblocks were produced and prints recycled in various editions of popular works such as Geiler's sermons or Pauli's book of popular tales. One widely accepted visual code was the cauldron, around which groups of women would gather. Closely related was the cooking stick, the instrument used by women to assist them in the preparation and distribution of food and drink. And then there was wild hair, that disruptive, disconcerting part of the witch's body which connected her to the wild and to the bestial, which linked her body to the fiery torch and belching cauldron, and which hinted at the turbulent gaseous state beneath the smooth surfaces of her skin. The argument of this chapter has been that the keen interest in witchcraft by visual artists, in the first half of the sixteenth century at least, rested on a fascination with the sexual and nurturing qualities of women's bodies. These bodies were imaged as seething cauldrons with the power both to sustain life and to wreak terrible destruction; they were bodies that could arouse desire as they could bring spiritual death. It would be quite limiting to see them simply, or even primarily, as instilling fear;[46] they were meant to stimulate fascination and wonder, as well as attraction and desire. While there is little doubt that their primary imagined viewer was figured as male, we cannot exclude consideration of the responses of female viewers to such scenes, as the new reading of Baldung's 1514 New Year's card (fig. 3.11) suggests we need to do. Witchcraft became a significant imaginative site in which different fantasies about the social power and especially the sexual power of women's bodies could be explored.

Such exploration is evident in a number of prints that are often described as scenes of witchcraft, although such a designation is quite uncertain. Dürer's 1497 engraving, entitled either *The Four Witches* or *Four Naked Women* (fig. 3.15), is primarily an image of interaction between women's bodies, a presentation of secret women's business; but precisely what kind of business remains far from clear.[47] The key may well be the mysterious letters 'O.G.H.', inscribed on a sphere that hangs from the ceiling together with the year of the print's composition. Most scholars have recognized the presence of evil in this gathering of naked women, and many, from as early as Joachim von Sandrart in 1675, have identified the scene as one of witchcraft. The skull and bone positioned at the women's feet warns of evil, sin, destruction and death, and the monstrous devil surrounded by flames and smoke in the doorway at left, underscores this reading. But the evil relates to the women's bodies. The screening effect of their backs and the unexpected positioning of their hands imply some kind of sexual intimacy; and the upturned eyes of the woman on the right suggest sexual arousal. If the scene is indeed one of witchcraft, it is witchcraft figured as sexual transgression. Dürer's print clearly struck a chord amongst contemporary artists, for it was copied four times within the next few years.[48] The brothers Sebald and Barthel Beham also reworked it in more explicitly erotic fashion in an engraving, *Death and the Three Nude Women* (fig. 3.16).[49] Here the figure of Death caresses the hair of a voluptuous woman, while the hand of her companion reaches out to her genitals. Hands and arms create an erotic fluidity and charge between the four figures, and the foot of the central woman resting on a skull conveys the sense of foreboding and evil. Another Nuremberg engraver, Ludwig Krug, also took up the theme, if not composition, in his *Two Nude Women* (fig. 3.17).[50] The curious interlocking of the women's arms in this print makes it clear that the subject is one of sexual

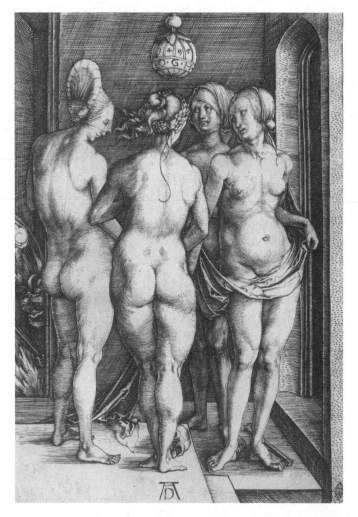

Figure 3.15 Albrecht Dürer, *The Four Witches*, 1497, engraving. Melbourne, National Gallery of Victoria, Felton Bequest, 1956.

transgression, while an hourglass has been added to the skull to emphasize the mortality and vanity of the sensible world as well as the spiritual death which it brings.

Visual evidence of a broad social acceptance of the association between witchcraft and the sexuality of women's bodies in the first half of the sixteenth century appears in a carnival image which has gone unnoticed by historians. It occurs in one of the so-called *Schembart* books, hand-written and illustrated records of the Nuremberg *Schembart* or pre-Lenten carnival, which included a procession through the streets of the city with dancers, runners, mummers and a central float called a *Hölle* (hell). In one of these picture books from the mid-sixteenth century there is an illustration of the float that featured in the procession of 1520 (fig. 3.18).[51] In the float, described as 'a summer house', are four figures. A fool wearing a red, yellow and blue costume, and recognizable by the bell on his cap and his bauble seems about to strike a Turk dressed in a red

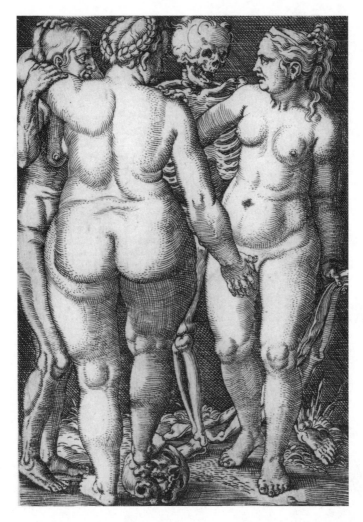

Figure 3.16 Barthel Beham, *Death and the Three Nude Women*, engraving, *c.* 1525–7. British Museum, London. © Copyright the Trustees of The British Museum.

costume and white turban. At the other end of the float is a raging green bear-like figure, clearly a devil; and in the middle a naked woman, immediately recognizable as a witch by her wild hair and cooking stick. We simply do not know whether the image was a faithful depiction of the original costumes worn by the mummers, and any such speculation is complicated by the fact that the textual description of the contents of the summerhouse varies from manuscript to manuscript. But in a number of sixteenth-century illustrations the woman appears naked. In one case she is even depicted with longer hair and has her arms outstretched rather than holding a cooking stick; and in another she is very similar to the witch in fig. 3.18.[52] Given that the earliest dating for these manuscripts is 1539, the year the *Schembart* was permanently banned in the city, the figures may well represent backward projections of how the witch was thought to have appeared. Even so, it remains significant that from approximately mid-century, artists who had to imagine a

Figure 3.17 Ludwig Krug, *Two Nude Women*, engraving, *c.* 1510. From TIB, vol. 13, p. 309, fig. 11 (541).

witch figure participating in the public performances of the Nuremberg carnival some 20, 30 or 40 years earlier, would have produced a figure remarkably similar to the witches of Hans Baldung Grien and his fellow artists from early in the century.

While such figures with their cooking sticks and cauldrons quickly transformed the earlier iconography of sorcery in the first half of the sixteenth century, it would be quite misleading to suggest that their adoption was universal. Individual sorcerers, clothed, often old, identified only by gestures of conjuration, continued to be produced. This was especially so for woodcut illustrations in printed books, the medium that achieved the greatest circulation through European societies. These older images were often simply modified so as to register the new language of witchcraft. The figure of the devil was introduced, for instance, as we have seen in the case of Schäufelein's 1511 woodcut (fig. 2.1), in order to stress the diabolical origin of the witch's power. Or alternatively, a visual

cue such as the cauldron was inserted in order to ensure that the viewers identified the scene as one of witchcraft. I have already presented a graphic example of this technique: the insertion of a cauldron and storm in an image of milk stealing in Geiler of Kaysersberg's *The Ants* (fig. 2.10). In the last section of this chapter I want to introduce a number of other examples of this technique, in order to demonstrate the extent to which the cauldron became central to the visual language of witchcraft in the sixteenth century.

The most widely disseminated image of witchcraft in the first half of the sixteenth century, as far as I've been able to gauge, was a woodcut by the Augsburg artist Jörg Breu the Elder, which largely ignored the new iconography developed by Baldung and others early in the century (fig. 3.19).[53] It was published for the first time in 1534 by the Augsburg press of Heinrich Steiner, in a work of Johann von Schwarzenberg, *Memorial der Tugend* (*Memory Prompts to Virtue*). Steiner used the image over and over again. After the first use in 1534, he repeated it in the 1535 and 1540 editions of the *Memory Prompts to Virtue*.[54] In 1534 he also used it – without the accompanying verses – in the first Augsburg edition of *Humour and Seriousness*, Pauli's extremely popular collection of moral tales, and he repeated it in the 1535, 1536 and 1537 editions.[55] In 1537 and 1544 he reproduced it in a third work, the German translation of Polydore Vergil's *De rerum inventoribus* (*On the Inventors of Things*).[56] The woodcut would have represented one of the most common ways witchcraft was imagined by a German readership in the first half of the sixteenth century.

Memory Prompts to Virtue was a kind of popular guide for the moral life, which provided numerous *exempla* of virtue from classical history and the Christian scriptures, collections of advice for the different estates and professions, and warnings about particular forms of behaviour. It was directed to a broad audience and took the unique form of a picture book with short, and often closely integrated, texts. It drew on the broader discourse of virtue and vice to which Vintler's work was a contribution in the fifteenth century, and which had been reworked by moralizing humanists such as Sebastian Brant at the turn of the sixteenth century, and those associated with the Reformation movement in the 1520s and 1530s. Schwarzenberg himself is likely to have exercised considerable influence over the contents of the woodcuts, as well as having written the text. In his preface he referred to his work as a series of 'Gedenkzettel' or 'memory prompts' to virtue: an art of remembering virtue and vice analogous to the arts taught at school; a series of stories, images and verses which tell of the praise of God and the shame of evil. He even expressed the wish that these stories could be painted and written on cloth hangings and walls, so as the better to be made visible as a permanent memorial.[57] Curiously, Schwarzenberg's wish was partly realized. Many of the images from the fresco cycle painted on the walls of the Ulm town hall by the artist Martin Schaffner in about 1540, were based on woodcuts from the *Memory Prompts to Virtue*.[58]

Breu's woodcut depicted healing by sorcery, and together with its accompanying verses contributed to Schwarzenberg's warnings about different vices. In the foreground two forms of healing become explicable with the help of the text above. On the left beneath a tree is a soldier, decked out in armour, helmet, sword and stirrups, bent over on the ground and charming a wound sustained by his horse. His words printed above make this clear: 'My word is embellished with holiness, so that your wound will neither hurt nor give you pain.'[59] On the right, a woman with hair flying out wildly behind her charms the pain from the head of a man with the following words: 'Truly believe, my word is a magic spell; so do I alleviate you of the pain in your head.'[60] But Breu also drew

Figure 3.18 Summerhouse with Devil, Witch, Turk and Fool (1520 Schembart carnival float), manuscript illustration, mid–16th century *Schembartbuch*. Stadtbibliothek Nuremberg, MS Nor. K. 444, fol. 63[r].

on a number of visual cues to communicate the fundamentally evil nature of these acts. The female figure's gesture of conjuration would have immediately identified her as a sorcerer;[61] but her flying hair, enmeshed with the figure of a demon, would have left no doubt that this sorcery was being presented as an act of diabolical witchcraft. Furthermore, in order that viewers harboured absolutely no doubt as to the nature of Schwarzenberg's warning, Breu introduced another visual cue: on the top of the hill in the background he inserted a witch brewing up a hailstorm with her cauldron.

The insertion of a visual cue of cauldron and storm into a traditional image of sorcery testifies to the importance of clearly identifying the content of this woodcut as witchcraft. For the primary aim was to communicate to the viewer that not just evil charms, but all forms of magic, including those that make use of Christian words and are directed to good ends, are to be condemned as witchcraft. This was also the function of the verses

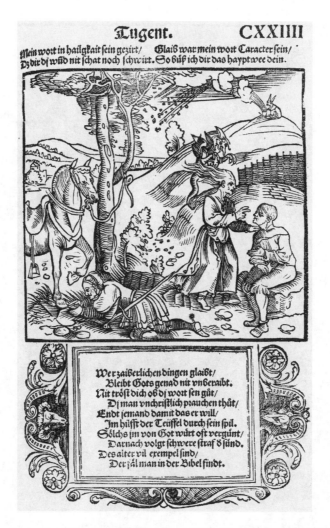

Figure 3.19 Jörg Breu the Elder, *Healing by Sorcery is an Unchristian and Diabolical Practice*, woodcut, in Johann von Schwarzenberg, *Das Büchle Memorial das ist ein angedänckung der Tugent*, Augsburg: Heinrich Steiner, 1535, fol. 124[r]. HAB, Wolfenbüttel [12 Ethica fol. (1)].

below, which were only included with the woodcut in the editions of *Memory Prompts to Virtue*. The text acts as a kind of frame for the visual scene and alludes to contemporary Reformation discourse about 'the Word'. It leaves no doubt that both forms of healing are to be condemned as ungodly, even if it continues to differentiate between practices which make use of Christian words and those which operate with magical spells: 'Whoever believes in magic and sorcery/ he will be deprived of God's grace;/ Place no trust even in good words/ which are put to unchristian use.' This second couplet no doubt refers to the charm of the male soldier, which he says is 'embellished with holiness'. His are the 'good words' put to unchristian use; while the charm of the female healer is described above as words with magical power ('Caracter'), evil words. If one uses either for unchristian ends, the text continues, it is to be condemned; for it provides an

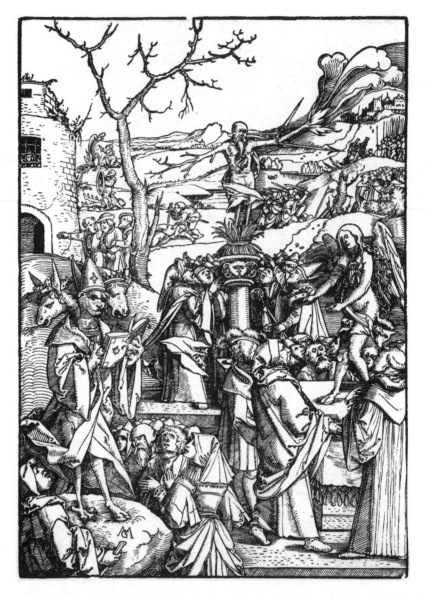

Figure 3.20 Matthias Gerung, *The Three-fold Idolatry of the Roman Church*, woodcut, *c.* 1550. From Strauss, vol. 1, p. 311.

opportunity for the devil's mischief, from which serious sin and punishment must follow. The witch, cauldron and storm on the hill underscore this meaning.

A witch and cauldron also appear as a visual cue for witchcraft in a woodcut produced as part of Reformation polemic in about 1550, *The Three-fold Idolatry of the Roman Church*, by the south German artist Matthias Gerung (fig. 3.20). The woodcut was one of a series of allegorical images that served as counterparts to a series illustrating the text of the Book of Revelations. Both woodcut series were created between 1544 and 1558 for a German translation of a commentary on Revelations by the reformed preacher of

Figure 3.21 Matthias Gerung, *The Three-fold Idolatry of the Roman Church*, woodcut, detail, *c.* 1550. From Strauss, vol. 1, p. 311.

Berne, Sebastian Meyer.[62] This complex woodcut displays three forms of contemporary idolatry in order to demonstrate how the Roman church is nothing more than godless superstition. In the left foreground a group of peasants and burghers worship a three-headed beast that represents the folly, avarice and arrogance of the church. On the right a group of nobles and monks surround a naked, hoofed and winged female figure with long hair, who would seem to embody a combination of Fortune, *Frau Welt* – a late medieval symbol of the carnal world – and Heresy. A large purse hangs from her neck and she stands on what looks like an altar, while offering a crown and money to her worshippers below. In the centre a group largely made of clergy demonstrate their allegiance with an oath to a macabre, semi-naked, scare-crow figure of an old man, whose one arm is a dried tree branch and the other a combination of dagger, arrow and flaming torch.

As Petra Roettig has argued, this gruesome central figure seems to represent a combination of the ancient planetary gods Saturn and Mars, and the Canaanite god Moloch. All three were associated with different forms of violence; and in the background Gerung depicts such violence as a contemporary consequence of the idolatry in the foreground. On the right, for instance, Turkish soldiers pursue members of the imperial and papal

armies; and a city is under siege. On the left two men lead a peasant to prison, another stabs a victim and an executioner breaks a criminal on the wheel. In the deep left background (fig. 3.21), a woman kneels before a cauldron on a flaming fire, in which one can see a skull; and beside her on the ground are human limbs she is cooking up. The cauldron in this case specifically emphasizes the physical violence of witchcraft: it suggests the dismemberment of human bodies and possibly acts of cannibalism – themes which, as we shall see in Chapter 8, only gained prominence in the second half of the sixteenth century. Although witchcraft is not a central theme in Gerung's polemic, it is significant that in presenting a catalogue of contemporary violence, the artist should include the violence of witchcraft. And the most recognizable visual code for witchcraft is a spewing cauldron.

A third example of the inclusion of a witches' cauldron into an image not dealing specifically with witchcraft occurs in the titlepage woodcut of a so-called devil book, *Der Zauber Teuffel* (*The Magic Devil*), written by the Lutheran lecturer at the Marburg Paedagogium, Ludwig Milich, and published in Frankfurt by Sigmund Feyerabend and Simon Hüter (fig. 3.22). The first edition of 1563 was printed by Hans Lechler in Frankfurt without a titlepage woodcut; but the later editions of 1564, 1565 and 1566 printed by Hans' brother and successor, Martin Lechler, did include it.[63] 'Devil books' were a new literary genre which became extremely popular with Protestant readers in the second half of the sixteenth century. They moralized and personalized vices such as swearing, drinking and dancing by associating them with particular devils dedicated to the promotion of these vices and in this way encouraged an increasingly demonized understanding of the early Protestant world. The first of such works appeared in 1552 and, by the end of the 1580s, 29 first edition devil books and numerous reprints meant that approximately 200,000 volumes were circulating among a German reading public. Frankfurt was the most prolific centre for the publication of this literature and Sigmund Feyerabend, the publisher of the *The Magic Devil*, was closely involved with the most significant publication of this kind, a collection of the 20 most popular devil books under the title of *Theatrum Diabolorum*, which first appeared in 1569 and then in expanded editions in 1575 and 1587/88.[64]

In the titlepage woodcut to *The Magic Devil*, the artist has clearly attempted to give expression to the work's overriding concern to condemn all forms of magic as diabolical – sorcery, divination, charming, conjuration, witchcraft and so on. The central figure is a ritual magician who stands within a circle replete with all kinds of magical and astrological symbols and signs. His dress marks him out as a man of some substance and probably also of education, so that he takes on a Faust-like appearance. But he holds no book. In his left hand is a magic wand, in his right a phial containing a devil, the so-called 'glass devil' that features in Baldung's painting of 1523 (fig. 3.12). On the edge of the magic circle is a satyr-like devil the magician has conjured. But in order to represent the necromancer's activity as nothing more than diabolically produced folly, the artist has introduced an iconographical motif borrowed from a woodcut frequently attributed to Dürer. In the collection of moral *exempla* called *Der Ritter vom Turn* (*The Knight of Turn*), a German translation of a fourteenth-century work by Geoffroy Chevalier de La Tour Landry published in Basel in 1493, the publisher Johann Bergmann von Olpe included a woodcut of a vain young woman looking into a mirror while combing her hair.[65] In order to make a visual statement about the diabolical nature of vanity, the artist had depicted the mirror not with the face of the young woman looking into it, but with a

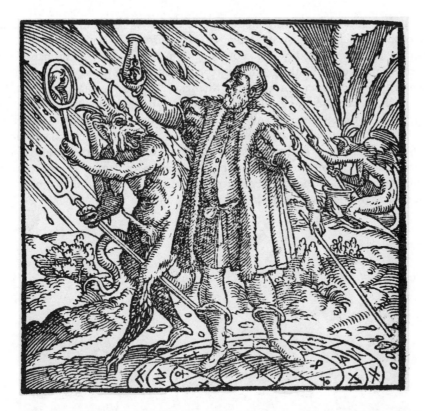

Figure 3.22 *Learned Magic and Witchcraft as Diabolical Arts*, titlepage woodcut, in Ludwig
Milich, *Der Zauber Teuffel. Das ist Von Zauberei, Warsagung, Beschwehren, Segen,
Aberglauben, Hexerey, und mancherley Wercken des Teufels … Bericht*, Frankfurt a.M.:
Sigmund Feyerabend and Simon Hüter, 1564. Stadt- und Universitätsbibliothek,
Frankfurt a.M.

reflected image of the arse of the devil, who stands behind her poking out his tongue and
spreading his buttocks to reveal his anus.

In *The Magic Devil* woodcut the artist has used the same visual cue. However, the
devil's arse in the mirror is not a reflected reality, unless it involves some kind of magical
magnification of the hindquarters of the devil in the urine glass. More likely, it represents
a visual commentary on the magical arts as no more than the shit and piss of the devil, the
illusion and vanity of knowledge and power. And as though to ram home his point, the
artist also figures learned magic as equivalent to witchcraft. Behind him on the right is a
female figure hunched over a belching cauldron, stirring it, cooking up a cataclysmic
storm of hail and lightning. The storm dominates the background and creates an atmo-
sphere of turbulent movement. It contrasts with the ritual magic in the foreground, but
embroils the magician in its energy. Witch and cauldron have transformed the refine-
ment and learning of the ritual magician into a practitioner of diabolical witchcraft.

In a fundamental way this crude woodcut gives expression to the process by which the
cauldron was exploited by artists in the sixteenth century to figure witchcraft as female.
For while the witch figure in the woodcut is clearly a devil with horns and tail, it is also an
indisputably female body and conforms to contemporary associations between female

97

bodies and cauldrons. The fully clothed male magician, assuming the authoritative stance of the physician, magistrate, judge or schoolmaster, with wand in one hand and phial in the other, protected by the knowledge of magical signs and talismans which he has inscribed in his circle on the ground, is represented as a figure tricked by the devil and his own delusions of power. The image of witchcraft, however, is that of a naked, female body, hunched over a seething cauldron, engaged in feverish physical activity with her cooking stick, at once elemental and also very destructive. The synergy between naked female body and cauldron is an expression of those complex associations explored by artists from the early years of the sixteenth century and accepted by this time as one of the most widely adopted visual codes for witchcraft. Another fundamental visual code developed for witchcraft in the early sixteenth century was that of the riding woman; and it is to that subject that I now turn in the following chapter.

4

WILD RIDERS, POPULAR
FOLKLORE AND MORAL
DISORDER

Lucas Cranach, the prolific court painter to the Elector of Saxony from 1505, wealthy Wittenberg apothecary and town councillor, champion of Luther's Reformation and leading German artist of the first half of the sixteenth century, created a remarkable series of four paintings on the subject of melancholy between 1528 and 1533.[1] Melancholy was a lively topic within the intellectual discourse of the sixteenth century, and not least among artistic circles. The nature and effects of melancholy had been subjects of ongoing interest in philosophical, medical and theological writings during the Middle Ages and received even greater attention from humanist and Neoplatonist scholars from the late fifteenth century. Visual artists also played a significant role in elaborating ideas concerning the relationship of temperaments such as the melancholic, to human behaviour and social organization.[2] Cranach's novel approach to melancholy was to link it to the delusions of witchcraft, and through that association to explore fantasies about sexuality and moral disorder in his society. He did this primarily by introducing a cavalcade of wild witch riders into his iconography. In the process he helped underpin the erotically inflected language of witchcraft that he learnt from his fellow German and Swiss artists earlier in the century, and expanded it to incorporate themes, ideas and allusions originally derived from popular folklore, from recent literary topoi and even from Reformation propaganda. Cranach's four paintings provide us with fascinating insight into the way some visual artists were able to link witchcraft to other contemporary discourses and thereby make it more credible and topical for their society. In the following chapter I want to explore Cranach's paintings and other images from the first half of the sixteenth century to help clarify one of the key questions of the new visual language of witchcraft: how did the figure of the riding witch achieve such long-lasting success as one of the key visual codes for the representation of witchcraft?[3]

In all four of his paintings Cranach depicted melancholy as a seated female figure *association* shown sharpening or peeling a stick, and surrounded – in three of the four cases – by objects traditionally associated with the melancholic (figs 4.1–4.7).[4] A key point of reference was Dürer's engraving of more than a decade earlier, his master engraving of 1514 simply entitled *Melencolia I*.[5] Cranach's sphere, the putti, the sleeping dog, the chisel, the compass, and the winged figure of Melancholy, all allude to Dürer's work. But Cranach clearly rejected Dürer's very positive attitude towards the creative power of melancholy. By locating Dürer's elements within a rural environment of mountain crags and a thick cloud populated by a cavalcade of riders on a variety of wild beasts, he effectively linked melancholy to dark forces within the human psyche. These wild and mostly naked figures represent the imaginative phantasms and human desires created by a

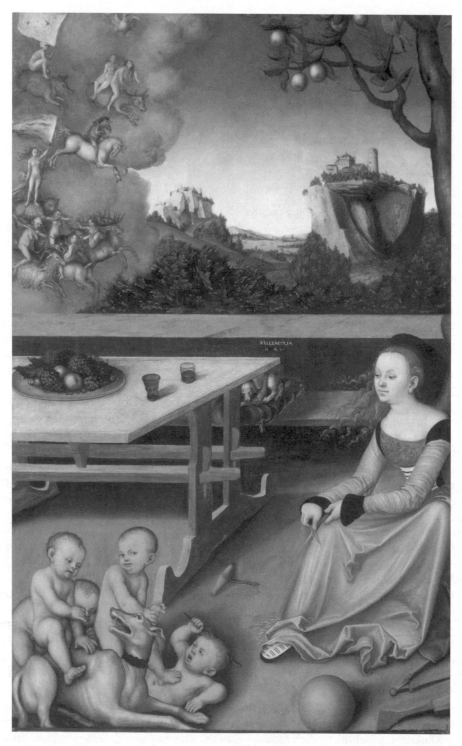

Figure 4.1 Lucas Cranach the Elder, *Melencolia*, 1528, oil on panel. National Gallery of Scotland, Edinburgh, on loan from a Private Collection.

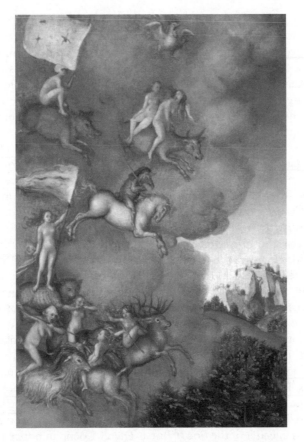

Figure 4.2 Lucas Cranach the Elder, *Melencolia*, detail, 1528, oil on panel. National Gallery of
Scotland, Edinburgh, on loan from a Private Collection.

physiological preponderance of black bile produced by a melancholic temperament. And
critical to Cranach's whole schema is the depiction of these figures as riding witches.

The different riders in the Melancholy series reflect Cranach's understanding of witch-
craft as a phenomenon linked to sexual inversion and emasculation as well as to moral
destruction and disorder. In the 1528 painting (fig. 4.1, 4.2), inscribed with the word
'Melencolia', all the riders are naked, the majority young, and all but one female.[6] The
forked cooking stick used as a mast in the topmost banner, and the naked females with
their wild flying hair, immediately identify the figures as witches. Moreover, the banners
held by the riders, one emblazoned with a serpent and the other with three toads, allude
to images of military bands.[7] But unlike the proud standard bearers of contemporary
woodcuts, decked out in the gaudy costumes and flamboyant hats that flaunt their
masculinity, the naked and unadorned female bodies in this painting represent a stark
contrast.[8] Cranach seems to be playing with notions of inverted sexual violence and
disorder, an allusion reinforced by the cock that hovers overhead, a well-known contem-
porary reference to the aggressive sexuality of the mercenary.[9]

Cranach also emphasizes the disordered nature of his female cavalcade by contrasting
it with the ritualized male violence of the hunt. The lower group of women riders,

101

mounted on a stag, a goat and a bull, make up a hunting party that encircles the figure on the goat, who endeavours to ward them off with a club. Here again Cranach is communicating gender reversal. He has completely inverted the intensely masculine ritual of violence and blood-letting, of flamboyant riders with their hunting swords, lances and cross-bows, a ritual frequently employed as a metaphor for the male sexual pursuit.[10] Naked women are the riders, and the animals they ride also allude to contemporary images in which the hunted become the hunters. Significantly, the figure without breasts – either a young man or pre-pubescent female – represents their prey, and is mounted on an unambiguously female animal. In this way, I would suggest, Cranach links the spirits unleashed by melancholy to gender disorder. This is a representation of an 'anti-hunt' or 'wild hunt', which reverses the societal order the hunt is meant to reflect and sustain. Analogous to the struggle between the children and the snarling dog in the foreground, Melancholy for Cranach spawns violent and destructive forces that endanger right order, similar to the destructive forces of witchcraft.

The second version of *Melancholy*, painted by Cranach in 1532 and now in Colmar (fig. 4.3),[11] includes many of the iconographical features found in the work of 1528: the winged woman peeling a stick, the naked children playing, the table with the bowl of fruit and – in this case – a goblet, and the sleeping dog now positioned in front of the table.[12] Two partridges, birds closely associated with the hunt in Cranach's work, have replaced the three instruments on the ground.[13] The cavalcade in the background (fig. 4.4) consists of four females riding on a wild boar, a horned cow and a dragon. All but one are old and, instead of holding banners, their leader carries a horse's skull on a stick.[14] The prey in this scene is a fully clothed male figure riding a mountain goat and holding its horns. In his red and gold slashed-fashion outfit and flamboyant crimson hat, both typical of the contemporary German nobleman or mercenary, he is very distinctive against the naked female bodies. This male figure has been understood by some scholars as the devil or as the leader of the ride.[15] But as Dieter Koepplin noticed many years ago, he is depicted as a very passive figure, as someone who has been abducted.[16] It seems more likely then that the female riders have taken him captive, one of them prodding him forward with her long forked cooking stick, an unmistakable visual cue for a witch.

A similar richly garbed male figure appears in another *Melancholy* painting completed by Cranach in the same year and now hanging in Copenhagen (fig. 4.5).[17] Apart from the horizontal format, the general composition is similar to the Colmar painting. There are some critical differences in the iconography of the foreground, but my particular interest is in the scene outside the window. In the top left corner in a thick black cloud and within a craggy mountain landscape, Cranach has again inserted his cavalcade of riders (fig. 4.6). As in the Colmar painting, the most prominent is a male figure riding a goat and holding its horns, dressed in the slashed-fashion style and flamboyant hat – this time all in bright red – and escorted by two naked witches riding a ram and a boar. The witch on the boar uses a distaff and spindle as a prod, in place of the earlier cooking stick; whereas a witch riding the large hound holds aloft an animal skull very similar to that of the leader in the Colmar painting. Cranach's replacement of the cooking stick with the distaff and spindle is highly significant. Distaff and spindle were common visual references to the female gender in sixteenth-century representation, and for that reason also appear in scenes of witchcraft.[18] But, as I have argued elsewhere, this particular distaff refers to Cranach's paintings of the Hercules and Omphale story, which were being completed at the same time in the early 1530s.[19] There it represents Hercules' sexual

Figure 4.3 Lucas Cranach the Elder, *Melancholy*, 1532, oil on panel. Musée d'Unterlinden, Colmar. Photo: O. Zimmerman.

emasculation and womanly rule, the divestment of his power and his subjection to the authority of women as a consequence of his lack of sexual control. A similar reading of the flamboyant male rider in the Melancholy paintings seems highly pertinent, and is supported by the demonstrative way in which he grasps the horns of the goat. Such a gesture, as I have already noted in the discussion of Dürer and Altdorfer, represented a failure to exercise masculine authority. This nobleman is a similar failure, led off as an emasculated captive by this cavalcade of women.

The stories associated with the sinful mountain paradise of the Venusberg, which first

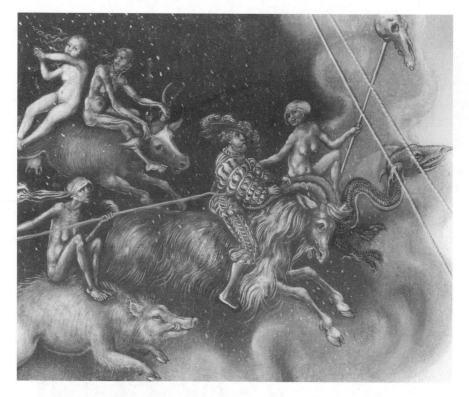

Figure 4.4 Lucas Cranach the Elder, *Melancholy*, detail, 1532, oil on panel. Musée d'Unterlinden, Colmar. Photo: O. Zimmerman.

appeared in European literature in the first half of the fifteenth century in association with the legend of the thirteenth-century knight and poet, Tannhäuser, seem to have provided the stimulus for Cranach's inclusion of this captive male in a representation of melancholic fantasy and delusion.[20] From the earliest references to this mountain paradise, it was a location not only for the court of Venus and its lustful pleasures, but also for the practice of the magical arts. This allowed for its early identification with the demonic and the description of Venus' servants as *incubi* and *succubi*.[21] The popularity of stories about the Venusberg is attested by the fact that the main float drawn through the streets of Nuremberg in the pre-Lenten carnival procession of 1518 was a Venusberg. In the form of a love garden, it seated Venus and her maidens, indulging in food, drink, music, song and sex.[22] A diabolical satyr sat on top of the maypole in the centre, in order to make its moralizing message quite clear. These allegorical dimensions were stressed in much contemporary literature. For Sebastian Brant, the Venusberg was yet another example of the world's folly, the seductions of lust and the devil's trickery.[23] For the Anabaptist David Joris, the Venusberg represented the carnal world, opposed to the mountain of heaven.[24] So while the sensual exploits of the Venusberg were described in contemporary literature, they were also attacked – as fable, fantasy, seduction and diabolical illusion.

Hans Sachs, for instance, told the story of a young doctor from Florence, who tried to ride on a black beast to the Venusberg in order to experience its beautiful women. But

Figure 4.5 Lucas Cranach the Elder, *Melancholy*, 1532, panel painting. Statens Museum for Kunst, Copenhagen. Photo: Hans Petersen.

the beast dropped him into a public latrine instead; and he came home, wrote Sachs, 'stinking of human shit'.[25] Sachs' story of the diabolical delusion of the Venusberg was a variation on a much older and broadly disseminated tale. In Geiler of Kaysersberg's sermon on witchcraft published in *The Ants* and already discussed in the last chapter, Geiler linked the night travel of witches to the Venusberg in the opening sentences:

> Now you ask me, what do you say about women who travel at night and meet at assemblies? You ask if there's anything in it when they travel to lady Venusberg? Or when witches travel here and there, do they really travel, or do they remain? Or is it an apparition? Or what should I think about this?[26]

Geiler went on to tell the story of the woman who claimed she took part in the witches' Wild Ride by sitting astride a kneading trough on a bench and concluded that this was simply the product of a rich imagination.[27] As I argued in the last chapter, the illustrator of this story (fig. 3.1) seems to have interpreted the event as a sexual ride; and in this he might have made use of the version from Johann Nider's work, *Formicarius* (*The Ant Colony*). In Nider's version the woman claimed to be travelling with Diana and other women, a clear reference to the ride described in the *Canon Episcopi*.[28] But when she fell asleep in the kneading trough, after rubbing herself with ointment and muttering malefic words, 'she had such powerful dreams of the lady Venus and other superstitions through the agency of a demon', that in her joy she cried out in a low voice and thrashed about with her hands – so much so that the kneading trough in which she was sitting fell off the stool.[29] Geiler also discussed the Venusberg in his sermon on the *Wütisches Heer* (the Furious Horde) in *The Ants*. There he claimed that the ride to the Venusberg, where one was supposed to find the good life, beautiful women, dancing and the lady Venus, was nothing more than a product of diabolical illusion or imagination ('Teuffels gespenst'). Again he referred to Nider, who related the story of a knight who imagined he was

Figure 4.6 Lucas Cranach the Elder, *Melancholy*, detail, 1532, panel painting. Statens Museum for Kunst, Copenhagen. Photo: Hans Petersen.

travelling to the Venusberg; but when he awoke, he found himself 'in a lake of shit'. That, commented Geiler, was the 'fraw venußberg'.[30]

Later attempts to describe and depict travels to the Venusberg may have helped draw connections between stories of the Venusberg, stories of the witches' night ride and stories of the Furious Horde. The so-called Heuberg, the place where witches through much of southern Germany were said to hold their assemblies, was often identical with the location of the Venusberg.[31] In a witch trial of 1501–1505 in the Val di Fiemme near Trent, the accused Giovanni Delle Piatte from Anterivo, confessed to travelling to a mountain paradise where the Lady Venus dwelt and to have ridden with Venus and her company of witches on black horses, cats, dogs, stools and brooms.[32] And in a Hans Sachs poem of 1559, one type of 'sorcery and the black art' was described as 'how one rides out at night on a cooking fork or a goat to the Venusberg, where one sees great marvels'.[33] As Wolfgang Behringer has suggested, we need to understand these accounts of the Wild Ride as a strategy of bricolage, the combination of building blocks in different ways to suit local beliefs and traditions.[34] In the case of Cranach, his Wild Ride primarily emphasizes the sinful and diabolical nature of melancholy; but with its resonances of the sexual pleasures, gender inversion and emasculation of the Venusberg, it also highlights the link with the seductions of female sexuality. So while Cranach was developing the language of witchcraft in quite novel directions in these paintings, he was also extending the range of meanings developed by artists two decades earlier.

Figure 4.7 Lucas Cranach the Elder, *Melancholia*, 1533, panel painting. From Max J. Friedländer and Jakob Rosenberg, *Die Gemälde von Lukas Cranach*, Basel: Birkhäuser, 1979, fig. 277.

Cranach's wild cavalcades also drew on two other traditions to give them social and cultural meaning and cohesion – on confessional critique and propaganda concerned with the licentiousness of the Catholic clergy, and on the popular stories and folklore associated with the Wild Ride and Furious Horde. Cranach's career as an artist was marked by active engagement as a propagandist in support of the Lutheran cause, and so it is hardly surprising that an attack on the Catholic clergy would feature as a powerful example of moral discord in his last *Melancholy* painting of 1533 (fig. 4.7).[35] Cranach has again used the seated figure of Melancholy who is depicted cutting or peeling her stick,[36] but he has dispensed with the objects associated with the melancholic temperament. Contrary to the quiet trance-like quality of the earlier versions, a raucous group of male children create a sense of moral disorder, underlined by their rather awkward, gyrating dance movements, as they gradually emerge from the deep sleep still enveloping some of their number.[37] Led by the piping and drumming child-musicians, this is probably a form of the *Moriskentanz*, a representation of a life governed by vanity and the senses, and a warning concerning its consequences.[38]

The imaginative fantasies of the wild cavalcade have also been expanded. They now take up more of the painting and have been brought into the room where the figure of Melancholy sits. The cloud has also become a body with a large, bearded head speaking the word 'melancholia'. This needs to be understood as the head and body of Saturn, the god-planet identified with the melancholic or Saturnine temperament, and a well-known patron by the early sixteenth century of such groups as the aged, the crippled, criminals and Jews, as well as clerics and witches (figs 8.1–8.3).[39] The activities of those in the melancholic body-cloud seem to parallel the uncontrolled dancers, responsive only to the fife and drum.[40] The women are all naked again, clearly signifying their seduction of the clothed males. One stands on an owl,[41] brandishing serpents in her left hand and toads in her right, the very beasts represented on the two banners in Cranach's 1528 painting (fig. 4.2). A couple rides on a horse, while a bat, tortoise, dragon and crab participate in the procession. And there are two further groups: on the left, a cleric with a book, embraced by a naked woman sitting on a devil and held by another woman at the hips; and on the right, one woman holding the arm of a monk, and another pulling a kneeling knight or mercenary towards her. There seems little doubt that in 1530s Saxony viewers would have read these scenes as the sexual liaisons of unreformed and dissolute, though supposedly celibate, Roman clergy.[42] The 1533 cavalcade seems to represent a confessional variant of Cranach's message: submission to a life governed only by the senses gives rise to the melancholic delusions of sexual desire, as we clearly see in the life of the Roman clergy. And for a Lutheran audience, at least, Cranach would have succeeded in clearly linking melancholic imagination to the devil.

All four of Cranach's wild cavalcades seem also to have drawn on the popular and learned traditions associated with stories of the Wild Ride and Furious Horde. This is most clearly registered by means of a visual reference to the Furious Horde in the Copenhagen *Melancholy*, the significance of which has not been understood.[43] Within the thick forest vegetation below the riders, Cranach has inserted a scene of a fierce military battle (fig. 4.6). Heavily armoured horses and knights engage in violent conflict, and some already lie dead, their pikes, swords and armour strewn across the battlefield. This is a scene of the violent battles and death associated with the Furious Horde, and together with the cavalcade streaming across the sky above, with their military banners and horse's skull, Cranach has conflated stories concerning the destruction of the Furious Horde

with the witches' Wild Ride. The significance of this conflation for the cavalcades depicted in the other *Melancholy* paintings demands some discussion of the literary topos on which it draws.

The Wild Ride or night ride of witchcraft had become an established feature of witches' activities in literary accounts of the early sixteenth century.[44] It had its basis in exegeses of the famous *Canon Episcopi* text from the ninth century, which was disseminated through the canon law collections of Burchard of Worms and Gratian. The text claimed that some women, deluded by demonic illusions, believed that they travelled great distances on beasts at night in the company of Diana, Herodia and other women. Although the canon and its later commentators condemned such beliefs, these rides came to be combined with other rides, such as those of the Furious Horde.[45] These usually involved cavalcades of demonic spirits and souls, especially of those who died before their time and enjoyed no peace – soldiers killed in battle, young children, victims of violent acts and so on. The Furious Horde was believed to bring widespread devastation to the countryside, and so at the time of such rides, the so-called Ember days at the change of seasons, people would lock their doors and set out food and drink to placate the spirits. While some of the hordes were wholly female, some were male and others of mixed gender. The leaders included mythical figures such as the Germanic goddesses Holda and Perchta, the classical goddess Artemis/Diana, the mysterious figures of Lady Abundia and Lady Satia, and Herodias, also identified with Hecate Proserpina, the goddess of the underworld. By the early sixteenth century Paracelsus could claim the conflation of these traditions: 'The Furious Horde is a meeting of all the witches together.'[46]

One graphic visual example of the fusion of these stories about the Furious Horde and witchcraft occurs in a pen drawing of *c.* 1515, probably by Hermann Vischer the Younger of Nuremberg (fig. 4.8).[47] The lower section depicts riders on horses, some of them prisoners with hands bound, some bearing torches and others skulls on pikes, one at least headless, others on foot and undergoing execution. As the corpse hanging from a gibbet and the body on the wheel indicate, these figures represent victims of a violent death. But amongst the frenetic energy and violence there are at least two female witches: at top left one rides a wild beast, holding a distaff and spindle in the manner of the witches of Dürer, Altdorfer and Cranach; while another holds a flaming vessel in one hand and a forked stick in the other, as developed by Baldung Grien and his imitators.[48] Hermann Vischer's drawing echoes an account of the Furious Horde in Geiler's *The Ants*:

> This is the opinion of the general populace: those who die before the time allotted to them by God, and those who have ridden out to battle and have been stabbed, hanged or drowned, they are required to travel around for a long time after their death … And they usually do so at the time of the Ember days, especially the Ember days before Christmas, which is the holiest time. And each travels in the clothes which are his, a peasant as a peasant, a knight as a knight. And they travel in a line, one carrying his entrails, another his head in his hand, while one rides out in front.[49]

As Jean Wirth has shown, similar literary descriptions can be found in contemporary sources such as Johann Agricola's *Collection of Proverbs*: some ride a horse, others travel on foot; some have recently died, others are still partly alive; one of them rolls the wheel to which he is bound; another runs while carrying his leg on his shoulder; another is headless.[50]

Figure 4.8 Hermann Vischer the Younger, *The Furious Horde*, *c.* 1515, pen and ink. From Heinrich Röttinger, *Dürers Doppelgänger*, Strasbourg: J.H. Heitz, 1926, fig. 87.

As a painting of *c.* 1515 attributed Urs Graf shows (fig. 4.9), artists could interpret the Furious Horde metaphorically.[51] Below the two naked figures, soldiers and flying spirits engage in furious battle at lower left, some already dead, with severed limbs and heads. At lower right are scenes of violent punishment and unnatural death – bodies hang from a gibbet and are broken on the wheel; others are bound as captives or transported lifeless into a river. This is a traditional representation of the Furious Horde;[52] while the naked figures above are Mars and Venus, the adulterous lovers who symbolize illicit sexual liaison. Mars' right leg fondles the buttocks and upper thigh of his female partner, while Venus adopts the crossed-feet stance, a common visual cue for immorality.[53] Venus' fireball would then represent a destructive version of her fiery attributes, while the fiery horn she holds, a so-called *Harsthorn*, alludes to the female vagina, a common counterpoint to Mars' phallic sword, arrow or lance in contemporary scenes of the couple's adultery. Here it contrasts with the spear (*Langspeer*), a local variant appropriate to the depiction of Mars as a Swiss mercenary, identifiable by his beard and the knotted ribbons (*Schützenbänder*) below his knee.[54] The connections here are between the physical violence of battle and the moral violence of unlicensed sexuality. The work attributed to Urs Graf has expanded the meaning of the Furious Horde's destruction to the moral sphere, so that the ride is now also linked to sexual excess and moral licence.

Another Swiss artist, Niklaus Manuel Deutsch, produced a thematically related image of witchcraft just a few years before the painting of the Furious Horde. This was a pen drawing of *c.* 1513, depicting a witch bearing Manuel's own skull (fig. 4.10).[55] Identifiable by her wild hair and the flaming vessel which rests on her left thigh, the witch is

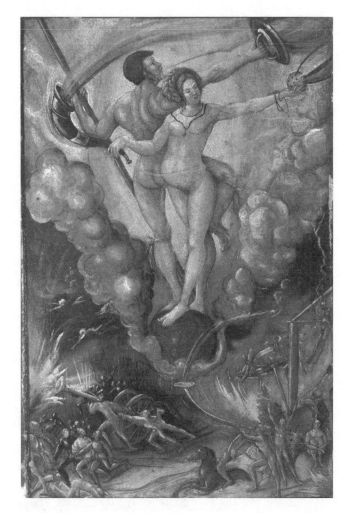

Figure 4.9 Attributed to Urs Graf the Elder, *The Furious Horde*, *c.* 1515, distemper on paper on limewood panel. Kunstmuseum Basel.

naked except for the necklace and jewelry which adorn her body, and sits on a sphere which doubles as a stool. In her right hand she holds an hourglass, on which is a pocket sundial and possibly also a compass, and in her outstretched left hand a skull decorated with an ostrich plume, from which hangs a tablet as a kind of name tag inscribed with Manuel's initials. She is travelling through the air high above the alpine landscape with a lake, castle and other buildings, and the white highlights on the orange-brown paper serve to heighten the fantastic effects.

Manuel's figure has been related to Dürer's famous engraving of *Nemesis* or *The Great Fortune*, who also appears naked and balances on a sphere as she travels over the landscape below. She has also been linked to the confession of a witch in Manuel's home town of Berne in 1522, whom the devil had carried to a witches' assembly on a three-legged stool nine years earlier.[56] But although Manuel's witch may have been inspired by this case, a naked female figure balancing on a sphere had clear associations with Venus.

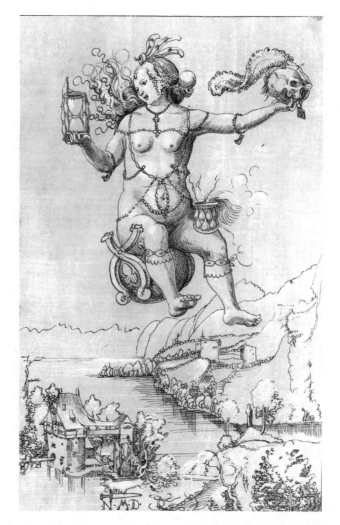

Figure 4.10 Niklaus Manuel Deutsch, *A Witch Bearing Manuel's Skull through the Air*, *c.* 1513, pen and ink, heightened with white on brownish-orange paper. Kunstmuseum Basel, Kupferstichkabinett.

Manuel himself had represented Venus that way in a drawing of about 1512,[57] as in the painting of the Furious Horde attributed to Graf (fig. 4.9). Moreover, the three male cuckoo feathers knotted into Venus' hair signified the victories of Venus over those male cuckoos, who through the folly of their uncontrolled lusts become her captives.[58] So while this complex amalgam of Fortuna/Venus balanced on a sphere and a wild witch riding on a stool represents death through the symbols of the hourglass and skull, it is primarily a moral death. Witchcraft clearly had a very personal meaning for Manuel, signified by the personal tag which identified the skull as his own. But it was not physical death at the hands of Fortune, but moral death at the hands of Venus. This conflation of physical and moral death and its representation through the figure of a naked figure travelling or riding through the sky was clearly stimulated by the visual code of the riding witch. It may well be that the quite unusual

Figure 4.11 The Furious Horde, woodcut, in Johann Geiler of Kaysersberg, *Die Emeis*, Strasbourg: Johann Grüninger, 1516, fol. 37ʳ. Bayerische Staatsbibliothek Munich [Rar. 2241].

introduction of a skull into such images was stimulated in turn by the relationship of the witches' Wild Ride to the destructive cavalcades of the Furious Horde.

Two woodcuts that illustrate one of Geiler's sermons in *The Ants* reflect this understanding of the older folk stories of the Furious Horde as moral and sexual disorder. In the 1516 edition the Strasbourg printer Johann Grüninger illustrated the Furious Horde by adapting a woodcut he had used years earlier in Sebastian Brant's 1502 edition of Virgil's *Opera* (fig. 4.11). He cut the section on the left of the image depicting the Roman poet away from the original block and the labelled three main characters.[59] In this way he transformed the scene into a Bacchic procession. Bacchus, the god of wine, seated in a carriage and adorned with a triumphal wreath, is drawn through a wooded landscape that features vines heavy with grapes. Silenus, the father of the satyrs, is depicted in customary fashion on an ass, reeling in his drunkenness. And third, a satyr plays the bagpipe, accompanied by a young drummer. The last figure represents not only music, but also sex; and so the woodcut becomes a celebration of sensual pleasures. Such associations would have been well known from images of Apollo on Mount Parnassus, which associate Bacchus, Silenus and the satyrs with the mountain island of Cythera, celebrated for the worship of Venus.[60] The Furious Horde in this case, therefore, represented the world of the senses, so often condemned by contemporary moralists as Geiler and Brant. And given the role played by Brant in advising printers on illustrations to be

Figure 4.12 The Furious Horde, woodcut, in Johann Geiler of Kaysersberg, *Die Emeis*, Strasbourg: Johann Grüninger, 1517, fol. 38ᵛ. HAB, Wolfenbüttel [457.2 Theol. 2° (5)].

used in various publications through to the 1520s, Grüninger's choice may well have been influenced by Brant himself.[61]

In the 1517 edition of *The Ants*, Grüninger employed quite a different woodcut for the Furious Horde (fig. 4.12). This featured a cart in which a soldier was standing on his head, and which was pulled by horses travelling backwards. It was clearly a reference to the inversions of carnival, when the world was turned upside-down and ruled by folly, when the lower body was allowed to dominate the head and the senses ruled over reason. The woodcut previously appeared together with a horoscope in the August 1497 Basel edition of Brant's *The Ship of Fools*, a Latin translation by Jacob Locher which went under the title of *Stultifera Navis*.[62] It accompanied a new chapter concerned with the break-down of order in contemporary society, not included in Brant's original text of 1494. The new chapter linked this disorder to past empires and warned that the conjunction of Saturn, Jupiter and Mars in the sign of Cancer in 1503 signified the imminent destruc-tion of the German Empire. Brant therefore pleaded with readers that all might return to the path of proper Christian order and help avert ruin by transforming the malevolent sign of Cancer into that of Scorpio. As part of this long chapter Brant included an expla-nation of the accompanying woodcut; and this serves as a key to understanding its later representation of the Furious Horde in the 1517 edition of Geiler's sermons.[63]

The four coats of arms situated below the cart represent the four beasts in the vision of Daniel (Dan. 7.1–9): from the right, they are the bear, the lion with the wings of an

eagle, the panther with the wings of four birds, and the terrifying beast with the iron mouth and ten horns. They signify the four great world empires, the last of which are the Romans, from whom the sceptre of empire has passed to the Germans. Brant warns that this empire will also perish as the three before them, if they refuse to subordinate themselves to proper order and authority and continue to act in the contrary, inverted fashion of the insubordinate soldier ('acephalus') in the cart. In this society, the woodcut is claiming, all is inverted and awry: the soldier walking on his head; the cart pulling the horses; the horses galloping backwards; the fool urging the horses on with the wrong end of his whip; the fool's spurs attached to the points of his shoes rather than to the heels. And as the larger coat of arms above the cart indicates, all this takes place under the influence of Cancer; while the cart is meant to move forward, in the manner of a crab it regresses. It is most interesting that the printer considered this representation of political and moral disorder from Brant's *The Ship of Fools* as a suitable image to illustrate the destructiveness of the Furious Horde in *The Ants*, and supposedly a much better choice than the woodcut of the bacchic procession he used the previous year. It exemplifies once again how in contemporary moralizing literature the destruction of the Furious Horde could just as easily refer to moral disorder as to physical ruin. Alongside the general popular understanding, which – according to Geiler – identified the Furious Horde with traditional stories concerning the destructive processions of those who suffered violent or premature death, writers and artists identified the Furious Horde with more general notions of moral disorder within contemporary society. It comes as no surprise then to read that the great moralizing playwright of Nuremberg, Hans Sachs, compared the members of the Furious Horde to the so-called Runners (*Läufer*) of Nuremberg's annual pre-Lenten carnival procession. These figures were known for their symbolic harassment of onlookers during the procession and for the symbolic violence and destruction of the main carnival float at its end. They represented that fundamental moral and social inversion on which late medieval carnival culture was premised.[64]

I would suggest that these ideas about the Furious Horde shaped the depiction of Cranach's witches, streaming across the background of the Melancholy paintings as a cavalcade on wild animals, engaged in hunting, capture, harassment and violence. The night rides of witchcraft have been conflated with the morally and physically destructive rides of the Furious Horde. Even well before his Melancholy series, Cranach seems to have understood witchcraft in these terms. In 1515 he illustrated eight pages of the never completed *Book of Hours* of Emperor Maximilian I – generally known as the *Prayer Book of Maximilian*. This complex and lavish luxury manuscript was probably planned as early as 1508 and was supervised by the Emperor's chief literary advisor, the humanist scholar and Augsburg city secretary, Conrad Peutinger.[65] Ten copies of the work were printed on velum at the end of 1513 by the court printer, Johann Schoensperger of Augsburg, and the team of artists employed to add the elaborate pictures and grotesques, constituted the foremost German artists of the second decade of the sixteenth century: Dürer – who produced about half the completed pen illustrations – Baldung, Jörg Breu, Hans Burgkmair, Albrecht Altdorfer, an unknown member of Altdorfer's workshop and Cranach. In the section of the Hours of the Immaculate Virgin Mary that includes the prophecy by John the Baptist's father, Zechariah, the so-called *Benedictus* (Luke, 1.68–9), Cranach inserted two witches depicted as riders participating in a hunt (fig. 4.13).[66] The younger woman, decked out in the flamboyant garb and hat of the nobility and holding an animal skull on the end of a long stick, rides a wild ram snorting thick smoke. An older woman

Figure 4.13 Lucas Cranach the Elder, *Wild Riders*, pen and reddish brown ink on vellum, in
Gebetbuch Kaiser Maximilians, Augsburg: Johann Schoensperger the Elder, 1515,
fol. 59ʳ. Bayerische Staatsbibliothek Munich [2° L. impr. membr. 64].

with exposed, sagging breasts, accompanies her and holds a similar stick or banner. The
four stags at the bottom of the page allude to a hunt, while the insects surrounding the
two riders are a common visual code for disorder. That the disorder is understood as
moral is strongly suggested by the extravagant hat of the main rider. Artists often used
such hats to identify prostitutes; and so the rider of the snorting ram may well have repre-
sented sexual disorder, accompanied, as was frequently the case in contemporary wood-
cuts, by an old procuress.[67] And the women's banners, which presage the violent end of
the hunt in death, may also have alluded to the moral death they bring through their
seduction.

In all these representations of witchcraft as a Wild Ride Cranach was drawing on a
visual language developed by his fellow artists over preceding decades. Dürer and
Altdorfer, as we have already seen, developed the visual code of the riding witch in the

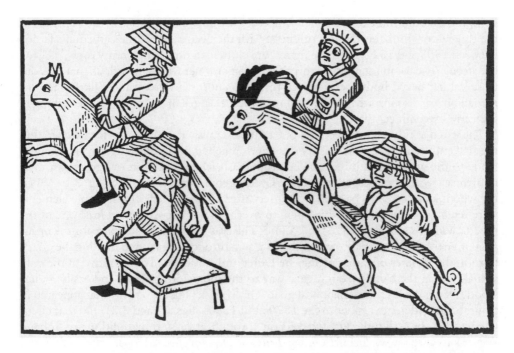

Figure 4.14 Wild Riders on a Wolf, Goat, Boar and Stool, woodcut, in Hans Vintler, *Buch der Tugend*, Augsburg: Johann Blaubirer, 1486, fol. 163^v. From Schramm, vol. 23, fig. 658.

first decade of the sixteenth century. As well as a figure of the wild, it was also a figure of moral inversion. It brought to the viewer's mind images of other female riders: those representing the vices – and especially that of lust – the Whore of Babylon mounted on her dragon, and those other sexual viragos of the sixteenth century, the courtesan Phyllis who rode the bridled Aristotle, and the popular German figure of sexual and social disorder, the *Siemann* or She-man.[68] Such visual and literary traditions were consolidated in Baldung's seminal image of witchcraft from 1510, and reproduced in various permutations by him and his copiers over the following decades.[69] And the moral dimensions of the Wild Ride were communicated in different ways: through the naked bodies and wild hair of the riders, through their flamboyant dress, through their holding of the goat's horn, or through the backward ride.

Some examples of witch-like figures riding animals certainly existed prior to the establishment of riding as a visual code for witchcraft in the first decade of the sixteenth century. Illuminations of the Waldensian witches from the later fifteenth century depicted a number of figures riding large beasts through the sky (fig. 2.24). Hans Vintler's *Book of Virtues*, both the printed version of 1486 (fig. 4.14) and the late fifteenth-century Gotha manuscript, depicted the participants of the Wild Ride mounted on a wolf, goat, bear and also a stool.[70] Striking frescoes in the Schleswig cathedral also depict naked riding women, one of them on a besom, the other on a large cat, and possibly represent Diana and Herodias as leaders of the Wild Ride. But they are more likely to date from the late fifteenth or sixteenth centuries, than the early fourteenth.[71] In the Lyon cathedral of St Jean as well, in one of the medallions located on the cathedral's right portal, there is also a curious image of a riding woman on a goat and in this case

swinging a rabbit. But this and other sculptures within the medallions in the voussoirs of the three doors probably did not originate with the decoration of the cathedral's façade between 1308 and 1322, for these figures are clothed in fifteenth-century dress.[72] Given the strong sexual connotations of this riding woman – her wild hair, a cloak that flies out to reveal her naked body, her grasp of the goat's horns, I think it most likely that this medallion was also inspired by the iconographical changes that I have been describing in the early sixteenth century.[73]

The witch as rider quickly became one of the established visual codes for witchcraft in the sixteenth century. The success of this development is nicely illustrated by the changes made to the woodcut of three women around a belching cauldron overseen by a male figure in a tree, first published by Johann Grüninger in *The Ants* in 1516 (fig. 3.1). When the woodblock ceased to be used by printers after 1543, the key iconographic elements were retained, except that the bird-demon overhead was excised and at least one of the raised cauldrons was lowered to the ground. This was meant to create space for the inclusion of a new element: a naked witch riding a goat through the sky and holding the goat's horn in the manner of earlier images by Dürer and Altdorfer. The narrative of the wild sexual ride on the baking trough gave way to the more conventional and easily understood ride on the lusty and diabolical goat. This is evident in a woodcut that appeared in a number of different versions in the 1570s and 1580s (figs 3.2 and 3.3), and that circulated widely in a slightly adapted version through at least three editions of Johann Weyer's treatise on witchcraft, *On the Tricks of Demons* (fig. 4.15) of 1566, 1575 and 1586.[74] A goat-riding witch with a cooking fork also occurs in the comprehensive visual statement of the diabolical deeds of witchcraft found in the titlepage woodcut to the 1591 edition of Peter Binsfeld's *Treatise concerning the Confessions of Sorcerers and Witches* (fig. 7.8). And a similar figure appears again, but this time bearing a flaming torch, in the 1565 engraving by Pieter van der Heyden after Bruegel, *St James and the Magician Hermogenes* (fig. 6.4). Even in Jacob Cornelisz van Oostsanen's 1526 painting of *The Witch of Endor* (fig. 6.1), the biblical narrative is supplemented by a wild and naked female figure in the top right hand corner, riding through the sky seated on a fierce goat which belches flames from mouth and arse, her mouth agape and holding aloft the familiar cooking stick. In all these instances the riding witch helps to identify the scene speedily and unambiguously as one involving diabolical witchcraft.

But as we have seen, in the case of Cranach's iconography, the animal on which witches were shown to ride was not limited to the goat. Even the early editions of Molitor's *De laniis* showed both male and female witches riding on what was meant to be a wolf (fig. 1.10), and in the 1544 and 1545 editions the wolf-rider of the text was represented as a backward ride on what appears to be a large cat (fig. 4.16). Agostino Veneziano mounted his terrifying witch on a monstrous animal carcass (fig. 5.1), while Bruegel depicted Hermogenes' domain as one inhabited by witches on monstrous fire-breathing dragons (fig. 6.4). Witches were also not limited to animals as mounts. From the mid-fifteenth century they were depicted riding sticks and various kinds of domestic and agricultural implements. The unknown illustrator of the 1451 manuscript of Martin Le Franc's *Le Champion des Dames* included a marginal representation of two women riding a besom and a stick (fig. 2.22), possibly influenced by the name of Waldensian sorcerers at this time as *scobaces*, a word derived from *scoba*, a besom. And likewise, the illuminations found in the three manuscripts of Johannes Tinctor's *Treatise against the Sect of the Waldensians* (figs 2.21, 2.23, 2.24) have sorcerers riding brooms, a distaff and

Figure 4.15 Witches around a Cauldron, titlepage woodcut, in Johann Weyer, *De Praestigiis. Der Erste Theil*, Frankfurt a.M.: Nicolaus Basse, 1575. HAB, Wolfenbüttel [H: M 322.8° Helmst]. (1)

a threshing flail, as well as animals, while there is the suggestion that they might also ride staffs and tongs. While accounts of Waldensian practices described the small wooden rod that devotees would smear with ointment, put between their legs and fly off – carried by the devil – artists may have chosen a set of quite different implements, in order to stress the nature of the ordinary country folk who were attracted to this particular form of sorcery. Likewise in Uppland, Sweden, the wall paintings in the churches of Yttergran and Övergran, completed by the workshop of Albert the Painter before 1480, featured three witches riding a rake, a broom and a spade;[75] while in the 1530s the Monogrammist NH depicted the Thessalian sorcerer Meroe riding through the sky on an enormous spatula (fig. 5.20).

Meroe's spatula was simply a variation on the cooking fork, which had been firmly established within the iconography of witchcraft by the 1530s. First used by the illustrators of Molitor's *De laniis* (fig. 1.10), the cooking fork fast became an integral attribute of witchcraft in the work of Baldung and his copiers and continued to be used, although not so often as a riding implement, through to the seventeenth century (fig. 7.8).[76] The cooking fork created a bond between witches and the hearth. It identified witchcraft with the preparation and distribution of food and established it as quintessentially women's business. The cauldron, and by extension the cooking fork, represented a visual version of the most significant claim made by the almost contemporary *Malleus Maleficarum*: that the malefice and evil of witchcraft was primarily perpetrated by women, that it was bound up with women's nature and women's work, and that it was related to the carnal lust and disorder of their bodies. This would seem to have laid the basis for the continuing use of this visual attribute within the iconography of witchcraft. It alluded to the female and carnal nature of the witch as well as to notions of wilful destruction associated with the folkloric Wild Ride. For as Molitor's text put it: witches ride out on such oiled sticks to their 'pleasure'. And at the same time the cooking stick allowed the artist to suggest that such rides were really cases of transportation at the hands of the devil. In the 1544 and 1545 editions of Molitor's work, this seems to have been the message of the woodcut depicting a witch riding a cooking stick: as her dress slips up her calves to suggest moral dishevelment, an aggressive male devil embraces and transports her in the very same action (fig. 4.17).

Yet in the second half of the sixteenth century, the tradition of depicting the broom rather than the cooking fork as the attribute of witchcraft began to achieve much more exposure, especially in France and the Low Countries. Earlier, witches had been associated with brooms in scenes of Waldensian sorcery (figs 2.21–2.23), in illustrations to several versions of the *Women's Dance of Death* (fig. 1.6) and also in Cornelisz van Oostsanen's painting of the biblical figure of the witch of Endor (fig. 6.1). How the besom or broom became an attribute of witchcraft is unclear, although it may relate to stereotypes of Waldensian heresy and sorcery in the fifteenth century. In the fifteenth and sixteenth centuries brooms seldom featured in images of interiors or in pictorial lists of implements used by women in domestic work. There are only a few examples of the short whisk broom hanging on the wall in the proximity of the hearth, and these have been generally considered references to chastity.[77] But from the seventeenth century, brooms begin to be included by Dutch and Flemish artists as symbols of moral and domestic cleanliness in domestic spaces in which women were often shown confined or waiting.[78] The adoption of the broom in images of witchcraft would seem to have gone hand in hand with the identification of domestic interiors as female space. For as artists adopted the broom as the witches' riding stick, they also moved the location of witches' meetings from isolated forest or rural environments to the interior space of domestic dwellings. The riding of the broom, then, became the witch's means of escape from the house and its related social and moral roles.[79]

The first and most influential image of witches leaving the house by riding up a chimney on their brooms occurs in an engraving by Pieter van der Heyden after Pieter Bruegel the Elder, *St James and the Magician Hermogenes* (fig. 6.4). Bruegel's iconography was clearly very popular and was repeated many times over in the later sixteenth and seventeenth centuries.[80] In a number of cases, a chimney inscribed with magical signs and its mantelpiece with lighted candles and a burning hand – the so-called Hand of

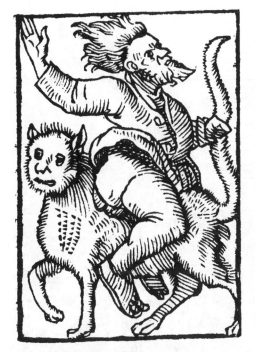 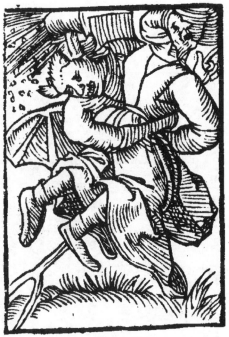

Figure 4.16 A Backward Ride on a Large Cat, woodcut, in Ulrich Molitor, *Hexen Meysterei ... ein schön Gesprech von den Onholden*, Strasbourg: Jakob Cammerlander, 1544, fol. 102ʳ. HAB, Wolfenbüttel [H: T 483.4° Helmst. (38)].

Figure 4.17 Witch Riding a Cooking Stick and Embraced by the Devil, in Ulrich Molitor, *Hexen Meysterei ... ein schön Gesprech von den Onholden*, Strasbourg: Jakob Cammerlander, 1544, fol. 102ʳ. HAB, Wolfenbüttel [H: T 483.4° Helmst. (38)].

Glory used to make witches invisible or to induce sleep in their victims – becomes a stand-alone visual statement of the witch's escape from the confinements and controls of her social space. With the escaping smoke of the cauldron, the witch rides up the chimney and out of the house, using the very implement that links her to the hearth and proclaims her female identity. Rather than seated at the open door or window, accessible to the outside world but protected from it by the house's walls, the witch ignores those recognized points of social and sexual negotiation. She breaches the house's confines and exits by a route largely confined to the creatures of the animal world. This is graphically illustrated in a woodcut that was possibly inserted in a 1579 treatise by Thomas Erastus, *Two Dialogues concerning the Power of Witches* (fig. 4.18).[81] Here the unknown artist presents us with a scene of women smearing their bodies with magical ointment and then riding their brooms up out of the house through the chimney. They are spied upon by a male viewer through a peephole – in an act of voyeurism that emphasizes the nature of witchcraft as women's business, and the ride up the chimney as an escape from the male authority of the household.

While the motif of the riding witch may have drawn its original energy from the proto-type and imagery of the folkloric Wild Ride, artists such as Altdorfer, Dürer, Baldung,

Figure 4.18 Witches Leaving a House by Riding Brooms up the Chimney, woodcut, *c.* 1579? ©
Private Collection/The Bridgeman Art Library.

Manuel and Cranach, tended to allegorize the destructiveness of the ride in moral and
sexual terms. In the image of riding women they already had an inversion of a
quintessentially male act. Riding was an act of male power which harked back to a male
military caste, and the sight of an unaccompanied riding woman was almost always a sign
that the event was outside the social norm and, more often than not, a sign of disorder.
Some wild women were shown riding unaccompanied in this period. There was the
biblical Whore of Babylon, for example, mounted on her seven-headed monster. There
was also the curious literary figure of *Siemann* or She-man, a sixteenth-century virago
who stopped at nothing to rob husbands of the symbols and instruments of their sexu-
ality and power, and wreak havoc on the broader society. Or most widely disseminated of
all – through images on church capitals, in town halls, on ivory caskets, tapestries, salt
cellars, household crockery, tiled ovens and especially on paper – there was the sexually
victorious figure of Phyllis who turned the sexual order upside down by riding the
bridled philosopher Aristotle. Phyllis was often depicted brandishing her whip and
dressed in the flamboyant costume and hat that signified the beguiling powers of the
prostitute.[82] In a woodcut of about 1519 by Hans Burgkmair, Phyllis has a halter around
Aristotle's neck as he leers up at her, and in her right hand she brandishes a forked stick,
quite possibly a visual cue meant to create resonances between this seducing virago and
that other contemporary symbol of male emasculation, the witch (fig. 4.19).[83]

Figure 4.19 Hans Burgkmair, *Aristotle and Phyllis*, woodcut, *c.* 1519. From Geisberg/Strauss, vol. 2, p. 469, G. 500.

It is within this web of complex allusions and associations that we can more easily understand a somewhat bizarre and also comical engraving by Parmigianino from the 1530s, that depicts a fully clothed woman, her face veiled, holding a distaff and spindle and mounted on a huge phallus (fig. 4.20).[84] On the phallus behind the witch is a hybrid creature with the body of a lion and head of a goat, while a winged demon struggles with the head of the giant phallus as though preparing it for flight. The crowd in the background – six females with little more than faces visible, a woman holding a baby, and an older woman with two spindles protruding from her headband – evoke a mixture of excitement and apprehension. The animal jawbone and skull on the ground, together with the two owls hovering above, help confirm the scene as one involving evil and death. This is the ultimate image of the woman on top, riding the beast, lording it over the male, turning the gender order on its head. It testifies to the way in which sixteenth-century artists were able to use the subject of witchcraft to explore contemporary fantasies about a range of issues and debates, and not least the relationship between sexuality

Figure 4.20 Francesco Mazzola, called Parmigianino, *Witch Riding a Phallus, c.* 1530, engraving.
British Museum, London. © Copyright the Trustees of The British Museum.

and the social order. But the capacity for exploring contemporary issues through the prism of witchcraft and thereby establishing a greater moral and social relevance was not limited to making links with other contemporary visual and literary discourses. It could also make use of authoritative examples from the past, such as those from classical literature. In the following chapter I turn to the way in which fifteenth- and sixteenth-century artists drew on well-known examples of witches and sorcerers from classical literature and employed them to disseminate and authorize particular understandings of witchcraft.

5

TRANSFORMATION, DEATH AND SEXUALITY IN THE CLASSICAL WORLD

In the second or third decade of the sixteenth century one or more Italian artists created one of the most striking visual images of witchcraft, a large engraving called *Lo Stregozzo* (fig. 5.1).[1] The engraver was probably Agostino dei Musi – generally known as Agostino Veneziano – or Marcantonio Raimondi, and the design may have been the work of either Raphael or Battista Dossi.[2] This curious yet very powerful image depicts a wild female figure seated as though enthroned on a triumphal wagon constructed from a giant animal carcass and drawn by two young naked males at the front and by another two at the rear. The seated woman is the epitome of the wild, with her sagging breasts, gaping mouth, extended tongue and hair flying backwards through the smoke or flame which streams from the vessel she holds in front of her. She is also a figure of death. With her right hand, she crushes the head of a small child, despite its gesture of supplication. At her feet lie three children – already the lifeless victims of her terrifying destruction. The animals in the procession also represent the living and the dead. In addition to the two goats, on the far side of the central skeleton directly beneath the wild woman, there is a bizarre ram-like beast covered with both feathers and fur; and on the near side a skeletal quadruped with a curious wing and a curious creature with a bird-like head.

The wild and destructive figure of the female is in sharp contrast to the beautiful naked figures of her young male consorts, their bodies luminous against the dark and marshy landscape of reeds and waterfowl through which the procession passes. An even younger male on a goat leads the retinue, blowing on his horn. The youth displays an unusually close bond with the goat he rides; his clothing of animal skin is entwined with hair from the goat's back to create a kind of baby sling, in which two infants nestle and peer out at the viewer. These tiny figures create a discordant note through the length of the procession. They link the horn-blower on the goat both to the male runner at his side, who has an infant clasped to his waist, and to the wild woman who crushes to death the skulls of one child after the other. These infants alert the viewer to the ambivalence and seduction of the beautiful bodies of the male youths. Their alluring beauty belies their complicity in death. It may well be, as Patricia Emison has recently suggested, that the insertion of sexually desirable men into this image represents a specifically Italian version of German fascination with the relationship between witchcraft and the seductions of sexuality.[3] Perhaps, as Emison has also argued, the male figures represent the seven male witches executed together with three females in the small north Italian territory of Mirandola in 1522–23. Gianfrancesco Pico, Count of Mirandola, disseminated details of the trials almost immediately through his 1523 Latin work, *Strix, sive de Ludificatione Daemonum* (*The Witch, or the Delusions of*

Figure 5.1 Agostino dei Musi [Agostino Veneziano], and/or Marcantonio Raimondi, *The Carcass, c.* 1518–35, engraving. National Gallery of Art, Washington D.C., Rosenwald Collection. Image © Board of Trustees, National Gallery of Art, Washington D.C.

Demons), and through the Italian translation by the Bologna Dominican, Leandro Alberti, published in Bologna in the very next year.[4]

The female figure at the centre of the image seems to allude to one of the pagan deities associated with witchcraft, the goddess Artemis/Diana. While Dürer's witch (fig. 1.12) provided the model and stimulus for this figure, the location for the procession as well as the woman's bearing and actions suggests she is Artemis/Diana, the goddess of fertility and wild nature, of war and destruction, whose sanctuaries were located in such reedy and marshy places.[5] The scene would then represent a witches' Wild Ride led by Artemis/Diana, the figure most frequently associated with such rides from the tenth century on. But we have also seen how the Wild Ride was associated with the Furious Horde in European folk belief, and how in the 1516 edition of Geiler's sermons the destructive ride became a bacchic procession (fig. 4.11). There may well be a reference to sexual seduction and illusion in the figures of the young men, whom Patricia Emison reads through Gianfrancesco Pico's filter as beautiful, fallen angels;[6] and as I argue below, the older male figure with the doleful and pallid expression, awkward in his attempt to keep astride two of the strange beasts he is riding, may allude to the god Saturn, who embodied fantasies and fears associated with destructive power and emasculation.[7] However the emphasis here is not primarily on moral disorder; this is no bacchanalia, even if the vessel of flaming fire from which Artemis/Diana inhales and which becomes enmeshed with her flying hair, has strong overtones of lust. The focus is on the relationship between witchcraft and death. The wild woman is the agent of death; she rides through the murky night with the skeletal dead; she is borne up in procession on an intricate throne of dead bones. Witchcraft is a ride of the animal dead.

This chapter explores the interest of fifteenth- and sixteenth-century artists in the sorcery of the classical world and how their images helped shape and gain credibility for the new visual language of witchcraft. I have already referred to the appropriation of classical gods and goddesses, such as Diana, Venus and Saturn, for the iconography of witchcraft. In this chapter I focus primarily on human figures known for their practice of sorcery in the classical past and the ways in which they were depicted in sixteenth-century images – figures such as Circe, Palaestra, Meroe, Pamphile and Medea. Fashioned for a literate audience that was influenced by humanism and attuned to the themes and narratives of classical literature,[8] these classical witches helped underpin the close relationship between witchcraft and women and identified female sexuality as the most powerful stimulus for its practice. They presented metamorphosis, the capacity to transform humans into animals, and communication with the world of the dead as the key attributes of witchcraft. For witches were able to negotiate and transgress the borders of the human realm; they had the power to move into the world of animals, just as they did into the world of the dead.

The association between witchcraft and death is a common theme in the early sixteenth century, as we have already seen. The scattering of human and animal bones and skulls around cauldrons or at the site of witches' meetings is common, as is the use of skeletal matter in conjurations and rituals of witchcraft.[9] Bones and body parts have always played an important role in everyday magic and sorcery, just as the relics of saints have in Christian rituals. The success of both was premised on links between the ritual actors in this world and the spirits or souls among the dead with whom they sought to communicate, or whose power they attempted to exploit. The relationship found explicit and powerful expression in witchcraft images such as Hans Frank's eerie

Figure 5.2 Hans Baldung Grien, *The Three Fates: Lachesis, Atropos and Clotho*, 1513, woodcut. National Gallery of Art, Washington D.C., Rosenwald Collection. Image © Board of Trustees, National Gallery of Art, Washington D.C.

representation of the physical destruction effected through the trances of witchcraft (fig. 3.14). And figures from classical mythology could be used to communicate the power which witches were believed to exercise over life and death. Baldung Grien, for instance, created a woodcut in 1513 of *The Three Fates* (fig. 5.2) in a manner very similar to his portrayal of witches.[10] The Three Fates – the Erinyes or Moirae of Greek myth – exemplified the power of women over individual and social life. Clotho, the 'Spinner' who spins out the thread of life at the moment of birth, is the younger smiling woman with the flower on the right. Lachesis, the 'Measurer' who calculates the length of the thread, is the middle-aged woman with a married woman's bonnet on the left. Atropos, the 'Inexorable' who cuts the thread of life, is the older woman with the wiry body and wild hair, standing ready with her shears. The different ages of the women as well as the outdoor

setting under a gnarled tree carry echoes of Baldung's witchcraft scene of three years earlier (fig. 1.1). Even the small child, picking a flower and meant to allude to the four stages of life, is reminiscent of the cupids that feature in Baldung's witchcraft drawings. The conflation of the classical Fates with the contemporary imagery of witchcraft successfully identifies witches as agents of death.

Witchcraft and the classical mythography of death were also linked in two different woodcuts of Virgil's underworld from the second half of the sixteenth century. Both occurred at the opening of the sixth book of Virgil's *Aeneid*, where they served as a preview of the figures and events which the reader would confront in the following pages. The first of the two appeared in the 1559 Frankfurt edition of Thomas Murner's German translation of the *Aeneid*, and was probably the work of an unknown wood-cutter who signed himself with the monogram '.S.F' on the titlepage (fig. 5.3).[11] The second was signed MB and appeared in a Latin edition of Virgil's works edited by the Leipzig professor for ancient languages and ethics, Gregor Bersman, first in Leipzig in 1581 and then five more times by 1623 (fig. 5.4).[12] Both woodcuts included at the very top of the frame the tiny figure of a female witch riding through the sky on a goat. While the witch figure was hardly prominent, it was significant that she appeared at all, for a goat-riding witch is not found in Virgil's text. By the second half of the sixteenth century, it seems to have become common sense for some artists and viewers to include a sixteenth-century riding witch in representations of the classical underworld.

The compositional centre of the 1559 woodcut, around which so much of the action revolves and which gives that action its meaning, is the labelled figure of Rhadamanthus (Radamanus), a son of Jupiter and judge of the underworld depicted with his staff of justice. Rhadamanthus appears in the *Aeneid* at the point when Aeneas sees the castle of Tartarus encircled by the fiery river of Phlegethon and asks his guide, the Cumaean Sibyl, to explain the nature of the punishments before him. Both woodcuts show Aeneas and the Sibyl crossing the Stygian marsh with Charon the boatman. This suggests that the model was the woodcut from the Murner translation published in Worms in 1543, rather than that in the first illustrated edition edited by Sebastian Brant and published by Johann Grüninger in Strasbourg in 1502 – and followed in many later editions – which has Aeneas and the Sibyl looking down on Tartarus from a crag above.[13] The graphic punishments depicted in the various editions of Virgil are similar, yet not identical: Salmoneus, who foolishly imitated the thunder and lightning of Jupiter only to be killed by one of Jupiter's real thunder bolts; King Tantalus, seated at a table and prevented from being able to satisfy his hunger and thirst by the harpie who watches over him;[14] Tityus, with his body stretched out and his liver gnawed by a monstrous vulture in punishment for his assault on Leto; and the Fury Tisiphone, who scourges with her snakes three figures bound to a stake.

The upper sections of the 1559 woodcut extend the iconography of earlier versions of Virgil's underworld in quite significant ways. In particular, the artist has borrowed fantastic elements from the Netherlandish traditions associated with artists such as Hieronymus Bosch and Pieter Bruegel. The gateway of hell has become a bespectacled walrus head, an inn sign protruding from its forehead, and hanging from it a sausage. Instead of the expected three-headed Cerberus at the gate, a fat, naked figure, clearly identifiable as demonic by his webbed foot, lies under a spit, one arm around a jug of beer and grilling his meat with flames from his mouth. A group of three behind this fat demon are involved in erotic games. Above there are further scenes of moral disorder

Figure 5.3 Monogrammist .S.F, *Aeneas and the Cumaean Sibyl View the Punishments of Tartarus*, woodcut, in Virgil, *Dreyzehen Bücher von dem tewren Helden Enea*, Frankfurt a.M.: David Zöpffeln, 1559, fol. R 3ᵛ. HAB, Wolfenbüttel [102 Poet.].

and tumult: a monk hangs from a rod and shits; a stick-man illuminates the scene with a lantern despite the conflagration around him; a satyr-like demon with an erection abducts a figure on his shoulders; and in the upper section of the hell-tower, a fish and a pair of breeches hang from the end of a rod. Meanwhile, at top left a large dragon in the form of an armed ship with wheels approaches, smoke belching from its canon, its navigator wielding a huge pair of spectacles. A human figure is strapped to the dragon's mast, which is fixed into a barrel, and on top of the mast is a dovecote with a hanging figure. The references to judicial punishment are matched by another mast towards the back of the dragon, which doubles as a mounting for a broken body on a wheel. On the tail of the dragon is another satyr-like demon with an enormous bottle on its shoulders. And clearly distinguishable in the sky, above all these images of judicial punishment and violence, a naked female witch rides a goat. She holds the goat's horn in the manner of so many witchcraft images, her hair flying out behind her as she streaks across the sky, adding to the hellish pandemonium.

A similar witch appears in Gregor Bersman's editions of Virgil (fig. 5.4). Many of the fantastic elements of the 1559 version are absent in this woodcut and, most appropriately for a Latin version edited by a classical scholar, Tartarus has classical architectural features, in place of the Christian hell-mouth of earlier versions.[15] But it is no less a place of punishment, and forms of sixteenth-century judicial punishment give the *Aeneid* narrative a contemporary inflection. A body hangs from a gibbet and others from suspended wheels. Insect-like demons fly through the sky, one with the typical hooked stick. And a witch is situated among this demonic host, clearly identifiable by her horned goat and forked stick. By the second half of the sixteenth century, the fairly common literary identification of Tartarus with the Christian hell also took on iconographical form through the inclusion of demons. The tendency is graphically illustrated by the same scene in a 1587 Froschauer edition of Virgil in Munich, in which a later gloss in pen and ink has inserted a demonic beast flying through the sky.[16] The same tendency probably stimulated artists to add the topical figure of the witch to scenes of the classical underworld. For while there is no reference to a witch in Virgil's text, the Furies, one of whom was Tisiphone, had been explicitly linked with witchcraft some 50 years earlier (fig. 6.5), and witches more generally had become one of the powerful signifiers of the realities of hell for literate Europeans. As the punishments of Tartarus were made more immediate to Christian readers by including demons, the presence of witches also helped identify them as hellish punishment. For by the second half of the sixteenth century witches were well known as the associates and assistants of the devils that seduced human souls in this life and tormented them in the next. And the proclivities of classical witches to transgress the borders between this life and the next simply helped to establish the identification.

Another fundamental way in which figures from the classical world helped shape the imaging of witchcraft in the late fifteenth and sixteenth centuries was the legitimation they provided for the link between witchcraft and metamorphosis. The metamorphoses or shape-shifting that witches were thought to be able to effect – transformation of themselves into the shape of animals such as cats or wolves, of other human beings or even of their victims – were explained theologically in one of two ways. Shape-shifting involved either an actual physical change produced by the devil in the material world, or an illusion produced by the devil within the imaginations of the witch, the victim or the observers, to make it appear that the transformation had actually occurred. Stories and

Figure 5.4 Monogrammist MB, *Aeneas and the Cumaean Sibyl View the Punishments of Tartarus*, woodcut, in Virgil, *Opera*, Leipzig: Johann Steinmann, 1588, p. 287. HAB, Wolfenbüttel [93 Poet.].

images from classical literature which communicated cases of the transforming powers of sorcerers and witches could not but help strengthen belief in these powers among their readers. Ovid's writings, for instance, were filled with stories of metamorphoses and would have generally supported an understanding of the world as enchanted, full of the marvelous powers of magic. Likewise, sixteenth-century images of the figures that

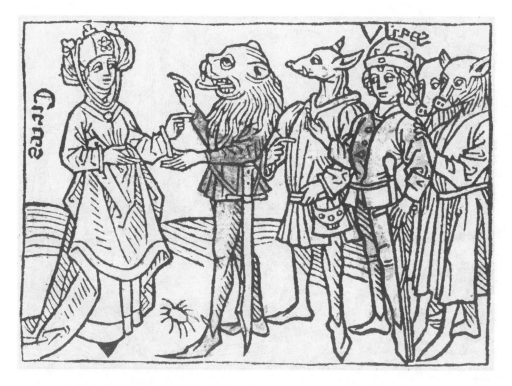

Figure 5.5 Circe with Ulysses and his Men Transformed into Animals, woodcut, in Giovanni
 Boccaccio, *Buch von den hochgerumten frowen,* Ulm: Johann Zainer, 1473, fol. 38ʳ.
 HAB, Wolfenbüttel [Lk 4° 11].

effected these transformations would also have helped consolidate belief in the powers of
contemporary witches to do likewise. As my analysis will show, their power rested on a
perception that they could breach the boundaries of human nature and share in the
mysterious powers of animals. And these breaches also involved considerable emphasis
on sexual power and desire, since it was in this sphere of human action that the link with
the animal world was considered most pronounced.

The figure from classical literature most frequently represented as a sorcerer or witch
in the fifteenth and sixteenth centuries was Circe.[17] The powerful sorceress of classical
mythology who transformed the companions of the wandering Odysseus or Ulysses into
deer, wolves, lions and pigs, Circe was an immensely popular subject in the art and illus-
tration of the period. The sources for her visual depiction were not Homer's *Odyssey,* as
one might expect, but the writings of Boccaccio, Boethius, Virgil and Augustine. Printed
editions of Boccaccio's *On Famous Women* began to include images of Circe from the
1470s and these were still being copied well into the sixteenth century.[18] In the 1473
edition printed by Johann Zainer in Ulm (fig. 5.5), for instance, Circe is depicted in
ornate and exotic garb, possibly in order to emphasize the 'singular beauty' and 'match-
less attraction', by which Boccaccio argues she could beguile men and make them lose
their human reason. The turban that resembles a crown reflects her status in Boccaccio's
text, as the sister of Aeëtes, king of Colchis, as wife of Picus, king of the Latins, and as
'daughter of the sun'. She stands before Ulysses and his transformed men – the first with

133

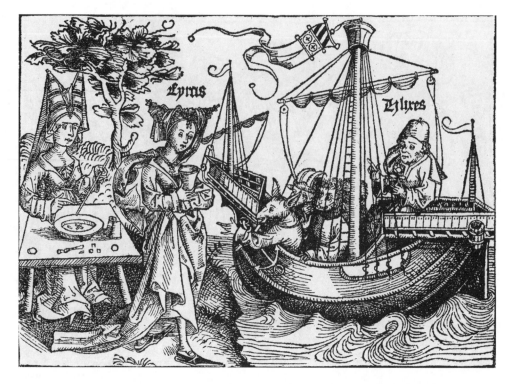

Figure 5.6 Michael Wolgemut and Wilhelm Pleydenwurff workshop [Albrecht Dürer?], *Circe and her Magical Arts Confronting Ulysses and his Transformed Companions*, woodcut, in Hartmann Schedel, *Liber Chronicarum*, Nuremberg: Anton Koberger, 1493, fol. 41ʳ. Special Collections, Information Division, The University of Melbourne.

the head of a lion, the second with that of a deer, and the two men behind with heads of swine. While the particular animals depicted do not conform with Homer's story, they create no conflict with Boccaccio's text, which leaves their particular form undefined. The focus of the artist is simply on the transformation of Ulysses' men, and the nature of Circe's sorcery is reduced to a pointing gesture, a visual reference to the casting of spells.[19]

Other artists, however, did focus on the magical means and instruments used by Circe to bring about metamorphosis. One of the most elaborate cases is a woodcut that originated in the Nuremberg workshop of Michael Wolgemut and Wilhelm Pleydenwurff, and may have been designed by the young Albrecht Dürer while he was an apprentice there (fig. 5.6).[20] It was published in Hartmann Schedel's *Nuremberg Chronicle*, first in a Latin edition and then in a German edition, both in 1493.[21] Described by Schedel – following Boccaccio – as 'very beautiful' and 'the daughter of the sun', the ornately dressed and bejewelled figure of Circe is depicted with the cup that contains the magical potion by which she transforms humans into animals. The Latin text claims she has created the potion by incantations and charms; while the German refers to her magical arts, but also introduces illusion ('gespenst'). And in order to emphasize the malefic and illicit nature of her arts to a vernacular readership, the German text also calls her a 'swartz koensterin', a dealer in the black arts. Despite her noble appearance, Circe is identified not simply as a magician, but as a sorcerer and witch. This is stressed by the inclusion of

further narrative elements from the *Odyssey*. Ulysses and his companions are situated in the boat in which they spent 10 years at sea after the Trojan war and journeyed to the island of Aeatea in southern Italy where Circe was said to live. They have already drunk of Circe's potion and are shown with the heads of a deer, lion and goat – although the third animal is listed as a boar in the text. Ulysses, on the other hand, is shown holding the Moly, the flower given him by Mercury as protection against Circe's 'trickery and sorcery' ('gespenst und zawberey').

One quite unique element in this woodcut is the inclusion of Circe's assistant. Wearing a Burgundian-style headdress, she sits at a table and points at the wand she holds over a number of different objects: a bowl, a short stick, two cups and a number of balls and dices. Her presence may be based on the maids that assist Circe's preparation of herbs in Ovid's version of the story; but she also constitutes a well-known visual reference to trickery and illusion. This visual code was long used to represent the trickery or illusion perpetrated by conjurors at fairs and carnivals. Numerous so-called 'Children of Luna' images of the fifteenth and sixteenth centuries feature a conjuror seated at a table with his cups, balls and wand.[22] As novel forms of social analysis and commentary, these images linked particular social classes, occupations, professions, societal groups, and even psychological profiles and states, with what were believed to be the specific signs of the zodiac that exercised the greatest influence over them. In this way conjurors were deemed to share the cold and moist qualities of the moon with sailors, fishermen, fowlers, millers, bathers and vagrants. All manifested the fluidity and speed of the moon in their fickle and unstable natures, the conjurors included by virtue of both their wandering from fair to fair and their practice of trickery and illusion. Many such images survive from as early as 1404, one beautiful example in the so-called *Medieval Housebook*, an illustrated manuscript completed between 1475 and 1485 by an artist known as the Housebook Master, or the Master of the Amsterdam Cabinet (fig. 6.8).[23] This figure of the conjuror was also popularized by Hieronymous Bosch and his copyists, and in the later sixteenth century was linked to witchcraft imagery by Pieter Bruegel (fig. 6.6).[24]

The inclusion of a similar conjuror in the *Nuremberg Chronicle* woodcut of Circe would seem to have been a conscious attempt to link the classical sorceress to this visual tradition.[25] It also seems to take up the emphasis in the German text, that Circe's powers of metamorphosis were based on both her sorcery and her use of illusion ('gespenst und zawberey'). By the second half of the sixteenth century, the rhetoric of 'trickery' and 'illusion' was clearly identified as the devil's work. The fundamental source for the understanding of magic and sorcery as demonic illusion was Augustine, and so it is unsurprising that Schedel's text begins with an acknowledgement of both Augustine and Boethius as his sources. In *The City of God*, Augustine specifically rejected the reality of Circe's transformation of Ulysses' companions, arguing that it was merely apparent and involved phantasms created by demons to deceive and delude the human senses.[26] It was precisely in this way that the near contemporary *Malleus Maleficarum*, already well known in Nuremberg in the early 1490s, and even more so after Koberger published editions in 1494 and again in 1496, made use of Augustine's interpretation of Circe's powers of metamorphosis.[27] Circe's assistant in the *Nuremberg Chronicle* woodcut appears to have been a visual statement claiming demonic illusion as the basis of Circe's sorcery.

The depiction of Circe's poison cup in the *Nuremberg Chronicle* woodcut derives from the account in Boethius' *Consolation of Philosophy*, the second source cited in Hartmann

Figure 5.7 Circe and her Magical Arts Confronting Ulysses and his Transformed Companions, woodcut, in Hartmann Schedel, *Liber Chronicarum,* Augsburg: Johann Schönsperger, 1496, fol. 43ʳ. Germanisches Nationalmuseum, Nuremberg [Inc. 5540 (G.549) 4°].

Schedel's text.[28] Boethius does not provide a narrative account, but presents the poison administered by Circe as a metaphor for the human bestiality to which some will succumb and others, like Ulysses, will resist. The woodcut depicts this magical struggle between the two protagonists: Circe with her poisonous cup and Ulysses with his protective Moly plant – even though Circe's magic is given more prominence than Ulysses' counter-magic. This contrasts with the simpler representation of metamorphosis in the earlier Boccaccio editions (fig. 5.5). The use of draughts or poisons was the witch's stock-in-trade by the later fifteenth century, and the wand and magical paraphernalia help underline the magical nature of Circe's drink. Perhaps the Wolgemut workshop had access to manuscript illuminations of Boethius, a number of which depict this confrontation between Circe with her cup and Ulysses with his Moly.[29] The strong association of Circe's powers with a magical potion persisted through the sixteenth century. When Johann Schoensperger brought out his pirated editions of the *Chronicle* in Augsburg in 1496, 1497 and 1500, for instance, the crude adaptation of the original print showed Circe's cup of poison spewing out flames (fig. 5.7). And in the 1530s and 1540s various artists such as Georg Pencz, Parmigianino, Antonio Fantuzzi and their various copyists

produced images depicting Circe presenting the cup to Ulysses and his men, a sign of the vices humans must choose to accept or resist.[30]

The power of Circe to cross and negotiate the borders between the beastly and the human constitutes a major theme in many of these images, and especially in those illustrating the Roman poets, Virgil and Ovid, who played the most significant role in endowing Circe with negative qualities.[31] The earliest illustration of Virgil's Circe appears in the first illustrated edition of Virgil's works edited by Sebastian Brant and printed in Strasbourg in 1502 (fig. 5.8).[32] This 1502 woodcut was subsequently employed in the 1515 German translation of the *Aeneid* by Thomas Murner and a 1529 Lyon edition. A rather coarse copy of the block was reproduced in the Venice editions of 1533 and 1552.[33] These woodcuts illustrated Virgil's brief account of Circe at the beginning of book seven. Clothed in an ornate garment and crowned, Circe sits on a hillside spinning. Around her are cages, in which three wolves, a bear and a lion are imprisoned, and a shed in which wild boars are feeding. These animals are Ulysses' transformed sailors and the cages seem to represent a visualization of the terrible sounds of the imprisoned, on which Virgil's text focuses. Behind Circe a fire burns vigorously; and at top right are the funerary rites of Aeneas' nurse, Caieta, which Aeneas performed just before the winds blew him to the island of 'the cruel goddess'.

This frequently reproduced image would have readily identified Circe as a malefic witch in the early sixteenth century. Her spinning was no doubt meant to illustrate the account in Virgil's text, while the prominent fire on the hill represented the cedar burning in her palace and illuminating the night. But by the second decade of the sixteenth century, if not earlier, the distaff and spindle had often been used to make visual associations with witchcraft.[34] And together with the belching fire – even without a cauldron – this scene would have clearly denoted sorcery or witchcraft. A woman whose natural domain was the animal world would also have fitted well with images of witchcraft. For Circe epitomized that liminal space witches were understood to inhabit between the realm of the human and the beastly, an idea strongly communicated from the turn of the sixteenth century through the common image of witches in the presence of animals. It is perhaps not surprising, then, that the 1508 Venice edition of the *Aeneid*, which featured only a single woodcut at the beginning of each of the 12 books, would depict Circe with the same attributes: a distaff and spindle, a belching fire, and caged animals.[35]

Ovid's account of Circe in *Metamorphoses*, book 14, emphasized a cruelty rooted in lust. It described a goddess whose heart was 'more susceptible to love' than any other emotion, and her wicked spells and potions, the black arts she had learnt from Hecate, were directed primarily at those who spurned her love. Scylla, for instance, had her legs transformed by Circe into a pack of barking wild dogs, when her lover, Glaucus, rejected Circe's love. Picus, king of Ausonia, was turned into a woodpecker for spurning her love, and Circe turned Ulysses' companions back into human shape in order to win Ulysses' love. This is the reason for the many scenes that depict Circe in her bed-chamber.[36] Bernard Salomon's woodcut in the edition of the *Metamorphoses* published in Lyon in 1557, was one such image that achieved widespread circulation.[37] Virgil Solis copied it for the 1563 Frankfurt edition of the *Metamorphoses* (fig. 5.9), and the Solis print later appeared in the 1581 Frankfurt edition of Nicholas Reusner's *Emblemata*.[38] The iconography clearly stresses the process of transformation. Circe is depicted offering her magical potion to a figure with a pig's head, while she taps him on the head with her wand. This is Macareus, who relates the story of his own dramatic transformation in Ovid's account, as

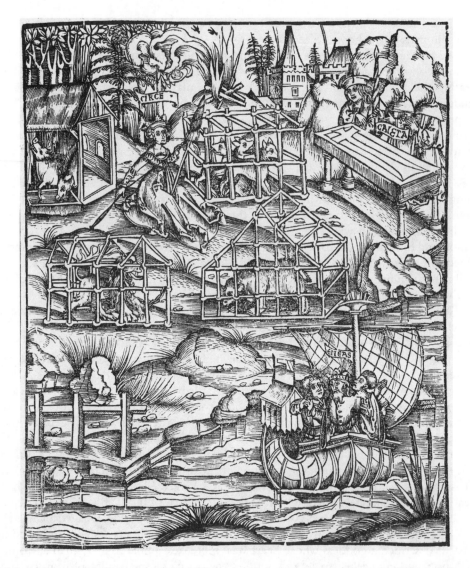

Figure 5.8 Aeneas Sailing around Circe's Island, woodcut, in Virgil, *Opera*, Strasbourg: Johann Grüninger, [1502], fol. 288. Special Collections, Information Division, The University of Melbourne.

his body begins to bristle with stiff hairs and his mouth hardens into a snout. In the background, the figure escaping through a doorway is Eurylochus, the only one of Ulysses' men to avoid the poisoned cup and to run to him for help. The figure of Circe herself is strongly influenced by Ovid's emphasis on her sexual drives. She is an alluring figure, her garments clinging to her body and revealing the contours of her stomach and breasts; while the split of her skirt uncovers her leg to the thigh. Salomon's Circe represents the woman of Ovid's *Metamorphoses*, driven by lust and vengeance against those who would spurn her.

A more heavily allegorical Circe is the subject of a painting by Dosso Dossi, dated

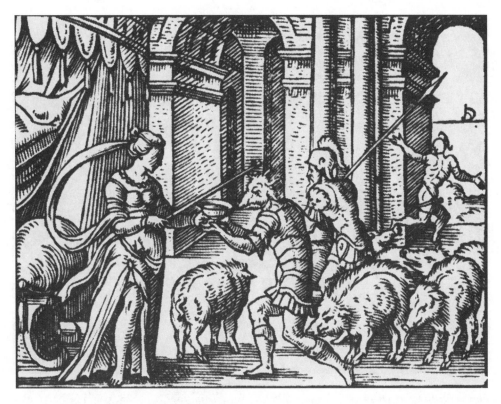

Figure 5.9 Virgil Solis, *Circe Turning Ulysses' Companions into Pigs*, woodcut, in Ovid, *Metamorphoseos,* Frankfurt a.M.: Jeremiah Reusner, 1563. From TIB, vol. 19, part 1, p. 513, fig. 7.165.

between 1511 and 1525 (fig. 5.10).[39] Dossi's Circe is located within an idyllic landscape, surrounded by many animals that play no part at all in literary accounts: a lioness, a spoonbill, a doe, an owl, a falcon, a stag and dogs. She is a female variant of the learned magician, who operates not with poisons or sorcery but with the learned incantations of high magic. The words inscribed upon the tablet to which she points and the magical talismans in the open book at her feet are the instruments she uses to transform her victims. Dossi's novel depiction of her as naked alludes to bodily seduction as the source of her power, a view which fits well with Ovid's emphasis on Circe's lust and Boccaccio's allegorical interpretation of the transformation of Ulysses' companions as the consequences of uncontrolled lust.[40] Dossi was perhaps familiar with Dürer's 1497 engraving of the four naked women or witches (fig. 3.15) and with Baldung's 1510 chiaroscuro woodcut (fig. 1.1), completed a couple of years earlier. In that case, it would have seemed appropriate to depict the beautiful sorceress and seductress of antiquity in a similar fashion, naked except for the flowers braided through her suitably loose, flowing hair.[41]

An equally elegant, yet sexually more powerful figure of Circe is found in a series of images from the first half of the sixteenth century which stem from the work of Parmigianino.[42] In Parmigianino's two drawings and a chiaroscuro woodcut, as well as in several copies of these three works by later artists, Circe stands before those soon to become her victims, statuesque before their bent postures, a part of her garment

Figure 5.10 Dosso Dossi, *Circe and her Lovers in a Landscape*, *c.* 1525, painting on canvas. National Gallery of Art, Washington D.C., Samuel H. Kress Collection. Image © Board of Trustees, National Gallery of Art, Washington D.C.

billowing out and framing her head and upper body like an aureole, as she supports the cup from which one of Ulysses' companions drinks her magical concoction. The contours of her body shape and breasts are clearly visible through her garments, as in the later engravings by Bernard Salomon and Virgil Solis (fig. 5.9). A 1542 etching by Antonio Fantuzzi in particular achieves an extraordinary sense of foreboding. To viewers who knew the *Metamorphoses*, it would have been reminiscent of Ovid's description of the observations of Picus' colleagues just before they were touched by Circe's wand and transformed into wild beasts: 'the stones seemed to utter hoarse rumblings, dogs barked, the earth crawled with black snakes, and shadowy ghosts flitted noiselessly here and there'.[43] Despite a composition that depends indirectly on the artist who designed the woodcut for the *Nuremberg Chronicle*, this scene is not an allegory of human nature and sin, or even the deceptive illusions of magic. Circe's raw sexual power and seductive evil is the focus. She is the mistress of the terrifying shapes around her, dispensing her evil brew, lording it over the men already under her power, though still in human form. This was Ovid's Circe, a figure of the ancient sorcerer driven by lust; but she also dovetailed perfectly with the contemporary witch of early sixteenth-century representation, subordinating male victims to her will, unmanning them and overturning the proper moral and gender order.

Circe's meaning as a figure of sexual seduction also achieved widespread circulation in the sixteenth century through the new genre of emblem books. Beginning with the

Emblemata of Andrea Alciato, first published in Augsburg by Heinrich Steiner in 1531, emblem books used visual images, poems and mottoes in a coordinated way to present moralizing messages to their readers.[44] The popularity of Alciato's emblems was extraordinary and the number of editions quickly multiplied, totalling more than 200 by the end of the seventeenth century. The motto for the emblem featuring Circe read 'Cavendum a meretricibus' ('Beware of Whores') and it was generally grouped in a series commenting on *luxuria* or licentiousness. A significant example is that created by the artist Pierre Vase or du Vase (Peter Eskreich) for the Alciato edition printed by Macé Bonhomme in Lyon in 1550, one of the most complete and influential editions of the later sixteenth century. The image must have featured in a large number of the 35 editions of the work published between 1548 and 1616 by Bonhomme, by his collaborator, the Lyon bookseller and publisher, Guillaume Roville, by the two in association, and by their heirs.[45] The meaning of the image is left to the last two lines of verse: 'Circe with her famous name indicates a whore and shows that any man who loves such a one loses his reason.'[46] It depicts Circe seated on a throne with her garment billowing around her head in the fashion developed by Parmigianino, his copyists and imitators. At her feet are those she has transformed into animals: a goat whose head she touches with her wand, a lion, two swine, and to her left a dog and two baboons. Circe presents an image of total dominance, with the animals at her feet displaying utter subservience. The wand doubles as a ruler's rod of justice and a phallus wielded by a harlot, an instrument by which men are unmanned and transformed into subordinate beasts.

A different image that also represents Circe as a sorcerer and prostitute appears in Alciato editions of the 1580s (fig. 5.11).[47] As in the works of Dosso Dossi (fig. 5.10) and Pellegrino Tibaldi, the sorceress is bare-breasted. Her representation as prostitute is complete, a lascivious destroyer of those who fall for her seductions. Geoffrey Whitney, who incorporated the image into *A Choice of Emblemes* of 1586, underlined this emphasis on sexual danger: his motto read 'Homines voluptatibus transformantur' ('Men are transformed by pleasure'), and he concluded his verses by addressing the reader or viewer directly: 'Oh stoppe your eares, and shutte your eies, of Circe's cuppes beware.'[48] The image of Circe held up to the viewer's eyes represented precisely that seduction. It was 'the wicked love' which men had to reject if they were to avoid the loss of human reason that pressed Ulysses' men into Circe's service and reduced them to the level of brute beasts. This identification of the prostitute Circe with the enslavement of reason linked the more overtly sexual understanding of her powers in the sixteenth century with the long allegorizing tradition from Boethius to Alciato, which interpreted the metamorphosis of Ulysses' men as a loss of human reason. Christofero Landino, Giovanni Pico, Simone Fornari and Natale Conti made Circe a representation of all the passions, the embodiment of Vice itself.[49] And Circe played out this role in the theatrical *ballet de cour* presented by Queen Louise of Lorraine and directed by Balthazar de Beaujoyeulx, on the occasion of the wedding between Louise's sister, Marguerite, and King Henri III's favourite, the Duke de Joyeuse, in October 1581.[50]

As well as Circe, a significant number of other classical sorcerers and witches captured the attention of sixteenth-century artists and were identified with metamorphosis. Many were illustrations of stories that went under the title either of *Lucius, or The Ass*, written by the Greek sophist, Lucian of Samosata, or of *Metamorphoses or The Golden Ass*, written by the Latin author, Lucius Apuleius of Madauros. Publishers and scholars in the sixteenth century confused the relationship between these works and they are still being

Figure 5.11 Circe and her Animals, woodcut, in Andrea Alciato, *Omnia Emblemata,* Paris: Claude Minos, 1589, p. 283. Special Collections, Information Division, The University of Melbourne.

unraveled today.[51] Many editions of Lucian's work, sometimes wrongly attributed to Apuleius, were illustrated. In *c.* 1477 the Augsburg printer, Ludwig Hohenwang, published an edition of Lucian's work entitled *The Golden Ass,* both in a Latin version by Poggio Fiorentino and in a German translation of Poggio by Nicholas von Wyle. The story tells how Lucius went on a trip to Thessaly and asked Palaestra, the maid of the house in which he was staying, if he could spy on her mistress, who was reputed to be a witch. After seeing this woman fly out a window transformed into a bird, Lucius begged Palaestra to steal the magic ointment her mistress used, so that he could try it on himself. Unfortunately, however, Palaestra stole the wrong container and Lucius was transformed not into a bird but into an ass. Hohenwang's Latin version included eight woodcuts, of which one was a repeat. Alongside the transformation scenes from human to animal and vice-versa, the woodcuts documented Lucius' various adventures as an ass: his freeing of a young girl captured by robbers; his betrayal of the master gardener; his tricks performed for a knight who taught him how to drink wine; and his escapades with a woman infatuated with the sexual proficiencies of an ass. Hohenwang's German translation used the same woodcuts, except that it excised the last of the series, displaying the ass in bed with his naked and infatuated female partner.[52] And in 1479, another German edition by the Strasbourg printer, Heinrich Eggestein, followed suit, replicating the order of Hohenwang's German edition.[53]

The title woodcut in Hohenwang's Latin edition became the first of a number of illustrations of this scene in the later fifteenth and early sixteenth centuries and the most popular woodcut from the series (fig. 5.12). Its popularity was no doubt related to its depiction of Lucius just at the point of transformation from human to animal form, as Palaestra holds out for him the container with the magic ointment.[54] Palaestra is dressed as a maid, complete with apron and large wooden spoon, and stands before a large open trunk from which she has supposedly taken the container. Lucius is smearing himself with the ointment and his head is already transformed.[55] This title woodcut appeared twice in Hohenwang's Latin edition, while in the German it appeared only once – and not as the title woodcut. Eggestein's German edition of the following year used a very close copy of this block and no significant variants appeared in the titlepage woodcuts for the Strasbourg editions by Bartholomäus Kistler in 1499 and Johann Knobloch in 1509.[56] By contrast, other sixteenth-century artists tended to depict Palaestra herself as the sorcerer or witch, rather than her mistress. Baldung's 1510 woodcut for a collection of Nicholas von Wyle's translations, for instance, shows Palaestra as a much older woman, and this is accentuated by the large purse and keys which hang from her belt.[57] It is she rather than Lucius who is depicted smearing the ointment on his transformed arm. And the very composition of the image, with Lucius seated and Palaestra standing, suggests that Palaestra is the protagonist. The metamorphosis is shown to be the result of

Figure 5.12 Palaestra and the Transformation of Lucius, woodcut, in *Asinus Aureus*, Augsburg: Ludwig Hohenwang, *c.* 1477. From Schramm, vol. 23, fig. 480.

Figure 5.13 Jörg Breu the Elder, *Palaestra and the Transformation of Lucius*, woodcut, in Nicholas von Wyle, *Translation, oder Deütschungen des hochgeachten Nicolai von Weil*, Augsburg: Heinrich Steiner, 1536, fol. 66ᵛ. HAB, Wolfenbüttel [12 Eth. 2°].

her action, and the various containers on the shelf behind help convey the sense that we are viewing the chamber of a professional sorcerer or witch. When Jörg Breu illustrated the 1536 Augsburg edition of Nicholas von Wyle's work (fig. 5.13),[58] he simply adopted Baldung's composition and iconography. Although located in a classical setting, his Palaestra fits the traditional representation of the aged sorcerer. She appears in total control as mistress of the house and is shown attending to her client surrounded by the potions and ointments used in her craft.[59]

One element in Breu's woodcut, the bunch of flowers on the mantelpiece in the background, alludes to the story of Lucius' re-transformation into human shape. This re-transformation was the subject of the titlepage woodcut in the Eggestein edition of 1479 and was included in all the editions published before 1510 (fig. 5.14). Lucius is depicted with the head of an ass, but his limbs and body are already human. He is eating flowers from the table in front of him, while an elegantly dressed woman and a number of men – one of them always bearded – stand opposite. The female figure is the wealthy and

144

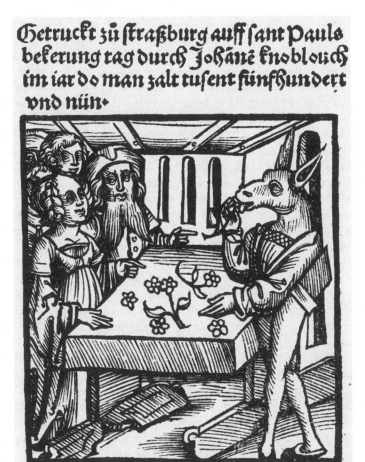

Figure 5.14 The Re-transformation of Lucius, woodcut, in *Ein hubsche history von Lucius apuleius in gestalt eins esels*, Strasbourg: Johann Knobloch, 1509. Bayerische Staatsbibliothek Munich.

sexually infatuated woman of Lucian's story, while the bearded man is Menacles, Lucius' last master, who decided to cash in on the couple's licentiousness by having them perform their sexual acts in public in the middle of the amphitheatre. The story tells how Lucius was wheeled out into the amphitheatre on an elaborate bed with his female lover, but gradually became troubled by the pressures of his impending performance. Fortunately, he noticed a man carrying flowers as he was served wine and delicacies, and among the flowers were roses. Now Lucius knew that eating roses would reverse his transformation. So he jumped out of bed, ate the roses, and was immediately changed back into human shape. The flowers in Breu's 1536 woodcut were primarily meant to remind viewers of this story and to blacken Palaestra as a witch who not only transformed men into animals but was also implicated in bestiality.[60]

The relationship between sorcery, metamorphosis and sex features prominently in the stories by Lucius Apuleius in his *Metamorphoses or The Golden Ass* and their sixteenth-century illustrations. This work includes not only the adventures of the narrator, Lucius,

145

who is transformed into an ass, but also those of Amor and Psyche, of the sorcerers Meroe and Panthia, and of the sorcerer Pamphile and her maid Photis. Photis in fact plays a role very similar to Palaestra in Lucian's *Lucius, or the Ass*. She has a torrid sexual affair with a traveller called Lucius, who is desperate to discover the sorcery techniques of Photis's mistress, Pamphile. Lucius finally persuades Photis to betray her mistress and fetch him her magical ointment. But Photis – just as Palaestra – brings the wrong ointment, with the result that Lucius changes into an ass rather than a bird. Even the roses appear in Apuleius's work, as well as a table laden with food and drink; but here they symbolise the sexual passion between Photis and Lucius. And this successful sexual liaison between traveller and cook – spiced up with frequent references to the relationship between food and sex – contrasts with the frustrated sexual desires of Photis' mistress, Pamphile, a frustration that impels her to satisfy her desires through sorcery. In contrast to the many illustrated editions of Lucian's work, I have found only one illustrated edition of Apuleius: a translation by Johann Sieder, secretary to the Bishop of Würzburg, completed as early as 1500 but not published until 1538 by Alexander Weißenhorn in Augsburg.[61] Of the 78 woodcuts, 41 by Hans Schäufelein illustrate the adventures of Lucius the ass and the story of Cupid and Psyche; while 37 by the Monogrammist NH illustrate the stories of Meroe and Panthia, of Pamphile and Photis, and of Lucius' own transformation.[62] Many of these provide us with very graphic examples of how sixteenth-century artists used the classical past to explore and represent the power of witchcraft to move between the human realm and the bestial.

The titlepage of the 1538 edition of Apuleius' *The Golden Ass* (fig. 5.15)[63] uses a scene that would have been familiar from earlier editions of Lucian. The narrator, Lucius, has his upper body and one arm transformed into those of an ass, while Photis stands before him holding the container with the magic ointment. Unlike a number of other woodcuts from this work, in which Photis wears the simple garb of a maid, here she is clothed most elegantly, with her hair braided and a necklace. The setting is a bedroom, most likely Photis' bedroom. For the reader the canopied bed would have immediately linked the sorcery of metamorphosis with sexual passion. This visual association is underlined in the expanded title and biblical text given above: 'A very lively and entertaining work of Lucius Apuleius concerning a golden ass, which teaches how timorous, weak and depraved human nature is, so that humans sometimes live as brute beasts, in ignorance, in the flesh without any reason, just as horses or mules, as David says; and also conversely, how with God's assistance they can recover and change from an ass to a human, who, God willing, is with full reason.' A scriptural warning from Psalm 32.9 follows: 'Do not become like a horse or mule, in which there is no understanding.' The didactic nature of this titlepage is typical of sixteenth-century moralizing literature, and also, as I have shown above, of the treatment of sorcery by humanistic authors, printers and publishers. Apuleius' work is certainly a fable about human nature but, as the titlepage woodcut demonstrates, it portrays human nature as misled by the potent combination of sorcery and sex.

The relationship between sorcery and sex was well established by the time the reader reached the account of Lucius' transformation towards the end of book three, where the titlepage woodcut was repeated.[64] The reader would have learnt of the mutual passion between Lucius and Photis, which persuaded Photis to betray the secret of her mistress, Pamphile. In response to her lover's entreaties, and fired up after many nights of sexual pleasure, Photis agreed to allow Lucius to spy on Pamphile while she carried

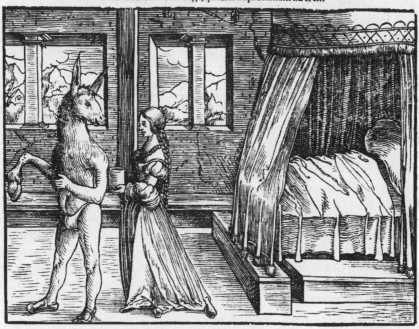

Am Schön Lieblich
auch kurtzweylig gedichte Lu=
tij Apuleij von ainem gulden Esel/darinn geleret/wie
menschliche Natur so gar blöd/schwach/vnd verderbet/ das sy
beweilen gar vihisch/vnuerstendig vnd fleischlich/ on verstand
dahin lebet/gleich wie die Pferdt vnd Maul/wie Dauid sagt/
auch herwiderumb sich möge auß Gottes beystand erholen/vñ
auß ainem Esel ein Mensch werden/Gott gefellig/auffrecht
vnd verstendig. Lustig zů lesen/mit schönen figuren zůgericht/
grundtlich verdeutscht/durch Herren Johan Sieder Secreta
rien/weilendt des hochwürdigsten Fürsten vnd herren Loren=
tzen von Biber/Bischoffen zů Würtzburg vnd
Hertzogen zů Francken rc.

Psalmo. XXXI.
Nolite fieri sicut equus & mulus, in quibus non est intellectus, in chamo & freno
maxillas eorum constringe, qui non adproximant ad te est.

Cum priuilegio Ro. Regiæ Maiestatis, Alexander Weissenhorn / Augustæ Vindelicorum
excudebat. Anno. M. CCCCC. XXXVIII.

Figure 5.15 Monogrammist NH, *Photis and the Transformation of Lucius into an Ass*, titlepage woodcut, in Lucius Apuleius, *Von ainem gulden Esel*, Augsburg: Alexander Weißenhorn, 1538. HAB, Wolfenbüttel [Lh 4° 7].

Sie macht sich Pamphile/Milonis weib/des Apuleü wirtin zü ainer nacht eylen/flugt also zü jrem bů-
len, zaigt das haimlich fotis Apuleio/wie sie in der zauberey püchßlin sey vmgangen/sich
gesalbet/vnnd zům vogel gemacht.

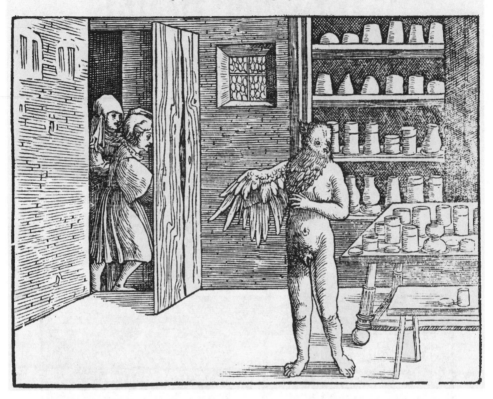

Figure 5.16 Monogrammist NH, *The Transformation of Pamphile into an Owl, Observed by Photis
and Lucius*, woodcut, in Lucius Apuleius, *Von ainem gulden Esel*, Augsburg: Alex-
ander Weissenhorn, 1538, fol. 17ʳ. HAB, Wolfenbüttel [Lh 4° 7].

out her magical rituals of transformation, and also to steal the magic ointment with
which Lucius could transform himself into a bird. Indeed, the motivation for Pamphile's
sorcery was sexual desire. Her aim in transforming herself into an owl, a scene that
Photis and Lucius witness through a crack in the door (fig. 5.16),[65] was to enable her to
fly to her lover, a Boeotian boy with whom she was desperately in love. She resorted to
the use of a magic ointment when all else had failed. Previously she sought to conjure
up the object of her passion by enchanting hair from the young man's head, which
Photis was ordered to steal from his barber. But unfortunately the hair Pamphile bound
and knotted together after she performed her various sorcery-rites and incantations on
her roof, turned out not to belong to her beloved. It was hair trimmed from goatskin
bags, that Photis had collected and presented to her mistress in desperation after the
barber had expelled her from his shop, threatening her with criminal action for her
practice of the black arts.

The Monogrammist NH depicted Pamphile's sorcery rituals on her roof in another
very graphic woodcut, which he paired with an image of the two lovers, Photis and

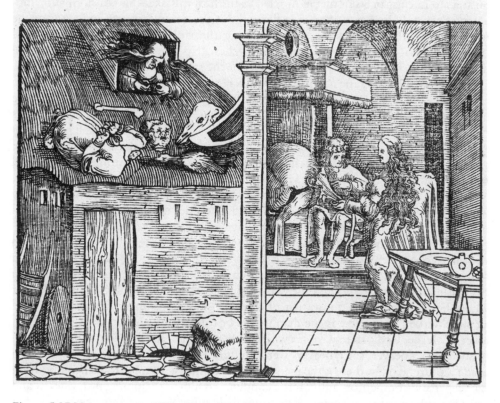

Figure 5.17 Monogrammist NH, *Photis Describes to Lucius the Sorcery Practices of her Mistress Pamphile*, woodcut, in Lucius Apuleius, *Von ainem gulden Esel*, Augsburg: Alexander Weissenhorn, 1538, fol. 16ʳ. HAB, Wolfenbüttel [Lh 4° 7].

Lucius (fig. 5.17).[66] Rather than a Thessalian roof, as Apuleius' story recounts, the setting is a typical south German thatched roof with an attic window, supposedly on the shady, northern side, away from the sun's rays. In front of Pamphile are the human and animal body parts she uses for her sorcery: a decapitated male corpse with tied hands suggesting it to be a criminal; a human head, probably from the same body; a dead fowl; a horse's skull; and a bone. The objects accord only loosely to those in the text, for the artist has clearly been concerned to create a scene recognizable as witchcraft. For the same reason he represents Pamphile with her hair flying out wildly – one of the most recognizable visible codes for a witch, as we have seen, although it finds no mention in Apuleius' text. The pairing of Pamphile's sorcery with the love of Photis and Lucius is also significant. The desperate and unrequited love of Pamphile contrasts with the passionate and fulfilled love of her maid. But the reader of the narrative would have recognized the one incongruous element in the idyllic love scene: Photis holds a strap in her hand which she presents to Lucius in order that he punish her as the source of all his troubles. For Photis was responsible for bringing the goatskin hairs to her mistress, instead of hairs from the head of her lover; and when they sprang to life, Lucius confused

them for robbers and murdered them, a crime for which he was subsequently tried. Threatened with a thrashing, Photis repented and agreed to reveal the sorcery arts of her mistress to Lucius, an event that in turn led to the next mistake – his transformation into an ass. Sexual desire keeps appearing throughout the complex twists and turns of the narrative; it is the stimulus for sorcery and for the violence that follows. As one of Apuleius' characters, Thelyphron, says of witches: 'No one can count the number of deceptions which these evil women contrive for the sake of their lust.'[67]

Another woodcut by the Monogrammist NH, an illustration of the story of Meroe, exemplifies the link between sorcery, metamorphosis and sexuality. Meroe is a female inkeeper and sorcerer in a story told to Aristomenes, a honey and cheese seller, by his old friend Socrates, whom he meets in the Thessalonian town of Hypata when Aristomenes arrives there to do business. The woodcut shows Socrates seated on the ground – sallow, shrunken and destroyed by fortune – telling Aristomenes of the evil fate he and others have suffered as a result of the sexual lust and revenge of the sorcerer, Meroe, depicted in the sky above (fig. 5.18).[68] In the manner of sixteenth-century witches her wild hair streams out behind her as she rides through the sky on her large oven spatula, a unique variation on the cooking fork and clearly a reference to her occupation. Below are the victims of her sorcery and lust. On the left is a pregnant woman with an elephant behind her. The wife of one of Meroe's lovers, she was foolish enough to insult Meroe; and was consequently condemned to a perpetual pregnancy and made to appear so large it was thought she would give birth to an elephant. Next is the lawyer whose head is transformed into that of a goat[69] – his punishment for having spoken against Meroe. Then there is the man with a beaver's head who sits on a wine vat. A lover of Meroe, he dared to have sex with another woman, and was consequently transformed into a beaver, since beavers were thought to cut off their genitals in order to evade capture. Finally, there is the man transformed into a frog. He was a neighbouring innkeeper and competitor, until Meroe condemned him to swimming in a wine vat and croaking at his former customers. The triumphal figure of Meroe above testifies to her most extraordinary act of vengeance. The house she carries belonged to a man who organized a town protest against her with the result that her sorcery was punished by stoning. In revenge, Meroe used necromancy ('zewberey in den toden grebern') to shut up the town's inhabitants in their houses for two days. Even when they finally agreed not to proceed against her, the ringleader was transported in the depicted house to a town on a nearby mountain, and there he was dropped at the town gate. Mimicking the devotional stories in which the Virgin's house was transported from Nazareth to Loreto, Meroe has become the avenging angel, driven by her lust to commit spiteful acts of malice.

Vengeance stimulated by frustrated sexual desire is also the principal theme of the another woodcut in Weissenhorn's edition involving Meroe – an illustration of the revenge of Meroe and her sister Panthia on the same Socrates and his friend, the honey and cheese dealer, Aristomenes (fig. 5.19).[70] The rendition of female violence in this image seems to have impelled the author of the caption to refer to these women as *Unholden*, a word that identifies them clearly as witches, rather than the more general *zauberin* (sorcerer). The narrative begins in the right background where Aristomenes – called Aristodemus in the caption – is pinned down under his bed. Apparently this occurred during the violent entry of Meroe and Panthia, when the door was torn from its hinges and Aristomenes' bed collapsed on top of him. But the primary object of the

Bie kompt der ain geferte Apuleij zů dem ellenden Socraten/der fagt im wie Meroe die zauberin iren bů=
len zů ainem Biber verzaubert/auch iren nachbauren ainem Wirt zů ainem frofch der vnden im faß die geft
empfacht/auch ein Jurißen der wider fie geredt zů ainem bock/vnd der folches von jr außpracht hauß vnd
hoff in die lüfft hingefiert habe.

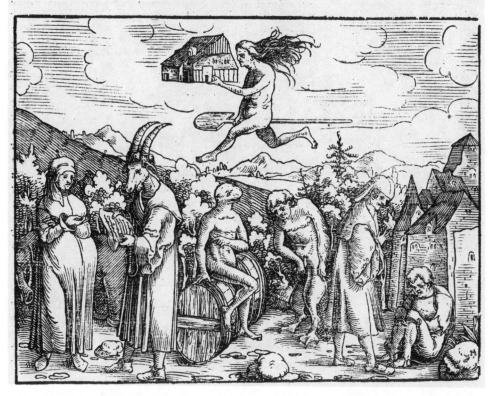

Figure 5.18 NH, *Meroe with the Victims of her Sorcery*, woodcut, in Lucius Apuleius, *Von ainem
gulden Esel*, Augsburg: Alexander Weissenhorn, 1538, fol. 2ʳ. HAB, Wolfenbüttel
[Lh 4° 7].

women's murderous rampage was Socrates, the lover who rejected Meroe. Here Meroe
is shown plunging her sword into Socrates' neck and collecting the blood that pours
from the wound. Panthia stands on the other side of the bed, holding back his head.
Having dispatched Socrates and collected his life spirit, the two women now attend to
Aristomenes in the centre foreground. After dragging him from under the bed, they sit
astride him, lift up their skirts, and defecate and urinate all over him.

The extremes of violence and ritual defilement in this last woodcut go well beyond
most representations of witchcraft in the early sixteenth century. They are reminiscent
of the violence of another witch, possibly the most famous of all classical witches,
Medea. Medea was widely known both from Ovid and Boccaccio and became the
prototype of the cruel and murderous witch from antiquity.[71] Rather than dealing with
transformations between the animal and human worlds, she stood more directly at the
intersection of life and death. The murder I refer to was that of King Pelias, Aeson's
brother who had usurped his throne. Artists frequently depicted this heinous act in the

Hie sticht Meroe dem Socrati in den hals/facht sein blůt fleissig auff/hebt im die Panthia hin/recht sich an
jm der verlassnen bůlschafft halben/vnd Aristodemus wirt von jnen gestürtzt/das sein bett das oberst zům
vndersten wirt/vnd wol von den vnholden beschissen vnd besaicht.

Figure 5.19 Monogrammist NH, *Meroe and Panthia Wreak Vengeance on Socrates and Aristo-
menes*, woodcut, in Lucius Apuleius, *Von ainem gulden Esel*, Augsburg: Alexander
Weissenhorn, 1538, fol. 3ᵛ. HAB, Wolfenbüttel [Lh 4° 7].

sixteenth century, not least Bernard Salomon in his illustrations to the 1557 edition of
Ovid's *Metamorphoses*, copied a few years later by Virgil Solis (fig. 5.20).[72] Solis and
Salomon depict Medea before Pelias' canopied bed. In the right foreground a young
lamb stands up in a cauldron over a fire. This is the ram that Medea rejuvenated after
slitting its throat and throwing its old limbs into a potion of magic herbs, in order to
trick Pelias' daughters that she could rejuvenate their father in similar fashion. But after
persuading his daughters – shown opposite the bed, with swords drawn and eyes
turned away – to strike their father and thereby drain the old, thin blood from their
father's body, she herself drew a knife, slit his throat and brought his life to an end.
Then the murderous and deceiving witch quickly escaped into the air by means of the
chariot drawn by winged dragons (right background).

In sixteenth-century images Medea's violence extended to further cruel and
murderous acts. She was frequently shown killing her children, or cutting off the limbs of
her young brother, Apsyrtos, and carrying his head.[73] Her witchcraft found most
dramatic expression in a number of images related to her rejuvenation of Jason's father,

Aeson. As described in the *Metamorphoses* and also depicted by artists such as Bernard Salomon, Virgil Solis, Léonard Thiry and Ludovico Caracci, at the full moon Medea invoked Hecate, the night, the earth, the stars and the moon to assist her spells and magic arts. With the help of her winged dragons she scoured the earth to collect plants and herbs for her magical potion, set up an altar, sacrificed a sheep and filled the surrounding trenches with sheep's blood, wine and milk. As one of Salomon's woodcuts shows (fig. 5.21), she then had the weakened body of the aged Aeson brought out, laid on a carpet of herbs beside the altar, and entreated Pluto and Proserpine not to remove his spirit. The woodcut shows her holding a wand in one hand and using a withered branch of an olive to stir the cauldron with the other; while behind her the torches that had been dipped in sheep's blood burn brightly. Next she will slit Aeson's throat, drain his blood and replace it with the liquid from the cauldron, whereupon his old age will vanish, his white hair turn dark, his wrinkles disappear and his limbs become strong once again. While actually an act of piety by Medea in Ovid's text, the artist's depiction of Medea's performance of these rituals bare-breasted and with loosened hair, stirring a cauldron before an altar engraved with magical talismans, and with Aeson's dead body lying beside it, would leave little doubt that this was indeed an act of witchcraft. Unlike sixteenth-century images of Meroe, Circe and Pamphile, images of Medea place less

Figure 5.20 Virgil Solis, *Medea Tricks Pelias's Daughters into Murdering their Father and Slits his Throat*, woodcut, in Ovid, *Metamorphoses*, Augsburg: Johann Sprenger, 1563. From TIB, vol. 19, part 1, p. 492, fig. 7.81 (320).

Figure 5.21 Bernard Salomon, *Medea Rejuvenates Jason's Father Aeson*, woodcut, in Ovid, *La Métamorphose d'Ovide figurée*, Lyon: J. de Tournes, 1557, p. 78. Special Collections, Information Division, The University of Melbourne.

emphasis on her power to transform than on her terrible cruelty and violence. But as with the other classical witches, her sorcery is largely motivated by her sexual passion for Jason and her rage and jealousy when her love is rejected. Seeking to extract meaning from the deeds of Medea for his readers, Boccaccio points to the significance of her lust:

> Certainly, if powerful Medea had closed her eyes or turned them elsewhere when she fixed them lovingly on Jason, her father's power would have been preserved longer, as would her brother's life, and the honor of her virginity would have remained unblemished. All these things were lost because of the shamelessness of her eyes.[74]

Witches from classical literature provided sixteenth-century artists with rich sources for their development of a new visual language of witchcraft. The powers of witchcraft that artists primarily chose to display involved the capacity to negotiate the borders between the animal and human worlds and those between the realms of the living and the dead. In some cases these powers involved shocking scenes of destructive violence, but in almost all cases they were stimulated and driven by sexual desire, either by the witch herself or by her victims. Such emphases fitted well with images of witchcraft devised in the early decades of the sixteenth century and inevitably helped expand the

154

iconographical range on which artists could draw. There is little evidence to suggest that the early images developed by Altdorfer, Dürer and Baldung Grien were primarily created through interaction with classical literature. Witchcraft, as a power that controls the borders between life and death, certainly appears early on in classical form in Baldung's work, in his 1513 woodcut of *The Three Fates* (fig. 5.2); but allusions to such powers in other images, as in depictions of the punishments of Tartarus or the destructive violence and regenerative sorcery of Medea, appear for the most part after mid-century. There is some evidence, as we have seen, of the visual cues and codes of witchcraft pushing their way into depictions of ancient witches. So there is likely to have also been an influence in the opposite direction, with the increasing number of such images helping underpin images of witchcraft developed in other contexts. The images of classical witches certainly must have lent greater credibility to perceptions of witches' critical powers over metamorphosis and death and have also confirmed the existence and power of such witch figures through history. Moreover, they would have also identified witchcraft as something quintessentially related to women and to female desire in particular. In the next chapter I explore how another group of literary and iconographical sources – stories taken from the Bible and medieval legends of the saints – were also used by artists to extend the historical and thematic range of witchcraft, and in that way helped lend credibility and definition to the shape of the sixteenth-century witch.

6

A BIBLICAL NECROMANCER AND
TWO CHRISTIAN SAINTS

In 1526 the north Netherlandish painter and woodcut designer, Jacob Cornelisz van Oostsanen, who had spent most of his career working among the burghers of the burgeoning town of Amsterdam, created an extraordinary painting of the only story of a witch from the Bible, that of the so-called witch of Endor (1 Sam. 28.3–20).[1] As so much of Cornelisz's work, *The Witch of Endor* (fig. 6.1) demonstrated his close relationship with German artists, in this instance with the images of witchcraft generated by Hans Baldung Grien. In a radical break from traditional medieval iconography, Cornelisz combined the image of a powerful female necromancer, seated in a magic circle and invoking the spirits of the dead, with a group of witches gathered around a grill, two of them on goats, cooking sausages, drinking and possibly making an offering. In this way, he transformed the individual necromancer of the biblical story into a member of the new group witchcraft of the sixteenth century. His painting demonstrates the successful dissemination of a new visual vocabulary of witchcraft, fashioned for the greater part in southern Germany over the previous two decades. Similar to the appropriation of witchcraft imagery from classical literature considered in the previous chapter, Cornelisz's painting exemplifies how sixteenth-century artists could introduce elements from the new iconography of witchcraft into their rendering of more traditional subjects and offer radically different readings. And the emphasis given to the role of the witch would lend credibility to claims about the ongoing history and powers of witchcraft.

Witches begin to appear in a number of traditional Christian subjects in the sixteenth century, in events central to the story of collective salvation such as the Last Judgment and the punishments of hell, or in scenes from the lives of individual saints known for their confrontation with diabolic powers, as in the many images of the Temptations of St Anthony.[2] This chapter limits itself to an examination of three such examples from Christian tradition that focused on the theme of demonic magic and shows how sixteenth-century artists drew on the new iconography of witchcraft to give these stories contemporary relevance. The first is the biblical story of the witch of Endor and King Saul, and the use of necromancy to call up the man of God, Samuel; the other two are the medieval stories of the apostolic saints, James and Peter, and the struggles they waged against the demonic powers of the ancient magicians, Hermogenes and Simon Magus. Visual accounts of such stories in the sixteenth century gave added emphasis and even a new prominence to the role of the demonic. The witch of Endor's capacity to raise the dead was presented as the product of necromantic rituals that depended for their success on diabolic power. Hermogenes was depicted as master of a world teeming with strange

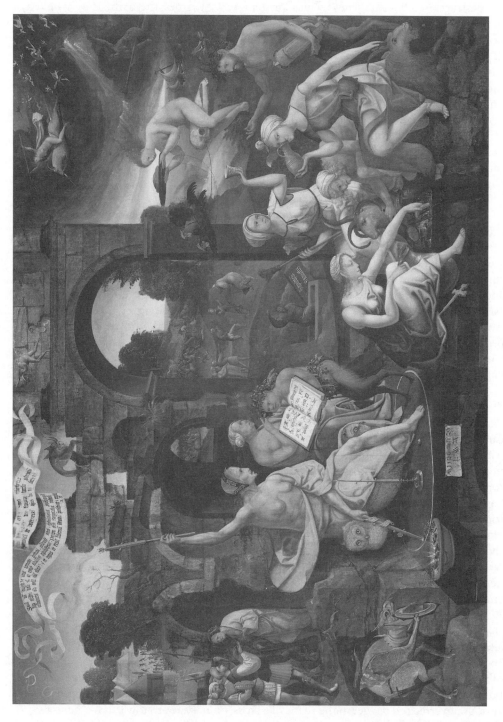

Figure 6.1 Jacob Cornelisz van Oostsanen, *The Witch of Endor*, 1526, panel painting. © Rijksmuseum Amsterdam.

demonic hybrids, who engaged in a variety of magical rituals including witchcraft. And in the destruction of Hermogenes by his Christian rival, St James, these rituals were linked to notions of the devil as arch-trickster, the master of illusion and father of lies. In depictions of his contest with St Peter, the magician Simon Magus was also shown as dependent on his demonic assistants; and by a series of associations, he was linked to the Antichrist and to images of diabolical magic drawn from medieval romance. Re-telling these traditional stories, and heightening the devil's role in them, underscored the significance of witchcraft in the contemporary world, representing it as part of that long history of struggle between God's people and the powers of evil. These images represented witchcraft as part of the age-old history of the devil's plan to bring about the destruction of Christian church and society, and they assured those calling for the eradication of witchcraft that they were indeed on the same side as the biblical prophets and Christian saints.

In his 1526 painting, Jacob Cornelisz confined the narrative of the woman of Endor to the left and centre backgrounds and provided a textual reference to the biblical account by means of the banderoles at upper left. The lower banderole recounts in Latin how the Israelite king, Saul, went in disguise with two men to Endor in order to consult a seer about the outcome of the war he was waging against the Philistines. Samuel was summoned and foretold the death of Saul and his three sons.[3] The meeting between Saul and the witch of Endor takes place on the left perimeter, and the military camp of the Israelites is depicted behind. Through the arch one can see the figure of Samuel rising from his sarcophagus; behind that, the figure of the terrified Saul hearing the dire prophecy from Samuel; and in the far background, the battle of Gilboa, in which Saul and his three sons meet their death (1 Sam. 31), and the very common image of Saul falling on his sword.

Necromantic witchcraft, on the other hand, was Cornelisz's primary interest and this dominates the foreground. As the upper banderole, written in vernacular Dutch, puts it: 'Saul gave himself up to witchcraft (*tovery*). By disturbing Samuel in his death he himself came to die.'[4] The woman of Endor appears as a ritual magician, seated on two owls within a magic circle, which is meant to protect her from the demonic spirits she is invoking. Her bared upper body is remarkably muscular and masculine, as she lights a torch from the brazier below and thrusts another high above her. Both lighted tapers have curious host-like attachments, and one of them phylactery-type scrolls; and together with the brazier, the candlestick, the book of invocations and mirror, they emphasize the highly ritualized character of this magic. The woman herself is naked to the waist, has her legs crossed in a common sign of sexual transgression, and her hair – as well as that of her female assistant – flies out in wild fashion behind her – all visual cues deployed by Baldung to designate the sexual disorder of witchcraft (fig. 3.12). The influence of Baldung and his copyists is clearly evident in the group of women on the right. Although they are clothed, the transparency and cut of their garments reveal their body shape; while the figure to the far right holds the horn of the goat on which she sits, an allusion to the works of Altdorfer, Dürer and Cranach, and looks out at the viewer in the coquettish style of one of Baldung's *Weather Witches* (fig. 3.12).[5] The woman on the left of the group has a large vessel between her legs, while she places a phallic sausage on the burning grill.[6] And reminiscent of the taper used in Baldung's 1514 drawing (fig. 1.3), a curious, inverted red dagger in the shape of a cross, points upward towards her genitals.

The group's actions may well be a play on a counter-Eucharist, as Jane Carroll has

suggested.[7] There is an elevation of a cup – inscribed with the word *Mal* – and above it a platter of bread. But the allusions are also to sexual gratification. The bread is presented by a naked woman, her legs crossed tightly around a horse's skull; while the cup is offered to a bearded satyr on the right, originally a representation of Pan, a figure closely associated with carnal lusts.[8] The wild and naked female figures riding through the sky in the top right corner, one with wild hair flying out behind her, the other on a goat that belches flames from its mouth and arse as she holds aloft her cooking stick, would have further accentuated the links between this biblical case of necromancy and the sexualized understanding of witchcraft. While the strange beasts in the foreground and the bird-hybrids clambering along the ledge of the arch serve to strengthen the overwhelming sense of demonic presence. Cornelisz has clearly integrated the ritual and demonic magic of the necromancer's craft, an essentially male domain, with the vernacular rites of female witchcraft that operate largely through the instruments of food and sex. This emphasis and iconography mark a dramatic change in the traditional representation of this biblical story.

Although the biblical story of Saul's visit to Endor was firmly established in Christian literature and iconography from the twelfth century, it was seldom represented visually; and when it was, it focused little on the figure of the witch and her act of conjuration.[9] In the Tickhill Psalter illuminations from the early fourteenth century, for instance, the most detailed cycle of the story, the act of necromancy receives no particular emphasis, and the central figures are those of Saul and Samuel. Likewise, in other medieval illustrations the witch of Endor is simply shown gesturing towards the figure or ghost of Samuel whom she has invoked and the key dynamic is between Saul and Samuel. This is the case in a thirteenth-century *Bible historiale* of Guyart des Moulins, in a French manuscript translation of Peter Comestor's *Historia Scholastica* from the 1290s, in the Bavarian *Kaiserchronik* written in German verse in the late 1370s, in the *World Chronicle* of *c.* 1340 from south-east Germany, in the German *Gumpertusbibel* before 1195, and in the Vienna *Soudenbalch Bible*, a *c.* 1460 copy of the very popular north Netherlandish *First History Bible*. The one exception is a miniature in Guyart des Moulins' *Bible historiale*, produced by the Parisian Boucicaut workshop and dated to the first quarter of the fifteenth century. Here the witch of Endor is positioned at the centre of the image, and her diabolical negotiations with Saul are its focus. As Jean-Claude Schmitt has argued, this miniature reflects a shift in the literary discourse of the fifteenth century, which constructs Samuel's apparition as the product of diabolical power.[10]

Cornelisz's 1526 painting demonstrates a further shift under the impact of the recently developed visual language of witchcraft, and his inclusion of a group of witches seems to have influenced a number of Flemish anamorphic paintings in the later sixteenth century.[11] Even the near contemporary woodcuts in editions of the so-called *Combined Bible*, designed by Heinrich Vogtherr the Elder and first published in Strasbourg in 1530, give a new emphasis to the witch of Endor's role, even if they largely continue with the medieval iconography (fig. 6.2).[12] For it is only in bibles from the later sixteenth century that the witch's necromancy is clearly figured as witchcraft. The first and most influential woodcut to effect such a change is one designed by Johann Teufel and published in the 1572 Wittenberg edition of the so-called *Luther Bible* (fig. 6.3), the German vernacular Bible translated by Luther between the 1520s and 1540s and then published in dozens of editions over the succeeding decades and centuries.[13] The Lyon engraver, Thomas Arande, was possibly its originator, for a similar woodcut appears with

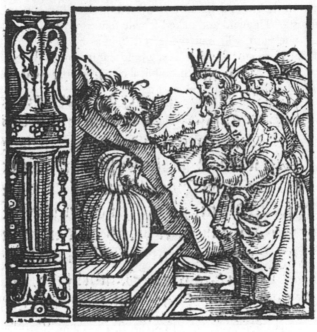

Figure 6.2 Heinrich Vogtherr the Elder, *King Saul, the Witch of Endor and the Ghost of Samuel*,
woodcut, in *Die gantz Bibel Alt unnd Neüw Testament. ... Item auch mitt Zweyhundert
Figuren*, Strasbourg: Wolfgang Köpfl, 1532, fol. 49ʳ. HAB, Wolfenbüttel [Bibel S 4° 7].

an attribution to Arande in the French and Italian editions of *Quadrins historiques de la
Bible* published in Lyon by Guillaume Roville in 1564.[14]

Teufel's woodcut was destined to become a very familiar image over succeeding
decades, not only through the 1572 bible, but also through the copies included in at
least six editions published between 1572 and 1610.[15] The emphasis on ritual magic in
Cornelisz's painting also found expression here, albeit in an understated fashion.
Located within a room of the woman of Endor's house, the scene featured the parapher-
nalia of ritual magic – an altar and a large candle, and a magic circle with three burning
candles and crosses ringing the perimeter. The woman holds a long staff, which would
surely have suggested a magician's ritual wand and, much more surprisingly perhaps,
prayer beads hang from her left arm. Teufel used this motif to link the necromantic prac-
tices of the biblical witch to what pious Lutherans regarded as abominable Catholic
superstition and magic.[16] As with many of Teufel's biblical illustrations, the rosary repre-
sented a very topical reference inserted into the biblical narrative.[17] In 1569, the date of
Teufel's print, Pope Pius V had issued a bull granting indulgences for praying and medi-
tating on the mysteries of the rosary; and in March 1572, the year it was published, the
same pope established the feast of Our Lady of Victories, in memory of the victory of the
Catholic alliance against the Turks at Lepanto in October of the previous year, a victory
attributed to the rosary.[18] Significant too was the close linking of the woman and Samuel

Figure 6.3 Johann Teufel, *King Saul, the Witch of Endor and Samuel*, 1569, woodcut, in *Biblia Das ist: die gantze heilige Schrifft Deudsch. D. Mart. Luth.*, Wittenberg: [Hans Krafft], 1572, vol. 1, fol. 197ʳ. HAB, Wolfenbüttel [Bibel S 2° 42].

within the circle, instead of the more expected positioning of Saul inside the circle, as protection against evil spirits who might respond to the woman's invocations. This reflected one of the main theological points of Luther's commentary, that the apparition was not in fact Samuel, but a ghost produced by the devil. Already in the 1534 *Luther Bible*, the marginalia explained that the apparition was none other than the evil spirit who had assumed Samuel's person and name. It was a *Teufelsgespenst* (diabolical ghost and illusion), that addressed Saul under the appearance and name of Samuel.[19]

The commentary in the 1572 edition also provided a rationale for including an illustration of the witch of Endor story in a *Luther Bible* for the very first time. It claimed that the story offered an example to secular authorities as to how they should punish and root out public idolatry and superstition. This was a very current issue in Wittenberg in 1572 because, in that year, the new Electoral Saxon Criminal Constitution was promulgated, the first territorial legal ordinance in the Empire to punish with death those who made a pact with the devil, even when no malefice was carried out. Even when simply a spiritual crime, the witch's pact with the devil became subject to capital punishment, together with divining, soothsaying and crystal gazing.[20] Teufel's woodcut seems to represent a visual version of Luther's biblical commentary on the story, an attempt to legitimate the current legal changes in Saxony and an encouragement to rulers to pursue their Christian office by removing witches from their territories. It hardly seems coincidental that

illustrations of the witch of Endor story begin to proliferate in *Luther Bibles* from this time on, and the primary emphasis is now on the figure of the female necromancer and the techniques she employed to conjure Samuel.[21]

The significance of the witch of Endor illustrations within the broader field of witchcraft imagery was, first, that they provided witchcraft with a long history stretching back to biblical times. Even in the days of the kings of Israel, such images asserted, necromantic witchcraft was practiced, and this despite clear divine prohibitions. Second, they provided a clear sanction for legal and political authorities to mount a concerted campaign against the threat of witchcraft. And third, Saul's abandonment by God was a chilling warning to any authorities that neglected the duties of their Christian office or, even more so, associated with conjurors or dabbled in the arts of magic and divination themselves. This long history of witchcraft and ongoing battle against all forms of diabolical sorcery, however, was not simply linked to biblical history; it was also transmitted through stories of the struggle of Christian saints against their diabolical enemies. The most graphic example to involve the incorporation of the new visual language of witchcraft into the iconography of saints' lives was the story of the apostle James and the ancient magician Hermogenes.

It was Pieter Bruegel the Elder who was the first to make an explicit link between witchcraft and the magician Hermogenes in the 1560s. A range of scenes from the story of St James had been frequently depicted in the late Middle Ages but, prior to Bruegel, witches were never included among the throng of demons that played so critical a role in the struggle between the two protagonists. The first of Bruegel's images, *St James and the Magician Hermogenes*, survives in an engraving by Pieter van der Heyden, which was published by Hieronymus Cock in 1565 (fig. 6.4).[22] The caption reads 'St James in the presence of the magician stands firm against his diabolical tricks';[23] and the print depicts James, clearly identifiable by his halo, pilgrim's cloak and staff, his hat decorated with shells, the pilgrim bag at his waist and water container hanging from his wrist, standing before the seated Hermogenes in the chamber of the magician. In the traditional fur hat and long robe of the magician, Hermogenes is reading from what is presumably a magical book and is surrounded by a throng of monstrous hybrids well known from Bruegel's other works. The hunched figure in the right background, seated on a stool within a magic circle, his head buried in his arms and back to the viewer, is Philetus. According to the *Golden Legend*,[24] one of Bruegel's principal sources, Philetus was a follower of Hermogenes, sent out to demonstrate the falsity of James' Christian teaching. His mission was a dramatic failure. James' miracles persuaded Philetus that it was James rather than Hermogenes who preached the truth. But when Philetus urged his master to follow James, Hermogenes flew into a rage and had Philetus bound by invisible magic bonds.

Although Bruegel's scene derives from the account in the *Golden Legend*, it only refers to it loosely. In that account James never comes to the magician's chambers. Rather, James releases Philetus from his invisible bonds by the power of his handkerchief (*suda-rium*), whereupon Hermogenes flies into a rage and commands the demons to bring James to him in chains. But the demons then change their allegiance: they appeal to James to release them from their master's service, and in return promise to bring Hermogenes back to James. The *dénouement* includes the release of the shackled Hermogenes by the new Christian convert and former follower, Philetus; the throwing of the magician's books into the sea; and finally, Hermogenes' own conversion to

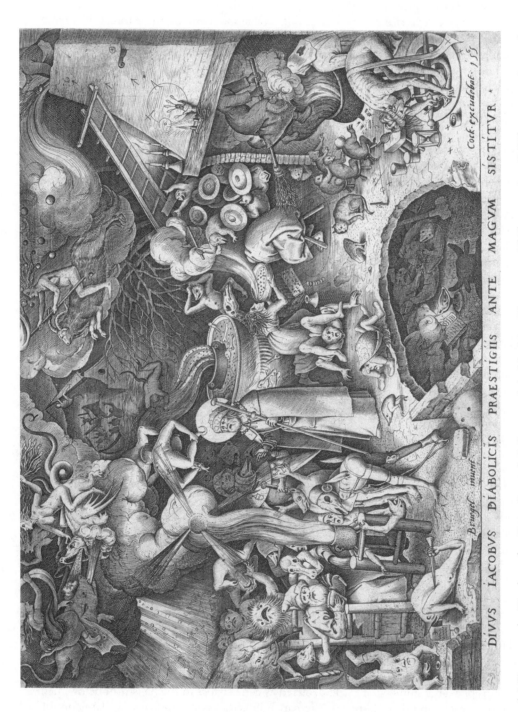

DIVVS IACOBVS DIABOLICIS PRAESTIGIIS ANTE MAGVM SISTITVR

Bruegel. inuent.

Cock. excudebat. 155

Figure 6.4 Pieter van der Heyden, after Pieter Bruegel, *St James and the Magician Hermogenes*, 1565, engraving. © Rijksmuseum Amsterdam.

Christianity. Bruegel's image only presents a few general references to this story, for his intention is to depict the range of magic and demonic forces over which Hermogenes was believed to exercise power. Witchcraft is prominent among these forces: it is represented by the riding witches above, the three different cauldrons with their clouds of belching smoke and the acts of terrible destruction depicted in between.

The witches appear in somewhat different forms. Above the cauldron in the hearth a witch rides a broom or besom, which from this time on will become the most common instrument for the witch's ride.[25] She is leaving the magician's chamber by way of a chimney, while another witch emerges at the top. This portion of Bruegel's scene, with its hearth, mantelpiece, lighted candles, magical signs and Hand of Glory, will appear many times over in the iconography of witchcraft in the later sixteenth and seventeenth centuries.[26] While the witches riding up the chimney are clothed, those in the upper register of the print replicate the visual type established by Baldung and Cranach earlier in the century. The central figure is naked and rides a goat; her hair flies out in wild fashion behind her, and she holds what appears to be a flaming torch. The storm and hail-stones generated in the cloud through which she rides wreak their destruction on a sinking ship from which survivors scramble to safety, and on a collapsing church steeple to which a figure desperately clings. Perhaps this represents an image of the church that appears to offer safety, but collapses in the face of diabolical onslaught. And while the naked witch riding through the sky on a goat was more likely to be immediately understood as one of the demonic powers that make up the kingdom of evil, those clothed in common garb and riding up the chimney on their brooms would underscore the everyday character of witchcraft and its claimed association with hearth and cauldron. The third group of witches on fire-breathing dragons at top left represent the conflict and disorder at the heart of this evil domain. Their appearance is reminiscent of medieval battles between the virtues and the vices and they possibly also allude to popular beliefs about the night battles in which witches were thought to take part.[27]

An unusual detail of this group is the fistful of snakes held by the witch to the right, barely distinguishable from her wild hair. These allude to the snakes of the Furies or Eumenides, the mythological chthonian powers of retribution. The visual association of the Furies with witchcraft would seem to date from 1542, when the Augsburg printer Heinrich Steiner used a woodcut – originally created by the Petrarca-Meister to illustrate the chapter 'On madness' in the 1532 German edition of Petrarch's *Of Two Kinds of Fortune* – to represent the subject of sorcery in Johann Pauli's *Humour and Seriousness* (fig. 6.5).[28] Among a literate readership the woodcut would have been well known. Adapted from the illustrations of Tisiphone and the other Furies in the 1502 Strasbourg edition of Virgil's *Aeneid*, it appeared in all seven sixteenth-century German editions of Petrarch's work. The madness and fury of witchcraft would have been disseminated by Steiner's use of it in the 1542 edition of Pauli's stories, and later again in the 1544 and 1546 editions. Yet it was not until Bruegel's drawing and Pieter van der Heyden's engraving of *St James and the Magician Hermogenes* in the 1560s, that the snakes of the Furies became almost an attribute of the riding witch, a motif that persisted well into the seventeenth century in the work of Jacques de Gheyn II and others.[29]

The witches in the top left corner of Bruegel's design appear to be the cause of the deaths of a large number of cattle depicted as eerie shapes in the hailstorm below them on the far left, and their destructive activity is linked to two cauldrons: the large double cauldron just right of centre, brimming with a liquid full of bones; and a much smaller

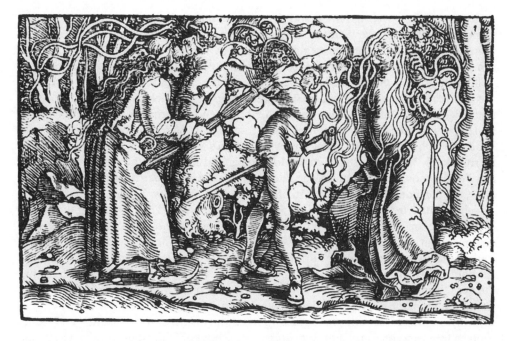

Figure 6.5 Petrarca-Meister, *On Madness*, woodcut, in Francesco Petrarca, *Von der Artzney bayder Glück des güten und wider wertigen*, Augsburg: Heinrich Steiner, 1532, fol. 146ᵛ. HAB, Wolfenbüttel [H: 0 48.2° Helmst. (1)].

cauldron on the stool in front of Hermogenes, that creates a dramatic explosion above. To extend on a suggestion made by Maxime Préaud,[30] all these circular forms in the print have an integrating function within the composition, connecting the different protagonists and the various forms of magic and conjuration: the explosion, James' halo, the monster with the sun-like head behind Hermogenes, the large central cauldron, the sieve being used by a woman for divination, the circle constraining Philetus, the curious saucer shapes to his right, the circle in which a ritual magician slaughters a reptile, even the hailstones at top right and the circle made by the dragon's tail at top left. The circular shapes gradually draw in the viewer's eye, suggesting in turn the chaotic vortex into which Hermogenes and all his magical rituals are being pulled.

The riding witches of hearth and sky are linked not only to the figure of Hermogenes, to the ritual and divinatory magic of his associates, and to the monstrous hybrids and diabolical cats, toads and apes that act as his servants and audience. The magical rituals below the ground also involve witchcraft. Through an opening in the floor one sees two monsters dismembering a disinterred corpse, while a figure that appears to be Hermogenes reads from a magic book by the light of a lamp. The corpses and body parts emphasize the deadly destruction of witchcraft; and link the destruction of community and allusions to the chthonic power of the Furies in the upper section of the print to the dismemberment of individual bodies in the lower. And the destruction is clearly diabolical. For in the underworld there is also a diabolical presence, overseeing the action as little more than a dark shape, yet recognizable by its two horns. It is an understated reference that nevertheless resonates through the print – with the goat carrying a witch through the sky, for instance, and the monster at Hermogenes' feet who carries a diabolical pact in its beak.

165

The struggle between James and Hermogenes is well documented in medieval iconography, and the originality of Bruegel's image becomes very clear when one surveys this earlier tradition.[31] The story first appeared in visual form in the early thirteenth century, as in the 16 scenes of a stained glass window from Chartres,[32] and became especially popular in Italy from the later fourteenth century. A fresco by Arrigo di Niccolò in the Prato cathedral features its scenes,[33] as does a fresco by Altichiero from the late 1370s in the Basilico del Santo in Padua, in which Hermogenes commands his demons to bring him St James.[34] Mantegna also completed a fresco in *c.* 1450 for the Eremitani Church in Padua, which included a scene in which James orders two demons to shackle Hermogenes.[35] In 1387–88 Lorenzo Monaco painted a panel for the predella of an altarpiece of the monastery of Santa Maria degli Angeli in Florence, that depicts three devils bringing the bound Hermogenes to St James and Philetus.[36] And in *c.* 1430, Fra Angelico completed an exquisite panel that shows the convert Philetus freeing the bound Hermogenes on James' command, while James stands by holding a group of terrible demons at bay with his staff.[37] The power of James and his Christian preaching over the learned magician constituted the primary message of a slightly later tradition in northern Europe, just as it had in Italy. From *c.* 1425 we have a series of panel paintings depicting the cycle from a St James altar by an unknown Bohemian master;[38] in *c.* 1490 a panel from the altar of the church of St James in Nößlach, Austria, by Ludwig Kornreuter, that shows two devils presenting the bound figure of the magician to the saint;[39] a 12-panel triptych by an anonymous Flemish master of the school of Dirk Bouts from *c.* 1510, one of which features many scenes from the story including the burning of Hermogenes' books;[40] and a relief of *c.* 1520 from the high altar of the Castle Church of the Teutonic Knights in Winnenden, that also depicts St James and Hermogenes burning the magician's books.[41] It is only in a panel of *c.*1510–20, possibly by Bosch, that anything like Bruegel's deep interest in the demonic world of magic and witchcraft begins to be registered. Hermogenes sits on an ornate throne reading a book, and seems to be relaying his spells and orders to the strange demonic creatures that cluster around him.[42]

Bruegel also pays little attention to the traditional narrative of James and Hermogenes in a follow-up drawing, *The Fall of the Magician Hermogenes*, which was completed in 1564 and then engraved by Pieter van der Heyden and published by Hieronymus Cock in 1565 (fig. 6.6).[43] The caption in the first state of the engraving does not even refer to either James or Hermogenes by name: 'He obtained from God [his prayer] that the magician be torn in pieces by demons.' Moreover, the depiction of the story is quite at odds with the account in *The Golden Legend*. There the demons tie up Hermogenes, bring him to James and ask if they might exact their revenge on him. James refuses and sets Hermogenes free, and even gives him his own staff for protection against the demons' attacks; and in response Hermogenes casts all his magical books into the sea. He then prostrates himself at James' feet and becomes a Christian. By contrast, Bruegel's image depicts a savage assault on Hermogenes by his demons, who quite literally tip him out of his throne. In this way the print provides a graphic example of the growing interest in the demonic in the sixteenth century, and of the violence demons were believed to inflict on their masters. The one witch that appears in the print is not, however, linked to these attacks. On the right perimeter of the massed phalanx of hybrid monsters, riding a broom that contrasts with the magical staff of the saint below her, and blowing smoke or fire from her mouth, the witch is one component of a complex scene that Adriaan Barnouw has called 'the make-believe *kermis* scene of *Vanity Fair*'.[44]

IDEM IMPETRAVIT A DEO VT MAGVS A DEMONIBVS DISCERPERETVR.

Figure 6.6 Pieter van der Heyden, after Pieter Bruegel, *The Fall of the Magician Hermogenes*, 1565, engraving. © Rijksmuseum Amsterdam.

The demonic assault on Hermogenes takes place in the context of a carnival fair, a writhing world of fools, musicians, contortionists, Morisco dancers, conjurors, jugglers, acrobats, tightrope-walkers, puppeteers and street performers, plying their trickery and illusion. Hermogenes has been brought to a square outside a church, while ecclesiastics look on from the door of the church behind St James, and townsfolk peer through a window at top left. A sideshow hanging previews some of carnival's wonders, a trumpet blast adds to the cacophony. Two fools act as further cues, one drumming at centre left and another performing a hand-stand with a tambourine in the central foreground, an inversion very appropriate for carnival and prominently displayed in Bruegel's engraving, *The Festival of Fools*.[45] There is also the energy, excitement, daring and illusion associated with acrobatics and street theatre. Yet this is also shot through with images of violence: there is the dancer with the two knives in the right foreground; the contorted body with a sword in its neck at top right; the ape-like beast with a knife through its nose immediately below the tightrope-walker; the rat-like beast who carries a similar knife in its mouth to the left of the ladder; a balloon-like monster with a knife through its hand and a nail through its tongue, at bottom left; and next to it on the table, a decapitated body and a head on a plate. These provide echoes of the violence attributed to Hermogenes; but they also signify the chaotic upheaval and violence associated with carnival. As the demonic assault brings Hermogenes to the ground, Bruegel presents it as an inversion of an upside-down world, so that it finally comes the right-side up.

Illusion, trickery and sleight of hand are also at the heart of Bruegel's print – together with the strange, hybrid beasts that seem to morph before one's eyes. And many of the illusions and tricks must have been well known. The decapitated body and head on a plate at left foreground, for instance, was a carnival trick called 'the decollation of John the Baptist'. It was described in an early sixteenth-century compilation of courtly entertainments, in Andreas Hondorff's 1575 collection of *exempla*, and in Reginald Scot's *The Discoverie of Witchcraft* (1584).[46] Scot even included an illustration to help readers master the trick, and claimed that a London man called Kingsfield had performed it before a large crowd on Bartholomew's day in 1582. Bruegel's beast with a knife through its nose positioned just below the tightrope-walker also appeared in Scot's work as one of his 'juggling knacks': 'To cut halfe your nose asunder, and to heale it againe presentlie without anie salve' – for which Scot provided an illustration of the different knives to be used. And the trick performed by the hybrid at bottom left was described and illustrated in a section headed: 'To thrust a bodkin through your toong, and a knife through your arm: a pitiful sight, without hurt or danger.'[47] Scot considered all these as 'the conveiances of legerdemain and juggling', with which demonologists and popish priests conspired to fool the simple.[48]

But for others, such as the professor of Greek and Mathematics and Rector of the University of Heidelberg in the 1560s and 1570s, Hermann Witekind, the world of tricks and illusion was dangerous because of its direct association with the devil. In *Christian Thoughts and Reflections on Sorcery* (1585), Witekind declared that trickery (*Gauckel*) was the work of the devil, because it blinds and confuses the human and animal senses.[49] It makes things seem not what they are, blurs notions of truth and provides an entry for the devil to wreak all kinds of destruction in society. Two deceptions described by Witekind as performed by 'the loose-living crew that goes about the country with the trickster's pouch' feature in Bruegel's print: locking up someone's mouth in such a way that it appears as though the lock goes through both lips; and

Figure 6.7 Balthazar van den Bos, *The Conjuror, c.* 1550, engraving. Staatliche Graphische
 Sammlung Munich, inv. no. 158407D.

claiming to cut someone's head off and then putting it back on. What appear to be harm-
less are in fact part of the devil's strategy. 'Such pranks might be endured, might be
acceptable,' he writes, '*if* they were no more than that, and *if* they did not produce super-
natural, non-human spectacles with the devil's aid, and bring the devil pleasure and
honor and God displeasure and dishonor'.[50]

The larger-than-life figure of the conjuror in Bruegel's print, shown playing with her
cups, balls and stick and mimicked by the gryllus at bottom right, creates another strong
link between carnival trickery and demonic magic. The figure is immediately reminiscent
of Bosch's *The Conjuror,* in which the protagonist plays a trick on an awestruck audience,
while also implicated in the theft of a spectator's purse. Bruegel has even included the
conjuror's dog from Bosch's painting, which suggests that this was the model. *The
Conjuror* was in fact a very popular image, with five painted copies, a pen-and-ink sketch
and a *c.* 1550 engraving by Balthazar van den Bos with Dutch verses on the tricks of
conjurors, all surviving beyond the mid-sixteenth century (fig. 6.7).[51] As discussed above
with reference to the Circe woodcut in the *Nuremberg Chronicle* (fig. 5.6), this conjuror
figure was also a well-known visual topos in the *Children of Luna* images, and both
Bosch and Bruegel must have drawn on it to give expression to carnival trickery and illu-
sion.[52] Indeed, in the drawing of *The Children of Luna* in the *Medieval Housebook,* an
illustrated manuscript of *c.* 1480 by an artist simply known as the Housebook Master or
the Master of the Amsterdam Cabinet (fig. 6.8), the conjuror with his cups and balls is

depicted with a trumpeter and a sideshow-hanging featuring acrobats and contortionists, just as in the Bruegel image of 85 years later (fig. 6.6).[53]

In *The Fall of the Magician Hermogenes* then, Bruegel seems to be making a double play on the diabolical illusions, which according to the caption of the companion print – fig. 6.4: 'St James in the presence of the magician stands firm against his diabolical tricks (or illusions)' – were used to create the wonders attributed to magic. First, there was the direct intervention of the devil through diabolical illusion, commonly believed to be at the root of sorcery and witchcraft and, more specifically, of the wonders created by figures like the witch of Endor and Hermogenes. Illusion had been central to notions of witchcraft from the *Canon Episcopi* of the early tenth century right through to the *Malleus Maleficarum* and *The Ants* of Johann Geiler in the late fifteenth and early sixteenth centuries. But it was even more topical in the 1560s because of the seminal work on the subject published in 1563 by the physician, Johann Weyer, *On the Tricks of Demons* (*De praestigiis daemonum*). Weyer's work claimed a critical role for the human imagination, female melancholy and diabolically-based illusion in explaining belief in the wonders claimed by witches and their accusers. And the book was immensely influential, running into many editions, both in Latin and in vernacular translations, over the next two decades.[54] Second, there was the make-believe and illusion of the carnivalesque setting and its performers, the world of inversion and disorder. As we have seen in the work of Hermann Witekind, the trickery and disorder of carnival was also linked to the influence of the devil. Bruegel drew on both these traditions in his St James and Hermogenes prints. In this way, he could underline the essentially diabolical nature of Hermogenes' magic and, by use of a carnival setting, could also give this ancient struggle between saint and magician a strong sense of contemporary relevance.[55]

Not surprisingly then, the one Bruegel print specifically dedicated to the subject of witchcraft, *The Witch of Malleghem*, also took up the themes of illusion and deceit (fig. 6.9).[56] Engraved by Pieter van der Heyden, the woodcut survives in eight different states, some with Flemish verses and others with French, and published originally by Hieronymus Cock in 1559 and by Theodore Galle and his son Jean in the early seventeenth century.[57] In this print Bruegel linked witchcraft to the deception and trickery of village quacks and to the gullibility of those who believed in them. The central character, as the inscription tells the viewer, is 'Vrou Hexe', Lady Witch. She announces to the residents of Malleghem, a Flemish allusion to a place called something like 'Foolsville' or 'Crazyham', that she has come with her four assistants to cure those suffering from stones in their heads.[58] The excision of stones was thought to be a cure for madness or folly performed by quacks at village festivals, and so the print represents a satire of the incurability of folly and of the gullibility played on by the witch.[59] She can be seen at work at the bench, holding up a stone she has just removed. One assistant holds a lantern, while another behind her prepares a man for the operation with a salve. A third works on a patient in the egg in the bottom right corner; while a fourth in the centre background carries a collection of salves and ointments, which have possibly been filled from the large jugs behind her. On the wall at the back a placard advertises these services, displaying a large knife and stones that have been removed from other fools. There are other allusions to folly, deceit and illusion throughout the print – such as the winking figure under the bench with the padlocked mouth and the fool's bauble up his sleeve; the figure with the huge stone on his head at centre left who clutches the purse of someone helping him; and the five figures on the left with visors on their capes, which feature in the central

Figure 6.8 The Housebook Master, or the Master of The Amsterdam Cabinet, *The Children of Luna*, *c.* 1480, pen and ink, in *The Medieval Housebook*. Schloß Wolfegg, Kunstsammlungen der Fürsten zu Waldburg-Wolfegg.

Ghy lieden van Mallegem, wilt mi wel fin gefint. Om-v te genesen, ben ick gecomen hier. Compt vry, den meesten met den minsten, sonder verheyen,
Ick Vrou Hexe wil hier oock wel worden bemint. T'uwen dienste, met myn onder meesterssen fier. Hebdy de wesp int hooft, oft loteren v de keyen.

Figure 6.9 Pieter van der Heyden, after Pieter Bruegel, *The Witch of Malleghem*, 1559, engraving.
© Rijksmuseum Amsterdam.

scene of Bruegel's *The Netherlandish Proverbs* or *The Blue Cloak*, painted in the same year and signifying the deceit of the cuckold.[60] The coupling of witchcraft and trickery, still largely directed to a critique of contemporary social behaviour in this print, seems to have provided the basis for Bruegel's later conceptual and visual articulation of magic and witchcraft as diabolical illusion in his Hermogenes images.

Similar to the manner in which the iconography of witchcraft became implicated in the struggle of St James against Hermogenes in the sixteenth century was the story involving another apostle, St Peter, in his contest with the ancient magician Simon Magus. Indeed, Bruegel's *Fall of the Magician Hermogenes* and the story of Simon Magus were so alike that the caption accompanying the third and fourth states of Bruegel's engraving – published by Jean Galle after Bruegel's death – referred to the death of Simon rather than Hermogenes: 'The death of Simon Magus. They gave him their attention because for a long time he had bewitched them with his magical arts.'[61] In this way, Hermogenes' upside-down, carnivalesque and illusory world gained another set of historical resonances. It echoed the story of a pre-eminent false magician, who was tricked by the devil into believing he was a god, and was subsequently vanquished by St Peter. Simon Magus was known primarily from the Acts of the Apostles (8.9–24) as the person who attempted to buy the power of the Holy Spirit from St Peter; and subsequently his name became synonymous with the sin of simony. But the principal source for the contest with St Peter was the *Apocryphal Passion of Peter and Paul*, and from there his story found its

172

way into the *Golden Legend*.[62] The *Golden Legend* told how Simon boasted that he would fly up to heaven since the earth was not worthy to hold him. This resulted in a contest between Simon and St Peter before the Emperor Nero in Rome, where both attempted to display their capacity to perform wonders. Amongst the marvels performed by Simon, the one described in detail was his power of flight. Nero built a huge wooden tower on the Field of Mars from which Simon launched himself; Peter commanded the angels who were holding Simon up without his knowledge to let him fall; and Simon came crashing down to his death.

The fall and death of Simon Magus was the scene most frequently depicted in the complex iconography and literary history of this magician in the late Middle Ages. The figure of Simon falling to the ground from the tower in an upside-down position was frequently juxtaposed with Peter praying nearby or crucified upside-down on a cross.[63] On a twelfth-century historiated capital of the Autun cathedral, Simon catapults to the ground regardless of the wings shown on his legs and feet.[64] In a twelfth-century prayer book Simon Magus's body is dismembered as he falls, drawing comparisons with the fate of fallen idols.[65] And in a well known painting of *c.* 1462 by Benozzo Gozzoli, the magician is borne up into the air by demons above Nero's tower and also lies dead on the ground before the Emperor, while Peter raises his right hand in a gesture of blessing, and Paul kneels beside him, his hands joined in prayer.[66] From the late fifteenth century, as in the case of Gozzoli's painting, artists began to give more emphasis to the manner in which Simon was borne through the air by demons. A 1512 drawing of the scene frequently attributed to Dürer, shows St Peter before the Emperor Nero, conjuring the three demons who hold Simon up (fig. 6.10) – as in a very similar scene in a 1516 drawing by Pieter Cornelisz.[67] A fascinating aspect of this iconography, which can only be touched on here, is the link to the subject of the Antichrist.[68] Joachim of Fiore's writings and Dante's *Divine Comedy* had already made the link, and with the growing parallels between the life and death of Christ and Antichrist, Simon's fall became a model for the death of the Antichrist. So in the *Nuremberg Chronicle*, for instance, the illustration of the Antichrist bears an uncanny resemblance to the fall of Simon Magus. The Antichrist is depicted preaching on the Mount of Olives, with the two apocalyptic witnesses, Enoch and Elias opposite him, before being borne up by demons and struck down by the archangel Michael.[69]

The emphasis on Simon's demonic flight, accentuated by the parallels between Simon and the Antichrist, seems to have laid the groundwork for a series of curious visual associations in the mid-sixteenth century that link Simon's magic to the discourse and representation of witchcraft. The recycling of woodcuts led first to a case of mistaken identity. In 1537, and again in 1544, the Augsburg printer Heinrich Steiner used a woodcut of Simon Magus to illustrate the chapter, 'On the Origin of Simoniac Sects', in Polydore Vergil's *On the Origin of Things* (fig. 6.11). Simon was depicted in a short skirt and large hat, flying through the sky with arms outstretched. The woodcut was by Jörg Breu and had been used almost 30 years earlier, in 1509, in the first Augsburg edition of the extremely popular, late medieval romance entitled *Fortunatus*.[70] The first part of *Fortunatus* told the story of a Cypriot adventurer of the same name, who drew an endless supply of money from a magic purse and could perform all kinds of wonders by virtue of a magic hat that he stole from the Sultan in Alexandria. The hat enabled Fortunatus to fly to distant lands in the blink of an eye, for instance, a facility displayed in the

Figure 6.10 Albrecht Dürer, *St Peter and Simon Magus*, 1512, pen and dark-brown ink. From
Walter Strauss, *Complete Drawings of Albrecht Dürer*, New York: Abaris, 1974, vol. 6,
p. 2987.

accompanying woodcuts, some of which were used by Steiner over 30 years later to
represent the flight of Simon Magus.

The story of Fortunatus' magic hat was used not only to extend credibility to the flight
of Simon Magus; it was also used to lend weight to claims of witchcraft. In 1560 the
Frankfurt printer Weygand Han brought out a new edition of Polydore Vergil's *On the
Origin of Things*. To illustrate the chapter on the origins of magic and witchcraft,[71] Han
ignored the woodcuts used in previous editions of the work, such as Jörg Breu's image of

Figure 6.11 Jörg Breu, *Simon Magus Flying through the Air*, woodcut, in Polydore Vergil, *Von den Erfindern der ding*, Augsburg: Heinrich Steiner, 1544, fol. 163ʳ. HAB, Wolfenbüttel [A: 142.1 Quod. 2° (5)].

two healers (fig. 3.19) and the Petrarca-Meister's depiction of different kinds of divination (fig. 2.18). Han used a woodcut, probably by Hans Brosamer, that had previously been used both by himself in 1556, and by another Frankfurt printer Hermann Gülfferich in 1554 (fig. 6.12), to illustrate the *Fortunatus*.[72] The scene he chose was from the second part of the *Fortunatus*, which concerned the story of Fortunatus' sons, Andolosia and Ampedo, who were not nearly as wise as their father in the management of their fortune. It depicted Andolosia meeting a hermit in a wild forest in Ireland. The hermit came to Andolosia's aid when the English Queen Agripina, a beautiful maiden he was courting and had taken to the Irish wilderness, abandoned him. To Andolosia's consternation, Queen Agripina flew back to her English castle and, even more seriously – as the woodcut shows – took with her the magic purse and magic hat. And to add to Andolosia's misfortunes, horns began to grow from his head when he consumed apples from a particular tree in the forest.

The recycling of an old wood block previously used for the *Fortunatus* certainly would have provided Weygand Han with a less expensive option for his edition of Polydore Vergil. But it also seems likely that the printer judged there to be a rough fit between the *Fortunatus* image and the Vergil text. This is suggested by Han's use of a similar solution in illustrating the chapter on the origins of necromancy and other forms of divining.[73] Han again chose a woodcut previously used by Gülfferich himself to illustrate the

Figure 6.12 Hans Brosamer [?], *Andolosia Meeting a Hermit in a Wild Forest in Ireland*, woodcut, in *Fortunatus, vonn seinem Seckel unnd Wüntschhütlin*, Frankfurt a.M.: Hermann Gülfferich, 1554, fol. 61ᵛ. HAB, Wolfenbüttel [A: 124.1 Eth.].

Fortunatus (fig. 6.13).[74] This one depicted an episode in the story of Andolosia's vengeance against Queen Agripina's treachery. Andolosia tricked Agripina into eating one of the apples that had previously caused him to grow horns, and then he masqueraded as a doctor who knew the secret remedy by which the horns could be removed. The woodcut shows Andolosia beside the bed of Agripina in the cloak and cap of a doctor, and with a large false nose. The length of her horns has already been considerably reduced and the doctor argues that he now needs more money for the final, and most difficult, stage of the treatment. When Agripina takes her magic purse to a table near the window to count out her payment, Andolosia quickly exchanges his doctor's cap for the magic hat, grabs the young queen and flies out the window with her. As with the woodcut illustrating the origins of magic and witchcraft, it would seem to be the combination of flight and horns that made this image seem so appropriate to illustrate the origins of the divinatory arts. The text of the *Fortunatus* even speaks of the horror which Agripina's horns provoked, leading some to believe that she was an evil spirit;[75] and part of Andolosia's scheme was to present himself as a doctor in necromancy, who had sworn himself to an evil spirit from whom he now received counsel.[76]

For literate readers aware of the *Fortunatus* story, the use of these woodcuts to illustrate the origins of the arts of magic, sorcery, necromancy and divining was probably not nearly so surprising as it appears today. The iconography found through the various

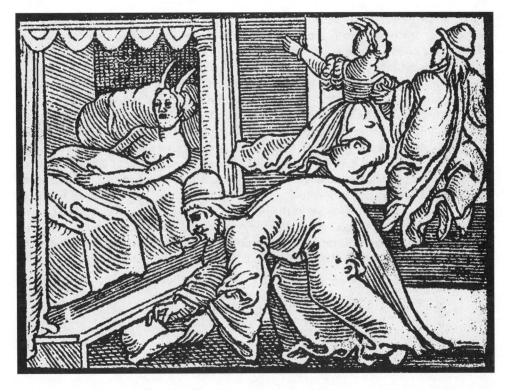

Figure 6.13 Hans Brosamer [?], *Andolosia Dressed as a Doctor beside the Bed of Queen Agripina*, woodcut, in *Fortunatus, vonn seinem Seckel unnd Wüntschhütlin*, Frankfurt a.M.: Hermann Gülfferich, 1554, fol. 66r. HAB, Wolfenbüttel [A: 124.1 Eth.].

editions of the story was remarkably consistent.[77] The *Fortunatus* was an extremely popular work by the 1560s. It told of numerous magical wonders, the most graphic of which was the ability to fly huge distances through the sky. And in a number of woodcuts, an act of flying through the air was combined with the growing of horns. Not only did this suggest the pride and idolatry of that originator of magic from apostolic times, Simon Magus. It also helped draw a line from Simon Magus to those contemporaries who claimed they could fly through the sky, although this belief, many claimed, rested on diabolical illusion. In this way, a popular story of magical wonders, a number of recycled images drawn from popular romance, and resonances of the struggles of saints against the forces of the devil, could be made to serve an account of the origins of the diabolical arts.

The rich stock of visual images illustrating stories of magic and witchcraft from the Bible and medieval legends of the Christian saints were crucial to expanding the cultural meanings of witchcraft in the sixteenth century. These images emphasized a theological understanding of witchcraft in which the rituals of invocation and the role of the devil played a key role. This was one of the ways in which the fifteenth-century iconography of invocatory magic (figs 2.15–2.18) was linked to the sixteenth-century imagery of witchcraft. Just as Hans Schäufelein combined different forms of village sorcery and diabolical witchcraft with ritual magic into a composite image of the diabolical arts (fig. 2.1), so Jacob Cornelisz and Johann Teufel represented the witch of Endor as a ritual magician

calling on the power of the devil (figs 6.1, 6.3). Bruegel, on the other hand, presented witchcraft as one of the prominent magical arts in Hermogenes' disordered world, and extended the range of such arts to include the illusions and trickery of carnival; and the printer Weygand Han used illustrations from a medieval romance to link witchcraft to the diabolical magic of Simon Magus. The significance of all these images lay not simply in the connections they created between traditional subjects and different forms of magic, sorcery and witchcraft, but also in the extended time frame created for witchcraft within the long history of struggle by Christians against the power of the devil. In this way witchcraft was less likely to be considered a new phenomenon about which doubts and uncertainties could arise. It was established as an integral part of Christian history and authorities needed to take adequate steps against it as they had always done in the past. But just as it was critical to locate witchcraft within the long history of Christian salvation, it was critical to locate it in the present. In the next chapter I examine how an increasing number of images, especially from the second half of the sixteenth century, read witchcraft as a sign of the devil's continuing attacks on Christian societies in the present and warn authorities to take adequate measures against such attacks.

7

REPORTING THE NEWS AND
READING THE SIGNS

In the second half of the sixteenth century stories of witchcraft and print came together in a significantly new way. As the number of witch trials increased, pamphlets and broadsheets reported the terrible crimes of witchcraft in towns and villages throughout Europe, as well as the cruel punishments meted out by authorities. Witchcraft became another subject that fed the appetite of Europe's literary classes for reportage and helped create a new print market for sensationalistic journalism. It belonged to that powerful mix of terrible crimes, natural disasters, wondrous births, calamities caused by freakish weather and strange customs of exotic cultures on the fringes of Europe and beyond. The new media quickly embraced witchcraft and its reports of horrifying crimes, revelations of secret practices and meetings, its sexual titillation and cruel punishments, and its occasional spectacular outbursts of supernatural power. 'A terrible story', 'a previously unheard of account', 'an incredible tale', and other similar expressions became the literary hooks used at the beginning of broadsheets to persuade potential readers and have them buy. And accompanying the lurid headlines was the graphic image, which summarized key elements from the report in order to entice the viewer to read, and attempted to reach out beyond the reader to the broader mass of the partially literate and illiterate.[1]

The purpose of these pamphlets and broadsheets was not simply to stimulate a taste or satisfy a need for sensational news. As part of the prophetic and apocalyptic thinking stimulated by the Reformation, they were meant to encourage the reading of history and nature as signs of God's providence and of the ongoing battle between the forces of good and evil. Comets, falling stars, monsters, wondrous births, floods and famine were all signs to be read, displays of God's anger, punishments for sin, warnings for the future. The terrible deeds of witches were also signs of the devil's onslaughts, testimony to diabolical power running riot in the world. Images of the public punishment of witches served as reminders of the need to support authorities in their unflinching campaign to eliminate witchcraft. As the century progressed, the struggle against witchcraft increasingly became representative of a broader cosmic conflict between God and the devil. Public rituals of exorcism, theatrical performances in which devils were expelled from the human bodies of those they invaded through the sacred objects and power of the church, represented one very visible sign of that conflict.[2] Pictorial representations of witchcraft and the justice meted out to its perpetrators represented another. Like the observers of witch trials and exorcisms, the viewers of these images could participate symbolically in the drama of demonic attack and divine counter-attack, and ultimately, in the rituals of conquest and purification.

An instructive, and in many ways typical, example of a broadsheet report on witchcraft was one printed in Nuremberg in 1555 by Georg Merckel (fig. 7.1).[3] Merckel, active in Nuremberg between 1554 and 1563, published a number of broadsheets recounting sensational events with illustrations probably by an artist only known as Master S G.[4] The broadsheet told of 'a terrifying story' involving three witches, which occurred in October 1555 in Derenburg, a small town just north of the Harz mountains near Halberstadt. The woodcut is limited to the stories of two of these witches, Gröbische and Gißlersche, who are engulfed by the fires of the stake in the left foreground.[5] Attending to them and stoking the fire is the executioner, recognizable in his gaudy, slashed-style clothing, and his assistant. The distinguishing feature of this scene of judicial punishment is the act of diabolical intervention. The devil, in the form of a monster with a pig's head, large wings, huge breasts and a serpent's lower body, has come to claim his own. The text tells the reader that Gröbische had confessed to having been the devil's lover for 11 years, and now, at the moment the fire is lit, the devil arrives to carry her off through the air for all to see. The artist has been careful to emphasize the public character of this display of demonic power by including a trio of onlookers in the background, one of whom is gesturing towards the remarkable event.

This story and scene represent a version of demonic abduction not unlike the story of the witch of Berkeley or the tales that cluster around the figure of Faust at this time.[6] At the point of death the devil will come to claim his own, following the pact he has made with the magician or witch. The abducted witch in this case takes the form of a soul, which gives expression to her true inner nature. Unlike the figures tied to the stake whose heads are covered, the hair of the devil's lover and victim fans out behind her in the well-established code for a lascivious witch. The text specifies her sexual intimacies with the devil as grounds for her execution, and the woodcut communicates this through this symbolic representation of her inner self. Indeed, the whole story revolves around acts of violence and passion. In the right background the two women are depicted surrounded by flames, with a male figure lying on the ground before them. The broadsheet explains how the witches returned to Gißlersche's house two days after the execution and threw Gißlersche's husband out of the door with such force that he died. A neighbour related that the women then appeared like fiery spirits dancing around a fire, while the husband lay dead outside the door. The apparition may have been intended to emphasize their punishment in hell, but visually, the fire also creates a link with their punishment at the stake. And as though to emphasize the connection to a whole chain of horrible crimes and moral disorder, Gröbische's husband is beheaded in the background – an event that occurred 11 days after his wife's execution, as punishment for his adulterous relationship with Gröbische's sister.

The exemplary and moral character of the events in the woodcut reflects the emphases in the broadsheet's text. Although the title refers to 'a terrifying story' of events in Derenburg in October 1555, the actual account of those events only makes up about a third of the text. The events are preceded by a discourse about the role of the devil in the world and the need for such *exempla* to be circulated in order to instill the fear of God and obedience, especially in these last times when the devil rages against Christ and his followers. A theological reflection follows concerning the evil the devil spreads through the world like a poison, and how this ought to stimulate our penitence and fear of God. In line with the visual emphases of the woodcut, the text also focuses on the susceptibility of women to diabolical temptations. Witchcraft's origins, reports the broadsheet,

Ein erschröckliche geschicht/ so zu Derneburg in der Graff-
schafft Reinstein am Hartz gelegen/ von dreyen Zauberin vnnd zwayen Mañen/ Jn etlichen tagen des Monats Octobris Im 1555. Jare ergangen ist.

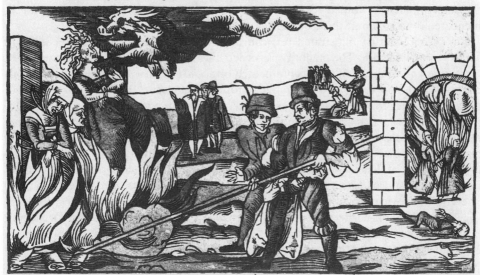

Die alte Schlang der Teüffel/ dieweyl er Got/ vnd zuuoran den Sun Gottes/ vnsern Herrn Jesum Christum/ vnd das gantze menschliche geschlecht/ fürnemlich vmb vnsers haylands Christi willen hasset/ hat er sich bald im anfang/ vnd kürtzlich nach der erschaffung vmb dz weibß bild/ als vmb die/ welcher same seinen kopff zertretten solt/ angenomen/ dieselbigen durch sein hinderlist vnd lugen/ zu dem jämerlichen fal/ deß vnglaubens vñ vngehorsams wider Got gebracht/ Darauß das gantz menschlich geschlecht/ in ewige verdamnuß vñ verderben komen were/ so Christus vnser hayland/ den zorn des Vatters nicht weck genomen/ vnd das gericht wider vns auffgschaben het/ Nu behelt der alte Feind gleichwol also den haß wider Christum/ vnd vns/ für vñ für/ vnd helt auch sein alte weyse/ er setzet sonderlich dem weiblichen geschlecht hart zu/ als dem schwecheren werckzeug/ damit er sie von Christo wegreysse/ vñ in ewige verdamnuß füre/ vñ wie er zu Eua sprach/ sie würden werde wie die Götter/ Also bläßt er noch das gifft in der weyber hertzen/ leret sie zaubern/ auff das sie klug mache/ das sie mehr wissen dann andere leüt/ vnd also den Göttern geleich werden/ damit macht er sie jm anhengig/ vnd zu Teüffels dienerin/ wie dise jämerliche geschicht/ welche warhafftigklich also wie vnden angezaiget/ am Hartz ergangen ist/ Die derhalben also gemalet vñ geschriben/ im druck auß gangen/ Auff das doch die roheloße welt/ zu Gottes forcht erwecket/ vnd von dem Gottlosen wesen abgeschreckt werden/ Dann Gott der allmächtige derhalben solche Exempel vns fürsehen laßt/ das er damit vnsere harten hertzen durch dise erschröckliche exempel / zur forcht Göttliches gerichts/ vnd straffe erwecke/ man mag es malen/ predigen/ singen vnd sagen/ vñ wie man jmer kan den leüten einbilden/ damit der laydige hauffe ein wenig zu Gottes forcht/ gehorsam/ vnd zucht gezogen werde/ besonder zu disen letzten zeyten/ in welche der listige Sathan/ dieweyl er merckt/ das der tag des gerichts sich nahet/ gar rassend toll vnd vnsinnig ist/ vnd bede durch sich vnd seine glieder/ grewlicher weyse/ wider Christum vnd sein armes heüfflein wüttet/ Die ellende welt aber dargegen so frey sicher in allem mutwillen dahin lebet/ als ob der Teüffel vor langst gestorben sey/ vnd kain Got/ kain gericht oder straff/ verhanden were/ Der Allmächtig Got vnd vatter/ vnsers Herrn Jesu Christi/ wölle dem grimigen feinde wehren/ vnd sein armes heüfflein vor jm vnd seinen glidern schützen vnd handthaben/ seinem vnd der seinen wütten vnd toben/ einmal ein ende machen/ durch Jesum Christum Amen.

Folget die geschichte / so zu Derneburg in der Graffschafft Reynstein am Hartz gelegen/ergangen ist/ Jm October des 1555. Jare.

Auff den Dinstag nach Michaelis/ den ersten Octobris/ seind zwu Zauberin gebrannt/ die eine Gröbische/ die ander Gißlersche genañt/ vñ hat die Gröbische bekandt/ das sie aylff jar mit dem Teüffel gebület habe/ vñ wie man dieselben Gröbischen zu der Fewrstat gebracht/ vnd an die saul mit Ketten geschlagen/ vnd das Fewr angezündt/ ist der bule/ der Sathan komen/ vnd sie in lüfften sichtiglich vor jederman weckgefürt/ Am Donerstag/ nach dem die Gröbische vñ die Gißlerschin am Dinstag zuuor seind gerichtet worden/ das ist den 3. Octobris/ seind dise bede Frawen auff den abend in der Gißlerschen hauß komen/ vnd der Gißlerschin man zur thür hinauß gestoßen/ das er nider gefallen vnnd gestorben/ als sie in Nachbaur gegen vber geh diet/ vnd zu glauffen ist/ durch die thür gesehen/ das zway weyber bede etzel sewrige/ vmbs sewr gedantzet/ der Gißlerschin man aber/ lag vor der thür vnd war todt/ Am Sonnabendt nach Dionisij/ das ist der 12. Octobris/ ist der Gröbischen man gerichtet worden/ vmb der vrsach willø/ das er bey seines weybs schwester geschlaffen hat/ welche er zuuorn zum weyb gehabt/ vñ darnach die Gröbischen genomen/ Des Montags darnach/ das ist der 14. Octobris ist ain weyb die Serck'schen genant/ auch verbrannt worden/ der vrsach/ das sie des Herrn Achaceius von Veldthaym des Stiffts Halberstat hauptmans weybe vergeben hat/ vnd ainem mañ zu Derneburg ain Krotten vnter die Schwöllen gegraben/ daruon man erlamet/ vñ jm das vihe vmb komen ist.

Hie sihet man waß der Teüffel an ainem ort einnistet/ vñ begundt zu Regieren/ vñ wie vil personen komen die vmb in wenig tagen/ vnd soll vns solch grewlich exempel billich raytzen zur buß/ vnd zur forcht Gottes/ auff das wir vns mit dem wort Gottes vnd gebette/ wider den gemelten feynd schützen/ vnd mag dise Histori den sichern gotlosen Epicuren vnnd Zaubern/ wol ain erinnerung sein/ dieweyl sie sehen/ das der Teüffel noch lebt/ vnd das das höllische fewr noch nit erloschen ist/ Der Almechtig Got wölle sie auch zur büße bringen/ vnd vns alle inn/ vnd bey seinem raynen wort erhalten/ vnd mit seinem hayligen Gayst regieren/ auff das wir leben inn aller Gottseligkayt/ Zucht vnd Erbarkayt/ zu ehren seinem hayligen Namen/ Durch vnsern Herren Jesum Christum/ A M E N.

Getruckt zu Nürnberg bey Jörg Merckel/ durch verleg Endres Zenckel Botten.

Figure 7.1 Master S G [?], *Burning of Witches in Derenburg in October 1555*, woodcut, in broadsheet, *Ein erschroeckliche geschicht so zu Derneburg … Im 1555. Jare ergangen ist*, Nuremberg: Georg Merkel, 1555. From Strauss, vol. 2, p. 738.

lie with the devil's original offer to Eve that she become like a god; and witchcraft represents the devil's ongoing strategy to target the female heart with his poison. While the broadsheet clearly plays on the sensationalism of sixteenth-century news reporting, it also offers an *exemplum* of the physical and spiritual destruction wrought by witchcraft, the susceptibility of women to seduction by the devil's temptations, and the punishments required to rebuff these diabolical attacks.

Before mid-century, illustrated broadsheets and pamphlets rarely reported cases of sorcery or witchcraft. The majority recorded the conflicts of the Reformation. But increasingly from the 1530s they commented on social issues, such as gender and family relations, and reported on a whole range of topical events, such as war, natural catastrophes, spectacular crimes, punishments and executions. Some recorded the tricks and illusions of the devil, such as an illustrated broadsheet of 1517 concerning a woman from the town of Wolfsberg in Carinthia, who was abducted by the devil in the guise of her husband seven days after she had given birth to a child, and then abandoned in a swamp in the middle of Lake Chiemsee, about 150 kilometres away in southern Bavaria.[7] Possibly the first broadsheet to report a case of witchcraft was published in 1533 and told of events in the vicinity of the small south-west German town of Schiltach near Rottweil (fig. 7.2).[8] This broadsheet exhibits some elements in common with the Derneburg broadsheet of 1555. Both were headed 'A terrifying story' and both were published in Nuremberg, this one by the woodcut colourist, Stefan Hamer. Hamer, who was active in Nuremberg between 1531 and 1562, published many broadsheets on the extraordinary events and apparitions of the late 1540s and 1550s.[9] The artist who designed the woodcut was even better known: it was the noted Nuremberg print-maker, Erhard Schön. Both broadsheets also depict the execution of witches by burning in the presence of an executioner. But there the visual similarities end. The 1533 broadsheet gives no hint of diabolical involvement and offers no moral or theological lessons. There are also no viewers in the scene to stress the social implications of the terrible events. The woodcut simply depicts a witch burning, and the cause is clearly the arson in the background. The fires of judicial execution serve to balance and counteract the fires of arson, while the fork of the executioner raised in demonstrative fashion alludes to the subordination of the witch to the power of judicial authority.

This 1533 woodcut demonstrates how artists such as Erhard Schön could simply ignore the demonic content and theological implications of such reports if they wished. For the text of the broadsheet is far more complex than the woodcut would suggest. It tells the 'terrifying story' of how the devil came to an inn in the town of Schiltach and stayed three or four days. He brought utter chaos to the inn, claimed the maid as his own, and threatened the innkeeper that he would burn down his house on Holy Thursday. On Holy Thursday, the maid alleged that she travelled two German miles (about 15 kilometres) from Rottweil towards Schiltach on her cooking fork – a journey which took her about half-an-hour, the broadsheet reports – in order to meet the devil. There the devil gave her a small cauldron and told her that if she tipped the cauldron up, it would burst into flames. That is precisely what happened. Then she set off for the nearby town of Oberndorf and, at the very time she did, the innkeeper's house and the whole of Schiltach went up in flames. Except for three houses the town was completely destroyed within an hour-and-a-half. These events became known through the witch's confession, as the broadsheet reports. She was seized on Good Friday in Oberndorf, imprisoned, and after she confessed, was burnt as a witch on the Monday before the feast

Ein erschröcklich geschicht Vom Tewfel
vnd einer vnhulden/ beschehen zu Schilta bey Rotweil in der karwochen.
M. D. XXXiii Jar.

Figure 7.2 Erhard Schön, *Burning of a Witch at Oberndorf in 1533, and her Arson in the Town of Schiltach*, woodcut, in broadsheet, *Ein erschröcklich geschicht … beschehen zu Schilta bey Rotweil*, Nuremberg: Stefan Hamer, 1533. From Geisberg/Strauss, vol. 4, p. 1206.

of St George. It was not only that she had done all kinds of damage to cattle and humans, she had also had sexual relations with the devil for 18 years; and she had apparently learnt all this from her own mother. The broadsheet concludes with a moral lesson drawn from such horrifying events: God uses them to draw us away from evil and temptation toward a better life in this world and the next. What is a quite complex story of demonic intervention, moral licentiousness, social disorder, communal disaster and divine warning, is represented visually as little more than an act of judicial punishment.

Another example of a broadsheet that presents witchcraft as a crime that is deserving of the most horrifying punishments is one featuring a woodcut by Lucas Cranach the Younger and depicting the execution of four persons convicted of witchcraft in Wittenberg in June 1540 (fig. 7.3). A 50-year-old woman, her son and two others,[10] have been mounted high on oak stakes to which they have been chained and slowly smoked dry. Cranach's woodcut displays their charred and dessicated corpses, the skin flaking from their legs, their intestines protruding through openings in the stomach, their dried-out arms stiffened into macabre dance-like positions. Biblical texts proclaim the responsibility of secular authorities to exact such punishment and identify these evildoers as enemies of society. Above is a verse from Paul's Epistle to the Romans, 13.3–4: 'Rulers or authorities are not to be feared by those who do good but by those who do evil. For they do not bear a sword in vain; they are God's servants and wreak vengeance on the evil-doer.' Below is a verse from Psalm 83.3: 'Crafty plans they make against thy people, and counsel against those you protect.' The longer text beneath the image briefly relates the grounds for the punishments displayed. The mother had been the devil's lover for years and, together with her son, had carried out weather sorcery and malefice, using her poisons against many poor people. She taught her techniques to her three co-

Paul. zun Rom. XIII. Die Gewaltigen oder Oberkeiten
sind nicht den die gutes/sunder den die böses thun/zufürchten/Denn sie
tregt das Schwert nicht vmb sonst/Sie ist Gottes diene-
rin/eine Racherin vber den der böses thut.

Vmb viele vnd mancherlei böse missethaten willen/sind diese vier Personen/wie abgemalt/am tage Petri Pauli mit feuer gerecht-
fertiget worden zu Wittemberg/Anno .1. 5. 40. Als nemlich ein alt Weib vber. 50 .jar/ mit jrem Son/der sich etwan dem Teufel er-
geben/In sonderheit aber das Weib/ welchs mit dem Teufel gebulet/ mit jm zugehalten/ etliche jar/Zauberey getrieben/Wetter ge-
macht/vnd auffgehalten/vnd zu mercklichen vieler armer Leut schaden vergifft Puluer gemacht/ auch dasselbige andere zumachen
geleret/damit allerley Viehweide/durch sie vnd jre drey mithelffer vergifft/ dadurch ein onzeliche menge Viehes von Ochsen/Küen/
Schweinen etc. an vielen orten nidergefelt/welche sie darnach geschunden vnd abgedeckt/ dadurch jren boshafftigen/ verzweiffelten
geitz vmb eines kleinen nutz willen gesettiget/ Vnd ist diese abkunterfeiung alleine darumb geschehen/ Dieweil der selbigen schedlichen
Rotten noch viel vnd mehr im Land/als etliche von Bettlern/Schindern/Henckers knechten/auch Hirten/vmblauffen/ zu abschew/
vnd das ein jtzliche Oberkeit fleissiges auffsehen bestelle/ dadurch armer Leute schaden vorhut werden müge/Gott der allmechtige
behüte alle Christliche hertzen/vor des Teufels listigen anschlegen vnd anfechtungen / Amen.

Psal. LXXXIII. Sie machen listige anschlege wider
dein volck / Vnd ratschlagen wider deine verborgene.

Figure 7.3 Lucas Cranach the Younger, *Execution of Four Persons Convicted of Witchcraft in Wittenberg, June 1540*, woodcut, in broadsheet, *Paul zun Rom. XIII. Die Gewaltigen oder Oberkeiten*, [Wittenberg, 1540?]. From Geisberg/Strauss, vol. 2, p. 639.

accused, so that they poisoned pastures and killed oxen, cows and pigs. Such gruesome punishment, the text continues, is necessary because of the increasing hordes of beggars, knackers, executioners' assistants and shepherds that roam the land to everyone's disgust, and the authorities need to ensure that they protect poor people from such harm. The text concludes by beseeching God to protect all Christians from the attacks of

the devil. Conceivably, the image was also meant as a counter-attack against the devil and his servants.

The number of German broadsheets and pamphlets concerned with witchcraft did not significantly increase until the 1570s and 1580s. This had much to do with the outbreak of large numbers of trials and executions in the German southwest from the 1570s and through the southeast and northwest in the later 1580s and 1590s.[11] As in the earlier broadsheets, a common subject is the punishment of witchcraft by authorities, together with some new account of the crimes committed. One of the most detailed and interesting is a news sheet ('newe Zeitung'), published by a leading Augsburg *Briefmaler* (sheet colourer) of the late sixteenth and early seventeenth centuries, Georg Kress. It tells of 'A terrible and previously unheard of news report concerning more than 300 women in the territory of Jülich who made a pact with the devil and were able to transform themselves into the appearance of wolves; and how many men, children and cattle they killed; and how 85 of them were punished by fire on 6 May 1591 at Ostmilich two miles from Jülich; and now put into print as a warning and example for all pious women and young girls' (fig. 7.4). The punishment of the witches takes place in the centre panel, with the various scenes from the news report surrounding it. Punishment is not limited to worldly authorities, for below the execution the artist has depicted a raging devil with a wolf's body, surrounded by numerous body fragments and limbs. The devil has clearly come to claim his own, and does so with terrifying violence. The text tells the reader that while the executioner was preparing the women for the fire, a sudden wind blew up and the devil took two of the women, tearing their bodies to pieces and delivering their souls to the eternal fires of hell. Earthly and eternal punishment is the principal lesson of the story.

The diabolical origin of these sensational events features in two scenes at middle and lower left of the woodcut. The devil, clothed in the long gown of a patrician, distributes magical skin girdles to more than 300 women who, according to the text, took up the devil's offer and pledged him their obedience. In imitation of the ritual of profession in a religious order, they now vow to promote calamity, terror, misery and death; and in order to help them to fulfill their vows, the devil provides each with a magic girdle, which, when put on, will transform their appearance and behaviour into that of a wolf. In the scene at middle left a number of the women appear in various stages of transformation, with girdles tied around their waists or necks. Across the top and on the right of the woodcut the terror, injury and death unleashed by the werewolf-witches is displayed. Ferocious wolves attack carriage drivers, their horses and cattle, tearing apart bodies, consuming flesh, ripping out organs and leaving mangled body parts strewn across the print. At bottom right a wolf terrifies children in a domestic garden. The terrible violence is not limited to attacks on life and limb, and also overturns the social order of household and commerce. But there is no real attempt by the artist to provide a detailed visual account of the broadsheet's narrative, which describes some of the numerous deaths to which the witches finally confessed: how they tore their victims to pieces, ate their brains and hearts, and sucked out their blood; and how they did this to 20 horses and two drivers, six journeymen, 34 men and 15 boys in Ostmilich; and to 37 oxen, 20 men and six boys in Kaiserswerth. Yet the horror and savagery of human dismemberment and cannibalism by the werewolf-witches is clearly registered, matched only by the violence that the devil exacts on them.

The general subject of Kress' broadsheet, one of a series of news sheets he produced in Augsburg on various extraordinary events between the 1590s and 1620s, was clearly

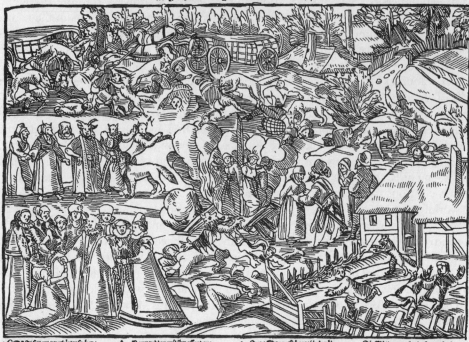

Figure 7.4 Georg Kress, *The Three Hundred Women in the Territory of Jülich who Made a Pact with the Devil, Transformed themselves into Wolves, Killed Men, Children and Cattle and how Eighty-five were Executed on 6 May 1591 at Ostmilch near Jülich*, woodcut, in broadsheet, *Erschröckliche und zuvor nie erhörte newe Zeitung … im Landt zu Jülich uber drey hundert Weibs personen*, Augsburg: Georg Kress, 1591. From Strauss, vol. 2, p. 548.

stimulated by the large number of witch accusations which swept through southern Germany around 1590. But interest in the activities of witches in the guise of werewolves would have been influenced by broadsheets circulating in southern Germany at this time about the werewolf Peter Stumpf.[12] Stumpf, a peasant from the small town of Bedburg near Cologne, had confessed under threat of torture in 1589, that he had killed 16 people as a werewolf; that he had procured the girdle by which he achieved his transformation from the devil by sorcery; that he had committed incest with his sister and daughter – the latter bearing him a child; and that he had engaged in sexual relations with many women, including a succubus for seven years and a gossip named Katherine Trompin. Trompin and Stumpf's daughter were convicted as accessories to a number of murders and were burnt at the stake with Stumpf in Bedburg in October 1589.[13] The case was given wide publicity by two broadsheets produced in southern Germany in the same year, one of them in Nuremberg by the *Formschneider* (block cutter), printer and publisher, Lucas Mayer (fig. 7.5), and another in Augsburg, with identical text and iconographical composition, and probably a copy of the Mayer broadsheet, by the Augsburg *Briefmaler*, Johann Negele.[14]

Georg Kress, who produced the broadsheet of the Jülich werewolf-witches in Augsburg in 1589, would have probably known both these broadsheets, and especially that by his fellow Augsburg artist, Johann Negele. But in the Mayer/Negele woodcuts the emphasis is almost totally on the details of Stumpf's execution: how he was tied to a wheel; how his flesh was pinched with red hot tongs in 10 places; how his legs and arms were broken with an axe; how his head was cut off, placed on a pole and attached to a wheel together with a wooden image of a wolf and 16 pieces of wood representing the 16 people he had killed; and how his headless corpse was then burnt at the stake together with his daughter and lover. Stumpf's attack on one of his victims in the guise of a wolf is depicted in the top left corner. It was this attack on a neighbour who cut off the wolf's paw that led ultimately to Stumpf's confession and capture.[15] But there is no reference to any witchcraft or involvement of the devil in the woodcut itself. Only the broadsheet text refers to the crimes as a devilish art, which Stumpf – described in the title as a sorcerer– was taught in exchange for his surrender to the devil; and relates that he enjoyed sexual relations with a female devil for 25 years.[16] The illustration is more in line with other contemporary news sheets which focus on heinous crimes and their punishment, such as one produced by Mayer in the same year depicting the torture and execution of the murderer Franz Seubold at Gräfenberg.[17] But the currency of the Stumpf case, and the sensational interest it created through the two broadsheets produced, may well have encouraged Kress to think that a news sheet telling of 300 werewolf-witches in Jülich might well be a commercial success.

Another witchcraft image to achieve wide circulation through a news sheet was also a response to the wave of witch trials in southern Germany around 1590. This was the titlepage woodcut of a 12-page pamphlet by an unknown author published in Ulm in 1590, *Erweytterte Unholden Zeytung* (fig. 7.6). The news sheet tells of the increasing number of witchcraft accusations in southern Germany in recent years, the damage which the accused were believed to have unleashed on society, and the high number executed in 1590.[18] The titlepage woodcut is unique in the iconography of witchcraft. It shows a naked witch standing in a large cauldron over a fire which is being fanned by an executioner. One of his assistants pours some substance over her from a long-handled pail. Behringer has suggested that the scene may refer to the execution of witches at

Figure 7.5 Lucas Mayer, *Mutilation of a Peasant Peter Stumpf, who Used Sorcery to Transform himself into a Werewolf, and was Executed together with his Daughter and his Godmother, in Cologne, October 1589*, woodcut, in broadsheet, *Warhafftige und Wunderbarlich Newe zeitung von einen pauren der ... zu ainen wolff verwandelt hat*, Nuremberg: Lucas Mayer, 1589. From Strauss, vol. 2, p. 701.

Ellingen in Franconia, where 70 witches had been put to death by the time this pamphlet was written in mid-July 1590. One sentence in the pamphlet relates how, in the previous May, two of the convicted witches were bound to a pillar while cauldrons of powder were placed under them; the gunpowder was then lit and the two women passed from life to death.[19] This account does not really correspond to the scene in the woodcut, unless it is possibly gunpowder that is being poured over the woman. The scene is more reminiscent of the martyrdom of St John, who is usually depicted seated or standing in a cauldron over a fire, while one of the executioners pours boiling oil over him in the manner of this woodcut.[20] Perhaps the unusual mode of executing the Ellingen witches had caught the artist's attention but, in the process of composition, he fell back on the well-known iconography of the evangelist's martyrdom.

In the late 1580s and early 1590s, the execution of those condemned for witchcraft also began to appear in printed pamphlets published in England. Earlier pamphlets featured simple representations of witches or their familiars, such as that of (Mother) Agnes Waterhouse casting a spell in a 1566 pamphlet that describes her trial and

Figure 7.6 Execution of a Witch, titlepage woodcut, in *Erweytterte Unholden Zeytung*, Ulm, 1590.
Bayerische Staatsbibliothek Munich [4° Eur. sp.182/5].

execution in Chelmsford in the same year;[21] or that of the strange animal – supposedly a
dog, but resembling a hedgehog with the head of an owl – found on the titlepage of a
pamphlet recounting the trial of four women convicted of witchcraft in Chelmsford in
1579.[22] In a pamphlet describing a third major trial held in Chelmsford 10 years later,
the titlepage woodcut features the execution of three of the four convicted witches, Joan
Cony, Joan Upney and Joan Prentice.[23] The woodcut reinforces the fact that since the
Elizabethan statute of 1563 witchcraft had become a felony punishable by death. The
1563 Act prescribed the death penalty for invocation of evil spirits, for witchcraft or
sorcery that resulted in the death of a human being, or for a second offence of witchcraft
or sorcery that resulted in injury to persons or their property.[24] The woodcut also empha-
sized that the evils of witchcraft were directly dependent on the intervention of the devil.
The animals below the scaffold are so-called 'familiar spirits', incarnations of the devil

189

who do the witches' bidding in much English witch-trial evidence of the period. The two frogs named Jack and Jill are the familiar spirits to whom Joan Cuny has promised her soul. Together with two other familiars, Nicholas and Ned, they would go out and injure her neighbours, the text explains, stealing their milk, overturning their woodpiles and harming their cattle. The two animals directly beneath the scaffold are most likely a mole and a toad, who carried out similar services for Joan Upney. The greatest prominence is given the third witch, Joan Prentice, who is specifically labeled and depicted with her familiar ferret called Bid. The pamphlet describes how in the evening as Joan was sitting on a stool about to prepare for bed, Bid – who had identified himself as Satan – would often come to her, jump onto her lap, suck blood from her left cheek and then ask what harm she would have him do. Such unnatural intimacy with beasts commonly associated with evil helped to justify the terrible punishments meted out to such women.[25] And as the number of executions increased dramatically through much of north-western Europe, so too did the images of executions.

Other pamphlets and broadsheets reporting on the activity of witches drew more directly on the iconography for witchcraft established early in the century. An image that was frequently reproduced throughout the south German region in the later sixteenth century, first appeared in 1571, as the titlepage to a pamphlet by a Catholic priest from Sélestat, Reinhard Lutz, entitled: *A True Report concerning the Godless Witches and Heretical Wives of the Devil Burnt in the Imperial Town of Sélestat in Alsace on 22 September 1570.*[26] It depended for its iconography and composition on the widely circulated woodcut of a witch's night ride, first published in 1516 and probably produced by Baldung's workshop (fig. 3.1). The 1571 woodcut was used again as a titlepage woodcut in a 1575 German translation of Ulrich Molitor's work, *On Female Witches and Seers,*[27] and once more in 1583, in a Frankfurt edition of *The Devil's Hoodwink* (fig. 3.2).[28] The three women in an outdoor setting grouped around a cauldron, with a fourth riding naked through the sky, hair flying and hand grasping the goat by the horn, closely follow Baldung's iconography and the strong association he created between witchcraft and sexual disorder. And a dead child beside the cauldron is grim confirmation of the destructiveness of witchcraft alluded to by the scattered bones and skulls. The male figure up the tree also survives from the 1516 model, but the crutch has now disappeared, suggesting that the complex associations with Saturnine melancholy, diabolical illusion and fantasy in the original woodcut have been lost to the later artist.

Another version of the same subject also helped disseminate and keep alive this image of witchcraft. The new version appeared on the titlepage of German translations of Johann Weyer's *On the Tricks of Demons* in 1566, 1575 and 1586;[29] and it also appeared in 1582, in a Frankfurt work by the Marburg lawyer, Abraham Saur: *A Short True Warning whether even at the Present Time among us Christians, Witches and Sare Active, and What they Can Do* (fig. 3.3). While the number of seated witches has been reduced to only two, the impact is considerably more powerful. The woman on the stool is now naked and her gaze is directed aggressively out to her viewers. The male up the tree is still included, but has become even more divorced from the central action. Most narrative elements from the original 1516 model have disappeared, while the emphasis on death and destruction in the Lutz/Frisius version (fig. 3.2) is also missing. Yet the key compositional elements from Baldung's original iconography remain evident, helping to ensure their survival through to the following century.

A competing iconography of the female witch, clothed in garb which signalled the

Figure 7.7 Walpurga Hausmännen and her Demonic Lover, titlepage woodcut, in *Urgicht und verzaichnuß so Walpurga Haußmännen zu Dillingen inn ihrer peinlichen Marter bekandt hatt ...* , n.p.,1588. Courtesy of the Division of Rare and Manuscript Collections, Cornell University Library.

ordinariness of everyday life, was also reflected in the news sheets and pamphlets of the second half of the century. It was evident, for instance, in a pamphlet that told of the witchcraft of the Dillingen midwife, Walpurga Hausmännen (fig. 7.7).[30] Dillingen, a city within the territory of the Prince-Archbishop of Augsburg, with a university under Jesuit direction since 1563, was considered 'a citadel of German catholicism'. Hausmännen was burnt there in 1587, one of seven executions in that year.[31] She was convicted of having had sex with the devil, made a pact, attended Sabbaths and profaned the Sacrament and the Virgin. As a midwife, her murderous crimes were directed primarily towards infants: she was accused of having murdered 22 unbaptized and 37 baptized children, as well as killing five adults and causing injury to another five humans and 15 animals. The titlepage of the anonymous pamphlet published in 1588, which recorded Hausmännen's crimes as a witch over 30 years, included two separate woodcuts placed side by side. One depicts Hausmännen in contemporary garb carrying the bag of a midwife and a rake. She is not depicted as the elderly woman she must have been at the time of her trial, but as she might have looked 31 years earlier. Recently widowed at that time, the text tells the reader, she was cutting corn for a Hans Schlumberger, together with one of his former servants, Utz im Pfarhoff, whom she seduced.[32] After the two

arranged to meet in Walpurga's room for sex, it was not Utz who arrived, but the devil in Utz's shape. This is why the satyr-like devil with a large beak, hoofed feet and tail in the left woodcut, carries a two-pronged hoe. He is the devil parading as the farm labourer Utz, whose sexual seduction by Walpurga marked the beginning of her life of diabolical apostasy and murderous crime. Given the range of graphic scenes available to the artist from the sensationalist confessions described in the pamphlet, it is significant that he focused on the devil rather than on witchcraft.

The increasing incidence of the devil's appearance in witchcraft scenes in the later sixteenth century was related to the growing popularity of the 'devil book' genre among German readers. During the 1560s, 14 new works on various kinds of devils, as well as 70 reprints, were published. Over the next two decades another 15 works on the devil appeared, totalling more than 200,000 copies in all. This literature gave birth to almost every conceivable kind of devil – trouser-devils, whore-devils, swearing, drinking and dancing devils, magician-devils – who served as both personifications of the vices and, as Lyndal Roper has argued, domestic figures of fun.[33] Devils were discovered everywhere and their terrible and disgusting deeds were recorded in massive compendia, such as Sigmund Feyerabend's *Theatre of Devils* (*Theatrum Diabolorum*), published in Frankfurt in 1569 and 1575, with a titlepage reference to these 'last, difficult and evil times'.[34] Devils were quickly absorbed into that world of sensationalist news reporting. They took up position whenever stories of terrible evils or disasters surfaced, and these included the crimes of witchcraft. While the devil literature helped domesticate the demonic, it also made the tricks and illusions of the devil far more credible.

This attribution of the source of witches' power to the devil is very apparent in the titlepage woodcut used in one of the Frankfurt 1583 editions of Paulus Frisius' pamphlet, *The Devil's Hoodwink*. Whereas the edition printed by Wendel Humm recycled a version of an earlier woodcut (fig. 3.2), another edition of the work published in Frankfurt in the same year featured a far more conventional scene of diabolical influence: a huge bird-like and winged devil uses bellows to blow evil thoughts into the mind of an innocuous-looking witch. The focus in this image was not on the activities of witches, but on the power of the devil as the ultimate source of those activities.[35] The widespread integration of images of the devil into scenes of witchcraft and witches' activities did not actually occur until the 1590s. This seems largely to be a response to that wave of witch persecutions that stimulated many of the news sheets which I have examined above; but it also seems related to the witches' Sabbath finally becoming a subject of interest to artists.

One graphic example of this development is a titlepage woodcut created for the German translation of *Treatise concerning the Confessions of Sorcerers and Witches*, which was written by the suffragan Bishop of Trier, Peter Binsfeld, translated into German by the assessor of the Munich court, Bernhard Vogel, and published in Munich by Adam Berg in 1591 and again in 1592 (fig. 7.8).[36] The publication of the treatise was part of an orchestrated campaign on the part of a particular group at the Bavarian Court Council to eradicate witchcraft from the Bavarian territory. With such an end in mind, an illustrated titlepage would sensationalize and help make claims of witchcraft more imaginable and credible in the face of what seemed to be widespread skepticism, even by some members of the Bavarian county courts.[37] As with Jean Bodin's work in France, Binsfeld's was the first major treatise written by a Catholic in the German territories since the early sixteenth century. It underlined the criminality of witches, the reality of their different forms of malefice, their capacity to perform wonders by virtue of a diabolical pact and the

TRACTAT

Von Bekanntnuß der Zau-
berer vnd Hexen, Ob vnd wie viel
denselben zu glauben.

Anfängklich durch den Hochwürdigen Herrn
Petrum Binsfeldium, Trierischen Suffraganien/vnd
der H.Schrifft Doctorn/kurtz vnd summarischer
Weiß in Latein beschrieben.

Jetzt aber der Warheit zu stewr in vnser Teutsche Sprach
vertiret/durch den Wolgelerten M.Bernhart Vogel/deß löblichen
Stattgerichts in München/Assessorn.
EXOD. XXII. CAP.
Die Zauberer solt du nicht leben lassen.

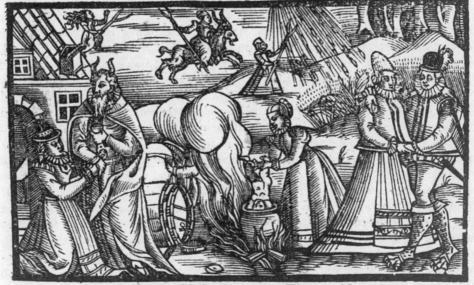

Gedruckt zu München bey Adam Berg.
ANNO DOMINI M. D. XCII.
Mit Röm:Kay:May:Freyheit/nit nachzudrucken.

Figure 7.8 The Diabolical Deeds of Witchcraft, titlepage woodcut, in Peter Binsfeld, *Tractat Von
Bekanntnuß der Zauberer und Hexen*, Munich: Adam Berg, 1592. HAB, Wolfenbüttel
[A: 25 Phys. (3)].

homage paid to the devil at their Sabbaths, and it urged that the most stringent measures be taken against them. And so the titlepage woodcut depicts, on the left, one witch paying homage and making sexual advances to a horned devil holding a vessel with magical powders, and another witch lowering a child into a cauldron to be cooked. On the right is the depiction of a demonic pact between a witch and her stylishly dressed, but hoofed, lover. In the background a witch rides a goat through the air, while another emerges from a chimney on a cooking stick; a third, also clearly identifiable by her cooking stick, brews up a storm. This unusually overt and active engagement of the devil in witchcraft activities is quite unusual for the sixteenth century. In fact, it is matched only by some of the drawings from the so-called 'Wonder Book' of the Zurich pastor, Johann Jakob Wick, illustrations with a function similar to many contemporary news-sheet woodcuts. It is to these that I now turn.

One of the richest and most instructive examples of the inclusion of the subject of witchcraft in the sensationalistic news reporting of the later sixteenth century was an extraordinary work compiled by the Swiss pastor Johann Jakob Wick.[38] A native of Zurich, Wick was pastor in a number of parishes in the canton of Zurich during the 1540s, became preacher in the Zurich *Spitalkirche* in 1552, and from 1557 until his death in 1588 held the position of Second Archdeacon in the *Großmünster.* Between 1560 and 1588 Wick amassed a vast range of documentary materials concerned with the state of contemporary Christendom – correspondence, travel reports, poems, decrees and so on, as well as 503 pamphlets and over 400 broadsheets. These materials came from a wide range of sources: from fellow pastors and scholars such as Heinrich Bullinger and Rudolf Gwalter; from correspondents of theirs such as Theodore Beza and Peter Martyr; from the various organs of Zurich government; from Wick's correspondence with members of parishes in the Zurich canton and east Switzerland; from reports of citizens and parishioners concerning news picked up in public places and local inns; as well as from various literary compilations of wondrous events, such as those recently published by Conrad Lycosthenes and Ludwig Lavater.[39]

Wick gathered this original material, had much of it copied, and in some cases added his own commentaries. As well as the textual material, the collection also included numerous woodcuts and engravings found in the broadsheets, some of which Wick seems to have had coloured, and also numerous coloured pen drawings which he had inserted as illustrations into the texts, some of them copies of original art works, others original works themselves. Wick organized this massive documentation for the most part chronologically into what were at the time of his death, and are still today, 24 large quarto and folio volumes. The collection was often referred to as a 'Wonder Book', the purpose of which was to astound its readers and have them wonder at the contemporary evils displayed within it. 'And so the reader who looks through it carefully', wrote one correspondent, 'will greatly wonder at our miserable times'.[40] We also know from contemporary letters that Wick lent parts of it to friends and acquaintances to take away and read; and that friends encouraged him not to weaken in his project, but to continue to increase and update it. In this way the 'Wonder Book' could act as a mirror that would stimulate men and women to bring about moral improvement in their lives. The sensational presentation of contemporary events, brutal murders, the horrors of torture and execution, all kinds of apparitions, natural catastrophes such as drought, flood and famine, wondrous human and animal births, as well as the evils associated with witchcraft, were all meant to exemplify the power of the devil in the world and to stress how

individual conversion and the punishment of the authorities were necessary for the ultimate victory over the devil and for the expulsion of such evil from the earth.

More than 30 of the 1,028 pen drawings found in Wick's collection, and completed by at least six different artists, depict scenes involving witchcraft. This makes this collection of coloured drawings the largest and most varied set of representations of witchcraft from the sixteenth century. The individual illustrations offer us a rare insight into the meanings that the reformed clergy in particular drew from witchcraft during this period, and the ways in which news of witchcraft was communicated to an educated and literate readership. Witchcraft becomes a news item, relayed from foreign parts, that reveals to Wick and his readers the terrible state into which God has allowed European Christendom to fall on account of its sins. The drawings therefore concentrate on two principal themes. First, they depict the harsh punishment and execution meted out to perpetrators of witchcraft. In this way they legitimate the contemporary treatment of witches and underline the threat they pose for a well-ordered Christian society. Second, they represent witchcraft as a diabolical crime. Witches are shown being abducted by devils, marrying devils, dancing with devils, paying devils homage, and also receiving from devils the powders with which they can unleash their destruction on society. Witches become agents of the devil in the world and their witchcraft is seen as a diabolical instrument in the devil's ongoing struggle against the forces of Christ and his church.

Two of the broadsheet woodcuts I have discussed above, the burning of witches at Derenburg in 1555 and at Oberndorf in 1533, were collected by Wick not only in broadsheet form (figs 7.1 and 7.2), but also in a coloured ink version that accompanied the hand-written version of the stories. Both exemplify the central role given to execution in the images of witchcraft in the Wick collection. In German-speaking lands judicial executions were more common in the sixteenth century than at any other time.[41] They were highly staged and carefully choreographed events that served to atone for the criminal, purify the community and deter onlookers from similar crimes in the future; and they also reflected the ultimate authority of the secular powers to judge the life and death of its subjects. In the case of crimes involving sorcery or witchcraft, executions in the Empire most frequently took the form of burning or drowning. In this way, witchcraft was linked through punishment with the crimes of heresy, sodomy and forgery. Burning was meant both to cleanse societies of evil and to annihilate the instrument by which the evil was perpetrated – by having the witch burnt to ash, and the ash then buried under the gallows or dispersed in a river.[42] For readers of Wick's 'Wonder Book', depictions of witchcraft executions would also have represented the harsh measures authorities were duty-bound to take in order to eradicate so great an evil from the earth.

The prominence of the executioner in these images, the judicial official to whom the condemned witch was committed by the court after judgment, symbolized the role of duly constituted authority in this 'theatre of horror'. It was the executioner's responsibility to prepare the execution and successfully implement the court's sentence. A failed or bungled execution could lead to anger on the part of spectators and even physical danger to the executioner.[43] Thus the executioner was usually shown tending the fire with some kind of fork or poker,[44] or bringing extra timber in order to maintain the level of heat;[45] while his instruments of death, such as the gallows or the wheel, were prominently displayed in the background.[46] The compositional formula of many of these images was repeated again and again. Erhard Schön's 1533 burning (fig. 7.2) seems to

have provided one early model; a woodcut from Johann Stumpf's *Schwyzer Chronik* provided another.[47]

Members of the court or ruling authority were also often included in such scenes along with the executioner. In an illustration of the burning of 25 witches in Colmar in 1572, the towering figure of a judge stands over the executioner, with an index finger extended in a gesture of warning (fig. 7.9). And in the drawing of the execution of Verena Kerez in Zurich in 1571, two representatives of the city council stand on each side of the blazing fire (fig. 7.10).[48] The councillors have removed their caps and their hand gesture indicates they are swearing an oath.[49] The text clarifies this as the 'oath of truce', an oath sworn that more lenient sentences would be imposed if the condemned abjured any revenge or actions against the authorities.[50] Verena Kerez was convicted of having abandoned God, of making a pact and having sexual relations with the devil, harming and killing animals, causing a hailstorm and bringing sickness upon a number of her neighbours. She nevertheless confessed her terrible deeds and returned to God; and as a result was given a 'merciful' sentence: she was taken directly out to the place of execution and burnt on a pyre made of brushwood, without the corporal punishments and mutilations commonly imposed for such serious crimes. The drawing demonstrates how executions were first and foremost rituals for the enactment of secular authority. And although the artist's omission of the witch's burning body may have meant to highlight the sentence of a speedy and more merciful death through the use of brushwood, it also helped emphasize the essentially political nature of the event.

While burning at the stake is the most common way witch executions are depicted in the 'Wonder Book', some burnings employ a wide board on which the convicted witches lie tied together. This seems to be a version of the ladder used in various parts of Switzerland. Witches were tied to a ladder which was then thrown onto the fire.[51] A wide board is used in the execution of three witches in Baden in 1574 (fig. 7.11)[52] and in the execution of three witches in Bremgarten in 1574 (fig. 7.12).[53] In the Baden execution the board is lowered onto the blazing fire by the executioner and his assistant, while a crowd of observers looks on, with judicial authorities identifiable by their swords to the front; while in the Bremgarten case the executioner and his assistant stand back and oversee their work. In both images the witches are fully dressed and their hair is intact, unlike many cases where they are naked and shorn (fig. 7.9). While the stripping of witches and cutting their hair was a formal act of degradation and humiliation, the shorn heads may also refer to the practice of searching for the devil's mark. This was that anaesthetic scar on a witch's body where the devil had scratched the witch as part of the initial pact, and was considered firm evidence of a pact with the devil. Since the mark could be located anywhere, the hair on the witch's head, under the armpits, and in the genital area was shaved off in order to help locate it. Searches for the devil's mark by judicial officials began in the 1530s in Protestant territories of the Swiss Jura, such as Geneva and the Pays de Vaud, but did not become widespread in Catholic regions until the turn of the century.[54] It is possibly significant that the five scenes of execution that feature shorn witches are all from Protestant territories;[55] whereas the four shown with head hair are from Catholic territories.[56]

Throughout Germany and Switzerland drowning was probably the most common form of capital punishment in the sixteenth century. It was primarily inflicted on women, especially those who had violated religious or moral norms.[57] Drowning was also used as a more merciful form of punishment than burning. The one illustration of an execution

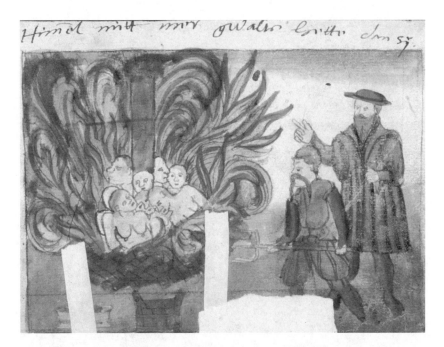

Figure 7.9 The Burning of Twenty-five Witches on One Day in Colmar in 1572, pen and ink, coloured, in Wickiana F.21, 85ʳ. Zentralbibliothek Zurich.

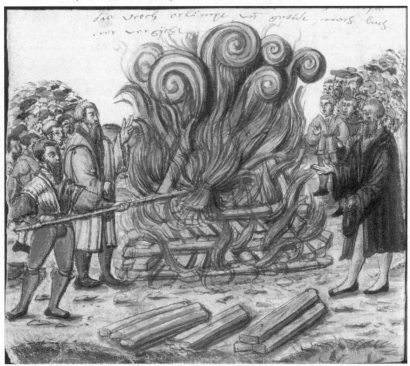

Figure 7.10 The Burning of Verena Kerez in Zurich in 1571, pen and ink, coloured, in Wickiana F. 19, fol. 277ʳ. Zentralbibliothek Zurich.

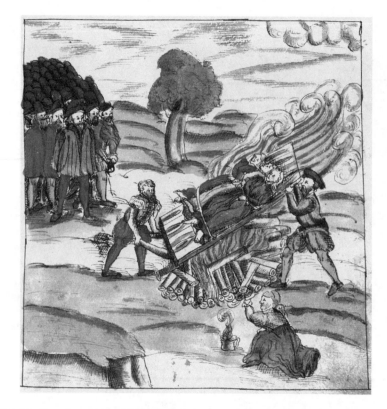

Figure 7.11 The Burning of Three Witches in Baden in 1574, pen and ink, coloured, in Wickiana F. 23, fol. 56. Zentralbibliothek Zurich.

of a witch by drowning in Wick's compilation is a case in point (fig. 7.13).[58] Agatha Studlerin of Zurich had suffered a reputation as a sexually promiscuous woman and she had a long history of laming and poisoning. Some even claimed that her witchcraft had made her husband impotent. When taken into custody and led to the place of torture, Studlerin freely confessed to her evil deeds, but also asked that she be spared death by fire. Her request was granted by the court, possibly because she was well connected in the Zurich region and powerful patrons had interceded on her behalf. The drawing shows Studlerin in the arms of the executioner in a boat on Lake Zurich. She has been trussed up, with her hands and feet both tied. Beside her stand two members of the council in their long black robes, witnesses to the enactment of the court's sentence.

Punishments could be accumulated as well as reduced. Cumulative punishments were especially common in witchcraft trials in Switzerland.[59] But they only occur in one image in the Wick collection, the death of the witch Agnes Muschin in Bremgarten in 1574 (fig. 7.14).[60] Muschin, an 80-year-old poor woman who lived off a pension she received from the *Spital* in Bremgarten, was accused of having a 16-year sexual liaison with the devil and of performing all kinds of evil, such as injuries to men and beasts, spells that drove people mad and destructive hail storms. Her sentence decreed that at four different locations on her way to execution she should be pinched with red-hot tongs and then be burnt together with the statement of her evidence. The illustration shows her taken in a cart to the place of execution. The executioner pinches her shoulder with

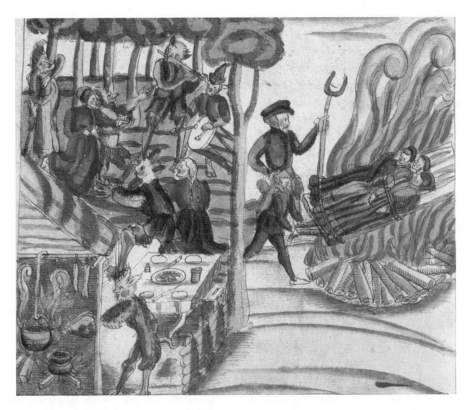

Figure 7.12 The Burning of Verena Trostin, Barbara (Regula) Meyerin and Anna Langin in Bremgarten in 1574, pen and ink, coloured, in Wickiana F. 23, fol. 399. Zentralbibliothek Zurich.

red-hot tongs in view of a crowd headed by a judge, while an assistant uses bellows to keep the coals hot in a brazier. The next stage, the witch's burning, follows an iconographical format often found in the Wick drawings: the accused witch is now naked and seated in the midst of a flaming fire, while an executioner brings another log to the fire. The iconographical details are clearly not of primary importance. The artist's aim is to represent a theatre of horror, so that the viewer might gain something of the experience felt by the onlookers within the frame itself.

It was with the executioner that the witch developed a complex relationship during her days and weeks of imprisonment, interrogation and torture. The executioner was the one who administered torture, applied the pain and tested the limits of endurance for the successful extraction of a confession.[61] Sometimes his judgment went terribly wrong and the interrogated met a premature death. This occurred in 1577, for instance, in the northern Swiss town of Mellingen, and became the subject of one of the Wick drawings (fig. 7.15).[62] A mother and daughter who were both accused of witchcraft are shown in a torture chamber in the presence of a judge and an executioner; the executioner is pulling the mother up on the strappado, while the daughter looks on weeping, her body seeming to tremble and her hands clasped together in a gesture which communicates anguish, entreaty and prayer. The floor is littered with the instruments of torture: a rope and stones for the strappado, and a flail. The mother's body appears lifeless; and the text

Figure 7.13 The Execution by Drowning of Agatha Studlerin in Zurich in 1546, pen and ink, coloured, in Wickiana F. 13, fol. 90ᵛ. Zentralbibliothek Zurich.

explains that she continued to deny the charges of witchcraft, even to the point of death. The mother's supposed guilt was later exposed by the daughter. While undergoing torture on the strappado, she confessed that both she and her mother had engaged in witchcraft. Despite her confession, the daughter died at the stake.

Witchcraft as a crime of mothers and daughters appears a number of times in the Wick illustrations. The witch burnt at Oberndorf in 1533 was said to have learnt her destructive craft from her mother (fig. 7.2). A witch burnt in Rötteln in the Breisgau in 1561 is shown joining the hand of her daughter to that of the devil.[63] But the most graphic representation of such an 'atrocious deed' is that of a mother and daughter who were tried and executed for witchcraft in Berne in August 1568 (fig. 7.16).[64] The drawing presents a composite scene. On the right the two women stand before the court, as the judge reads out their sentence. The curious aspect of this case is that the court tended not to believe the women's story of their marriage with the devil, preferring to attribute it to diabolical fantasy and deception ('Einbildung und Betrug'). Its view was supported by the report of a midwife who examined the daughter and found she had never had sexual intercourse. Yet the two women continued to confess their guilt and express repentance for their terrible sin. Ultimately the court committed them to the fire, a scene depicted in the right background. The artist has inserted a devil at the foot of the court official on the left in order to allude to belief in a continuing relationship between the daughter and the devil throughout the trial. For when the daughter was condemned, the text tells the reader, the court became aware of a most putrid smell, a sign that Satan had finally abandoned the young woman's soul.

The left half of the drawing represents the wedding of the daughter to the devil, to which both women confessed. The text only mentions that festivities were held in the

Figure 7.14 The Punishment and Burning of Agnes Muschin in Bremgarten in 1574, pen and ink, coloured, in Wickiana F. 23, fol. 424. Zentralbibliothek Zurich.

forest and that the marriage was later consummated, preferring to concentrate on the circumstances that led to the wedding and the consequences that followed. Apparently the mother agreed to the wedding after being pressured by the devil; but the daughter took fright and sought help by praying to Jesus. The devil confronted the mother again, threatening her with all kinds of harm; and so finally the daughter agreed. Satan gave his bride gold that subsequently turned out to be no more than leaves and left the young woman so poor that the city provided her with a pension. The artist, however, was more interested in the sexual liaisons of both mother and daughter at the forest wedding. He depicts both dancing with devils, while other devils provide the accompaniment on fife and drum and prepare the wedding feast in a cauldron. The women have surrendered themselves to the sexual advances of the devils, the mother acting as a procuress who facilitates the prostitution of her daughter.

The forest wedding with its dirty demon dancing must have seemed appropriate to Wick's illustrators as a way of representing some of the key elements of sixteenth-century witchcraft belief: the sexual proclivities of witches, diabolical liaison as the source of a witch's power, and the threat posed by the sexual knowledge passed from mothers to daughters.[65] The left-hand side of the drawing was copied in an illustration of three women accused of witchcraft in Bremgarten in 1574 (fig. 7.12). It may well have been that the diabolical liaisons of two of the Bremgarten women, Regula Meyerin and her daughter, Anna Langin, reminded the artist of the mother and daughter from Berne.

201

Figure 7.15 The Torture of a Mother and Daughter at Mellingen in 1577, pen and ink, coloured, in Wickiana F. 26, fol. 226r. Zentralbibliothek Zurich.

Figure 7.16 A Mother and Daughter are Tried and Executed as Witches in Berne, 1568, after Marrying the Devil and Celebrating a Wedding Feast in the Woods, pen and ink, coloured, in Wickiana F. 18, fol. 146v. Zentralbibliothek Zurich

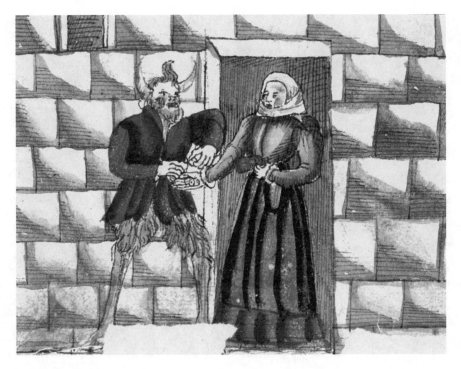

Figure 7.17 Regula Meyerin Receives Money from a Devil called Lüzelhüpsch before her Bremgarten House in the Korngasse, 1574, pen and ink, coloured, in Wickiana F. 23, fol. 409ᵛ. Zentralbibliothek Zurich.

Regula and Anna confessed that both had enjoyed sexual intercourse with the one lover, a devil called Lüzelhüpsch. This first occurred in a bush above the stream in the Hermetschwil woods, a couple of kilometres south of Bremgarten, and was then repeated with both women – so many times they could not remember, they said – in their Bremgarten house in the Korngasse.

For a Zwinglian pastor like Wick, witchcraft exemplified the devil's power in the contemporary world and warned of the need for repentance and conversion. He constantly stresses the agency of the devil, who appears to women at times of crisis as a potential lover, promising to supplant their suffering or loss with material prosperity and a fulsome life. So it is with Regula Meyerin, depicted with Lüzelhüpsch in front of her Bremgarten house receiving coins from her demon lover (fig. 7.17). The money is a token of the devil's promise to care for her, a symbol of mutual exchange and obligation and consummated by an act of sexual intercourse. But for readers of a story about a woman who repeatedly 'had her wanton and shameful way' ('üppigen schantlichen mutwillen') with the devil under the house by the woodpile, the devil's coins would surely have been read as the payment of a prostitute.

While devils pretended to offer women comfort in distress, their depiction as cruel masters revealed their true nature. An established image of the devil's cruelty was his abduction of the so-called witch of Berkeley in the medieval story (figs 2.20, 8.10). Wick's 'Wonder Book' also recounted and illustrated this story (fig. 7.18).[66] The woman on the horse with the devil, her wild black hair streaming out in all directions, is clearly

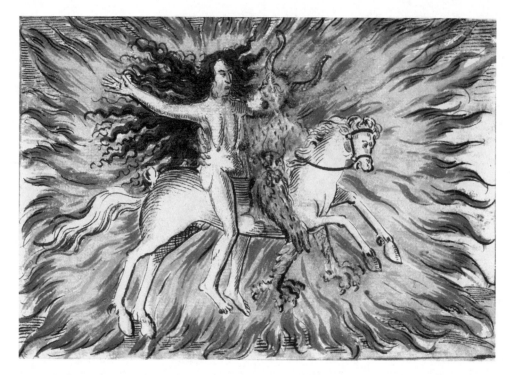

Figure 7.18 The Devil Abducts the Witch of Berkeley and Consigns her to the Fires of Hell, pen and ink, coloured, in Wickiana F. 12, fol. 9ʳ. Zentralbibliothek Zurich.

identifiable as a witch. Her arm raised in a gesture of vulnerability, she is an old woman whom the devil has dragged from her coffin, beaten, forced onto his horse and abducted. The flames through which the couple ride signify the flames of hell to which the devil consigns his victim; but they also represent the terrifying violence and vengeance which the devil unleashes on those who deliver themselves into his power. While not always expressed so graphically, the devil's harsh handling of witches appears elsewhere in Wick's work. Anna Langin, for instance, appears being beaten by the devil, as he strikes and drags her by the hair (fig. 7.19).[67] The devil is a wife-beater and violent master, enraged by Anna's inability to understand his instructions on how to make a storm to destroy the local fruit, and annoyed by her general skepticism and diffidence about witchcraft.

The devil also taught sorcery to Agnes Muschin, who was executed in Bremgarten in 1574. It was her lover, the devil Kleinhänsli (Little Johnny), who provided her with a small cauldron and instructions on how to beat up a wild hailstorm. This occurred at mid-summer when the honourable women of Bremgarten organized a feast at the town hall and Agnes wished to bring the conviviality to an end. Kleinhänsli met her out on the porch, sat himself in the cauldron which he had brought and asked Agnes to tip him out, down onto the ground – whereupon a massive storm broke out and totally disrupted the event. A variation on the devil's weather sorcery lesson occurs in the confessions of Regula Meyerin and Verena Trostin of Bremgarten (fig. 7.20). They claimed that the devil approached them around the time of Candlemas to interest them in his plan to whip up a sudden frost that would freeze the vine shoots.[68] He instructed Trostin to

Figure 7.19 Anna Langin Beaten by the Devil for her Incompetence and Unwillingness to Engage in Weather Sorcery, in Bremgarten, in 1574, pen and ink, coloured, Wickiana F. 23, fol. 419. Zentralbibliothek Zürich.

bring wood to the fire, and Meyerin to heat some herbs he gave her with water in the cauldron, letting it simmer while stirring it with a stick. She was then to pour it all out. True to the devil's word, the weather immediately turned extremely cold and the vine shoots froze. That year there was no wine.

The most powerful visual statement of the diabolical nature of witchcraft, and also the most historically significant of all the Wick drawings, is the illustration of a witches' Sabbath that accompanies an account of male and female witches in Savoy, who were executed in 1570 by authorities in Geneva and Berne (fig. 7.21).[69] While the author of the document initially argues that Sabbaths take place in the imagination as a consequence of the illusion and trickery of the devil, he includes this story as confirmation that they also occur 'in the flesh'. The central figure of Satan in the drawing is based on the description in the servant's story, combined with a more general statement about such 'synagogues' – as the text calls the witches' Sabbath – supposedly based on the many confessions made at the these trials. Satan, dressed in the long robe appropriate to a potentate, is seated on a throne woven out of serpents. His horns, hooves and tail, shown emerging from the back of the throne, clearly identify him as the devil. He is handing Turranus' servant a container. It is certainly filled with one of the two powders that witches apparently receive from the devil, according to the text; one to be used to bring illness and death, the other – surprisingly – to be used in healing. The second container is held by a figure in oriental-type costume behind him, a devil called Moreth,[70] who has been appointed to be the master of the young servant and his teacher in the diabolical

Figure 7.20 Regula Meyerin and Verena Trostin are Instructed by the Devil How to Whip Up a Frost with a Cauldron, in Bremgarten, in 1574, pen and ink, coloured, in Wickiana F. 23, fol. 408. Zentralbibliothek Zurich.

arts. The servant later used this powder to murder two of Turranus's children and one of his maidservants. But when he used the healing powder to reverse the debilitating illness he had caused in another maidservant, his victim notified the Genevan authorities. As a result, Turranus's servant and more than 30 people he claimed to have seen at this Sabbath were executed.

In what is almost a unique representation of the Sabbath before the 1590s, the artist has introduced a number of scenes of individual witches and devils around the central figure of Satan. Although the text specifically refers to the 'many men and women' in fine-looking clothes who surrounded the throne with their devils, all the witches in the drawing, except for the male figure kneeling before Satan, are women. An act of weather sorcery is depicted in the top left corner, as though to clearly identify the scene, for there is no reference to weather sorcery in the text. In the centre foreground a female witch performs the 'obscene kiss' on the backside of a devil who has dropped his pants. On her right another holds up her two containers of powder, while on her left a third witch gestures in the direction of the throned devil, as though awaiting her own instruments of evil. The two short devils attending to the standing witches in the foreground may possibly be engaged in branding them with the devil's mark. And at bottom left a devil prepares powders in a vat or large mortar, from which another figure fills smaller containers. The overwhelming message of the image is not that witches meet in their Sabbaths to engage in sensual delight, or even in anti-Christian ritual; they meet to collect from their diabolical masters the powders they then use to bring harm to society.

The theme of sexual transgression is depicted in quite unusual fashion in a second illustration of the confession made in Geneva in 1570 (fig. 7.22). Here the artist has chosen to represent the relationship between Turranus's wagon driver and his devil,

Figure 7.21 A Genevan Wagon-driver and his Devil Moreth Come Upon a Witches' Sabbath in the Woods near the City, in 1570, pen and ink, coloured, in Wickiana F. 19, fol. 147ᵛ. Zentralbibliothek Zurich.

Moreth, through a number of scenes. Moreth first meets the wagon driver in the woods, threatening to beat him with the wagon driver's own whip; he then drops his pants to allow the wagon driver to perform the obscene kiss; and finally Moreth takes him back to his wagon on horseback. The male kiss on male buttocks is certainly an extremely rare scene in images of witchcraft, and for that reason would have reinforced the view of witchcraft as utterly depraved. The depiction of a female witch kissing the posterior of a diabolical beast (fig. 7.21) also represents witchcraft as a shameful vice, of course. But the unusual, if not unique, visual depiction of a homosexual relationship in a scene of witchcraft, which has no echo in the text, suggests that the artist has been concerned to emphasize that the diabolical pact involving male witches such as the wagon driver is largely identical with the pacts made between female witches and the devil.

The literature and judicial investigation of witchcraft that developed from the mid-fifteenth century was firmly rooted in the theology of the devil. The evil of witchcraft was explained by reference to the power of the devil. Even sorcery practices directed at overcoming evil were condemned because of the claim that they depended on the devil's intervention. The evil and beneficial effects created by witchcraft, argued witchcraft theorists, was not the result of any power, skills or techniques exercised by the witch. It was the result of a pact or agreement with the devil, which bound him to exercise his powers whenever he received a sign from a witch. Theologians applied the semiotic theories of Augustine, Aquinas and other scholastics to make sense of witchcraft's wondrous

Figure 7.22 The Relationship between a Genevan Wagon-driver and his Devil Moreth, in 1570, pen and ink, coloured, in Wickiana F. 19, fol. 147v. Zentralbibliothek Zurich.

effects. The sign to which the devil responded was usually the verbal form of spells or charms, but it could also be bodily gestures or other rituals, such as gathering herbs or body parts at auspicious times and seasons, or of cooking up potions according to prescribed formulae. And the pact was formalized by an act of sexual intercourse with the devil, by which the witch surrendered herself sexually and spiritually to the lordship of a new master in return for the promise of his power and protection.

Fundamental to the world of witchcraft as described by the treatises and trial evidence of the fifteenth and sixteenth centuries, and contrary to widely-held and popular conceptions of the practices and powers of those accused of witchcraft, was the involvement of the devil. The devil was involved in a range of different ways. He was often represented as the target of the witch's magic, a respondent to the signs communicated through her words and actions. He was also the companion and sexual partner of the witch, a symbol of the pact upon which the witch's power was based. He was present at the scene of sorcery or malefice as the trickster, the source of mental and sensory illusions that led victims, observers and even the witch to credit results to the witch's own actions or words. The devil was also the perpetrator of violence against the witch, in response to an act of disobedience, or as a brutal demonstration of his sexual and spiritual mastery over her in this life or in the next, or as a lord come to finally claim what was rightfully his through the pact. The devil also featured in the literary representation of witchcraft as the master of the Sabbath, to whom witches performed homage and adoration, offered

and sacrificed children, from whom they received poisonous powders, potions and instruction, and with whom they engaged in dancing and sexual intercourse.

Visual artists, unlike their literary counterparts, seldom chose to represent witches' Sabbaths presided over by the devil in the sixteenth century. In most images from the first half of the century, the devil's presence during acts of witchcraft was barely registered. A goat or some other beast possibly represented his presence, but this was often left ambiguous. Moreover, apart from the illuminations of Waldensian devil-worshippers from the 1460s and 1470s (figs 2.21, 2.23, 2.24), the first depiction of a diabolical Sabbath as described in the witchcraft treatises did not occur until c.1570, in one of the drawings from the Wick collection (fig. 7.21). The next such image approximating a Sabbath scene occurred in 1591 (see fig. 7.8 for the 1592 printing) and it was only with the turn of the seventeenth century that depictions were created in any detail and in greater numbers. The reason for such a lag in visual representation remains unclear, but strongly suggests that the diabolical Sabbath was not a widely held belief before the 1590s. What is clear is that the broadsheets of the later sixteenth century were critical for elaborating and disseminating the role of the devil in witchcraft belief. Possibly the dissemination of news reports of very similar descriptions of witchcraft activity and prosecution in different regions of Europe helped promote belief in the more learned, theological view of witchcraft that had its common cause and basis in the power of the devil. In the next chapter I examine how the attribution of witchcraft practices to peoples beyond the borders of Christian Europe in the late sixteenth century served to underpin a view of witchcraft as not simply diabolical but also universal. Its practitioners could then become identified as unnatural elements within the body of Christian Europe, as threats to the very integrity of Christian society itself.

8

ON THE MARGINS OF CHRISTIAN EUROPE

Sometime in the 1580s, the Dutch artist, Crispin de Passe, who was closely associated with the print industry in Antwerp and an inhabitant of Cologne from the late 1580s, engraved and published a print of the planetary god Saturn and his so-called 'children' (fig. 8.1). The print was one of a series of the seven planetary gods and their children, originally designed by the leading Antwerp artist, Martin de Vos, with whom de Passe worked on a number of projects at the time. The depiction of planetary gods as the parents of particular children on earth served to link certain groups in society – age groups, social classes, occupations, social and cultural activities – with particular planetary influences.[1] This was a common literary and iconographical schema in the late Middle Ages that gave expression to traditional homologies between the cosmic macrocosm and human microcosm. As well as being depicted in each of de Passe's seven prints, the idea was also well expressed on the titlepage with which de Passe prefaced the whole series: an image of *The Golden Chain*, which represented the Platonic Chain of Being that linked the three-fold cosmos of supercelestial, celestial and elemental worlds. But the distinguishing mark of Crispin de Passe's print was that among Saturn's children he included two groups who had not commonly appeared in fifteenth- and sixteenth-century examples of the genre, European witches and Amerindian cannibals.

De Passe's engraving depicts the god-planet Saturn riding through the sky in a chariot drawn by two dragons. His 'house' is located between Capricorn and Aquarius, the zodiacal signs depicted in the two top corners. Below Saturn's chariot are the different groups and activities over which he holds sway. He is ruler over all the lands of the West, the text informs us, he uncovers mines and fills magicians with an evil spirit.[2] There are Indians working in mines, paying homage to their ruler, and Spanish galleys firing on a group of fleeing natives. At lower right there is a common sixteenth-century scene of Amerindians as cannibals: a male figure chops up a human body on a table, while two women place various body parts to be cooked on the grill over the fire and another sits nearby nursing her young child. At lower left are the magicians and witches, the *magi* of de Passe's text. A long-robed figure reads from a book and is clearly engaged in the art of necromancy, for a human skeleton shape stands before him within a cauldron that rests on a lighted fire. Nearby, a group of witches take part in an orgiastic dance. Of the four dancers – of whom at least two are women – two are wholly naked and two partly clothed. Three other women are depicted flying up into the air, one of them naked and holding a candle in one hand and a broom in the other, two others with skirts billowing up to their waist, revealing their bare buttocks; and one of them holding what seems to be a spindle. The smoke billowing from the fire serves to link these flying witches and

Figure 8.1 Crispin de Passe, after Martin de Vos, *Saturn and his Children*, late 1580s (?), engraving. © Rijksmuseum Amsterdam.

their dancing companions to the cauldron and the act of necromancy. The rituals of witchcraft are linked to the bookish and formulaic arts of necromancy, and the depiction of human bones, in this case a skeleton, links both to the world of the dead.

Crispin de Passe's engraving exemplifies how some artists connected the activities of witches to European traditions of anthropophagy and to recent accounts and images of Amerindian cannibalism in the New World. Thus, it alerts us to how notions of witchcraft were implicated in some of the broader cultural trends of the sixteenth century. While the histories and literature of the classical and pre-classical worlds were employed to understand, explain and encompass the cultures of the New World, the ethnographic interest in these cultures went hand in hand with an interest in the customs and folklore of European societies themselves. Civilizing and christianizing the native at home was critical to European hegemony abroad and the theologization of sorcery and magic as forms of superstition or witchcraft played a part in this. This chapter examines how visual images of witchcraft were used to define those on the geographical or imaginative margins of European society and how this process significantly modified the developing image of a witch. The association of witchcraft with the classical figure of Saturn, for instance, served to universalize and extend notions of witchcraft to include indigenous Amerindians, while the focus on Saturn's violence and aggression helped underline the fundamentally antichristian and antisocial nature of witchcraft. It also built on a tradition of the melancholic in European Christian thought and grouped witches with those who were imaginatively deluded and mentally disturbed, conditions ultimately linked to the demonic. A view of witchcraft as a demonic superstition widely practiced through pre-Christian societies was further disseminated through the popular ethnological account of Scandinavian culture, *History of the Northern Peoples*, by the Swedish bishop, Olaus Magnus. By the late sixteenth century the witch would be widely understood as a dangerous threat to the integrity, and even the survival, of Christian community.

The relationship between witchcraft and Saturn was not simply an individual interest of Crispin de Passe. Allusions to Saturn in witchcraft iconography are found from the first decade of the century and culminate in de Passe's print and two closely related versions from the 1580s.[3] The first of these versions is an engraving by Jan Sadeler the Elder, which was made after a design of Martin de Vos and probably executed in the late 1580s (fig. 8.2).[4] The second is an engraving by Henri Leroy, the lower half of which is a copy of de Passe and the top half a copy of Sadeler.[5] In both the Leroy and Sadeler versions, the figure of Saturn strikes a curious pose, with his right leg awkwardly balancing on the left, a position that clearly signifies his lameness and alludes to his castration. But in the Sadeler, the most important differences appear in the bottom half, and these partly relate to the general programme of this particular series of the planetary gods and their children.[6] The series depicts the provinces, regions and cities over which the different gods exercise their influence. The craggy cliffs and seascapes of de Passe's print have been replaced by a landscape of towns, the cannibalism cameo has been removed, although de Passe's scene of mining and native homage remains, and the scene of necromancy and witchcraft has been replaced by a number of discrete figures practising different forms of magic and witchcraft. Two women are shown by a cauldron; a bearded magician points with his wand to a magical talisman in a large book; a woman with two wands seems to be creating a storm; and two other figures have their arms raised to the heavens. While Saturn features again as the patron of witchcraft and the magical arts, the removal of cannibalism redirects the focus away from the Americas to

Figure 8.2 Jan Sadeler the Elder, after Martin de Vos, *Saturn and his Children*, late 1580s (?), engraving. © Rijksmuseum Amsterdam.

some more general scene of conquest and economic exploitation. Indeed, the caption refers to the territories and cities of Eastern Europe and Asia, over which Saturn rules; it emphasizes Saturn's relationship to the chthonian underworld of magic and the dead, rather than to the violence and cruelty of the Amerindian cannibal.

The clear link to Amerindian cannibalism in the prints by de Passe and Leroy, on the other hand, is emphasized by recourse to a well established iconography: the preparing of human flesh on a cutting table, the roasting of it on a barbecue, and the presence of a woman nursing a child.[7] More generally, the depiction of sorcerers and witches as the children of Saturn facilitated an association with Saturn's violent sexual persona as a god who castrated his father and with his ultimate oral aggression as a god who ate his own children. Alternately, witches could be associated with Saturn's other children – the old, the poor, grave-diggers and corpse-robbers, agricultural labourers and butchers, tanners and criminals. Crispin de Passe, Henri Leroy and Jan Sadeler were hardly the originators of such schemas. What they succeeded in doing was making more explicit some of the

213

varied associations from the iconography of Saturn, which other artists could readily draw on. The figure of Saturn was especially employed to associate the rituals of witches and their liaison with the dead with the same sexual aggression and terrible violence of their 'father'. This in turn rendered them the ultimate enemies of Christian society, kin to those 'wild, naked and furious cannibals' of the New World, well known from the descriptions and illustrations found in contemporary European descriptions and prints.[8]

The violence, and more especially the sexual violence, associated with the figure of Saturn was transmitted to sixteenth-century scholars by late medieval mythographers and the fifteenth-century translators of Arabic authors.[9] Saturn, god of agriculture and of the Roman Saturnalia, was identified with the Greek god Kronos. According to Hesiod, Kronos came to power by castrating his father Uranus with a sickle. From Uranus' genitals, which were thrown into the sea, Aphrodite, the goddess of love, was born. But according to late medieval accounts such as that of Boccaccio, Kronos or Saturn suffered the same fate as his father. Because of a prophecy that claimed he was to be overthrown by his own son, Saturn decided to devour his children in order to thwart it. One of them, called Zeus or Jupiter, was able to survive because of a trick by Saturn's consort, Rhea. So when Zeus grew up, he took power by castrating his father Saturn. In some accounts Zeus executed this with the very same sickle or scythe with which Saturn had castrated his father Uranus.

The god Saturn was also linked to the planet Saturn. And the planet Saturn, as the coldest, driest and slowest of the planets, was linked to the Saturnine or melancholic temperament and to melancholic illnesses produced by black bile. By the late Middle Ages, the sinister characteristics of the mythical Saturn – his old age, malevolence, violence, tyranny and so on – were stressed. These characteristics were then also attributed to his 'children', those who lived under his planet – criminals, cripples, beggars, the elderly and low-born, the poor and those involved in vulgar and dishonourable trades. Increasingly from the late fifteenth century, Saturn's children also included the dead, magicians and witches. These relationships were given pictorial form in the so-called Children of the Planets images, which became especially popular in northern Europe in the later fifteenth and sixteenth centuries, and were disseminated through popular almanacs, calendars and astrological handbooks. In one example from a German blockbook illustration of *c.* 1470 (fig. 8.3), we see representations of farming, tilling and other rural activities: a solitary hermit, criminals undergoing punishment and death, cripples and pigs – animals closely linked to Saturn, which draw connections between Saturn and the Jews. In this print Saturn wields a sickle, rather than his scythe, and he leans upon a crutch. Although both implements clearly refer to Saturn's association with farmers and cripples, they also represent his genital mutilation.[10]

The physical violence and bodily mutilation of the Saturn legends is not given much attention by artists until the late fifteenth century. Saturn's castration is usually referred to symbolically, by means of a crutch or wooden leg; although in some cases it now receives more overt and graphic representation. One such graphic woodcut, which was first published in a *Moralized Ovid* of 1476, appears in sixteenth-century French editions of Boccaccio's *Genealogy of the Gods* (fig. 8.4). In a narrative scene, which would have achieved considerable exposure as the frontispiece to the 1531 edition, Zeus holds up the genitals of his father which he has just removed with his knife, while the castrated Saturn, blood pouring from his wound, devours one of his children.[11] In images of Saturn in a chariot drawn by dragons, the frequent positioning of the sickle or scythe on

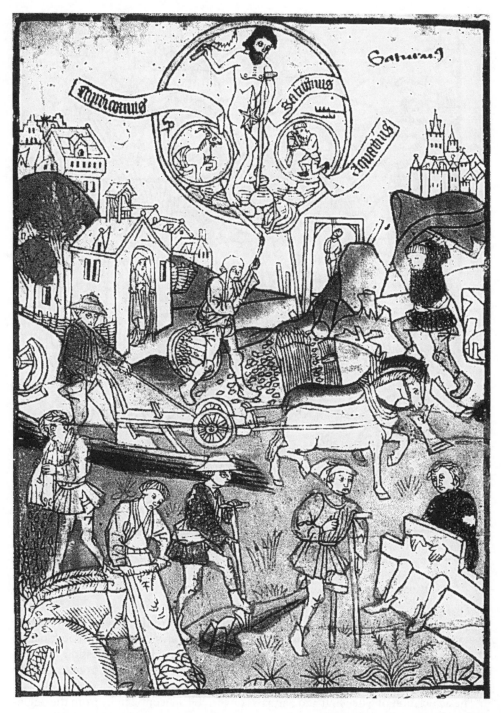

Figure 8.3 Saturn and his Children, block woodcut, in *Die Schwabacher Planetenblätter, c.* 1470, affixed to Leonardus de Utino, *Sermones aurei de sanctis*, Ulm: Johann Zainer d. Ä., 1475. Kirchen-Kapitelsbibliothek Schwabach.

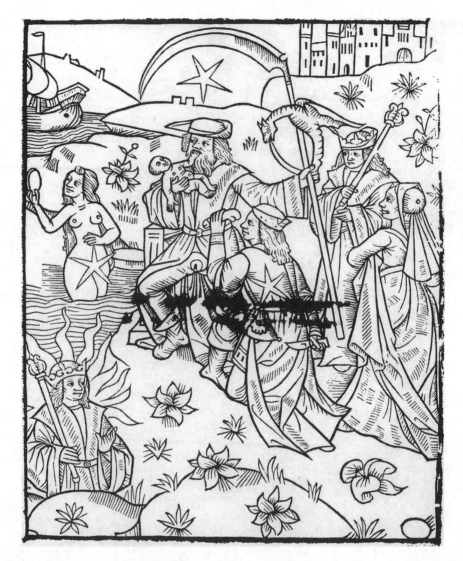

Figure 8.4 *The Castration of Saturn*, frontispiece woodcut, in Giovanni Boccaccio, *De la généaologie des dieux*, Paris: Philippe le Noir, 1531. The Bodleian Library, University of Oxford, Douce ss.453.

the penis of one of his children or hooked around the tails of the dragons, plays on the castration motif which was central to Saturn's rise to power.[12] And it is the combination of this sexual aggression with the more commonly displayed oral aggression, that has Saturn literally sinking his teeth into the flesh of a child or ripping skin from the child's body with his teeth.[13]

The association of witchcraft and Saturn is discernible in iconography from the beginning of the sixteenth century. It appears in some representations of the goat, for instance, as a symbol of lust and also a sign of the zodiac. The original model must have been Dürer's engraving of the *Witch Riding Backwards on a Goat*, for this goat, as Maxime

Préaud has argued, is an astrological goat, a Capricorn (fig. 1.12).[14] The hind quarters of the goat are not clearly depicted, but seem to become the tail of a fish or serpent, as is the case with the numerous Capricorn figures of the period. The astrological Capricorn was closely associated with the planet-god Saturn, as in the print by Crispin de Passe; for Saturn's 'house', the part of the zodiac over which he exercised power, was located between Capricorn and Aquarius, and Capricorn was Saturn's nocturnal domicile. In Dürer's work, the allusion highlights the inversion of the gender order in this image, a representation of the witch as the castrating and cuckolding woman who emasculates and appropriates male power. As his older Nuremberg fellow citizen and playwright, Hans Sachs, put it in 1531, one of the foremost powers of witches was 'to remove a penis from a man, so that he in no way remains a man'.[15] It is significant that the Capricornian goat survives as an image of diabolical power, as in an etching of devil worship by Jacques Callot of more than a century later.[16] But the range of subtle allusions as conveyed in Dürer's engraving is certainly no longer evident here, and any consciousness of an association with the classical god Saturn would seem to have been lost.

The figure of Saturn also seemed to work for artists as a motif through which to link beliefs about the sexual aggression of witchcraft and the view of witchcraft as diabolical fantasy and delusion. This was based on the traditional relationship between the planet Saturn, the melancholic temperament and melancholic illness, and found clearest expression in the Melancholy series of paintings by Lucas Cranach (figs 4.1–4.7). As we have seen, all four paintings use the female figure of Melancholy combined with a wild cavalcade in a dark cloud, in order to link melancholy to visions of the Furious Horde or Wild Ride. In this way claims of witchcraft's Wild Rides are identified as no more than the fantastical products of a disordered imagination corrupted by sinful lust and the devil's delusions. In the 1533 *Melancholia* painting, however, such melancholic disorder is quite explicitly linked to the figure of the planetary god, Saturn. In this painting the cloud in which the wild cavalcade appears throughout the series takes on the form of a billowy extension of a phantom head, and from the mouth of this head slips the word 'melancholia'. The head is most likely to be that of Saturn, within whose melancholic body-cloud the vision of moral disorder takes shape.[17] While it was Hans Baldung Grien who in 1516 created a chalk drawing of a bearded head of Saturn with some similarities to that in Cranach's painting,[18] there is little doubt that Cranach was fully aware of the cultural significance attributed to Saturn in recent literature and iconography. In the 1503 *Passauer Missale* he incorporated a male figure devouring children into his rendering of an initial B, and this has been identified as Saturn; and in 1515 he produced a drawing as a design for an astronomical table featuring the children of the planetary gods, which included the children of Saturn.[19] Cranach's Melancholy series, then, was in part an attempt to explain the claims of witches' destructive night rides by reference to the delusions and fantasies created through Saturnine melancholy.

A similar message and set of associations would seem to be the explanation for some puzzling aspects of an image I have discussed above in Chapter 3 (fig. 3.1). Probably a product of Baldung Grien's Strasbourg workshop and first published in the collection of Geiler of Kaysersberg's sermons in 1516, the woodcut came to be one of the most widely reproduced images of witchcraft in the sixteenth century. The central scene features a wild sexual ride by a woman seated astride a baking trough, an illustration of Geiler's text. But Geiler's broader purpose in retelling a story he took from a fifteenth-century work by Johann Nider, and the visual frame provided for the central scene by the artist,

was to highlight the role of diabolical delusion and fantasy in producing belief in such Wild Rides by witches. The artist seems to have picked this up from Geiler's text. For following his account of the Wild Ride taken from Nider's work, Geiler had inserted the well-known story of a Wild Ride from the legend of St Germain, in which the riders were revealed by the saint to be none other than demons in human form (fig. 4.14). It seems as though the artist has intended to underscore the message of Geiler's text by including the partly naked figure up the tree on the edge of the action. Although the figure is sometimes described as Satan, the crutch suggests that this could only be a Saturn figure, ministering over the scene below him. In the works of spiritual writers from John Chrysostom to Hildegard of Bingen, Nicholas of Cusa, Trithemius and to Luther, melancholy was nothing less than a diabolical vice.[20] By introducing a version of Saturn and his children, the artist communicates the diabolical source of the fantasies and delusions depicted in the image and described in the story, and is also able to link claims about the woman's delusion to a discourse about sexual independence and power.

The range of such visual associations inherent in the iconography of Saturn made him a compelling figure for artists to consider in their representations of witchcraft. Saturn allowed the visionary world of the dead and demons to be linked to fears of the power of sexuality, to the delusions of a disordered and diabolically influenced imagination and also to acts of terrible violence and destruction. Thus Saturn became a compelling, if also confusing figure, who was employed by artists to help establish particular visual codes for witchcraft in the sixteenth century. In the first half of the sixteenth century artists used the iconography of Saturn to integrate their traditional images of invocatory magic with everyday sorcery and also with fears about female sexuality, which arose in the context of the urban moralism of southern Germany and the Netherlands. The bones and body parts that had been used to signal necromancy, sorcery practice and sexual power, were now linked through their association with the stories and iconography of Saturn. The gruesome scarecrow figure of death and destruction, which represents some combination of Saturn, Mars and Moloch in Gerung's mid-century image of idolatry (fig. 3.20), with its range of social disorders and upheavals including witchcraft, points to the overtly more aggressive and destructive role which Saturn assumes in the second half of the sixteenth century.

It was only in the late sixteenth century, it seems, that visual links began to be drawn between the cannibalism of Saturn and witchcraft. Earlier visual representations of witches engaged in cooking or eating human flesh are simply not to be found.[21] The surprisingly slow process by which cannibalism as anthropophagy became part of the visual representation of witchcraft was one in which the figure of Saturn played a significant role. The engravings of Crispin de Passe and Henri Leroy from the 1580s suggest that a critical connection was that between Amerindian cannibals and the figure of Saturn. This would have been facilitated by the popularity of visual depictions of Amerindians as cannibalistic 'savages' from the 1530s and especially after the 1550s. By the beginning of the seventeenth century, readers of texts, images and maps from throughout Europe would have readily identified the native populations of the Americas, and especially the Brasilian Tupinamba, with such deeds. The ritual cannibalism of the Tupinamba had been made particularly famous by the various editions of Hans Staden's illustrated account. The illustrations to his work picked up the main elements of cannibalistic imagery which had become a stock element in the depiction of Brasilian Indians from the early years of the century and had featured widely in the maps of Martin

Waldseemüller, Lorenz Fries, Simon Grynaeus, Sebastian Münster and others. The cannibalism of the Tupi was also graphically illustrated in works by André Thevet and others from the late 1550s, and achieved new status in the widely disseminated narratives of European voyages to America put together and illustrated by Theodore de Bry and his sons between the 1590s and the 1620s. Over the sixteenth century, as I have argued elsewhere, the legs, arms and heads which were exhibited spread out on Amerindian grills or hung from their trees, began to take on meaning through their association with the dismembered bodies and relics of Christian saints, and even with the *ex votos* with which Catholics festooned their sites of healing and pilgrimage.[22] As these broken bodies and body parts became widely symbolic of the dangers threatening the disintegration of Christian societies, witchcraft may also have come to be more frequently imagined and projected as part of that broader threat.

The prints of Crispin de Passe, Henri Leroy and Jan Sadeler were all part of that large and varied pamphlet and travel literature which attempted to construct a new mental geography of the world with Europe at its centre. Just as de Passe represented naked natives as symbols of wildness and savagery by contrasting them with clothed and conquering Europeans, so he identified the representatives of the magical arts and witchcraft through their association with the Amerindians. They were a wild and marginal people, at worst savage and cruel cannibals, who also needed to be ordered, controlled and reformed like the Amerindian natives. In this way, magicians and witches found a new identity and a new cultural significance in late sixteenth-century European culture. They were no longer conflated with the Waldensian heretic of a century earlier, who had to be interrogated and hopefully reformed (figs 2.21, 2.23 and 2.24); they were now conflated with wild indigenes who needed to be civilized. This reflects new European ways of encompassing the expanded world, with its new markets and cultures, by locating it within a specifically European past and present. As Saturn expands his rule out over the borders of Christian Europe, even as far as the new continents, so the cultures of the Americas are adapted and made subordinate to a European worldview. The conflation of witchcraft with Amerindian cannibalism through the agency of the figure of Saturn – together with all those resonances of violence, sexual aggression, disordered imagination and social marginality which were traditionally associated with the figure of the planetary god – simply constituted one aspect of the complex process of merging cultural outsiders at home with foreign natives abroad.

The vast ethnographic project of uncovering and making sense of the New World was matched – it was even to some extent premised on – similar projects at home. The impulse to collect and document social customs and practices within Europe went hand in hand with the travel literature of the period.[23] Already in the 1470s the Carthusian, Werner Rollevinck, had written an account of Saxon customs in his *Praise of Saxony*. In 1518, the Swabian, Franciscus Irenicus (Franz Friedlieb), published his *Interpretation of Germany*, an account of the Germanic tribes from the earliest times until the migrations, which drew heavily on Tacitus. A member of the Teutonic Order in Ulm, Johannes Boemus, published a survey of different regions and their social manners and mores in his 1520 work *On the Customs of All Peoples*. Boemus' book was then reworked for a much broader audience by the Spiritualist printer and soapmaker, Sebastian Franck, in his *Book of the World*, published in 1534. Other important cosmographies were published by Peter Apianus in 1524, Gemma Frisius in 1529 and Sebastian Münster in 1544. One rich example of this new kind of geographic and

ethnological literature, presented for the greater part as a series of *exempla* and suitably peppered with stories drawn from classical and more recent literature, was the *History of the Northern Peoples*, written by the Swedish archbishop, Olaus Magnus, and first published in Rome in 1555.[24]

Olaus Magnus' book was immensely popular during the sixteenth century. An abridged version was published by Cornelius Scribonius in Antwerp in 1558, followed by at least three more Latin editions before the end of the century. Scribonius' abridgement was quickly translated into French, Italian and Dutch in the early 1560s, and a further two Italian translations of the work and one each in Dutch, German and French also appeared in the sixteenth century.[25] Scandinavian peoples had previously appeared infrequently in accounts of the barbarian Germanic tribes, usually referred to as Ostrogoths or Visigoths, or simply as Goths. Tales of these vast and frozen lands of the Gothic north, the geographical and cultural margins which created a kind of bridge between Europe's Christian present and its pre-Christian past, could quickly appeal to that thirst for exoticism and sensationalism which, as we have seen, the new print media attempted to both satisfy and promote. Not surprisingly, an important aspect of Olaus Magnus' *History* was its documentation and condemnation of the superstitions of the Scandinavian peoples and, in particular, the superstitious worship of devils. This included the practice of magic, sorcery and witchcraft, as well as belief in its outcomes and effects, which Olaus primarily explained as the consequence of demonic illusion. The woodcuts that accompany these chapters provide us with keen insight into the relationship between the widespread concern over the practice of witchcraft and this more specific ethnographic literature with its interest in the social customs of the various peoples of the world and their regions.

Olaus Magnus had been consecrated Archbishop of Uppsala in Rome in 1544.[26] However, as a consequence of the political and religious turmoil associated with Gustav Vasa's successful rebellion against Denmark, and Gustav's subsequent election as king and adoption of the Lutheran reform, Olaus had been absent from his native Sweden since 1526. He had spent the years between 1526 and 1544 in Danzig, and then he relocated to the Church Council in Mantua, to Venice, and finally to Rome. He worked in the service of his brother, Johannes Magnus, who preceded him as Archbishop of Uppsala. In 1544, Johannes died and, as his successor, Olaus spent most of his remaining years – first at the Council of Trent (1545–52) and then in Rome (1552–57) – trying to persuade ecclesiastical and secular authorities to regain Sweden for Catholicism. One of the key instruments Olaus used to bring the Swedish question and Swedish history to the attention of these authorities – and to his network of scholarly colleagues and contacts, Italian and European readers, as well as the clergy and nobility within Sweden itself – was the press. In 1553, he installed a printing press in the hospice of St Birgitta in Rome and quickly published a biography of St Birgitta, followed in 1557 with an edition of her *Revelations*. In 1554, he published his brother Johannes Magnus' *History of the Gothic and Swedish Kings* and, in 1557, his *History of the Archepiscopal Seat in Uppsala*, works both written in the 1530s. In 1555, Olaus produced his own *History of the Northern Peoples*, a work that exploited contemporary fascination with prodigies and wonders, as well as the exoticism of distant lands. It drew on decades of Olaus' geographical and classical studies, which were already clearly evident in his *Carta marina*, a modern map of northern Europe with Italian and German descriptions, which was published in Venice in 1539.[27]

A special aspect of Olaus' encyclopaedic *History* of 22 books and 476 chapters is the large number of woodcuts: 481 in total. A substantial number of the woodcuts were heavily based on, if not directly copied from, earlier works. Such works included his own cartographic masterpiece published in 1539, the *Carta marina*, Johannes Magnus' *History of the Gothic and Swedish Kings*, the Tyndale Bible and Ariosto's *Orlando Furioso*, and the work of artists such as Hans Holbein and Hans Sebald Beham.[28] But a large number of woodcuts were clearly produced for this particular work, with the intention of emphasizing what John Granlund has called Olaus' three basic contentions: that 'the North is the home of the god of war, of demon powers and of the cold' – contentions meant to emphasize the cultural contrast between north and south. Granlund has even suggested that Olaus himself made preliminary sketches for some of the woodcuts.[29] This does not seem fanciful, for Olaus' genuine interest in images and the manner in which his work presents a pictorial, as well as literary, account of the geography, human culture and fauna of the Scandinavian north, finds clear expression at the beginning of his preface. Here he describes how he has followed classical travellers such as Democritus and, without the dangers one inevitably confronts on real travels, has placed before peoples' eyes the lands of the frigid north. This is achieved not only by words, but also by images. Olaus includes a long digression on pictorial art, largely drawn from Franciscus Patritius, which stresses the value of the illustrious art of *pictura*, a kind of poetry without words which preserves the memory of the past and incites the viewer to strive after honour and praiseworthy action.[30] In individual chapters of his book, moreover, Olaus sometimes explains his subject by direct reference to the image found at the head of that chapter.[31] Olaus' images were clearly meant to be an integral component of his representation and explanation of this marvellous world at the northern periphery of European civilization, even if a number of later editions reduced the number of Olaus' images very considerably, or omitted them completely.[32]

It is hardly surprising that the images in Olaus' work would include versions of the sorcery beliefs and practices which were so exercising ecclesiastical and secular leaders in Europe in the same period, and that they would be influenced by the iconographical and stylistic emphases adopted for images of European sorcery and witchcraft. The northern peoples' world of magic and sorcery occupies book three, following consideration of the geography, climate and topography in the first two books, and preceding further consideration of social customs, material culture and warfare in the following. The chapter heading 'Concerning the superstitious worship of demons', provides a succinct formulation of the primary motivation driving much of Olaus' work as well as a conceptual framework for his stories and descriptions of Scandinavian magic and sorcery, Scandinavian gods and other related ritual practices, such as human sacrifice. Scandinavian sorcery for Olaus constituted what demonologists would have called the 'art of prestidigitation'. Trickery, deceit, illusion, fraud and phantasm are words that frequently occur in Olaus' descriptions and their success depends on the intervention of demons.[33] While Olaus does not directly cite any demonological works among the many sources he uses, and we have little idea of his views concerning the prosecution of contemporary witchcraft, the trickery and delusion of the devil is a prominent concept in the contemporary discourse of witchcraft, as we have often seen.

The woodcuts in Olaus' *History* that deal with magic, sorcery or witchcraft can be usefully grouped according to the nature of demonic intervention – whether intervention was considered explicit or simply implicit. Divination, for instance, is represented by

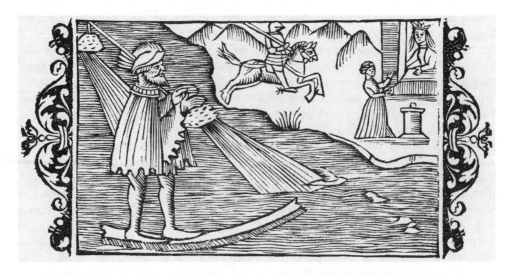

Figure 8.5 *The Magician Holler Crossing the Seas on a Bone Engraved with Fearful Spells*, woodcut, in Olaus Magnus, *Historia de Gentibus Septentrionalibus*, Rome: [Johannes Maria de Viottis], 1555, p. 122. Courtesy of the Division of Rare and Manuscript Collections, Cornell University Library.

a diviner before a king in the 1555 edition, and by four diviners before a king in the 1567 editions.[34] The diviners are surrounded by stars, mountains and fish, which (the text tells the reader) are instruments for foretelling the future – through interpreting the stars of the heavens, the leaping and noise of fish, the music and vapours of the mountains. There is no reference to demonic intervention, neither in the image nor in the text.[35] Likewise, a number of woodcuts depict the feats of various magicians, but provide no visual allusions to overt demonic intervention. There is King Erik, for instance, with his so-called windy hat, depicted by the woodcutter in the shape of a crown. Surrounded by his men, he throws his hat towards the clouds. Whatever direction the hat was turned, the wind would blow precisely from that point. Yet the hat was not the source of Erik's power; his power came from his familiarity with evil demons, the text tells us, whose worship he especially cultivated. There is also the magician Holler, who specialized in marine magic. He is shown crossing the seas on a bone engraved with fearful spells, in the manner of an ancient surfer (fig. 8.5).[36] The text explains that Holler's magical reputation of being able to skim across the water as speedily as though he had wind-filled sails depended on deceit and illusion combined with superstition. In the same chapter, Olaus also tells of another marine magician, Oddo, who was said to have made use of sorcery and 'deceitful spells' ('praestigiosis carminibus') to stir up tempests to destroy enemy ships and walk over churning seas. Both magicians perished at the hands of their enemies.

Another woodcut that cannot easily be understood as a scene of demonic magic without reference to Olaus' text depicts a Finnish sorcerer selling magical knots to becalmed merchants.[37] When the buyer unravelled the first knot he would be provided with gentle winds, with the second knot, stronger winds, and with the third, fierce tempests would be unleashed. Olaus refers to the image as displaying the power of magicians and sorcerers ('maleficorum') in constraining the elements, either through their own incantations or those of others, and this practice is then contextualized by

Figure 8.6 The Giant and Sorcerer Gilbert in a Cave on the Island of Visingsö in Lake Vättern, with his Hands and Feet Bound, woodcut, in Olaus Magnus, *Historia de Gentibus Septentrionalibus*, Rome: [Johannes Maria de Viottis], 1555, p. 124. Courtesy of the Division of Rare and Manuscript Collections, Cornell University Library.

references to how zealously witchcraft ('maleficium') was taught in Finland and Lappland in ancient times – as if Zoroaster himself had been their instructor in 'this damned science'. And not just the Finns and Lapps, but the Britons also seemed to be bewitched by such sorcery, comments Olaus. He then adds one of the key messages for this section of his work: 'so ... does the whole world, having much the same attitude to this and similar practices, indulge in the art of sorcery'.[38]

An image related to the theme of tying and untying, which Olaus' sixteenth-century viewers would have immediately recognized as a form of magical practice, occurs in chapter 20.[39] It depicts an Ostrogoth giant and sorcerer, Gilbert, seated in a vast, dark cave on the island of Visingsö in Lake Vättern (fig. 8.6).[40] His hands, feet and mouth are stuck to wooden staffs, on which runic letters have been engraved. The text tells the reader that Gilbert's own teacher, Kettil, had used magic to fetter Gilbert in punishment for his insolence. Kettil threw Gilbert his magic staff; and as soon as Gilbert caught it, his hands became fixed; and when he used his feet and teeth to try to wrest himself free, they too became fixed. It is somewhat puzzling at first why this story should have been given such prominence and a chapter of its own in the account of the superstitions of the Goths. Also puzzling is why this particular woodcut should have been included in those editions of the work where the total number of woodcuts was drastically reduced and the woodcuts from each book were limited to either two or three. I can only suggest that the image of such a giant/sorcerer whose huge hulk fills almost a whole island, and who has become a victim of the arts which he himself practices, would have fitted well with the sensationalistic purposes of the book and its references to contemporary fascination with the wonders of the exotic and barbarous north. Moreover, the woodcuts which appeared in the fully illustrated 1567 editions, and in those editions with a reduced number of illustrations, would seem to suggest that the prominently displayed magical runes carved into the timber manacles – clearly at least one of the magical instruments used to achieve

223

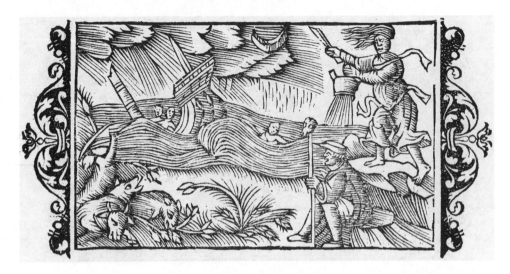

Figure 8.7 *A Female Sorcerer Unleashes a Storm with her Upturned Cauldron, while Another Raises a Horse's Head on a Pole*, woodcut, in Olaus Magnus, *Historia de Gentibus Septentrionalibus*, Rome: [Johannes Maria de Viottis], 1555, p. 117. Courtesy of the Division of Rare and Manuscript Collections, Cornell University Library.

the incarceration of the giant – were also a reason for the woodcut's popularity. Runes were known from the writings of Tacitus and were associated with Anglo-Saxon and Scandinavian magic.[41] So when Olaus Magnus sent a copy of his *History* to Emperor Charles V shortly after its publication, he also sent a dedication to Charles and a runic alphabet to his adviser, Nicolas Perrenot de Granvella.[42]

Olaus dedicates a separate chapter to female sorcerers. The accompanying woodcut does not feature a particular individual or *exemplum* from the chapter, as in most other cases; it presents female sorcerers as a type, and then explains the image in the text. The woodcut depicts a female sorcerer on a cliff, with her hair streaming out in front of her, brandishing a knife in one hand and an upturned pot or cauldron in the other (fig. 8.7).[43] From the pot she unleashes a torrid storm that causes masts to snap and ships to sink, passengers to be thrown overboard and drowned, trees to be stripped of their branches and animals to be terrified. The image shows the woman with a pot, Olaus explains, because this is the most common utensil used by female witches ('maleficarum'). In it they boil up their juices, herbs, reptiles and entrails, entice the idle to their schemes, and speed up ships, horse riders and runners. They also set horses' heads on poles with their teeth bared – as depicted at bottom right of the woodcut – in order to excite fear in enemy soldiers.[44] While certain elements of the woodcut, such as the brandished knife and possibly even the horse's head on a pole, might have been considered as exotic, the flying hair and cauldron, together with the raising of a storm, are well-known visual cues which would have clearly identified this figure as a contemporary witch. And the horse's head, though displayed on a pole only in the work of Lucas Cranach (figs 4.4, 4.6, 4.13), was generally well known in the form of a skull in sixteenth-century scenes of witchcraft (figs 1.1, 1.13, 2.1, 3.2). While the images of male sorcery in Olaus' work were quite varied and would have appeared somewhat exotic and idiosyncratic for a sixteenth-century reader, female magic conformed far more to a well-known stereotype. The

Figure 8.8 *A Shaman in a Trance Procuring Information about a Distant Acquaintance*, woodcut, in Olaus Magnus, *Historia de Gentibus Septentrionalibus*, Rome: [Johannes Maria de Viottis], 1555, p. 121. Courtesy of the Division of Rare and Manuscript Collections, Cornell University Library.

female witches of the pagan north might well demonstrate some cultural peculiarities, but they were clearly not that different to the contemporary witch of Christian Europe.

One woodcut in Olaus' book depicts a form of sorcery practice not generally documented in European iconography, namely the use of demons in shaman-like trances to procure information across distance (fig. 8.8). The purpose of this form of magic was not unlike that of the crystal-gazer, although the techniques were quite different.[45] The woodcut is located at the beginning of chapter 17, 'On magical implements used in Bothnia'.[46] Olaus' maps locate Bothnia in north Sweden and Finland, and Lapplanders and Finns are described in his text as having particular expertise in such shamanistic techniques. The male figure lying on the floor in this woodcut is a shaman in a trance.[47] He is acting on behalf of a client who wishes to know the condition of a distant acquaintance. He has entered the dark room with his wife or another companion and has struck a prescribed number of hammer-strokes on either the brass frog or the serpent, both displayed in the background. Then, while reciting charms, he has spun himself round and round, until he falls down in a trance, lying on the floor as though dead. This is the stage of the ritual depicted in the woodcut. The shaman's spirit now leaves his body through the power of charms and, led by an evil demon, sets off to procure the information required by his client. When the spirit returns, it brings back not only the information, but also some other token of a successful mission, such as a ring or a knife. The female figure shown with the knife and lighted torch above the magician may therefore represent the returned spirit of the shaman with his token. But her stance suggests she is more likely to be his wife or companion, who is described as guarding him from every living creature while his spirit is absent from his body.

The small vessel on a fire in the bottom left corner is not mentioned in Olaus' description. It would seem to represent the artist's attempt to employ a common visual cue that would immediately identify the scene for his viewers as a work of witchcraft. And this is

225

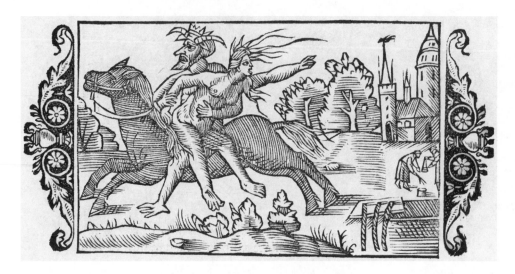

Figure 8.9 The Devil Abducts the Witch of Berkeley, woodcut, in Olaus Magnus, *Historia de Gentibus Septentrionalibus*, Rome: [Johannes Maria de Viottis], 1555, p. 126. Courtesy of the Division of Rare and Manuscript Collections, Cornell University Library.

an identification supported by Olaus' text, which describes shamans as witches and magicians ('malefici et magi') and their technique as illusion ('praestigia', 'modus praestigiandi'). Indeed, it is significant that in the abbreviated editions of Olaus' work first published in 1558 by Scribonius, this particular woodcut was chosen to illustrate the epitome of book three.[48] Shamanic trances represented a form of magic or sorcery that was clearly peculiar to societies in Europe's far north and its iconography was significantly distinct from the iconographies of sorcery and witchcraft developed throughout mainland Europe. But the woodcut also included a cauldron on a fire and thus created an appreciable link between exotic forms of sorcery on the periphery of Europe and accepted visual codes for witchcraft. The shamanistic magic of the Lapps and Finns could well be regarded as simply one more version of a diabolic art that was being slowly discovered in one region of Europe after another.

In the editions of the *History* that included the full complement of illustrations, one woodcut testified very clearly to the links Olaus was attempting to draw between the sorcery of the northern peoples and contemporary witchcraft. This was an image of the witch of Berkeley (fig. 8.9), which accompanied chapter 21, 'On punishment of witches'.[49] Olaus included the whole story in detail so that readers would not think that only sorcerers or witches from the northern regions would meet the terrible fate of the imprisoned giant, Gilbert, who was the subject of the previous chapter. Here was the story of a witch from an English village, he claimed, that exemplified how all those who rely on the tricks of evil demons will meet a terrible fate at their hands. The source for Olaus' account was Vincent of Beauvais' *Speculum Historiale*, a version of the twelfth-century *exemplum* originally found in William of Malmesbury's writings, which had been published in at least eight printed editions by 1546.[50] Illustrations of the devil taking the evil woman off on his horse after having broken open her coffin were well known in the sixteenth century, as we have already seen. The two versions of the wooduct included in the five editions of Schedel's *Nuremberg Chronicle* (fig. 2.20) must have made the image widely known in Europe in the

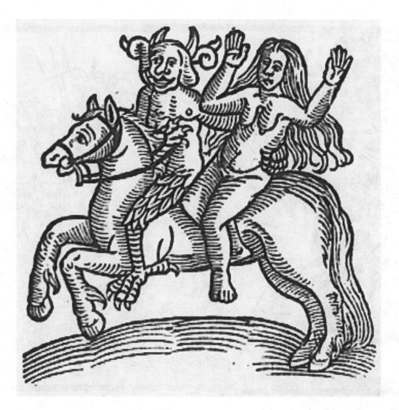

Figure 8.10 The Devil Abducts the Witch of Berkeley, woodcut, in Conrad Lycosthenes, *Prodigiorum ac Ostentorum Chronicum*, Basil: Adam Henriepetri, 1557, p. 378. HAB, Wolfenbüttel [39 Phys. 2°].

first half of the century. Then, in 1557, Conrad Lycosthenes included a version in his *Book of Prodigies* (fig. 8.10), which was clearly modelled on the woodcut in the *Nuremberg Chronicle*. The version in Olaus' *History* develops the earlier iconography in a more narrative fashion, paying closer attention to the actual text. The village church, the coffin with its broken chains, the black horse with iron hooks protruding from it upon which the body of the witch was placed, are all presented graphically for the reader. Most especially the artist conveys something of the terror and violence of the diabolical abduction scene, having possibly learnt from masterpieces of the genre such as Dürer's etching of *The Abduction of Proserpine on a Unicorn* (1516). The woodcut included in the 1567 editions (fig. 8.11), while artistically far more primitive, emphasizes these narrative elements even more. Here the principal devil is shown with the other demons, who had been unable to break the strongest chains which bound the stone to the top of the tomb.

The depiction of the devil or demon who abducts the witch of Berkeley in the *History* woodcuts bears characteristics very similar to the demonic figures found in the woodcuts to chapter 22, 'On the services performed by demons' (fig. 8.12),[51] and to chapter 11, 'On the nocturnal dance of elves, that is, spectres' (fig. 8.13).[52] In the image depicting the different services provided by demons, the viewer sees demons sweeping out stables, finding treasure in a mine, transporting individuals and even wagons through the sky,

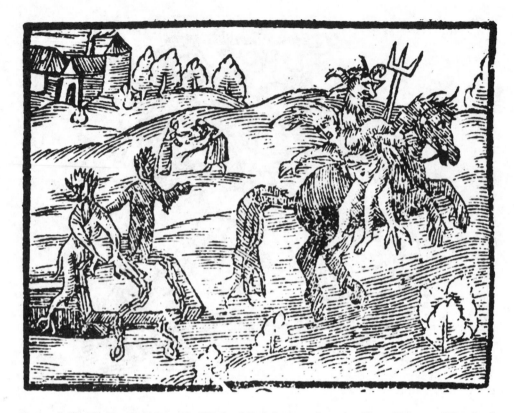

Figure 8.11 *The Devil Abducts the Witch of Berkeley*, woodcut, in Olaus Magnus, *Historia de Gentium Septentrionalium variis conditionibus statibusque*, Basel: Adam Henricpetri, 1567, p. 119. HAB, Wolfenbüttel [A: 77 Quod.].

and creating winds for travellers in ships. But as the text clarifies, in these thousands of ways demons delude humans and draw them to dangerous errors. In fact, throughout the northern lands – which are specified as 'in a literal sense the abode of Satan' – demons assault and do damage to the lands and their inhabitants, killing their cattle, destroying their fields and ruining their castles and watercourses. It is precisely these demons, the supposed supporters of human beings, and often in human guise, who generate human destruction.

Demonic beings in human shape who provide various services to human beings are also mentioned at the end of chapter 11, where they are identified with the fauns, satyrs and elves who dance in circles at night.[53] The woodcut of the nocturnal dance of demonic elves represents these creatures in their different forms – most of them as satyrs, one with webbed feet, a number with tails (the bagpipe player's tail doubling as a penis), females as well as males. There is no evidence to support the view that Olaus has included witches in this gathering, let alone that this is a representation of a Sabbath dance.[54] As Olaus' text makes clear, demons appear in a variety of guises and are given different names by various authorities such as Saxo, Virgil, Horace, Ovid and Pomponius Mela. They appear as satyrs, fauns, elves, spectres, fairies, shades, ghosts, harpies and so on, and they also appear in human shape. Some claim, adds

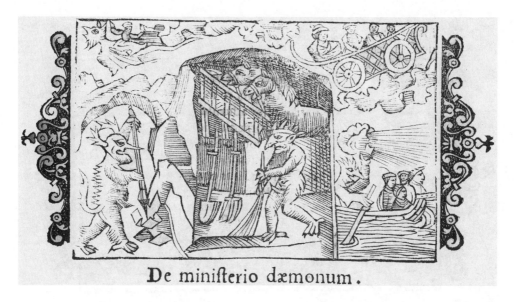

De minifterio dæmonum.

Figure 8.12 Demons Perform Different Services, woodcut, in *Historia de Gentibus Septentrionalibus*, Rome: [Johannes Maria de Viottis], 1555, p. 126. Courtesy of the Division of Rare and Manuscript Collections, Cornell University Library.

Olaus, that they are the souls of those who, having devoted themselves to bodily pleasures, now wander around the earth in corporeal form.[55] This is another variant, and to some extent amalgam, of those processions of people and phantoms of the night found in local and regional folklores.[56] For sixteenth-century authorities they are increasingly identified with the demonic – and witches are also counted among their number. At the beginning of this chapter Olaus refers to such sights as 'well known' to night travellers and shepherds. It is 'a monstrous, nocturnal game' which the inhabitants of the northern regions call 'the dance of the elves' ('Chorea Elvarum'). The sexual proclivities of these dancers are not simply registered in the text, they are given graphic exposure in the image (fig. 8.13). Bagpipe and lute, common metaphors for male and female sexuality are prominently displayed; and the message is underscored by the snake of the male dancer on the left and the flower of the female dancer on the right. The ring, around which the dancing couples cavort, is an impression created by their extraordinary heat.

This woodcut of the nocturnal dance of the elves became an important image for developing an iconography in the later sixteenth century that would help integrate the gatherings and dances of the various spirit-figures of regional folklore and classical mythology with the rituals of the witches' Sabbath of the demonologists. The woodcut in the 1567 editions of the *History*, by an artist who signed himself CG, gives expression to such a shift (fig. 8.14). First, the male and female couple positioned towards the top of the circle in the earlier woodcut has been replaced by a trio of male demons. Second, this trio has now taken on an authoritative and officiating role in the proceedings, rather than simply representing a couple motivated by lust. The two couples dancing below have clearly become subordinate to their demonic masters above. And third, the satyr figures have become appreciably more grotesque and demonic, while two of the dancers below

DE SVPERSTITIO. CVL. DAEMO.

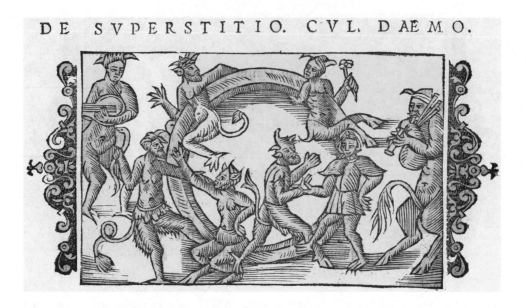

Figure 8.13 The Nocturnal Dance of Elves, woodcut, in Olaus Magnus, *Historia de Gentibus Septentrionalibus*, Rome: [Johannes Maria de Viottis], 1555, p. 112. Courtesy of the Division of Rare and Manuscript Collections, Cornell University Library.

could well be identified as female. Thus the stage was set for adapting the elves' dance of Scandinavian folklore into the Sabbath dance of witches and their diabolical paramours.

In 1593, when Sebastian Henricpetri, the son of the printer who had used the woodcut of the elves' dance in the 1567 German edition of Olaus' *History*, used this same woodcut again on a new titlepage, the melding of these two traditions was complete. The image was now the titlepage woodcut for a new work on witchcraft, *Christian Thoughts and Reflections on Sorcery*, by Hermann Witekind (alias Augustin Lercheimer), professor of Greek and mathematics and rector of the University of Heidelberg.[57] As a titlepage woodcut, the image would now have far greater public exposure. Most importantly, an overt association had been created between its content and the subject of sorcery and witchcraft. Loosed from its earlier context in Olaus' *History*, where it illustrated Scandinavian beliefs about elves, the woodcut could now be understood as the representation of a Sabbath dance of demons with witches under the leadership of Satan and his two demonic assistants. This is clearly seen by the fact that more than 30 years later, in 1628, when the Henricpetris published a new edition of Sebastian Münster's *Cosmography*, they chose the woodblock again to illustrate a dance of the evil spirits said to have occurred near Plauen in 1478.[58]

The 'diabolization' of Scandinavian folk beliefs went hand in hand with the burgeoning devil literature of the second half of the sixteenth century. Indeed there are some compositional and iconographical similarities between the 1567 woodcut by CG (fig. 8.14), which was recycled in Witekind's 1593 work, and the illustration by Jost Amman which was used as the titlepage to the 1569 and 1575 editions of Sigmund Feyerabend's collection of devil literature, the *Theatre of Devils* (fig. 8.15).[59] In an oval cartouche three devils face the viewer with the others grouped around them in a circle,

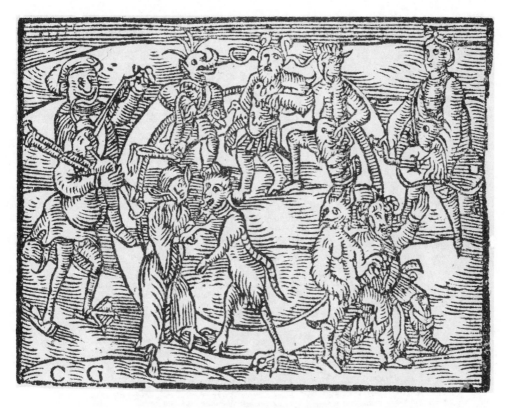

Figure 8.14 Master CG, *The Nocturnal Dance of Elves and Demons*, woodcut, in Olaus Magnus, *Historia de Gentium Septentrionalium variis conditionibus statibusque*, Basel: Adam Henricpetri, 1567, p. 107. Courtesy of the Division of Rare and Manuscript Collections, Cornell University Library.

and two female consorts are also included among this bizarre group, representative of drinking, gambling, trouser-devils and their like, with their curious body shapes and flamboyant dress. Together with this christianizing of folk belief, which brought with it a hardening of attitudes towards those outside the community of Christian believers, the figure of the witch also seems to have become more aggressive, as greater emphasis was given to her destructiveness and violence. There are some powerful examples of such aggression from the first half of the century, including Agostino Veneziano's *The Carcass*, with its image of a wild female figure crushing the life out of the children before her (fig. 5.1), and images depicting the violent murders of Aristomenes and Pelias (figs 5.19, 5.20). But it is in the work of Jacques de Gheyn II and other seventeenth-century artists that such destructive images proliferate. The identification of witches as 'children' of Saturn and siblings of Amerindian cannibals is part of this development, particularly that most horrific characteristic of Saturn's cannibalism, the eating of his own children. Similar to Saturn, the witch figure is the evil mother who transgresses not only the moral strictures of Christian doctrine, but also the instincts of human nature itself, and gives way to the most horrible form of infanticide.

That the destruction, infanticide and cannibalism of the witch in the late sixteenth century were not just considered variations of those other terrible stories of murder and

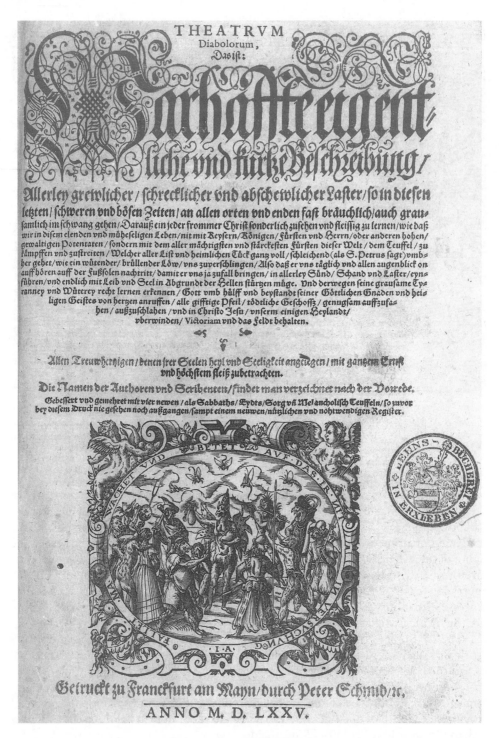

THEATRVM
Diabolorum,
Das ist:

Warhaffte eigent
liche vnd kurtze Beschreibung/

Allerley grewlicher/ schrecklicher vnd abschewlicher Laster/ so in diesen
letzten/ schweren vnd bösen Zeiten/ an allen orten vnd enden fast bräuchlich/ auch grau-
samlich im schwang gehen/ Darauß ein jeder frommer Christ sonderlich zusehen vnd fleissig zu lernen/ wie daß
wir in disem elenden vnd mühseligen Leben/ nit mit Keysern/ Königen/ Fürsten vnd Herrn/ oder anderen hohen/
gewaltigen Potentaten/ sondern mit dem aller mächtigsten vnd stärckesten Fürsten dieser Welt/ dem Teuffel/ zu
kämpffen vnd zustreiten/ Welcher aller List vnd heimlichen Tück gantz voll/ schleichend (als S. Petrus sagt) vmb-
her gehet/ wie ein wütender/ brüllender Löw/ vns zuverschlingen/ Also daß er vns täglich vnd allen augenblick on
auffhören auff der fußsolen nachtritt/ damit er vns ja zufall bringen/ in allerley Sünd/ Schand vnd Laster/ eyn-
führen/ vnd endlich mit Leib vnd Seel in Abgrundt der Hellen stürtzen müge. Vnd derwegen seine grausame Ty-
ranney vnd Wüterey recht lernen erkennen/ Gott vmb hülff vnd beystandt seiner Göttlichen Gnaden vnd hei-
ligen Geistes von hertzen anruffen/ alle gifftige Pfeil/ tödtliche Geschoß/ genugsam auffzufa-
hen/ außzuschlahen/ vnd in Christo Jesu/ vnserm einigen Heylandt/
vberwinden/ Victoriam vnd das feldt behalten.

Allen Treuwhertzigen/ denen jrer Seelen heyl vnd Seeligkeit angelegen/ mit gantzem Ernst
vnd höchstem fleiß zubetrachten.

Die Namen der Authoren vnd Scribenten/ findet man verzeichnet nach der Vorrede.

Gebessert vnd gemehret mit vier newen/ als Sabbaths/ Eydts/ Sorg vnd Melancholisch Teuffeln/ so zuvor
bey diesem Druck nie gesehen noch außgangen/ sampt einem newnen/ nützlichen vnd nohtwendigen Register.

Getruckt zu Franckfurt am Mayn/ durch Peter Schmid/ tc.

ANNO M. D. LXXV.

Figure 8.15 Jost Amman, *A Diabolical Assembly*, titlepage woodcut, in Sigmund Feyerabend,
ed., *Theatrum Diabolorum, Das ist Wahrhaffte eigentliche und kurze Beschreibung*,
Frankfurt a.M.: Peter Schmid, 1575. HAB, Wolfenbüttel [S: Alv.: Ga 14a 2°].

madness, which circulated in sensationalistic broadsheets in the later sixteenth century, is suggested by a little noticed series of allegorical images created by the Zurich artist, Christoph Murer, from the mid-1580s through to the second and third decades of the seventeenth century. Adapting the original imagery of his master, south German artist Tobias Stimmer, Murer created these images to represent the figure of Innocence in the prolific emblem literature of the period.[60] The first was a pen-and-ink roundel created as early as 1585, when Murer was still a journeyman in the service of Stimmer in Strasbourg (fig. 8.16). The image was incorporated into a stained-glass window featuring an allegory of good government and justice, which Murer designed for the Nuremberg city council in 1598.[61] It was also the subject of two further drawings – one possibly from the 1590s and another design dated 1608 – and an etching, probably also dated 1608. The latter was originally intended as an illustration for a monumental drama concerning the persecuted Christian community of Edessa in Mesopotamia at the time of the Arian Emperor Valens, which Murer was writing from the 1590s, but in the end the etching was published only after Murer's death in 1622 by his brother's son-in-law, Johann Heinrich Rordorf, in a collection of 40 *Emblemata*.[62]

All of these images by Murer depict Innocence as a golden-haired, male child, naked and chained to a marble slab, protected by the figure of Justice with her sword and scales above, and attacked by the vices around him. On the left an older male figure lunges, slicing a heart with a knife. The circular badge on his right shoulder clearly identifies him as a Jew. To the right, a female figure grabs the child's hair as though to steady him for the thrust of the knife; her wild hair and sagging breasts are the stereotypical attributes of the sixteenth-century witch. Behind is a heavily armed warrior directing his halberd at the defenceless child, and on the other side a king, labelled a judge in some of the images, covers his face with his hands to prevent himself from witnessing the terrible scene. The older male figure is clearly a personification of avarice, whereas the female represents envy and the warrior the furies of war. Turning a blind eye is a figure of princely authority. As Thea Vignau-Wilberg has shown, this is a well-worked allegorical depiction of the virtues and vices. Yet one also needs to recognize the contemporary visual referents from which the allegory has been constructed. The figure with the knife is not simply a representation of avarice, he is also a representation of the Jew as ritual murderer, who murders Christian children to make use of their blood in Jewish magic, just as he murders the Christ-child in the form of the host.

The object of this attack, Innocence, clearly represents the Christ-child, a figure that was widely disseminated from the late fifteenth century onward through visual images of the child-martyr Simon of Trent and other alleged victims of Jewish ritual murder.[63] In the *Nuremberg Chronicle*, Simon was depicted being held up by a number of Jews while the major perpetrator of this evil, Moses, punctures his body with a knife in order to collect his blood in a bowl below. In Murer's image he is also approached by a Jew with the same circular badge on his garment cutting the child's heart with his knife. But Murer's Christ-child also resembles other images of Simon, which depict him lying flat and exposed on a bench, surrounded by the instruments of his passion and martyrdom. The assistant to the Jew/Avarice figure is not simply a personification of envy; she is Envy in the form of a witch. Not only does this identification reflect the critical manner in which envy features as a key emotion in the social experience and construction of the witch, it represents the witch as an old and dried-up post-menopausal mother, an assistant and accomplice of the Christ-killing Jew. Though Jews could never be technically accused of witchcraft, they

Figure 8.16 Christoph Murer, *Innocence as a Chained Child, Protected by Justice and Attacked by the Vices*, pen and ink with a grey wash, design for a stained glass window, 1585. © 2006 Kunsthaus Zurich.

were the traditional children of Saturn and disciples of Satan, and the discourse of witchcraft, with its Sabbaths and its synagogues, was shot through with the anti-Jewish rhetoric and polemic of Christianity. In league with the warrior behind, the Jew and the witch in Murer's image are a powerful combination, an evil father and mother about to destroy a radiant infant. This is a counter-nativity scene, complete with a wise king and a soldier who has succeeded in finding the child Herod wished to destroy. It also draws added cultural meaning from the contemporary homologies of family and state as elaborated in the social and political discourse of the late sixteenth century.

The subject of Murer's images preoccupies him over a relatively long period – as a young artist under the strong influence of his master, Tobias Stimmer, in the mid-1580s;

again in the later 1590s when he is writing his drama on the persecuted Edessa commu-
nity and completing his set of four stained-glass windows for the Nuremberg council;
and finally in the first decade of the seventeenth century, when the public performance of
his Edessa drama was not supported by the Zurich authorities because of fears of confes-
sional tension and Murer sought to have it circulate as a printed work with illustrations.
The coupling of witch and Jew as a threat to golden-haired, Christian Innocence, is
symptomatic of how the witch had been visually integrated into traditional Christian
iconography over the previous century. The witch is at once the figure of the wild, the
destroyer identified with those uncivilized and pagan peoples beyond the borders of
Christian Europe, whether in contemporary geographical space or in distant, pre-
Christian time. But she is also a figure like the Jew, at the very heart of Christian Europe,
the 'other' against which every community, household and individual needs to protect
itself. Indeed she is an even more dangerous threat than the Jew, because she cannot be
so readily identified. This emphasis on the perverted and destructive nature of witchcraft
at the end of the sixteenth century seems to point to a terrifying anxiety at the heart of
Christian communities, after more than half a century of escalating violence in their reli-
gious wars at home and in their colonial conquests abroad, and as they are propelled
headstrong towards the further brutalities and violence of the Thirty Years War. Just like
the murderous Jew through much of the late Middle Ages, the cruel and savage witch
has also become a terrifying projection of European fears about the destruction of its
integrity and innocence.

NOTES

INTRODUCTION

1 Among the vast literature on witchcraft in early modern Europe, some of the most important recent English-language titles – many of which have guides to foreign-language literature – are: Purkiss, *The Witch in History*; Sharpe, *Instruments of Darkness*; Clark, *Thinking with Demons*; Clark, *Languages of Witchcraft*; Kors and Peters, *Witchcraft in Europe*; Ankarloo and Clark, *Witchcraft and Magic in Europe*; Briggs, *Witches and Neighbours*; Stephens, *Demon Lovers*; Waite, *Heresy, Magic, and Witchcraft*; Behringer, *Witchcraft Persecutions*; Behringer, *Witches and Witch-hunts*; Roper, *Witch Craze*; Levack, *Witch-hunt*.

2 Trevor-Roper, *The European Witch-craze*; Thomas, *Religion and the Decline of Magic*; Midelfort, *Witch Hunting in Southwestern Germany*; Cohn, *Europe's Inner Demons*; Kieckhefer, *European Witch Trials*; Monter, *Witchcraft in France and Switzerland*; Peters, *The Magician, the Witch, and the Law*.

3 The phrase is taken from Levack, *Witch-hunt*, p. 27.

4 Night flight only featured in some of these early accounts; and Michael Bailey ('The Medieval Concept', 433–5) regards it as a secondary or ancillary element of the Sabbath.

5 Stafford, *Body Criticism*, p. 6. Amongst the growing number of studies exploring the visual in early modern European history, see Edgerton, *Pictures and Punishment*; Porter, 'Seeing the Past'; Freedberg, *The Power of Images*; Zapalac, *'In His Image and Likeness'*; Scribner, *For the Sake of Simple Folk*; Scribner, 'Ways of Seeing', pp. 93–117; Scribner, *Religion and Culture in Germany*, pp. 104–45; Merback, *The Thief, the Cross and the Wheel*; Silver, 'Nature and Nature's God'; Zika, *Exorcising our Demons*, pp. 523–51; Spinks, 'Monstrous Births'. On theories of the image and visual culture more generally, I have been especially influenced by Bryson, 'Semiology and Visual Interpretation'; Bryson, Holly and Moxey, *Visual Culture*; Moxey, *The Practice of Theory*; Stafford, *Artful Science*; Mitchell, *Picture Theory*; Clayson, 'Materialist Art History'.

6 Schade, *Schadenzauber*. An earlier compilation of images was Givry, *Witchcraft, Magic and Alchemy*, first published in French in 1929; while the 1973 exhibition catalogue by Maxime Préaud, *Les sorcières*, marked a new level of interest in such images.

7 Schade, 'Kunsthexen – Hexenkünste'. For a much shorter survey, concentrating on the sixteenth and seventeenth centuries, see Zika, 'Art and Visual Images', pp. 59–63.

8 See their studies in the list of works cited.

9 Another recent art historical study to stress artistic inventiveness as the basis of Baldung's interest in witchcraft, but for quite different reasons to Linda Hults, is Margaret Sullivan, 'The Witches of Dürer and Hans Baldung Grien'.

10 Swan, *Art, Science and Witchcraft*; Hults, *The Witch as Muse*. Although Hults's book is predominantly concerned with seventeenth- and eighteenth-century artists, apart from Baldung and his circle she gives brief attention to Cornelisz van Ooststanen and Pieter Bruegel.

11 Davidson, *The Witch in Northern European Art*.

12 See especially Schild, 'Hexen-Bilder'.

13 For printing, see especially Eisenstein, *The Printing Press*; Eisenstein, *The Printing Revolution*; Chartier, *The Cultural Uses of Print*; Watt, *Cheap Print and Popular Piety*; Scribner, *For

the Sake of Simple Folk; Walsham, *Providence in Early Modern England*, pp. 8–64; Füssel, *Gutenberg and the Impact of Printing*.

14 For early printmaking, see Landau and Parshall, *The Renaissance Print*; Parshall and Schoch, *Origins of European Printmaking*.

15 Such themes have been the recent focus of Hults, *The Witch as Muse*, and Swan, *Art, Science and Witchcraft*.

CHAPTER 1 FASHIONING A NEW VISUAL LANGUAGE FOR WITCHCRAFT

1 For the development of the chiaroscuro technique, see Landau and Parshall, *The Renaissance Print*, pp. 184–202.

2 Mende, *Hans Baldung Grien*, pp. 20–21. For Baldung's life and career, especially see Mende, *Hans Baldung Grien*; Bernhard, *Hans Baldung Grien*, pp. 9–83; von der Osten, *Hans Baldung Grien*; Brady, 'The Social Place of a German Renaissance Artist', 295–315; Marrow and Shestack, *Hans Baldung Grien*; Durian-Ress, *Hans Baldung Grien*.

3 For analysis of this woodcut, Radbruch, *Elegantiae Juris Criminalis*, pp. 33–5; Marrow and Shestack, *Hans Baldung Grien*, pp. 114–19; Schade, *Schadenzauber*, pp. 54–61; Hults, 'Baldung and the Witches of Freiburg', 251–5; Koerner, *The Moment of Self-portraiture*, pp. 323–33; Hults, *Witch as Muse*, pp. 75–85; Durian-Ress, *Hans Baldung Grien*, pp. 174–7 (which includes reproductions of two chiaroscuro woodcuts).

4 For a rich example of this idea, see Wolf Traut's woodcut, *The Mass of St Gregory, with the Crucified Christ as the Origin of the Seven Sacraments* (*c*.1510). Traut was a member of the Dürer workshop at the same time as Baldung.

5 See below at fig. 1.12.

6 Mâle, *Religious Art in France*, pp. 302–11; Roques, *Les peintures murales du sud-est de la France*, pp. 46–50, 158, 239, 263, 332, 382, 387; Katzenellenbogen, *Allegories of Vices and Virtues*; Zika, *Exorcising our Demons*, pp. 308–10.

7 For the sexual connotation of open legs in linguistic usage, Roper, *Oedipus and the Devil*, p. 68; Kratz, 'Über den Wortschatz der Erotik', pp. 516–19. For lighting torches from genitals, Zika, *Exorcising our Demons*, pp. 275–8.

8 For carnival sausages as phalluses, see Peter Burke, *Popular Culture*, p. 187. For the linguistic interchange in carnival literature, Schade, *Schadenzauber*, p. 148, n. 430; Bax, *Hieronymus Bosch*, pp. 228–30. One graphic example of this use of sausages is in Erhard Schön's 1533 broadsheet, *Coat of Arms of the Land of Cockaigne* (Geisberg/Strauss, vol. 3, p. 1137). Also note a passage from *Vom Ehebruch Hürerey*, cited in Ozment, *When Fathers Ruled*, p. 56 at n. 20: 'How many respectable young girls go about with their bellies swollen by unroasted bratwursts.'

9 *Malleus Maleficarum*, part 2, q. 1, ch. 7. For a new reading of the significance of penis stealing by witches in the *Malleus*, see Stephens, *Demon Lovers*, pp. 300–21.

10 Kratz, 'Über den Wortschatz der Erotik', pp. 130–34; Müller, *Schwert und Scheide*, pp. 87–90.

11 For the most detailed listing of *Malleus* editions, see Kramer, *Malleus Maleficarum*, ed. Schnyder, pp. 1–23.

12 *Tractatus perutilis de phitonico contractu*, Strasbourg, 1499.

13 See below at fig. 2.1.

14 For these drawings, see especially Hults, 'Baldung and the Witches of Freiburg'; Hults, *The Witch as Muse*, pp. 85–96; Durian-Ress, *Hans Baldung Grien*, pp. 184–9 (in which they are reproduced in colour).

15 These details are more clearly visible in the copy by Urs Graf (fig. 3.7).

16 Scribner, *For the Sake of Simple Folk*, pp. 197–200; Meier, 'Der Rosenkrantz', 296–303. I am not convinced by the interpretation of Hults ('Baldung and the witches of Freiburg', 255), who understands this rosary as an attack on Marian devotion and its Dominican promoters such as Jakob Sprenger. This seems less likely with the growing view that Sprenger had little or no role in writing the *Malleus*.

17 This is especially stressed by Koerner, *The Moment of Self-portraiture*, p. 335.

18 For this reading and its relationship to Brant's Venus and the Virgil story I am indebted to Schade, *Schadenzauber*, p.104.

19 Brant, *The Ship of Fools*, ch. 13: 'Venus mit dem strohernen Steiß' refers to the highly inflammable nature of lust. Of the 13 German editions of the *Ship of Fools* published by 1512, three were published in Strasbourg in 1494, 1497 and 1512. See Aurelius Pompen, *The English Versions of the Ship of Fools*.

20 Roper, 'Mothers of Debauchery'.

21 Lauts, *Hans Baldung Grien*, p. 276; Bartrum, *German Renaissance Prints*, pp. 69–71.

22 Landau and Parshall, *The Renaissance Print*, pp. 31–2 provide estimates of editions from woodblocks and metal plates as between 50 and several thousand.

23 Seven of these series are found in Schramm, vol. 5, pl. 77; vol. 8, pl. 195; vol. 9, pl. 96; vol. 13, pl. 66; vol. 16, pl. 78–9; vol. 21, pl. 125; vol. 22, pl. 130, 192. Schramm's reproductions of illustrations from Cornelius von Ziericksee's Cologne edition are taken from two different editions by that printer.

24 Newly illustrated editions which went under the name of *Hexenmeysterey* were published in Strasbourg in 1544, 1545 and 1575. Editions without illustrations were published in Paris (1500, 1561), in Cologne (1576, 1595) and in Frankfurt (1576).

25 For Molitor and his work, see Ziegeler, *Möglichkeiten der Kritik*, pp. 111–36; Schade, *Schadenzauber*, pp. 25–31; Molitor, *Schriften*; Maxwell-Stuart, *Witchcraft*, pp. 32–42.

26 Ziegeler, *Möglichkeiten der Kritik*, pp. 82–110; Ammann, 'Der Innsbrucker Hexenprozess von 1485', 3–87; Wilson, 'Institoris at Innsbruck', pp. 87–100; Broedel, *The Malleus Maleficarum*, pp. 1–19.

27 It features as titlepage in four Cologne editions: Cornelius von Ziericksee, *c*. 1496–1500; in Leipzig: Arnold von Köln, 1495; in Basel, *c*. 1510. It is repeated in the four Cologne editions and in two editions of Basel: Johann Amerbach, 1490–95.

28 *The Laws of the Salian Franks*, trans. Drew, pp. 125, 199.

29 Nider, *Formicarius*, book 5, ch. 4; *Malleus Maleficarum*, part 2, q. 1, ch. 15.

30 Kieckhefer, *European Witch Trials*, pp. 61–3, 74, 76; Zika, *Exorcising our Demons*, pp. 163–6.

31 Labouvie, 'Perspektivenwechsel', pp. 48–9; Accati, 'The Spirit of Fornication', pp. 110–15.

32 The titles of almost all Latin editions of Molitor's work use the word 'laniae' (from 'laniare' - tear apart, butcher), rather than the more expected and often incorrectly cited 'lamiae'. For a discussion of these terms, see Leutenbauer, *Hexerei- und Zaubereidelikt*, pp. 5–6, 14.

33 An exception to the flowing hair is found in the Zainer edition, where the witch wears a scarf (Schramm, vol. 5, pl. 416).

34 For the 1491 version, see Zika, '"Magie"–"Zauberei"–"Hexerei"', p. 350. A later version (*La grant danse macabre des femmes hystoiriée*, Paris: Mathieu Husz, 1499) uses a close copy of the woodcut in the 1491 edition. For the manuscript version, *The Danse Macabre of Women*, ed. Harrison, pp. 15–16, 21–2, 39, 110–11. The other attribute of the witch in the manuscript version is the broom, a feature found only in French images in this period.

35 The other versions of the woodcut, with the exception of the Zainer edition, have the witch shooting what looks like a splayed stick.

36 Ebermann and Bartels, 'Zur Aberglaubensliste', 125–6; Stöber, *Zur Geschichte des Volks-Aberglaubens*, p. 64.

37 *Malleus*, part 1, q. 1, chs 8–10; part 2, q. 1, ch. 9.

38 The ass features widely in the various woodcut series of the *Ship of Fools*. For the rooster and folly, see *La Folle*, in *Grant danse macabre des femmes*, Paris: Guy Marchant, 1491, fol. B3ᵛ, which is reproduced in *The Danse Macabre of Women*, ed. Harrison, p. 40; the woodcut by Jörg Breu the Elder, from Johann von Schwarzenberg's *Ain Büchle wider das zütrincken* of 1535 and 1538, is reproduced in Hollstein, vol. 3, p. 182. Also Bax, *Hieronymus Bosch*, pp. 190–91.

39 For the Zainer woodcut, see Zika, *Exorcising our Demons*, p. 325, fig. 40. In two editions the witch is also shown gesturing with his right hand, casting the spell referred to in the text (Schramm, vol. 8, fig. 928; vol. 13, fig. 334).

40 *De laniis*, fol. d2ʳ; *Von den Unholden*, fol. F4ᵛ.

41 Thomas Murner, *Schelmenzunft*, Strasbourg: Beatus Murner, 1512, ch. 18; Warner, *From the Beast to the Blonde*, pp. 27–43.

42 The Cologne and Basel images in Zika, '"Magie"–"Zauberei"–"Hexerei"', pp. 361–2, are incorrectly labeled and should be reversed.

43 For a detailed study of this engraving and further references, see Zika, *Exorcising our Demons*, pp. 305–32, on which the following is based; also Schoch, Mende and Scherbaum, *Albrecht Dürer*, pp. 86–7.

44 I am following the suggestions of Russell, *Eva/Ave*, pp. 166–7, which are based on the fascinating study by Blok of *cornutes* (men who wear horns) in Mediterranean societies. See Blok, 'Rams and Billy-goats'.

45 Mesenzeva, 'Zum Problem', 187–202.

46 See below, ch. 8.

47 For Montagna, see Mesenzeva, 'Zum Problem', 194–5; TIB, vol. 25, p. 432. For the bronze, see below ch. 4, n. 69.

48 Schade, *Schadenzauber*, pp. 62, 142 n. 307. Alternatively the connection might have been made through Erhard Altdorfer, Albrecht's brother, who was also an artist and settled in Nuremberg in 1510; or through Lucas Cranach during 1507–8, when Baldung was working in Halle.

49 For this drawing, see Schade, *Schadenzauber*, pp. 62–4; Mielke, *Albrecht Altdorfer*, pp. 34–5; Goldberg, *Albrecht Altdorfer*, pp. 81–2. For Altdorfer and the German forest, see Silver, 'Forest primeval'; Wood, *Albrecht Altdorfer*, pp. 128–200.

50 Now in Budapest; see Becker, *Die Handzeichnungen*, p. 134, no. 112.

51 This was one of the sermons published in the *Die Emeis* of 1516, and reproduced in Stöber, *Zur Geschichte des Volks-Aberglaubens*, pp. 20–24. For the recent revision in the dating of these sermons from 1508 to 1509, see Voltmer, *Wie der Wächter auf dem Turm*.

52 There is a general consensus as to this date, yet some scholars such as Mende date it to 1534 (Mende, *Hans Baldung Grien*, p. 48, no. 76). On the woodcut, see Radbruch, *Elegantiae Juris Criminalis*, pp. 39–41; Hartlaub, *Hans Baldung Grien*, pp. 22–4; Mesenzeva, '*Der behexte Stallknecht*', 57–61; Hults, 'Baldung's *Bewitched Groom* Revisited', 259–79; Russell, *Eva/Ave*, pp. 169–70; Marrow and Shestack, *Hans Baldung Grien*, pp. 272–5; Koerner, *The Moment of Self-portraiture*, pp. 437–47.

53 Although Baldung's two-pronged forks are always cooking forks, there are rare instances in the early sixteenth century in which a hay fork or pitch fork is shown with only two prongs.

54 This is also emphasized by Diane Russell (*Eva/Ave*, pp. 169–70).

55 Radbruch, *Elegantiae Juris Criminalis*, pp. 40–41.

56 von Térey, *Die Handzeichnungen des Hans Baldung*, vol 1, p. x; Préaud, *Les sorcières*, pp. 2–3; Hoak, 'Art, Culture and Mentality', 488–510.

57 Mesenzeva, '*Der behexte Stallknecht*', pp. 58–60.

58 In the *Bewitched Groom* it is reversed. For two of Baldung's woodcuts of his family coat of arms, see Lauts, *Hans Baldung Grien*, pp. 285–6; Marrow and Shestack, *Hans Baldung Grien*, p. 274.

59 G.F. Hartlaub, '*Der Todestraum*', 13–25; also Koerner, *The Moment of Self-portraiture*, pp. 426–37.

60 Hults, 'Baldung's *Bewitched Groom* Revisited', 273, 279.

CHAPTER 2 THE TRANSFORMATION OF SORCERY AND MAGIC IN THE FIFTEENTH CENTURY

1 For Tengler, and the influence of his work, which ran into 17 editions of both versions by 1560, see Stintzing, *Geschichte der populären Literatur*, pp. 411–47.

2 *Von kätzerey warsagen schwartzer kunst, zauberey, unholden*, in Ulrich Tengler, *Der neü Layenspiegel*, Augsburg: Hans Otmar, 1511, fols 190–95. The section is reprinted in Hansen, *Quellen*, pp. 296–306. Also see Behringer, *Witchcraft Persecutions*, pp. 74–6; Schade, *Schadenzauber*, pp. 32–4, 134, n. 36.

3 Schreyl, *Hans Schäufelein*, vol. 1, p. 95, no. 417; vol. 2, no. 417. Also reproduced in Behringer, *Witchcraft Persecutions*, p. 75; Zika, *Exorcising our Demons*, p. 248. The woodcut was also used in a 1511 Strasbourg edition of Matthias Hupfuff, in a 1512 Augsburg edition of Hans Otmar, and in a 1518 Strasbourg edition of Johann Knoblauch (Hollstein, vol. 43, p. 168).

4 Hansen, *Quellen*, p. 299. It may, on the other hand, depict another prohibition in the text (p. 306, lines 26–33) against procuring medicament, help or counsel from witches or sorcerers, even for the purpose of counter-sorcery. I think this reading less likely because of the structural dynamic of the woodcut.

5 See Hans Schäufelein's carts in the treatise by Hans von Leonrod, *Hymmelwagen ... Hellwag* ..., Augsburg: Sylvan Otmar, 1517, fols F3ᵛ, Qʳ.

6 For the two Schäufelein woodcuts which feature Tengler, see *Der neü Layenspiegel*, Augsburg: Hans Otmar, 1511, fol. 5ʳ, 6ʳ; Schreyl, *Hans Schäufelein*, no. 414, 415. The second depicts Tengler presenting his work to the emperor in the presence of his family of three wives and 24 children, among whom Christoff Tengler is shown in clerical garb and with tonsure.

7 The use of modern terminology such as 'magic' and 'sorcery' to describe such practices is very problematic. I use the term 'magic' as the more general description for practices which make use of powers either not understood or of limited access. I use 'sorcery' for those magical practices which are specifically directed towards some kind of malefice or harm. However it is often unclear whether harm is intended in particular instances, or whether harm for one individual is simply the unintended effect of a benefit procured for another.

8 See below at fig. 2.12.

9 Bailey, 'The Medieval Concept'; Borst, *Medieval Worlds*, pp. 101–22; Paravicini Bagliani, Utz Tremp and Ostorero, 'Le sabbat dans les Alpes'; Andenmatten and Utz Tremp, 'De l'hérésie à la sorcellerie'; Paravy, *De la chrétienté romaine*, chs 14–16; Blauert, *Frühe Hexenverfolgungen*; Paravy, 'Zur Genesis der Hexenverfolgungen'; Modestin, *Le diable chez l'évêque*; *L'imaginaire du sabbat*, eds Ostorero, Paravicini Bagliani and Utz Tremp; Bailey and Peters, 'A Sabbat of Demonologists'; Behringer, 'How Waldensians Became Witches'.

10 See the list of works cited in ch. 1, n. 26; also the introduction by Günter Jerouschek and Wolfgang Behringer in Kramer, *Der Hexenhammer*, pp. 31–81.

11 I have used the copy held by the Bayerische Staatsbibliothek, Munich (2° Inc.c.a.1852). An edited text based on the various manuscripts is found in Hans Vintler, *Die Pluemen der Tugent*, ed. Ignaz von Zingerle, Innsbruck, 1874. For Vintler and his work, see also Schweitzer, *Tugend und Laster*; Ziegeler, *Möglichkeiten der Kritik*, pp. 34–60; Ebermann and Bartels, 'Zur Aberglaubensliste', 1–18, 113–36. For a more detailed consideration of Vintler's work, illustrations and further references, see Zika, '"Magie"–"Zauberei"–"Hexerei"', pp. 324–38.

12 Consideration of 'unglauben' is found at lines 7694–8497, and this constitutes 803 lines out of a total of 10, 172. Line numbers here and below refer to Vintler, *Die Pluemen*, ed. Zingerle; the figure numbers are those given by Schramm, vol. 23.

13 For the calculation of 52, see Zika, '"Magie"–"Zauberei"–"Hexerei"', p. 326, n. 112.

14 The woodcuts have been reproduced in Schramm, vol. 23, figs 487–719. The manuscript is Cod. Chart. A 594 of the Forschungsbibliothek, Gotha. Zingerle established the relationship between the printed version and the Gotha manuscript in his edition of Vintler, *Die Pluemen*, pp. 32–3 and in his 'Beiträge zur älteren tirolischen Literatur', 289–91. This relationship has been largely accepted by Schweitzer, *Tugend und Laster*, pp. 189–92, 233–8. Given that almost all the images in one series are inversions of the other, Schweitzer's suggestion that the Gotha manuscript illuminator may have copied the woodcuts (p. 237) would only be possible in the unlikely situation that the illuminations had been copied from the actual blocks. Schreiber, *Manuel de l'Amateur*, vol. 5, p. 313, no. 5436, suggests that the model may well have been a manuscript from the Rhine region of *c.* 1475 on account of the Burgundian costumes. Some miniatures from the Gotha and Vienna manuscripts have been reproduced in Rumpf, *Perchten* (plates 1, 2, 4, 5).

15 For an important study of woodcut illustration in terms of the consumer, see Bottigheimer, 'Publishing, Print, and Change', 199–235, especially 204, 216–18.

16 I limit discussion below to the first and largest group of 32 woodcuts that can be clearly differentiated from the remaining 20. Of these, 29 are closely grouped within a block of only 258 lines of verse (lines 7731–988).

17 Schramm, vol. 23, figs 631, 635, 643–4, 647–50.

18 Schramm, vol. 23, figs 635, 637, 641.

19 Schramm, vol. 23, figs 630, 632–3, 639–40, 642.

20 Although no more than a rough guide, these figures offer a marked contrast to the text, in which females are clearly predominant.

21 Labouvie, 'Men in Witchcraft Trials', pp. 51–7.

22 Schramm, vol. 23, p. 22, describes this scene incorrectly as a woman expelling sickness from her child by means of a wooden stick, and relates it to lines 7963–74. This is described as a technique for dealing with a child's sleeplessness. It is in fact an illustration of lines 7991–2 on fol. 161ᵛ–162ʳ: 'Und etlich stelent auß der pruech / Dem mann seyn geschirr gar.' See also Ebermann and Bartels, 'Zur Aberglaubensliste', 132–3. The Gotha manuscript illumination relates to Schramm's description.

23 For the post with the axe on the right, see discussion of fig. 2.6 below.

24 For discussion of this text, see Zika, '"Magie"- "Zauberei"- "Hexerei"', pp. 330–31, n. 23.

25 See HDA, vol. 2, col. 1176 (for epilepsy), vol. 8, col. 1455 (for invisibility), vol. 1, cols 318–319 (for mandragora). Also Wuttke, *Der deutsche Volksaberglaube*, pp. 136–7, nos. 188–9.

26 For women and death, see Schramm, figs. 642, 652, 654.

27 For magic related to wealth and treasure seeking, see Roper, *Oedipus and the Devil*, pp. 125–44.

28 Schramm, fig. 639.

29 Schramm, figs 643, 647, 650.

30 'Was die gelerten Unglauben lerent.' The Gotha manuscript, fol. 166ʳ has a heading in red ink which reads: 'Von der Zaubrey ain figur.'

31 Ginzburg, *The Night Battles*, pp. 40–44; Rumpf, *Perchten*, pp. 77–87; Behringer, *Shaman of Oberstdorf*, pp. 56, 68–9.

32 *Malleus Maleficarum*, part 1, q. 10; part 2, q. 1, ch. 8.

33 As well as the Gotha manuscript, which was probably produced late in the fifteenth century, a Stockholm manuscript also originated in south Germany and has been dated *c*. 1500. It has spaces for illuminations, but these were never completed. See Schweizer, *Tugend und Laster*, pp. 188–9, 221–4, 248; Asmus Mayer, *Ein newer spruch von der Zauberey und dem unglauben*, Nuremberg: Hans Guldenmundt [after 1526?]. See Ebermann and Bartels, 'Zur Aberglaubensliste', 3–12.

34 See Schouten, *The Pentagram*, pp. 29–35; HDA, vol. 4, col. 587.

35 Cod. Chart. A 594, fol. 173ᵛ. Schade, *Schadenzauber*, p. 34, suggests that the pentagram alludes to milk stealing by magical means. For milk sorcery in general, see Grimm, *Deutsche Mythologie*, pp. 896–7, nos. 1025–6; Wuttke, *Der deutsche Volksaberglaube*, pp. 158–9, no. 216; HDA, vol. 6, cols 293–352.

36 The Eppingen fresco is described and reproduced in Schmidt, *Glaube und Skepsis*, pp. 33–4. The sermon is in Geiler of Kaysersberg, *Die Emeis*, Strasbourg: Johann Grüninger, 1517, fols 54ᵛ-55ᵛ.

37 The large purse, found in many images of witchcraft, may be an allusion to the woman's rapaciousness. See Zika, '"Magie"-"Zauberei"-"Hexerei"', pp. 367–8, n. 82.

38 D'Evelyn, *Peter Idley's Instructions*, pp. 115–17.

39 *Robert of Brunne's* Handlyng Synne, ed. Furnivall, pp. 19–22.

40 For this and the following, see Wall, *Tjuvmjölkande väsen*, vol. 1. (The book includes an English summary on pp. 245–60). Also see Johansen, 'Hexen auf mittelalterlichen Wandmalereien', pp. 217–40. I thank Mindy MacLeod for translations from Swedish and Danish.

41 Wall, *Tjuvmjölkande väsen*, vol. 1, p. 49, figs 10a-c. These images are reproduced in colour in Nyborg, *Fanden på væggen*, pp. 80–81.

42 Wall, *Tjuvmjölkande väsen*, vol. 1, figs 1, 4b, 15b, 16; Nyborg, *Fanden på væggen*, p. 83.

43 Wall, *Tjuvmjölkande väsen*, vol. 1, pp. 22–3. This is depicted in a fifteenth-century fresco from the village church of Schönemoor west of Bremen, reproduced in Schwarzwälder, 'Die Geschichte des Zauber- und Hexenglaubens', following p. 196. At least five similar frescoes have survived in the German state of Lower Saxony.

44 Such practices continue to be recorded in the sixteenth and seventeenth centuries. See Boguet, *Discours des Sorciers*, p. 240; Wall, *Tjuvmjölkande väsen*, vol. 1, ch. 3.

45 Reproduced in Schreiber, *Handbuch*, vol. 11, *Der Einblattholzschnitt und die Blockbücher*, fig. 110; and in Kieckhefer, *Magic*, p. 178, fig. 18. Also Schreiber, *Handbuch*, vol. 4,

Holzschnitte Nr. 1783–2047, pp. 51–2, no. 1870. The xylographic text is provided in a modern transcription by Kristeller, *Holzschnitte*, pp. 36–7.

46 Kieckhefer, *Magic*, p. 176 incorrectly claims that this is King Saul.
47 Hansen, *Quellen*, pp. 5–6.
48 The reference here is to the Theodosian Code 9, 16, 4 or to the Justinian Code 9, 18, 5.
49 The text includes a warning about the devil from Ecclesiasticus 13, but because of the damaged text it remains illegible.
50 This point has been made by Schreiber, *Manuel de l'Amateur*, vol. 2, p. 255, no. 1870.
51 *Decretals*, causa 26, quaestio 7, canon 16. Causa 26 provides a long discussion of various forms of magic and sorcery and is the source of the famous *Canon Episcopi* witchcraft text (at quaestio 5, canon 12). See *Corpus Iuris Canonici*, ed. Friedberg, cols 1030–31.
52 For the *De erroribus*, see Jean Gerson, *Oeuvres complètes*, vol. 10, pp. 77–90 (with the *Conclusio* at pp. 86–90). An English translation of the *Conclusio* is found in Johann Weyer, *Witches, Devils and Doctors*, ed. Mora, pp. 576–80; and in Kors and Peters, *Witchcraft in Europe*, pp. 129–32.
53 Schreiber, *Handbuch*, vol. 11, *Der Einblattholzschnitt und die Blockbücher*, p. 45, no. 1870; Schreiber, *Handbuch*, vol. 4, *Holzschnitte Nr. 1783–2047*, pp. 51–2, no. 1870.
54 Peters, *The Magician*, pp. 143–6; Bossy, 'Moral Arithmetic', pp. 214–34.
55 See Camille, 'The Illustrated Manuscripts'; Camille, 'Reading the Printed Image', pp. 259–91; Faral, *Guillaume de Digulleville*; Faral, 'Guillaume de Digulleville, Jean Gallopes et Pierre Virgin', pp. 89–102; Deguileville, *Pilgrimage*, ed. Furnivall.
56 Images of the figure of Sorcery are found in the following French manuscripts: BN fr. 377, fol. 88ᵛ (*c.* 1395); BN fr. 825, fol. 124ʳ (*c.* 1420); BN fr. 829, fol. 112ʳ (*c.* 1404). The Lydgate translation is found in the British Library MS Cotton Tiberius A.7. For the relationship of the Lydgate translation and the French manuscript, see Camille, 'The Illustrated Manuscripts', pp. 250, n.12; 212–13, 274, 313–17, 322–4, 328–31.
57 Deguileville, *Pilgrimage*, ed. Furnivall, lines 21074–86, 21154–84. The illumination in BN fr. 825 is the only case of the four in which a hand is shown in the basket.
58 *Le pèlerinage de l'homme*, Paris: A. Vérard, 1511, fol. 75ʳ: 'La mer et ses flotz'. For this printed version, see Camille, 'Reading the Printed Image', p. 261, n. 5, pp. 269–74.
59 BN fr. 377, fol. 77ᵛ; BN fr. 825, fol. 108ᵛ; BN fr. 829, fol. 98ᵛ; BL MS Cotton Tiberius A.vii, fol. 49ʳ; *Le pèlerinage de l'homme*, Paris: A. Vérard, 1511, fol. 72ᵛ (here Necromancy is not winged). Lydgate contains illustrations of the practice of necromancy at fol. 44ʳ (fig. 2.15) and 42ʳ (reproduced in Kieckhefer, *Magic*, p. 173). For the account of Necromancy and the Messenger, see Deguileville, *Pilgrimage*, ed. Furnivall, pp. 494–505 (lines 18471–924).
60 Whitaker, 'Maso Finiguerra and Early Florentine Printmaking', pp. 45–71; Whitaker, 'Maso Finiguerra, Baccio Baldini and *The Florentine Picture Chronicle*', pp. 181–96; Degenhart and Schmitt, *Corpus*, vol. 2, pp. 573–621; Colvin, *A Florentine Picture-chronicle*; Oberhuber, 'Baccio Baldini', pp. 13–21.
61 Degenhart and Schmitt, *Corpus*, vol. 2, p. 598. These individuals are found at fols 12, 31–3 of the original.
62 Colvin, *A Florentine Picture-chronicle*, fig. 50; Degenhart and Schmitt, *Corpus*, vol. 2, no. 592.
63 Most scholars no longer believe that the artist in question was Hans Weiditz. For this and the complexities of the publishing history, see Petrarca, *Von der Artzney bayder Glück*, pp. 195–200; Scheidig, *Die Holzschnitte des Petrarca-Meisters*, pp. 7–11; Musper, *Die Holzschnitte des Petrarca-Meisters*, p. 11; Fraenger, *Hans Weiditz und Sebastian Brant*, pp. 7–16; Knape, *Die ältesten deutschen Übersetzungen*, pp. 70–74.
64 Augsburg: Steiner, 1532, 1539; Frankfurt: Egenolf, 1551, 1559, 1572, 1584, 1596.
65 In the latter point I am following Scheidig, *Die Holzschnitte des Petrarca-Meisters*, p. 106. However I cannot agree with Scheidig's claim that the main scene depicts a trick played on the devil who is denied entry to the circle once he has indicated the location of the treasure.
66 The woodcut is at the head of book one, ch. 112: 'On the promises made by all kinds of divination'. As well as appearing in the seven editions listed above, this woodcut was also included in three other works published by Steiner: the 1537 and 1544 editions of the German translation of Polydore Vergil's *De inventionibus rerum*, and in the 1541 edition of Petrarch's *De rebus memorandis*.

67 Scheidig, *Die Holzschnitte des Petrarca-Meisters*, pp. 174–5. A similar gipsy features in a drawing by Burgkmair of *c.* 1500 (see Falk, *Hans Burgkmair*, fig. 11), and also in Polydore Vergil, *Von der Erfindung der Ding*, Augsburg: Heinrich Steiner, 1544, fol. 157ʳ.

68 Hope, *The Autobiography of Benvenuto Cellini*, pp. 66–8; Kieckhefer, *Forbidden Rites*, pp. 186–7.

69 Deguileville, *Pilgrimage*, ed. Furnivall, p. 563, lines 21103–14. The image is reproduced in Kieckhefer, *Magic*, p. 11, fig. 1.

70 MS Cotton Tiberius A.vii., fol. 69ʳ; reproduced in Zika, '"Magie"–"Zauberei"–"Hexerei"', p. 340, fig. 29.

71 Deguileville, *Pilgrimage*, ed. Furnivall, p. 562, lines 21078.

72 See Wilson and Wilson, *The Making of the Nuremberg Chronicle*; Rücker, *Hartmann Schedels Weltchronik*; Landau and Parshall, *The Renaissance Print*, pp. 38–42.

73 See Kors and Peters, *Witchcraft in Europe*, pp. 70–72; Zika, 'Berkeley, Witch of', in Golden, *Encyclopedia of Witchcraft*, vol. 1, pp. 110–11.

74 The model drawing in the Latin exemplar book (fol. 211ʳ) already includes the basic elements of the later woodcut, which appears in both the 1493 German and Latin editions at the same folio (189ᵛ). The woodcut in the later pirated editions (fol. 93ʳ in the 1497 ed.; fol. 72ᵛ in the 1500 ed.) is a cruder version of the 1493 woodcut, with the only significant difference the lack of a shroud and very frizzy hair.

75 For the editions of Tinctor's work and illustrations, see Balberghe and Gilmont, 'Les théologiens', pp. 393–411; Balmas, 'Il "Traité de Vauderie"', pp. 1–26; Préaud, *Les sorcières*, pp. 59–60, nos. 88–90. For the Arras *vauderie*, see Singer, '*La Vauderie d'Arras*'; and a recent study for which there has not been time to integrate into this work, Mercier, *La Vauderie d'Arras*.

76 Paravicini Bagliani, Utz Tremp and Ostorero, 'Le sabbat dans les Alpes', pp. 73–6.

77 For the above, Singer, '*La Vauderie d'Arras*', pp. 66–78; Hansen, *Quellen*, pp. 18, 118–22, 149–83, 188–95, 408–15; *L'imaginaire du sabbat*, eds Ostorero, Paravicini Bagliani and Utz Tremp, pp. 7–22, 509–23; Behringer, 'How Waldensians Became Witches'.

78 Balberghe and Gilmont, 'Les théologiens', pp. 396–404.

79 Singer, '*La Vauderie d'Arras*', p. 96.

80 For claims of illusion, and for the long appeal process and settlement, Singer, '*La Vauderie d'Arras*', pp. 88–9, 104, 122–44.

81 It was transcribed on behalf of Louis de Bruges, Seigneur de Gruuthuse. See Balberghe and Gilmont, 'Les théologiens', p. 403; Balmas, 'Il "Traité de Vauderie"', pp. 16–17; Singer, '*La Vauderie d'Arras*', pp. 153–4.

82 The translation is by Singer, '*La Vauderie d'Arras*', p. 92. Part of the text is also translated in Baroja, *The World of Witches*, pp. 90–91. Mercier, *La Vauderie d'Arras*, pp. 126–30, understands the image as an inversion of the scene depicted in *The Adoration of the Lamb* by Jan and Hubert Van Eyck (1432).

83 The illuminations have been widely reproduced. For Martin Le Franc and his poem, see Le Franc, *Le Champion des Dames*, ed. Deschaux; Le Franc, *Le Champion des Dames*, ed. Piaget; Piaget, *Martin Le Franc*; Fischer, 'Edition and Study of Martin Le Franc's *Le Champion des Dames*'; Brooks, 'La filiation des manuscrits du *Champion des Dames*'; *L'imaginaire du sabbat*, eds Ostorero, Paravicini Bagliani and Utz Tremp, pp. 439–508.

84 The other illustrated manuscripts and the two printed editions of the work (1485 and 1530) include quite different images.

85 BN, MS fr. 12476, fols 105ʳ-109ᵛ; BN, MS fr. 841, fols 123ᵛ-128ᵛ. For a modern edition of the full text, see Le Franc, *Le Champion des Dames*, ed. Deschaux, vol. 4, 113–44; and for this particular section, with commentary and notes, *L'imaginaire du sabbat*, eds Ostorero, Paravicini Bagliani and Utz Tremp, pp. 451–82. An English translation of part of the text is in Kors and Peters, *Witchcraft in Europe*, pp. 166–9.

86 Hansen, *Quellen*, p. 240, lines 29–30. For further evidence of riding sticks, see *L'imaginaire du sabbat*, eds Ostorero, Paravicini Bagliani and Utz Tremp, pp. 503–5.

87 The word *facturière* is based on the old Provençal *fachurar*, 'to charm' or 'to bewitch' (*L'imaginaire du sabbat*, eds Ostorero, Paravicini Bagliani and Utz Tremp, p. 452, n. 8), also used by Claude Tholosan in the Dauphiné. The word *vaudoises* does appear in two places on the previous folio (MS fr. 12476, fol. 105ʳ), as an inserted heading and a marginal

note, both in red ink. Martine Ostorero and Jean-Claude Schmidt (*L'imaginaire du sabbat*, pp. 505–6) consider this use of the feminine term to be one of the drivers of the feminization of sorcery in the fifteenth century.

88 'La Vauderye de Lyonois en bref', in Hansen, *Quellen*, p. 188, lines 26 ('que Valdesia vulgariter seu faicturerie gallice nuncupatur') and 31–2 ('que Valdesia vulgariter, sexus utriusque, qui vulgo ibidem faicturiers et faicturières nuncupantur'). It is instructive that Le Franc's patron and employer, the antipope Felix V, was referred to in a 1440 decree by his rival, Pope Eugenius IV, as 'seduced by the sorceries and phantasms of those followers of the devil, who in everyday speech are called *stregule* or *stregones* or *Waudenses*'. See Hansen, *Quellen*, p. 18.

89 'La Vauderye', in Hansen, *Quellen*, p.189, lines 6–9 ('ad quandam convencionem…que apud quosdam eorum gallice dicitur "le Fait", apud alios "le Martinet", sed vulgariter magis et communiter "la Synagogue" nuncupatur.')

90 Van Gennep, *Manuel*, pp. 2818–41, especially 2820, 2827. This reading is implied by Hansen, *Quellen*, p. 189 and Singer, '*La Vauderie d'Arras*', p. 74. Also see 'Recollectio' in Hansen, *Quellen*, p. 164, line 39, which states that one of the largest Waldensian assemblies was held on St Martin's eve.

91 For the linguistic evidence and argument, see *L'imaginaire du sabbat*, eds Ostorero, Paravicini Bagliani and Utz Tremp, pp. 506–8.

92 Balberghe and Gilmont, 'Les théologiens', pp. 403–4; Singer, '*La Vauderie d'Arras*', p. 154.

93 Balberghe and Gilmont, 'Les théologiens', pp. 402–3; Singer, '*La Vauderie d'Arras*', p. 154. The attribution to Loyset Liedet or his workshop is rejected by Balberghe and Gilmont: 'Les théologiens', p. 403, n. 51.

94 Balmas, 'Il "Traité de Vauderie"', pp. 20–22 argues that these are initiations.

95 Shachar, *The Judensau*.

96 See the fifteenth-century German wood block in Schachar, *The Judensau*, fig. 30.

97 Shachar, *The Judensau*, p. 41; Hsia, *The Myth of Ritual Murder*, pp. 63–4. In one of his polemical tracts of 1543, Luther also used the *Judensau* to refer to Jewish magical wisdom as the shit derived from the sow of the *Talmud* (Shachar, *The Judensau*, pp. 43–5, 86–7).

98 See especially Scribner, *Popular Culture and Popular Movements*, pp. 277–99; Hsia, *The Myth of Ritual Murder*, 212–17; Oberman, *Luther*, pp. 106–9, 154–7.

99 Hansen, *Quellen*, pp. 118–22 at 119. For the *Errores*, see Bailey, 'The Medieval Concept', p. 423; *L'imaginaire du sabbat*, eds Ostorero, Paravicini Bagliani and Utz Tremp, pp. 267–337.

100 Stöber, *Zur Geschichte des Volks-Aberglaubens*, p. 39; also Russell, *Witchcraft in the Middle Ages*, p. 241.

101 See the sermon of Pierre le Broussart in Singer, '*La Vauderie d'Arras*', p. 92; Balmas, 'Il "Traité de Vauderie"', p. 7.

102 See Kieckhefer, 'Avenging the Blood of Children', pp. 91–109.

103 Kieckhefer, 'Avenging the Blood of Children', p. 105.

104 Treitzsaurwein, *Der Weiß Kunig*, ed. Dreissiger; Biedermann, *1473–1973. Hans Burgkmair*, no. 181, fig. 156. The circulation of these prints in the sixteenth century was limited to the distribution of folios, and the work was not published until 1775.

CHAPTER 3 WITCHES' CAULDRONS AND WOMEN'S BODIES

1 See the list of works cited for the full title. This woodcut is at fol. 36v in the 1516 edition and fol. 37v in the 1517 edition. Lauts, *Hans Baldung Grien*, p. 130, no. 320 attributes the print to the Monogrammist HF, possibly Hans Frank of Basel, but the attribution has not been generally accepted.

2 *Das buch zu distillieren*, fol. 195v.

3 *Das Büch Schimpf und Ernst*, Strasbourg: Bartholomäus Grüninger, 1533, fol. 31r; *Schimpf und Ernst durch alle Welthändel*, Strasbourg: Bartholomäus Grüninger, 1538, fol. 30v (for Christian Egenolph). The woodcut precedes the group of four tales headed 'Von den Zauberern'.

4 At fol. 29ᵛ in both editions.
5 Geiler of Kaysersberg, *Die Emeis*, fol. 37ʳ–38ʳ; Stöber, *Zur Geschichte des Volks-Aberglaubens*, pp. 18–19. Although the sermon is simply titled 'Von den Unholden oder von den Hexen' (1516) and 'Von den Hexen und unholden' (1517), the opening questions refer to the main subject matter of night travel as reality or illusion.
6 Nider, *Formicarius*, book 4, ch. 2. For further discussion of Nider's text, see Chapter 4 of this book. The passage is translated – with some omissions – in Kors and Peters, *Witchcraft in Europe*, p. 237.
7 Geiler of Kaysersberg, *Die Emeis*, fol. 37ᵛ: 'da wont sie sie für / und het semliche freud inwendig' ('she pleasured herself and felt so much joy in it'). For the use of *Wonne* and *Freude* in an erotic sense, sometimes in combination, see Kratz, 'Über den Wortschatz der Erotik', pp. 404, 413–4. This critical phrase, as well as reference to the kneading trough, is unfortunately omitted from the English translation in Kors and Peters, *Witchcraft in Europe*, p. 237.
8 Schade, *Schadenzauber*, p. 108. Schade does not seem to have noticed the bird-demon.
9 Scribner, *For the Sake of Simple Folk*, pp. 96–7; Geisberg/Strauss, vol. 3, pp. 790–91 (G. 825–6).
10 The engraving of c.1495 is either called *The Jealous Wife*, or *The Angry Wife*. See Russell, *Eva/Ave*, p. 194; Moxey, *Peasants, Warriors and Wives*, pp. 104–6. For further discussion of this genre and the codpiece, see Zika, *Exorcising our Demons*, pp. 263–5.
11 Geisberg/Strauss, vol. 3, p. 1123 (G.1176); Moxey, *Peasants, Warriors and Wives*, pp. 101–3.
12 Ginzburg, *The Night Battles*, pp. 40–44; Behringer, *Shaman of Oberstdorf*, pp. 56, 68–9. What appears to be a swan in the right background may be an allusion to the story of Diomedes.
13 Augustine, *The City of God*, book 18, chs 16, 18; Stöber, *Zur Geschichte des Volks-Aberglaubens*, pp. 32–3.
14 Lutz, *Warhaftigge Zeitung*; Molitor, *Von Hexen und Unholden*, Strasbourg: Christian Müller, 1575; Frisius, *Dess Teuffels Nebelkappen*. For Frisius, see Zika, *Exorcising our Demons*, pp. 481–521.
15 There seem to have been three German editions of the work published in 1566, one of them in Cologne and the other two translated by Fuglinus and published in Frankfurt. The Cologne edition (VD16, W2671), has no titlepage woodcut. Of the two Frankfurt editions, the one held by the BSL in Munich (VD16, W2670) includes a quite different titlepage woodcut and some minor orthographic differences from that held in the BL. The Munich woodcut features three women pointing to a devil flying in the sky and later appears as the titlepage to the second part of Weyer's work in the Frankfurt 1575 German translation (VD16, W2675) and as the titlepage to the Latin edition published in Frankfurt in 1586 (VD16, W2654). The titlepage of the 1566 edition held in London, which does not seem to be included in VD16, has been reproduced in Schade, *Schadenzauber*, p. 109. The recent argument by Claudia Swan concerning the limited and chronologically late illustration of Weyer's work as indicative of Weyer's scepticism (Swan, *Art, Science and Witchcraft*, p. 169), clearly requires some modification.
16 Saur, *Ein kurtze treuwe Warnung Anzeige und Underricht*. The titlepages from Saur, the 1566 Weyer and the 1583 Frisius are all reproduced in Schade, *Schadenzauber*, pp. 109–11.
17 Schade, *Schadenzauber*, pp. 99–100. On Murner, see the introduction to Murner, *Narrenbeschwörung*, ed. Spanier; Könneker, *Satire im 16. Jahrhundert*; Zika, *Exorcising our Demons*, pp. 274–7.
18 Murner, *Narrenbeschwörung*, pp. 288, 291. In the 1512 edition, the woodcut in ch. 46 shows a male fool in a boat, battered by a hailstorm; that in ch. 47 depicts a male fool stirring a cauldron on the fire while he looks at his reflection in a hand-mirror.
19 Murner, *Narrenbeschwörung*, p. 289.
20 Murner, *Narrenbeschwörung*, p. 292, lines 15–19.
21 Murner, *Narrenbeschwörung*, pp. 291–3, lines 1–4, 21–32, 65–6. One of the best known of such images was of Venus and her fools in Brant's *Ship of Fools*, ch. 13. See Zika, *Exorcising our Demons*, pp. 512–13, fig. 89.
22 For linguistic usage, see Kratz, 'Über den Wortschatz der Erotik', 68 (*Hafen*), 60–63 (*Fasz*);

Müller, *Schwert und Scheide*, pp. 42–3 (*Fass*). For St. John's day, see Roper, 'Tokens of Affection', p. 157.

23 Goddard, *The World in Miniature*, p. 171, no. 45.

24 Schade, *Schadenzauber*, pp. 98–100; Vogel, *Der Mythos von Pandora*, pp. 28–42; Panofsky and Panofsky, *Pandora's Box*.

25 Brugerolles and Guillet, *The Renaissance in France*, pp. 36–40; Carroll, *Rosso Fiorentino*, pp. 298–301.

26 Vogel, *Mythos von Pandora*, pp. 28–42; Schade, *Schadenzauber*, pp. 99–100.

27 *Ein schön weltlich spil*; see Vogel, *Mythos von Pandora*, p. 34.

28 For the magical power of the female body, see Accati, 'The Spirit of Fornication', pp. 111–16; Ruggiero, *Binding Passions*, pp. 88–129; O'Neil, 'Magical Healing, Love Magic and the Inquisition', pp. 88–114; Sanchez Ortega, 'Sorcery and Eroticism as Love Magic', pp. 58–92.

29 Koch, *Die Zeichnungen*, p. 197; Bernhard, *Hans Baldung Grien*, p. 277.

30 Two of these, one in the Öffentliche Kunstsammlung in Basel and another auctioned in Amsterdam in 1929, are described in Koch, *Die Zeichnungen*, p. 197. The Basel copy is reproduced in Hults, 'Baldung and the witches of Freiburg', 251–5, fig. 4. The third, which has sustained extensive water damage and considerable retouching, is in the Boston Museum of Fine Arts (accession number 69–1065).

31 For the Virgil legend, see Spargo, *Virgil the Necromancer*, pp. 136–206.

32 For a study of the visual images, see Müntz, 'Études iconographiques', 85–91; Spargo, *Virgil the Necromancer*, pp. 254–67. For the power of women, see Smith, *The Power of Women*; Russell, *Eva/Ave*, pp. 147–75; Pigeaud, 'Woman as Temptress', pp. 50–52.

33 Müntz, 'Études iconographiques'; Spargo, *Virgil the Necromancer*, pp. 255–9; Hind, *Early Italian Engraving*, pl. 46.

34 Although dated 1519, the first known appearance of the Graf border was in a Paris edition of 1520 printed by Pierre Vidoue for Conrad Resch. It then appeared in five other works published by these two printers. The copy was used by Philippe le Noir in at least 10 works published between 1523 and 1532. See Spargo, *Virgil the Necromancer*, pp. 263–6. For a version used in the *Dictionarium Graecum*, Paris, 1521, see Schade, *Schadenzauber*, p. 106, fig. 46; Butsch, *Handbook of Renaissance Ornament*, pl. 107.

35 Koch, *Die Zeichnungen*, pp. 101–2; Hults, 'Baldung and the witches of Freiburg', pp. 269–71; Koerner, *The Moment of Self-portraiture*, pp. 336–8.

36 Levy, 'The Erotic Engravings of Sebald and Barthel Beham', pp. 40–53; Lemarchand and Dunand, *Les compositions de Jules Romain*; Zerner, 'L'estampe érotique au temps de Titien'; Talvacchia, *Taking Positions*, pp. 71–4.

37 Koch, *Die Zeichnungen*, p. 100; Schade, *Schadenzauber*, pp. 112–14; Hults, 'Baldung and the witches of Freiburg', 267–9; Koerner, *The Moment of Self-portraiture*, pp. 330–3; Durian-Ress, *Hans Baldung Grien*, pp. 186–7.

38 'Der Corcappen' of the inscription would have been *Den Corcappen* if it referred to ecclesiastical canons (*Chorherren*). Petra Gottfroh-Tajjedine suggests 'Corcappen' is a Latin combination of *cor* (heart) and *capen* (from *capere*, to catch or capture). See Durian-Ress, *Hans Baldung Grien*, p. 186.

39 The relevance of the proverb was first suggested by Radbruch, *Elegantiae Juris Criminali*, p. 44.

40 Hults, 'Hans Baldung Grien's *Weather Witches*', 124–30; Hults, *The Witch as Muse*, pp. 96–9; Andersson, 'Hans Baldung Grien', pp. 13–16; Radbruch, *Elegantiae Juris Criminalis*, pp. 35–9.

41 Andersson, 'Hans Baldung Grien', p. 16.

42 Hults, 'Hans Baldung Grien's *Weather Witches*', 124, describes this as an attempt to conceal the goat.

43 This is possibly an allusion to contemporary discussions of the illicit involvement of aquavit women in the manufacture of distilled waters for malefic purposes. See the comments by the fifteenth-century Vienna physician, Michael Puff von Schrick, cited by Harold J. Abrahams in the introduction to the modern reprint of the 1530 English translation of *Das buch zu distillieren* by the Strasbourg contemporary of Baldung, Hieronymus Braunschweig (Braunschweig, *Book of Distillation*, pp. xlvi-xlvii, cvi). The prologue of this work contrasts

the medicine of natural efficacy ordained by God with the unnatural efficacy of wicked words or charms invented by the devil.

44 Schade, *Schadenzauber*, p. 92, entitles the drawing, *A Resting Young Witch is Fetched to be Taken to the Night-ride*, an example of the tendency in the study of witchcraft to subordinate the content of images to extraneous narratives and stereotypes.

45 Hults, 'Baldung and the witches of Freiburg', 261–3; Lauts, *Hans Baldung Grien*, pp. 129–30; Grünwald, 'Die Beziehungen des Jungen Hans Weiditz zu Hans Frank', 26–36.

46 An undue emphasis on fear has been incorrectly attributed to me on the basis of my early article, 'Fears of Flying' (Zika, *Exorcising our Demons*, pp. 237–67.)

47 For recent detailed consideration and the rich literature, see Hults, *The Witch as Muse*, pp. 62–72 – who does consider this a group of witches; Schoch, Mende and Scherbaum, *Albrecht Dürer*, pp. 61–4.

48 Goddard, *The World in Miniature*, p. 184, n. 5.

49 Sebald copied Barthel's 1525–7 engraving in *c*. 1546–50. See Goddard, *The World in Miniature*, pp. 183–4.

50 Two copies of this print survive. See Hollstein, vol. 19, p. 192; Bock, 'The Engravings of Ludwig Krug', 88, 97, 113 (in which the print is dated early in Krug's career, *c*. 1510–15).

51 Kuster, *Spectaculum vitiorum*; Maas, 'Schembart und Fastnacht'; Kinser, 'Presentation and Representation'; Roller, *Der Nürnberger Schembartlauf*, pp. 132–3; Sumberg, *The Nuremberg Schembart Carnival*, pp. 169–70.

52 See Stadtbibliothek, Nuremberg, Nor. K. 551 for the first case; Amb. 54. 2°, fol. 239ᵛ for the second. In a number of other manuscripts there is reference to several women who are called 'alte Trutten', evil female spirits or witches of folklore; and also to their weddings with devils. The latter seems to be the subject of the illustration in manuscripts Gs.2196 Hs.-5664, fol. 60ʳ of the GNM, Nuremberg, which depicts four fools, two devils, a monk and a woman – clothed, but with a low bodice – surrounded by festive bunting; and of Cgm 2083 of the BSB, Munich, in which devils and women are shown embracing. Similar scenes are found in other manuscripts from the sixteenth century. For an extensive (yet flawed) listing of manuscripts, see Roller, *Nürnberger Schembartlauf*, pp. 193–200; Kuster, *Spectaculum*.

53 *Das Büchle Memorial*, Augsburg: Heinrich Steiner, 1534, fols 96–7, 124ʳ. For the following, including further references, see Zika, '"Magie"–"Zauberei"–"Hexerei"', pp. 370–77; Gose, *Reformationsdrucke*, pp. 188–9, no. 426.

54 At folio 124ʳ, as in the 1534 edition. A reproduction in Schade, *Schadenzauber*, p. 37, fig. 11 is incorrectly labelled 1531 and 1535; it is actually a reproduction of the 1534 edition which displays minor orthographic differences to the later editions. I have not found a 1531 edition.

55 The 1534 *Humour and Seriousness* edition is dated 17 November and therefore just post-dates *Memory Prompts to Virtue*, published on 20 January 1534. In all four editions of *Humour and Seriousness* it is located at fol. 28ᵛ. Steiner finally replaced it in the 1542 Augsburg edition of *Humour and Seriousness* (and again in 1544 and 1546) with a Petrarca-Meister woodcut (fig. 6.5).

56 Vergil, *Von den erfyndern der dyngen*, Augsburg: Heinrich Steiner, 1537, fol. 29ᵛ; 1544, fol. 27ʳ. The employment of the woodcut in the 1537 edition represents a loose relationship between image and text. It prefaces a chapter on the origins of the 'Zauberische kunst Magica', and of the use of exorcisms and conjurations in the healing of illnesses (book 1, ch. 22). It argues that the magical arts derive from medicine, provides a genealogy beginning with Zoroaster and including Circe and Solomon, and concludes that we ought to follow the advice of priests and drive evil spirits from the body with holy words, which are much more powerful against the devil than magical arts. However in the 1544 edition, the Breu woodcut is now placed at the head of book 1, ch. 23, which is concerned with divination by necromancy, pyromancy, aeromancy, hydromancy, geomancy and chyromancy, and has nothing to say of healing.

57 *Memorial der Tugend*, fol. 97ʳ.

58 Koepf, *Das Ulmer Rathaus*, pp. 18–42.

59 'Mein wort in hailigkait sein gezirt/ Dz dir di wund nit schat noch schwirt.'

60 'Glaib war mein wort caracter sein/ So büß ich dir das hayptwee dein.'

61 For this gesture, see above fig. 2.2; and Zika, '"Magie"–"Zauberei"–"Hexerei"', pp. 373–4, fig. 47.
62 Roettig, *Reformation als Apokalypse*, pp. 9–11, 96–105; Hofmann, *Luther und die Folgen*, pp. 142–3.
63 Grimm, 'Die deutschen "Teufelbücher"', 523, 562, fig. 14, 563. The 1563 edition has been published in Stambaugh, *Teufelbücher in Auswahl*, vol. 1, pp. 1–184.
64 The *Zauber Teuffel* was republished in the three editions of the *Theatrum Diabolorum*, which were compiled and introduced with a preface by Sigmund Feyerabend. See Grimm, 'Die deutschen "Teufelbücher"', 529–32. For the devil books, also see Midelfort, *Witch Hunting in Southwestern Germany*, pp. 69–70; Roos, *The Devil*.
65 *Der Ritter vom Turn* was composed for the education of Geoffroy de la Tour Landry's daughters. See Kautzsch, *Die Holzschnitte*. For the attribution to Dürer or Dürer's involvement, see Strieder, *Dürer*, pp. 93, 95–6; Knapp, p. xi, figs 110– 3 (including the 1493 woodcut); Koerner, *The Moment of Self-portraiture*, pp. 350–52, fig. 166.

CHAPTER 4 WILD RIDERS, POPULAR FOLKLORE AND MORAL DISORDER

1 For Cranach and his work, see especially Schade, *Cranach*; Friedländer and Rosenberg, *The Paintings of Lucas Cranach*; Grimm, Erichsen and Brockhoff, *Lucas Cranach*.
2 The classic study is Klibansky, Panofsky and Saxl, *Saturn and Melancholy*, which was republished in 1990 in a revised and extended German translation, *Saturn und Melancholie*.
3 For the following analysis and further references, see Zika, *Exorcising our Demons*, pp. 333–74.
4 A detailed listing of the four works is given in an appendix to Klibansky, Panofsky and Saxl, *Saturn und Melancholie*, pp. 564–6. This complements and corrects the information found in Friedländer and Rosenberg, *Die Gemälde von Lucas Cranach*, p. 125. Also see Heck, 'Entre humanisme et réforme'; Günter Bandmann, *Melancholie und Musik*, pp. 63–98; Koepplin and Falk, *Lukas Cranach*, vol. 1, no. 171, fig. 133.
5 From the large literature on Dürer's engraving, see especially the exhaustive study, Schuster, *Melencolia I*.
6 The painting is on loan from a private collection to the National Gallery of Scotland, Edinburgh. A copy of this work in the Museum of Fine Arts, Columbus, Ohio, has been attributed to Cranach, but is now widely accepted as a later sixteenth-century copy by an unknown artist. See Paris, *The Frederick W. Schuhmacher Collection*, pp. 195–6.
7 For similar figures, see Filedt Kok, *The Master of The Amsterdam Cabinet*, pp. 222–4; Klibansky, Panofsky and Saxl, *Saturn und Melancholie*, figs 30, 42.
8 Roper, *Oedipus and the Devil*, pp. 108–10, 117–19.
9 Moxey, *Peasants, Warriors and Wives*, pp. 82–7.
10 For Cranach's images of the hunt and further references, see Zika, *Exorcising our Demons*, pp. 339–40. For the hunt as erotic metaphor, see Cummins, *The Hound and the Hawk*, pp. 81–3.
11 Cranach's son, Hans, may have collaborated on this work. See especially Heck, 'Entre humanisme et réforme'; Koepplin and Falk, *Lukas Cranach*, vol. 1, pp. 292–3, no. 172; Klibansky, Panofsky and Saxl, *Saturn und Melancholie*, pp. 565–6.
12 The sleeping dog refers to melancholy as the source of the vice of sloth (*acedia*). See Koepplin and Falk, *Lukas Cranach*, vol. 1, p. 292; Koepplin, *Cranachs Ehebildnis*, pp. 226–8.
13 Partridges also feature in a number of Cranach's paintings of the *Reclining Water Nymph*, a member of Diana's hunting party. See Friedländer and Rosenberg, *Die Gemälde von Lucas Cranach*, nos. 402–4; Koepplin and Falk, *Lukas Cranach*, vol. 2, pp. 631–41.
14 For the association of horses' heads and skulls with the dead and their use in various magical practices, see HDA, vol. 6, col. 1664–70.
15 Friedländer and Rosenberg, *Die Gemälde von Lucas Cranach*, no. 276; Klibansky, Panofsky and Saxl, *Saturn und Melancholie*, p. 534.
16 Koepplin and Falk, *Lukas Cranach*, vol. 1, p. 293.
17 See Klibansky, Panofsky and Saxl, *Saturn und Melancholie*, p. 535, fig. 134; Heck, 'Entre

humanisme et réforme', 259–60, fig. 5; Friedländer and Rosenberg, *Die Gemälde von Lucas Cranach*, no. 276.

18 See for example, figs 1.14, 1.15, 3.1, 3.3, 3.16, 5.3, 5.11, 5.12, 7.8.

19 Zika, *Exorcising our Demons*, pp. 361–3.

20 For the following, see especially Barto, *Tannhäuser*, pp. 18–57; Clifton-Everest, *The Tragedy of Knighthood*, pp. 1–20.

21 Clifton-Everest, *The Tragedy of Knighthood*, p. 139.

22 For an illustration and references, Zika, *Exorcising our Demons*, pp. 363–8.

23 Brant, *The Ship of Fools*, ch. 13; Barto, *Tannhäuser*, p. 27.

24 Joris, *Twonderboeck*, Deventer: Dirk van Borne, 1542, part 2, fol. 38^{r-v}; Waite, 'Talking Animals, Preserved Corpses and Venusberg', 152–3.

25 Sachs 'Der doctor in Venus-perg' (1545), in *Hans Sachs*, ed. Keller, vol. 22, pp. 319–20. For other poems by Sachs which include consideration of the Venusberg, see 'Das unhulden-bannen' and 'Der pawrenknecht mit dem nebelkappen' in *Hans Sachs*, ed. Keller, vol. 9, pp. 271, 507.

26 My translation of: 'Nun fragestu was sagstu uns aber von den weibern die zu nacht faren und so sie zusamen kumen. Du fragest ob ettwas daran sei. Wen sie faren in fraw Venußberck oder die Hexen wen sie also hin und her faren. Faren sie oder bleiben sie, oder ist es ein gespenst oder waz soll ich darvon halten.' Geiler of Kaysersberg, *Die Emeis*, Strasbourg, 1517, fol. 37r. A translation is also in Kors and Peters, *Witchcraft in Europe*, p. 237.

27 Geiler of Kaysersberg, *Die Emeis*, Strasbourg, 1517, fol. 37^{r-v}.

28 For the *Canon Episcopi* see below.

29 Nider, *Formicarius*, p. 71: 'opere demonis somnia de domina venere et de aliis super-stitionibus tam fortia habuit'. The account of the story in Bailey, *Battling Demons*, p. 47, makes no reference to Venus, but only to Diana; and refers to the kneading trough as a caul-dron. The story is also in Luther's *Tabletalk*, the common source for which, according to Jörg Haustein, is Gottschalk Hollen's *Praeceptorium*; but this ignores the *Formicarius* version. See Haustein, *Martin Luthers Stellung*, p. 58.

30 Geiler of Kaysersberg, *Die Emeis*, Strasbourg, 1517, fol. 39v. Luther told the same story of a knight's brush with harsh reality ('there he lay in deep shit') in one of his sermons on the first commandment, but made no reference to the Venusberg. See Haustein, *Martin Luthers Stellung*, pp. 59–60.

31 Behringer, *Shaman of Oberstdorf*, pp. 56–7, 101–2; also List, 'Holda and the Venusberg', 307–11.

32 Bonomo, *Caccia alle streghe*, pp. 74–7.

33 'Die unsichtige nacket haußmagdt', in von Keller, *Hans Sachs*, vol. 22, pp. 502–3: 'Der fünfft saget auch her ein fabel,/ Wie man nachts außfuhr auff der gabel/ Und auff dem bock in Venus-berck,/ Dorinn man sech groß wunderwerck.'

34 Behringer, *Shaman of Oberstdorf*, pp. 32–3; and for 'bricolage', see pp. 146–51.

35 The most detailed account is in Bandmann, *Melancholie und Musik*, pp. 63–98, but it concentrates almost wholly on the foreground. Also see Klibansky, Panofsky and Saxl, *Saturn und Melancholie*, pp. 535–6, fig. 135; Heck, 'Entre humanisme et réforme', 260–2, fig. 6; Friedländer and Rosenberg, *Die Gemälde von Lucas Cranach*, p. 125, no. 277; Dieter Koepplin, *Cranachs Ehebildnis*, pp. 225–30; Zika, *Exorcising our Demons*, pp. 369–74.

36 The figure's lack of wings seems to be the result of the canvas being cut, as in the case of the 1528 version. See Klibansky, Panofsky and Saxl, *Saturn und Melancholie*, p. 536; Heck, 'Entre humanisme et réforme', 264, n. 43.

37 An analogous use of children to represent disorder by Cranach is his 1530 painting *Bacchus at the Wine Tub*. See Friedländer and Rosenberg, *Die Gemälde von Lucas Cranach*, p. 122, no. 260.

38 Bandmann, *Melancholie und Musik*, pp. 67–73. As well as the examples of the *Moriskentanz* and *Affentanz* reproduced by Bandman (figs 22–4), also see Vignau Wilberg-Schuurman, *Hoofse minne en burgerlijke*, figs 26–31.

39 See below Chapter 8.

40 See also Bandmann, *Melancholie und Musik*, pp. 79–81, who takes the opposite position, that these figures represent an antithesis to the dancing figures of the children in the

foreground. A serious difficulty for analysis is the poor quality of available reproductions of a painting in private ownership.

41 For the owl and its use by Cranach, see Koepplin, *Cranachs Ehebildnis*, pp. 224–37.

42 Hoffmann, 'Cranachs Zeichnungen', 10.

43 It has been noticed by Roger Callois, *Au coeur du fantastique*, p. 116, and Heck, 'Entre humanisme et réforme', 259.

44 For the description below, see especially Behringer, *Shaman of Oberstdorf*; Ginzburg, *The Night Battles*, pp. 40–61; Ginzburg, *Ecstasies*, pp. 89–121; Wirth, *La jeune fille et la mort*, pp. 94–104; Schmitt, *Ghosts in the Middle Ages*, pp. 93–123.

45 *Wütendes Heer* is one term for a phenomenon which goes by numerous other names such as *Wütisheer*, *Wuotas*, *Muetas*, *Wilde Fahrt* (Wild Ride), *Wilde Jagd* (Wild Hunt), *Geisterheer* (Horde of Spirits), which are often regional in their use. See especially Behringer, *Shaman of Oberstdorf*, pp. 26–34, 48–50, 56–8, 72–3; Kors and Peters, *Witchcraft in Europe*, pp. 60–63.

46 'Nun ist Wütis Heer eine Versammlung aller Hexen und Unholde zusammen.' Theophrastus Paracelsus, 'De Sagis', p. 461. For this process of conflation, see Behringer, *Shaman of Oberstdorf*, pp. 32–4, 57–8, 72–3.

47 Wirth, *Jeune fille et la mort*, p. 95. The earlier attribution was to Peter Vischer the Younger; see Röttinger, *Dürers Doppelgänger*, p. 228.

48 See figs 1.1, 1.2, 1.14, 2.1, 3.13, 3.14, 4.6.

49 Geiler of Kaysersberg, *Die Emeis*, fol. 38ʳ. For the original text, also see Zika, *Exorcising our Demons*, p. 349, n. 26.

50 The *Sprichwörtersammlung*, cited in Wirth, *Jeune fille et la mort*, pp. 95–6.

51 For the following, see Wolfram, *Studien*, pp. 15–54.

52 It was described as such in 1586 by Basil Amerbach. See Wirth, *Jeune fille et la mort*, p. 96.

53 For the crossed feet, see Andersson, 'Hans Baldung Grien', p. 16, n. 8; Friedländer and Rosenberg, *Die Gemälde von Lucas Cranach*, nos. 240–42, 398–9. For the slung leg motif, see Steinberg, 'Michelangelo's Florentine *Pietà*', 343–53. For images of Mars and Venus, see Russell, *Eva/Ave*, pp. 131, 137, 141–3; Dunand and Lemarchand, *Les compositions de Jules Romain*, figs 1, 5, 13, 131, 144, 145, 222, 405, 413–15, 585–9, 606–7, 609, 701, 754, 755.

54 Wolfram, *Studien*, pp. 18, 40. For two striking examples of Venus holding a vessel and Mars his sword, see the engravings by Georges Reverdy and Jean-Baptiste Ghisi, in Dunand and Lemarchand, *Compositions de Jules Romain*, p. 290, figs 585, 587. For Venus holding a long torch with a flame, see the engraving by Marcantonio Raimundi, in Russell and Barnes, *Eva/Ave*, p. 137.

55 See Müller, *Das Amerbach-Kabinett*, pp. 25–6, no. 70; Menz and Wagner, *Niklaus Manuel Deutsch*, pp. 323–5, no. 160, fig. 95; von Tavel, 'Dürers *Nemesis*', 290; Koerner, *The Moment of Self-Portraiture*, pp. 417–22.

56 Menz and Wagner, *Niklaus Manuel Deutsch*, p. 324.

57 von Tavel, 'Dürers *Nemesis*'.

58 The male cuckoo (*Gauch*) was the subject of much moralizing literature among upper Rhenish humanists such as Sebastian Brant and Thomas Murner. See von Tavel, 'Dürers *Nemesis*', pp. 287–9; Zika, *Exorcising our Demons*, p. 512.

59 Virgil, *Opera cum quinque vulgatis commentariis...*, Strasbourg: Johann Grüninger, 1502, fol. 61ʳ. The excised section of the block survived and the two parts were used together in some later editions of Virgil's *Opera*, such as the Lyon 1529 edition and the Venice 1552 edition. The relationship of the Virgil woodcut and *The Ants* woodcut was registered by Carlo Ginzburg in *The Night Battles*, pp. 45–7.

60 See the woodcut, generally attributed to Hans von Kulmbach, which appeared in the 1507 Augsburg edition of Gunther von Pairis, *De gestis Imperatoris Caesaris Friderici primi*, in Strauss, *Albrecht Dürer*, pp. 612–13; Röttinger, *Dürers Doppelgänger*, fig. 84. For further details and references, see Zika, *Exorcising our Demons*, pp. 352–4.

61 Apart from Brant's involvement with the illustrations to many editions of the *Narrenschiff*, the most significant publications on which he is known to have worked as an adviser for illustrations are the richly illustrated editions of Virgil's *Opera* (first ed. 1502) and Petrarch's *On Two Kinds of Fortune* (first ed. 1532; woodcuts by the Petrarca Meister completed *c.* 1520).

See Scheidig, *Die Holzschnitte des Petrarca-Meisters*, pp. 17–21; Fraenger, *Hans Weiditz und Sebastian Brant*, pp. 16–36; Schneider, *Vergil*, pp. 66–7.

62 The woodcut appeared in this second Basel edition and also in the third, but not in the first (March 1497). For details, see Zika, *Exorcising our Demons*, pp. 354–5, n. 37.

63 The chapter, headed 'De corrumpto ordine vivendi pereuntibus. Inventio nova Sebastiani Brant', is at fols 142ᵛ-152ʳ; the explanation of the 'Figura Coeli' of 1503 is at fols 147ʳ-148ʳ. Brant elaborates on the significance of his prediction of this dreadful conjunction in a letter to Konrad Peutinger of 1504 (Strauss, *Manifestations of Discontent*, pp. 223–7).

64 Sumberg, *The Nuremberg Schembart Carnival*, p. 131

65 For a history of the project and a facsimile of the work, see *The Book of Hours*, ed. Strauss; *Das Gebetbuch*, ed. Sieveking.

66 *The Book of Hours*, ed. Strauss, p. 129; *Das Gebetbuch*, ed. Sieveking, fol. 59ʳ; Jakob Rosenberg, *Die Zeichnungen Lucas Cranachs d.Ä*, fig. 24. While Cranach's illustrations seldom relate to the text, this image may refer to the words: 'Salutem ex animicis nostris: et de manu omnium qui oderunt nos...de manu inimicorum nostrorum liberati serviamus illi.'

67 Schade, *Schadenzauber*, p. 67, considers only the older woman to be a witch.

68 For an elaboration of this argument, see Zika, *Exorcising our Demons*, pp. 293–9, 328–32.

69 Figs 1.1, 1.2, 3.2, 3.3, 3.8, 3.14, 4.15. See also the bronze statuette of a *Witch Riding on a Goat*, reproduced in Mesenzeva, 'Zum Problem', p. 195, fig. 11. The statuette was purchased by the Kunsthistorisches Museum, Vienna in 1955; and according to the former director, Dr Manfred Leithe-Jasper, can no longer be considered the work of a Paduan artist, but must be attributed to a south German artist from the early sixteenth century (letter of 6 October, 1993).

70 Vintler, *Buch der Tugend*, Augsburg: Johann Blaubirer 1486, fol. 163ᵛ; Gotha, Forschungs-bibliothek, Cod. Chart. A594, c. 1500, fol. 179ᵛ. This ride illustrates the well-known story of St Germain from *The Golden Legend*.

71 The early dating, heavily based on studies from the 1930s supported by the National Socialist research institute, the Ahnenerbe, has been uncritically adopted in the literature: see Duerr, *Dreamtime*, pp. 170–1; van Dülmen, *Hexenwelten*, p. 53. But Schnittger-Schleswig, 'Vom Dom zu Schleswig', 487, claimed shortly after the frescoes were uncovered and restored in the late nineteenth century that they date from a period 'close to the Renaissance'. On iconographic and stylistic grounds this seems most likely; and Wolfgang Schild has recently supported the later date on the basis of Scandinavian wall paintings and the likely function of these images. For a detailed study of this issue and the literature, see Schild, 'Die zwei Schleswiger Hexlein'.

72 The image is reproduced in Givry, *Witchcraft, Magic and Alchemy*, p. 51, where the animal swung by the woman is called a cat. See Michalon, *La cathédrale de Lyon*, p. 41, for the dating. The medallion is located on the left of the right portal, on the second level from the base and on the middle of the three pillars.

73 Oursel, 'La Primatiale Saint-Jean de Lyon'; Michalon, *La cathédrale de Lyon*, pp. 40–1; Leutrat, 'Les médaillons de saint Jean', 1, no. 11, 1969, 34 (this article continues in six fort-nightly editions to 15, no. 1, 1970). Givry relates this image to one opposite (*Witchcraft, Magic and Alchemy*, p. 51). Leutrat considers it as part of a programme concerned with female power, but is unconvincing. He also refers to a male and female witch in two other medallions, no. 289 and 290, on the opposite side of the right door and also at level two ('Les médaillons de saint Jean,' 15, no. 1, 1970, 38).

74 See the discussion of these images in Chapters 3 and 7 below.

75 Wall, *Tjuvmjölkande Väsen*, pp. 50–1; Nyborg, *Fanden på vaeggen*, pp. 86, 88 (a church in Knutby).

76 For use of the cooking fork, see figs 1.1, 1.2, 1.9, 1.14, 2.1, 3.1, 3.2, 3.3, 3.7, 3.8, 3.13, 3.14, 4.4, 4.8, 4.15, 4.18, 7.8.

77 Gottlieb, 'The Brussels' Version of the Mérode *Annunciation*', 55; Bedaux, *The Reality of Symbols*, pp. 21–68. Also see the 1475 broadsheet which begins 'Wer sich zu verehelichen gedenkt...' ('Whoever is thinking about getting married...'), reproduced in Kühnel, *Alltag im Spätmittelalter*, Graz, p. 198.

78 Franits, *Paragons of Virtue*, pp. 2, 15, 76–7, 97–100; Schama, *The Embarrassment of Riches*, pp. 375–97.

79 For a reading of the ritualized sexual and social space of the house, see the article by Lyndal Roper, 'Tokens of Affection', pp. 152–8.

80 A rich example is in an etching appended to a pamphlet published in 1593 and again in 1594, by an author with the pseudonym Thomas Sigfridus (*Richtige Antwort auff die Frage*, Erfurt: Jakob Singen, 1593). For a reproduction of the etching and references, see Zika, *Exorcising our Demons*, pp. 440 n. 50; 441, fig. 76.

81 This woodcut is widely held to be from Thomas Erastus, *Deux dialogues touchant le pouvoir des sorciers*, which was published in two separate editions in Geneva in 1579. However, the woodcut is not found in any of the editions of this work held by the Bibliothèque de Genève, by the BN or by the Cornell University Library. It may have been inserted as a single-leaf woodcut into one or more copies of this work – and this has possibly led a number of scholars, including Grillot de Givry (*Witchcraft, Magic and Alchemy*, p. 64), Robert Muchembled (*La sorcière au village*, fig. 14), Wolfgang Schild (*Die Maleficia der Hexenleut*, p. 95) and others, to cite Erastus' work as the source of the woodcut. The Bridgeman Library claims the artist is of the English School; but the grounds for this are unclear. The woodcut was later published as the titlepage woodcut for Abraham Palingh, *'t afgerukt Mom-Aansight Der Tooverye*, Amsterdam: Jan Rieuwertz, 1659 (reproduced in Franz, *Friedrich Spee*, p. 92). For Erastus and his work, see Gunnoe, 'The Debate between Johann Weyer and Thomas Erastus'. I thank Ian Coller, Charles Gunnoe and Fabienne le Bars of the Department of Rare Books, BN, for their assistance in this matter.

82 For some examples and discussion, see Zika, *Exorcising our Demons*, pp. 300–303, figs. 30, 31.

83 Biedermann, *1473–1973. Hans Burgkmair*, fig. 88, cat. no. 114.

84 In a 1732 copy by Bernard Picart, the phallus has been given legs and feet with large claws, while the head of the phallus has become that of a beast (King, *Witchcraft and Demonology*, p. 63).

CHAPTER 5 TRANSFORMATION, DEATH AND SEXUALITY IN THE CLASSICAL WORLD

1 Emison, 'Truth and *Bizzarria*', 627–8, 635, n. 31; Albricci, '*Lo Stregozzo*', 55; Hofman, *Zauber der Medusa*, p. 289; Peltzer, 'Nordische und italienische Teufels- und Hexenwelt', pp. 275–8; Tietze-Conrat, 'Der "Stregozzo"', 57–9. The size of the engraving varies between 299 x 625 and 302 x 645 in different copies and states. Peltzer gives the date as 1518 (p. 276); Emison as early 1530s (631). The traditional title, *The Carcass*, is found in TIB and others; while some translate the Italian as *The Witch's Hunt* or *Wild Ride*, Albricci explains 'stregozzo' as deriving from Veneto dialect and meaning a procession among the screech owls ('andare in strighezzo'); while Emison understands 'strige' to refer to 'witch' and translates as 'a procession to a witch's Sabbath' (623, 634, n. 3).

2 I follow the majority of recent commentators in attributing the engraving to Agostino Veneziano, largely on the basis of the initials AV which were inscribed on the twisted horn of the leading goat in the final known state of the print, and which were also originally inscribed on a tablet – located near the right foot of the left leading male – from which they were later erased in an earlier, possibly first, state of the print. The design has also been attributed to Girolamo Genga and others. See especially the argument and references in Emison, 'Truth and *Bizzarria*', 627–8, 631.

3 Emison, 'Truth and *Bizzarria*', 626. But I cannot agree with Emison that they 'represent fallen angels now engaged in devil worship' (629).

4 The Italian work was entitled *Strega, o delle illusioni del demonio*. A further translation into Tuscan was published in 1555. See Emison, 'Truth and *Bizzarria*', 630; Burke, 'Witchcraft and Magic in Renaissance Italy', p. 34; Herzig, 'The Demons' Reaction to Sodomy', 58–9, 69–72. The relationship with the Mirandola trials is one reason why Emison supports a late dating for the engraving.

5 That Dürer provided the model is generally accepted. On the identity of the female figure I follow Lesourd, 'Diane et les sorcières', 55–74. Tietze-Conrat, 'Der "Stregozzo"', identifies the woman as the goddess Hecate, one of the manifestations of Artemis/Diana. Also see

Behringer, *Shaman of Oberstdorf*, pp. 51–5. For a quite different reading of the image as the procession of a witch, the devil and fallen angels, modelled on Gianfrancesco Pico's work of 1523, *Strix sive de ludificatione daemonum*, see Emison, 'Truth and *Bizzarria*', 630.

6 Emison, 'Truth and *Bizzarria*', 630.

7 The relationship between witchcraft and Saturn is developed below in Chapter 8.

8 This is one of the fundamental arguments of Sullivan, 'The Witches of Dürer and Hans Baldung Grien', 332–401.

9 For example see figs. 1.1, 1.2, 2.1, 3.1, 3.2, 3.3, 3.14, 3.17, 3.21, 4.8, 4.10, 4.15.

10 Russell, *Eva/Ave*, p. 174; Marrow and Shestack, *Hans Baldung Grien*, p. 36, fig. 31; Jones and Stallybrass, *Renaissance Clothing*, pp. 116–33.

11 Virgil, *Dreyzehen Bücher von dem tewren Helden Enea*, Frankfurt a.M.: David Zöpffeln, 1559, fol. R 3ᵛ. The woodcut is used again in a Jena edition of the work in 1606; and a close copy is found in a Cologne edition of 1591. Schneider, *Vergil*, pp. 162–4 (D 159).

12 Virgil, *Opera Omnia*, Leipzig: Johann Steinmann, 1581, p. 287 (on the same page as in the 1588 edition; see fig. 5.4). Schneider, *Vergil*, pp. 83, 87–8 (D 25, D 32).

13 Virgil, *Dreyzehn Aeneadische bücher von Troianischer zerstörung*, Worms: Gregorius Hofmann, 1543, fol. 127ᵛ; Virgil, *Opera cum quinque vulgatis commentariis*, 1502, fol. 274ʳ; also Virgil, *Opera*, Lyon: J. Crespin, 1529, p. 316. See Schneider, *Vergil*, pp. 66–7, 162 (D 5, D 158).

14 The case of Tantalus is not referred to in Virgil's text; but the commentaries comment on it at length.

15 It may be that the model was the Tarturus found in many Christopher Froschauer editions of the 1560s and 1570s.

16 Virgil, *Dreyzehen Bücher von dem tewren Helden Enea*, Zurich: Christoph Froschauer, fol. Q vii ʳ [BSB: A.lat.a.2163].

17 For a more detailed discussion of visual representations of Circe, see Zika, 'Images of Circe', on which this section draws.

18 The so-called Brussels Woodcutter made only minor changes in Boccaccio, *Liber de claris mulieribus*, Louvain: Aedigius van der Heerstraten, 1487, fol. D2ᵛ; also see Conway, *The Woodcutters of the Netherlands*, pp. 128–30. The illustrator of the sixteenth-century editions extended the range of animals into which Ulysses' companions had been transformed and clothed them in more contemporary garb; see Boccaccio, *Ein Schöne Cronica oder Hystoribüch von den Fürnämlichsten Weybern*, Augsburg: Heinrich Steiner, 1541, fol. 31ʳ; 1543, fol. 31ʳ. For an English edition of the text, see Boccaccio, *Concerning Famous Women*, pp. 77–8.

19 For the same gesture used for sibyls, see above at fig. 1.11.

20 For Dürer as designer, see Strieder et al., *Dürer*, p. 61; *Albrecht Dürer 1471–1971*, pp. 72–3, fig. 117.

21 *Liber Chronicarum*, Nuremberg: Anton Koberger, 1493, fol. 41ʳ. The two editions had large runs of 1,000 and 1,500 and were widely marketed throughout Europe. See Wilson and Wilson, *The Making of the Nuremberg Chronicle*; Rücker, *Weltchronik*; Smith, *Nuremberg*, pp. 94–5.

22 See Chapter 6 for further details and for sixteenth-century examples. The relevant materials have been gathered in a lengthy illustrated essay by Kurt Volkmann, first published in the German magazine *Magie* from 1952 to 1954, then as a monograph, *Das Becherspiel des Zaubers*, and in translation as *The Oldest Deception*. See also Philip, 'The Peddler' by Hieronymus Bosch', 22–5; Hauber, *Planetenkinderbilder und Sternbilder*.

23 Filedt Kok, *The Master of The Amsterdam Cabinet*, pp. 218–25; Waldburg Wolfegg, *Venus und Mars*, pp. 38–42.

24 See the discussion below at figs 6.5–6.8.

25 If the young Dürer was indeed the artist, he may well have learnt of the motif from the Housebook Master, whose influence upon Dürer is widely attested. See Filedt Kok, *The Master of The Amsterdam Cabinet*, pp. 38, 60; Strieder et al., *Dürer*, pp. 87–9; *Albrecht Dürer 1471–1971*, pp. 74, 81–7. We do know that the assistant to Circe and her table already featured in the very early designs created for the layout volumes in 1487–8, when Dürer was an apprentice there. For an illustration and further references, see Zika, 'Images of Circe', paragraph 11, fig. 5, n. 17.

26 Augustine, *The City of God*, book 18, chs 17–18. Also see Chapter 3 above for Geiler of Kaysersberg and illusion.

27 See *Malleus Maleficarum*, part 1, q. 10; part 2, q. 1, ch. 8; Endres, 'Heinrich Institoris', p. 209; Kunstmann, *Zauberwahn und Hexenprozeß*, p. 142.

28 Boethius, *Consolatio Philosophiae*, book 4, ch. 3, pp. 87–8. The German edition of the *Chronicle* simply refers to Boethius, while the Latin edition cites the particular work.

29 As in a fifteenth-century Cambridge manuscript, and a late fourteenth-century Paris manuscript. For these and other manuscript illustrations of Circe in Boethius, see Dwyer, *Boethian Fictions*, p. 28, figs 2, 3; Courcelle, *La consolation de philosophie*, pp. 194–6, figs 108, 3; 109, 1–2; 110, 1–3; 111.

30 See the woodcuts after Parmigianino, in Zika, 'Images of Circe', figs 12 and 13, as well as the literature and other examples by Parmigianino, Master L.D. and Giulio Bonasone, at paragraphs 22–3, n. 44–5. And for a similar scene in a fourteenth-century Paris manuscript, see Courcelle, *La consolation de philosophie*, fig. 109, 2.

31 Yarnall, *Transformations of Circe*, ch. 4.

32 Virgil, *Opera cum quinque vulgatis commentariis*, Strasbourg: Johann Grüninger, 28 Aug. 1502, fol. 288ʳ.

33 These later prints do not include the additional double-line border found on the left side of the 1502 version. See Virgil, *Dryzehen Aeneadische Bücher von Troianischer zerstörung*, Strasbourg: Johann Grüninger, 1515, fol. 92ʳ; *Opera Virgiliana cum decem commentis*, Lyon: J. Crespin, 1529, p. 343; *Opera…in pristinam formam restituta*, Venice: L.A. Giunta, 1533, fol. 159ʳ; *Opera Omnia*, Venice: L.A. Giunta, 1552, fol. 361ᵛ.

34 See above figs 1.12, 1.13, 3.1, 3.2, 4.6.

35 Virgil, *Omnia Opera*, Venice: Bartolomeus de Zannis de Portesio, 1508. Circe was not chosen as the key image at the beginning of book seven in a number of German translations of the *Aeneid*, such as the editions of 1543 and 1559.

36 Three examples are: Ovid, *Metamorphoseos*, Milan: Giovanni Angelo Scinzenzeler, 1517, fol. 167ʳ; Ovid, *Metamorphoseos*, Lyon: Jacobus Huguetan, 1518, fol. 103ʳ; Ovid, *Metamorphoseos*, Venice: Nicolaus Moretus, 1586, p. 273.

37 *La métamorphose d'Ovide figurée*, Lyon: Jean de Tournes, 1557, p. 163.

38 TIB, vol. 19, part 1, p. 513, fig. 7.165; p. 577, fig. 9.103. In Reusner's work the image appears in association with the motto 'Idleness is a wicked siren' (*Improba Siren desidia*), and not in relation to the vice of lust as in Alciato's emblem books which are discussed below.

39 The standard dating of *c.*1525 has been revised in Humfrey and Lucco, *Dosso Dossi*, pp. 89–92; Humfrey, 'Two Moments in Dosso's Career', pp. 204–7; see also Gibbons, *Dosso and Battista Dossi*, pp. 215–16, no. 80, fig. 34; Walker, *National Gallery of Art, Washington*, pp. 192–3, no. 222.

40 Peter Humfrey considers Dosso's *Circe* to be modelled on Leonardo da Vinci's painting, *Standing Leda*, *c.*1506 (Humfrey and Lucco, *Dosso Dossi*, p. 90). Circe also appears naked above the waist in Whitney, *A Choice of Emblemes*. For other examples from the later sixteenth and seventeenth centuries, see Zika, 'Images of Circe', paragraphs 20, 26, n. 38.

41 This depiction of Circe matches a closely related painting of *c.*1515–16 by Dossi, which is often given the title of *Circe* and depicts a female figure richly clothed in scarlet and gold brocade, wearing an exotic oriental turban ornamented with jewels and gold thread and lighting her torch from a brazier. As Peter Humphrey, Felton Gibbons and others have argued, the subject is more likely to be a depiction of Melissa, the good fairy or unwitcher from Ariosto's *Orlando Furioso*, who breaks the spells of her Circean opposite, Alcina. See Humfrey and Lucco, *Dosso Dossi*, pp. 114–18; Gibbons, *Dosso and Battista Dossi*, pp. 198–200, no. 59, figs 28–29; Manning, 'Transformation of Circe', p. 689.

42 For the following, see Zika, 'Images of Circe', n. 44–5, figs 12–13.

43 *The Metamorphoses of Ovid*, trans. Innes, p. 322.

44 For the complicated history of emblem literature, see Alciato, *Emblemata: Lyon, 1550*; *Andreas Alciatus*, ed. Daly; Henkel and Schöne, *Emblemata*.

45 Alciato, *Emblemata: Lyon, 1550*, p. xvi. No detailed study of the images used in these editions of Alciato and in the emblem books of other authors exists. The du Vase Circe was also used in the 1567 Frankfurt edition of Alciato collected and edited by Jeremias Held of

Nördlingen. See Henkel and Schöne, *Emblemata*, col. 1694–5. See Zika, 'Images of Circe', fig. 15.

46 The translation is by Betty Knott, from Alciato, Emblemata: *Lyon, 1550*, p. 84. The epigram in Marquale's Italian version, published in Lyon in 1551, includes the same woodcut and is even more expansive: 'Thus, those who set out to chase women lose their mind and reason.' See *Andreas Alciatus*, ed. Daly, vol. 2, emblem 76.

47 For instance, in the Paris editions of 1583 and 1589, which include Claude Mignault's commentary.

48 Whitney's verses are reproduced in Yarnall, *Transformations of Circe*, p. 103; for the image without the verses, see Paster, *The Body Embarrassed*, p. 129. There is a similar reference to resisting whores in the epigram in Matthias Holtzwart, *Emblematum Tyrocinia*, Strasbourg: Bernhard Jobin, 1581, no. 26 (reproduced in Henkel and Schöne, *Emblemata*, col. 1696).

49 Hughes, 'Spenser's Acrasia', 387–8, 397.

50 Balthazar de Beaujoyeulx, *Le Balet Comique, 1581*, ed. McGowan. The text was by La Chesnaye, poet and almoner of the queen, the music by Lambert de Beaulieu, and the engravings by Jacques Patin, who was also responsible for the painting of the original scenery. The *Ballet* was later published in *Recueil des plus excellens ballets de ce temps*, Paris, 1612. For a description and reproduction of the first engraving depicting the opening scene, and further references to the *Ballet*, see Zika, 'Images of Circe', paragraphs 28–30, fig. 16.

51 See *Lucian of Samosata*, ed. Macleod; Apuleius, *Metamorphoses*, ed. Hanson. Also Warner, *From the Beast to the Blonde*, pp. 142–6. The copy of the Eggestein edition I consulted (HAB: 130 Qu 2°) concludes with these words: 'Hye endet der guldin esel durch lucium apuleium in krichischer zungen beschriben dornach durch poggium florentinum in latin transzferiett und zü letzt von niclas von wyle geteutschet.'

52 Schramm, vol. 23, p.18, figs 480–86.

53 Five of the six woodcuts are reproduced in Ohly, 'Ein unbeachteter illustrierter Druck'.

54 Schramm, vol. 23, 18, describes this incorrectly as as a cup of wine. The text of the Strasbourg Eggestein edition reads (fol. 9ᵛ): 'buchssen mit salben'.

55 It is significant that this last detail as well as many others aspects of the woodcut do not accord with the details of the text.

56 The 1499 edition woodcut is reproduced in Schramm, vol. 20, fig. 1254, where the printer is incorrectly listed as Johann Prüss. The title in both editions is *Ein hubsche history von Lucius apuleius in gestalt eins esels verwandelt...* In the 1509 edition, the ornamental border of the earlier edition has been dispensed with.

57 *Nicolai von Weil den zyten Statschriber der Esselingen: etlicher bücher Enee silvij*, Strasßbourg: Johann Prüss, 1510; reproduced in Hollstein, vol. 2, p. 142, pl. 244.

58 Reproduced in Hollstein, vol. 4, p. 168, pl. 44; and in Geisberg, *Die deutsche Buch-illustration*, vol. 8, fig. 857 – but in both cases without the ornamental border.

59 Modern commentators have also been misled. See the captions to both woodcuts repro-duced in Jurina, *Vom Quacksalber zum Doctor Medecinae*, p. 123, which read 'The Sorcerer Palaestra'. By the eighteenth century, Palaestra is even depicted with magical circle, skull and wand; see Warner, *From the Beast to the Blonde*, p. 142.

60 Palaestra is described at one point as 'a veritable man-cooker' (*Lucian of Samosata*, ed. Macleod, p. 61). The Nicholas von Wyle translation, however, places far less emphasis on sex than the original Lucian and omits the long account of Lucius' sexual exploits with the wealthy woman. See *Lucian of Samosata*, ed. Macleod, pp. 133–7, 141–3.

61 Lucius Apuleius, *Ain Schön Lieblich auch kurtzweylig gedichte*. Also see *Welt im Umbruch*, vol. 1, p. 331, no. 318; Schreyl, *Hans Schäufelein*, vol. 1, pp. 176–7.

62 Schreyl has followed Campbell Dodgson in attributing the first 37 woodcuts to the Monogrammist NH (Schreyl, *Hans Schäufelein*, vol.1, p. 176). Heinrich Röttinger attrib-uted these woodcuts to Weiditz and dated them 1516–18 (Röttinger, *Hans Weiditz der Petrarkameister*, p. 63, no. 3). The 37 woodcuts cover the stories in books 1–3.

63 Reproduced in Geisberg, *Die deutsche Buchillustration*, vol. 2, fig. 235.

64 Apuleius, *Ain Schön Lieblich auch kurtzweylig gedichte*, fols 17ᵛ-18ᵛ, where the titlepage woodcut is repeated; Apuleius, *Metamorphoses*, ed. Hanson, pp. 169–73.

65 Reproduced in Geisberg, *Die deutsche Buchillustration*, vol. 2, fig. 234.

66 Reproduced in Geisberg, *Die deutsche Buchillustration*, vol. 2, fig. 233.

67 Apuleius, *Ain Schön Lieblich auch kurtzweylig gedichte*, fols 11ʳ (Apuleius, *Metamorphoses*, ed. Hanson, p. 103): 'und mag niemand gnug erzelen/ die behendigkait die dise bößen weiber zü irer begierde erdencken'.

68 Apuleius, *Ain Schön Lieblich auch kurtzweylig gedichte*, fols 2ᵛ-3ʳ (Apuleius, *Metamorphoses*, ed. Hanson, pp. 13–25). The woodcut has been reproduced in Geisberg, *Die deutsche Buch-illustration*, vol. 1, fig. 110; and in Musper, *Die deutsche Bücherillustration*, vol. 2, p. 200.

69 Apuleius' text has ram (*aries*), but the German translates as goat (*Bock*).

70 Apuleius, *Ain Schön Lieblich auch kurtzweylig gedichte*, fols 2ᵛ-3ʳ (Apuleius, *Metamorphoses*, ed. Hanson, pp. 25–31). The woodcut has been reproduced in Geisberg, *Die deutsche Buchillustration*, vol. 9, fig. 111. *Unholden* is also used in the caption of the woodcut on fol. 4ᵛ, another reference to Meroe and Panthia.

71 The imagery and literature on Medea in the sixteenth century is vast and requires detailed examination. Some important titles are: Reid, *The Oxford Guide to Classical Mythology*, vol. 2, pp. 643–5; Morse, *The Medieval Medea*; Emiliani, *Bologna 1584*; Gramaccini, 'La Médée d'Annibale Carracci', pp. 491–519.

72 Ovid, *La Métamorphose d'Ovide figurée*, Lyon: Jean de Tournes, 1557.

73 Some examples can be found in: TIB, vol. 19, part 11, p. 492, fig. 7.83 (320) (Virgil Solis); *Andreas Alciatus*, ed. Daly, vol. 1, emblem 54; Matthews Grieco, *Ange ou Diablesse* (Bernard Salomon); Brugerolles and Guillet, *The Renaissance in France*, p. 102, fig. 35a (Léonard Thiry); Boccaccio, *De claris mulieribus* (eds of 1473, 1487, 1541).

74 Boccaccio, *Concerning Famous Women*, p. 37.

CHAPTER 6 A BIBLICAL NECROMANCER AND TWO CHRISTIAN SAINTS

1 Carroll, 'Cornelisz. van Oostsanen [von Amsterdam], Jacob', pp. 868–70; Carroll, 'The Paintings of Jacob Cornelisz van Oostsanen' pp. 90–104; Os et al., *Netherlandish Art in the Rijksmuseum, 1400–1600*, p. 126; Kloek, *Art Before the Iconoclasm*, pp. 13–14; Schmitt, 'Le spectre de Samuel', 53. For consideration of the painting, also see my earlier work on which I here draw: Zika, *Exorcising our Demons*, pp. 379–81; Zika, 'The Witch of Endor', pp. 241–6.

2 See Trebbin, *David Teniers und Sankt Antonius*, for some examples of this rich theme.

3 The inscriptions are reproduced in the original language in Filedt Kok et al., *Kunst voor de beeldenstorm*, p. 133; and in translation in Carroll, 'The Paintings of Jacob Cornelisz van Oostsanen', p. 90. The Latin word I translate as 'seer' is *pythone*; while the inscription on the woman's red cap reads 'pitonissa Saulis'. The word python referred originally to the huge serpent that guarded the Delphic Oracle and was slain by Apollo; and then, by association, to the spirit that gave one power to divine the future. By the late fifteenth century, *mulieres pythonicae* or *mulieres phitonicae* were synonymous with *Unholden* (witches) for some writers. For further references, see Zika, 'The Witch of Endor', p. 236, n. 1.

4 'Saul tot tovery heeft ghegeu Samuel te verwrecke qua hi te sneven.' Although this banderole clearly refers to sorcery or witchcraft by its use of the word *tovery*, Carroll's translation of 'iussu numinis' in the lower banderole as 'through magic' seems unwarranted, and could just as well refer to divine permission (Carroll, 'The Paintings of Jacob Cornelisz van Oostsanen', p. 90).

5 For the holding of the goat's horn, see figs 1.12, 1.13, 4.6, 4.15.

6 The other women are cooking pancakes, and Carroll relates this to a Dutch adage: 'When it rains and the sun shines, witches are making pancakes' (Carroll, 'The Paintings of Jacob Cornelisz van Oostsanen', p. 100).

7 Carroll, 'The Paintings of Jacob Cornelisz van Oostsanen', p. 100.

8 Major restoration during 1976–80 revealed that the hurdy-gurdy was originally a double flute, the attribute of Pan; and that the chickens were also added in the seventeenth century (see Carroll, 'The Paintings of Jacob Cornelisz van Oostsanen', p. 93, n. 9). The inclusion of this figure suggests that the model may well have been the popular woodcut that first appeared in Geiler of Kaysersberg's *Die Emeis* of 1516 (fig. 3.1). For the hurdy-gurdy as an

instrument associated with the devil, see Jones Hellerstedt, 'Hurdy-Gurdies from Hieronymus Bosch to Rembrandt'.

9 For details of the late medieval iconography, see Schmitt, 'Le spectre de Samuel', 47–8, 51–3; Zika, 'The Witch of Endor', pp. 238–9.

10 Schmitt, 'Le spectre de Samuel', 52–3; and for a coloured reproduction, Schmitt, *Ghosts in the Middle Ages*, fig. 1.

11 Leeman, *Hidden Images*, pp. 52, 57, fig. 44; Baltrusaitis, *Anamorphic Art*, pp. 24–5, 172, n.16, fig. 16.

12 The woodcut was included in at least two editions of the 1530 Combined Bible published in Strasbourg by Wolfgang Köpfl [HAB: Bibel S 4° 7] and by Petrus Renner [HAB: Bibel S 4° 6], and in a 1532 Strasbourg edition published by Köpfl (see Schmidt, *Die Illustration der Lutherbibel*, p. 436).

13 The Master I.T. is generally identified with the woodcut designer Johann Teufel. For this woodcut, see Zika, 'Reformation, Scriptural Precedent and Witchcraft'. For the 1572 Wittenberg *Luther Bible* published by Hans Krafft, also see Schmidt, *Die Illustration der Lutherbibel*, pp. 274–96.

14 For Arande, generally identified with the artist called 'le maître à la capeline', and a reproduction of his woodcut, see Zika, 'Reformation, Scriptural Precedent and Witchcraft', pp. 153, 161, fig. 2. The Arande woodcut also appeared in the 1577 Lyon edition of the *Quadrins historiques* published by Roville.

15 See Schmidt, *Die Illustration der Lutherbibel*, pp. 431–2, 436, fig. 349, which only refers, however, to the 1572 and 1584 editions.

16 For the rosary as an object by which Catholics were identified, see Meier, 'Der Rosenkranz in der Reformationszeit'. It does not appear in Thomas Arande's earlier version of 1564.

17 See, for instance, his illustration of 1 Kings 15.12–13, in which King Asa of Judah is depicted overseeing the destruction and burning of idols in the company of Luther, Elector Frederick the Wise and Duke Augustus of Saxony; Reinitzer, *Biblia deutsch*, pp. 259–60, fig. 169.

18 For further discussion and references, see Zika, 'Reformation, Scriptural Precedent and Witchcraft', pp. 153–5.

19 *Die Luther-Bibel von 1534*, fol. 79ᵛ: 'Das erzelet die Schrifft darumb/ auff das sie warne jederman/ das er das nachfolgende Gespenst von Samuel recht verstehe und wisse/ das Samuel tod sey/ und solchs der böse Geist mit der Zeuberinnen und Saul redet und thut/ in Samuels person und namen.' This is on fol. 197ʳ in the 1572 edition. Others, such as the Lutheran physician, Johann Weyer, also drew on the authority of Augustine to claim that Samuel was a devil-specter, 'clad in [a demon's] likeness', and the woman of Endor was therefore a demonic familiar and 'servant of the devil' (Weyer, *Witches, Devils and Doctors*, pp. 127–33 (book 2, chs 9–10)).

20 See the extract in Behringer, *Hexen und Hexenprozesse in Deutschland*, p. 157. Also Schmidt, 'Das Hexereidelikt in den kursächsischen Konstitutionen von 1572', pp. 111–36; Zika, 'Reformation, Scriptural Precedent and Witchcraft', pp. 156–8.

21 For seventeenth- and early eighteenth-century images, see Zika, 'The Witch of Endor', pp. 249–59.

22 Bruegel's original preparatory drawing is lost. For reproduction of the three states of the engraving, see Bastelaer, *The Prints of Peter Bruegel the Elder*, pp. 142–4, cat. 117. Also see Orenstein, *Pieter Bruegel the Elder*, pp. 230–31, no. 101; Marijnissen, *Bruegel*, p. 239; Préaud, *Les sorcières*, pp. 10–12; Klein, *Graphic Worlds*, pp. 259–61.

23 An alternative reading is 'St James is brought before the magician by means of his diabolical tricks'.

24 For the *Legenda Aurea* story, see Jacobus de Voragine, *Legenda Aurea*, ed. Graesse, pp. 422–3; and Jacobus de Voragine, *Legenda Aurea*, ed. Ryan, vol. 2, pp. 3–5.

25 Previously the broom is found only in a few instances in French-speaking regions (figs 1.6, 2.22, 2.23), and then in Jacob Cornelisz's painting (fig. 6.1).

26 For witches riding up or out of a chimney, see above at fig. 4.18. For two examples of this hearth used in witchcraft scenes, see Zika, *Exorcising our Demons*, pp. 441, 454, figs 76, 80. Before Bruegel, the only depiction of a witch emerging from a chimney is in a manuscript illumination (fig. 2.23).

27 For the battle of the virtues and vices, see the references above in Chapter 1, n. 6; and for the night battles see the discussion of the Furious Horde in Chapter 4.

28 Johann Pauli, *Schimpff unnd Ernst*, Augsburg: Steiner 1542, fol. 30ᵛ; Francesco Petrarca, *Von der Artzney bayder Glück des güten und wider wertigen*, Augsburg: Heynrich Steiner, 1532, fol. 146ᵛ.

29 See de Gheyn, *The Witches' Kitchen* (Préaud, *Les sorcières*, no. 41), also called *The Dance of the Witches* (Hollstein, vol. 7, p. 96). For some recent incisive comments about the relationship of Bruegel and de Gheyn, see Swan, *Art, Science and Witchcraft*, pp. 144–8.

30 Préaud, *Les sorcières*, p. 12.

31 For the iconography in general, see Kimpel, 'Jakobus der Ältere', col. 32–3, 37–8; Réau, *L'iconographie de l'art chrétien*, vol. 3, part 2, pp. 695–702.

32 Manhes-Deremble and Deremble, *Les vitraux narratifs*, pp. 306–7; Mâle, *The Gothic Image*, pp. 304–6. Also see the St James scenes in the window of *c.* 1225 in Bourges cathedral, in Hell and Hell, *The Great Pilgrimage*, pl. 81.

33 Fahy, 'The Kimbell Fra Angelico', 178.

34 Gamboso, *La basilica del santo di Padova*, p. 77; D'Arcais, 'La decorazione della cappella di San Giacomo', pp.15–42, figs 28–32.

35 Tietze-Conrat, *Mantegna*, figs 9, 10.

36 The panel is now in the Louvre. See Zeri, 'Investigations into the Early Period of Lorenzo Monaco I', 554–58, figs 6, 9; Fahy, 'The Kimbell Fra Angelico', pp. 178, 181, fig. 1.

37 This panel is now in the Kimbell Art Museum, Fort Worth, Texas. See Kanter et al., *Painting and Illumination*, p. 327; Fahy, 'The Kimbell Fra Angelico'.

38 Kotalík et al., *Staré české umení*, pp. 60, 72, nos. 53–5.

39 Valentinitsch and Schwarzkogler, *Hexen und Zauberer*, pp. 135–6, fig. 10/6; Schild, *Die Maleficia der Hexenleut*, p. 29.

40 The panel is now in the Indianopolis Museum of Art. See Gitlitz, 'The Iconography of St. James', pp. 116–17, fig. 6.2.

41 Hell and Hell, *The Great Pilgrimage*, p. 257, pl. 161. The burning of Hermogenes' books is specifically rejected in the *Golden Legend,* lest the smoke do injury to bystanders.

42 Boon et al., *Jheronimus Bosch*, p. 65, no. 8; Orenstein, *Pieter Bruegel the Elder*, p. 231, fig. 99; Kors and Peters, *Witchcraft in Europe*, p. 140, fig. 2. Even the engravings by the early seventeenth-century Polish artist Jan Ziarnko, the author of one of the best known images of witchcraft, the depiction of the Sabbath which accompanied Pierre de Lancre's *Tableau de l'inconstance des mauvais anges*, Paris: Nicolas Buon, 1613, make no reference to magical and demonic activities beyond the narrative. However they do place primary emphasis on the figure of Hermogenes and the role of demons. See Sawicka, *Jan Ziarnko*, pp. 142, 178–9, fig. 48.

43 Bruegel made a mistake in dating the drawing 'MDXLIIII' instead of 'MDLXIIII'. For the drawing, see the reproduction in Marijnissen, *Bruegel*, pp. 240–41; and in Boon, *Netherlandish Drawings*, vol. 2, pp. 36–7, 40; see also Mielke, *Pieter Bruegel*, pp. 65–6. For the print, see reproductions of the first two of the four states in Bastelaer, *The Prints of Peter Bruegel the Elder*, pp. 145–6, cat. no. 118; also Orenstein, *Bruegel the Elder*, pp. 232–3, nos. 102–3; Klein, *Graphic Worlds*, p. 265; Préaud, *Les sorcières*, pp. 12–13; Milne, 'Dreams and Popular Beliefs', pp. 320–22.

44 As cited in Klein, *Graphic Worlds*, p. 263.

45 Bastelaer, *The Prints of Peter Bruegel the Elder*, pp. 259–62, no. 195.

46 Hondorff claimed that the trick was performed as early as 1272. See Volkmann, *The Oldest Deception*, p. 39, for the reference to Andreas Hondorff, *Theatrum Historicum, sive Promptuarium Illustrium Exemplorum* of 1575, and for a drawing depicting the trick from a manuscript of *c.* 1530, *Ingenieurkunst- und Wunderbuch*. See also Scot, *The Discoverie of Witchcraft*, ed. Summers, pp. 198, 203 (book 13, ch. 34). The suggestion by Orenstein (*Bruegel the Elder*, p. 234) that this is a reference to the future beheading of St James does not seem likely.

47 Scot, *The Discoverie of Witchcraft*, ed. Summers, pp. 196–202 (book 13, ch. 34). There are also instructions for putting a ring through the cheek, relevant to the gryllus with the padlock at bottom right of Bruegel's print; and for thrusting knives into head and stomach, relevant to the two figures with swords thrust into their necks.

48 The cited phrase is from the original title of the work; see Scot, *The Discoverie of Witchcraft*, ed. Summers, p. xxxiii.

49 The work appeared under Witekind's pseudonym: August Lercheimer, *Christlich Bedenken und Erinnerung von Zauberey*, Basel: Sebastian Henricpetri, 1593, pp. 53–54 ('Von Gauckel Zauberey'). The first edition was published in Heidelberg in 1585 and this was followed by three more editions and reprintings in other collections in the sixteenth century. See Golden, *Encyclopedia of Witchcraft*, vol. 4, pp. 1221–2.

50 Witekind, *Christlich Bedenken*, 59–60. The emphasis is mine and the translation an adaptation of that in Volkmann, *The Oldest Deception*, pp. 47–8.

51 Unverfehrt, *Hieronymus Bosch*, pp. 114–17, 247–9, figs 55–9; Philip, '*The Peddler*', pp. 22–5; Volkmann, *The Oldest Deception*, pp. 28–36.

52 As well as appearing in the fifteenth-century images referred to in Chapter 5, the topos appears in the sixteenth century in the work of Hans Sebald Beham (1531) and in one of the Petrarca-Meister's woodcuts for the German translation of Petrarch's *On Two Kinds of Fortune* (1532), which was reproduced at least four times before the 1560s. See Volkmann, *The Oldest Deception*, pp. 40–45.

53 The link between Bosch's conjuror and the Housebook Master's trickster was made by Philip, '*The Peddler*', p. 22, but the close similarity between the settings seems not to have been noticed. See Filedt Kok et al., *The Master of The Amsterdam Cabinet*, pp. 218–25; Waldburg Wolfegg, *Venus und Mars*, pp. 38–42.

54 Nahl, *Zauberglaube und Hexenwahn*, pp. 57–65.

55 Bruegel's print continued to be published by Hieronymus Cock and his widow through to the 1590s, then by Theodore de Bry in a collection of 1610, and later by Jean Galle (1600–1676), the grandson of Philip Galle (1537–1612), who received the plates from Cock's widow in the early seventeenth century.

56 For reproductions see Bastelaer, *The Prints of Peter Bruegel the Elder*, pp. 254–8; also Marijnissen, *Bruegel*, pp. 110–11; Klein, *Graphic Worlds*, pp. 167–9; Marijnissen and Seidel, *Bruegel*, pp. 66–7.

57 For the nine different states and a copy by Theodore de Bry, see Bastelaer, *The Prints of Peter Bruegel the Elder*, pp. 254–8.

58 The English translation of the Flemish verses reads: 'You residents of Mallegem wish now to be healthy/ I, Lady Witch, will become loved here as well/ In order to cure you have I come here/ At your service, with my assistants four /Most everyone should come freely with the least delay/ If you have a wasp in the head, or if you are troubled with stones.'

59 A 'cure of folly' scene featured in a *tableau vivant* for the procession of Our Lady in Antwerp in 1563 (Pinson, 'The Water Mill in Brueghel's *Witch of Malleghem*', p. 32). It was also the subject of another print after Bruegel, *The Dean of Renaix* of 1557 (Bastelaer, *The Prints of Peter Breugel the Elder*, pp. 251–3; Marijnissen, *Bruegel*, p. 389) and of a painting by Hieronymus Bosch, *The Cure of Folly*, of which there were at least four copies. See de Tolnay, *Hieronymus Bosch*, pp. 337–8; Philip, '*The Peddler*', pp. 45–6.

60 The proverb to which the cape refers is: 'she hangs the blue cloak on her husband'. Bruegel's painting was one of a number of contemporary representations of this and other proverbs. See Marijnissen and Seidel, *Bruegel*, pp. 38–40; Marijnissen, *Bruegel*, pp. 133–45; Gibson, *Bruegel*, pp. 66–79.

61 'SIMONIS MAGI INTERITUS/ Attendebant eum quod multo tempore/ Magicis suis artibus eos dementasset.' The wording in the fourth state adds 'IDEM' at the beginning of the inscription. My translation is influenced by the French and Flemish versions that are also included in the third and fourth states. See Bastelaer, *The Prints of Peter Breugel the Elder*, p. 147, cat. no. 118.

62 See Ferreiro, 'Simon Magus', pp.147–65; Flint, *The Rise of Magic*, pp. 338–44. For the *Legenda Aurea*, see Jacobus de Voragine *Legenda Aurea*, ed. Ryan, vol. 1, pp. 340–9.

63 An example of the former is found in an eleventh-century sacramentary from Udine (see the cover illustration on the paperback edition of Flint, *Rise of Magic*); an example of the latter is from a retable altar of *c.* 1425 from the church of St. Lamberti in Hildesheim (Marburger Index, no. 2445 A8).

64 For the Autun image, see Borst et al., *Tod im Mittelalter*, p. 340, fig. 6. For similar images on church capitols and in stained glass windows (the cathedrals at Chartres, Bourges, Tours,

Rheims and Poitiers), see Emmerson, *Antichrist in the Middle Ages*, pp. 122–4; Mâle, *The Gothic Image*, pp. 297–8; Herzman and Cook, 'Simon the Magician', pp. 29–43; Rode, *Die mittelalterlichen Glasmalereien des Kölner Domes*, pp. 194–6, figs 28, 533, 537–8, coloured plate 15. For the iconography in general, see LCI, vol. 4, col. 158–60; Réau, *Iconographie de l'art chrétien*, vol. 3, part 3, pp. 225–6.

65 Hamburger, 'A *Liber Precum* in Sélestat', p. 224, n. 85, fig. 24.

66 See Cust and Horne, 'Notes on Pictures in the Royal Collections', pp. 377–82. There is a colour reproduction in Moncrieff, 'The Royal Collection', p. 228.

67 Boon, *Netherlandish Drawings*, vol. 2, pp. 54, 62, no. 149.

68 For this fascinating relationship, see Emmerson and Herzman, 'Antichrist, Simon Magus, and Dante's "Inferno" XIX', pp. 379–82; Emmerson, *Antichrist in the Middle Ages*, p. 143, fig. 11; McGinn, *Antichrist*, pp. 141–2.

69 Schedel, *Liber Chronicarum*, Nuremberg: Anton Koberger, 1493, fol. 189v.

70 *Fortunatus*, Augsburg: Hans Otmar, 1509. The woodcut was also used in later editions of the *Fortunatus*, such as the Augsburg 1548 and Frankfurt 1554 editions. It has been reproduced in Geisberg, *Die deutsche Buchillustration*, vol. 6, pl. 267, no. 640. For the *Fortunatus*, see Killy, *Literatur Lexikon*, vol. 3, pp. 458–9; Herkommer and Lang, *Deutsches Literatur-Lexikon*, vol. 5, col. 369–72.

71 This is headed: 'Wer erstlich die Zauberkunst Magicam erfunden und gelobet auch die arth Teuffel außtreiben odder Incantationes hab lassen außgehn durch welche kranckheiten abgetrieben worden' (book 1, ch. 22).

72 Polydore Vergil, *Eigentlicher bericht der Erfinder aller ding*, Frankfurt a.M.: Weygand Han, *c.*1560, fol. 65r; *Fortunatus. Von seinem Seckel, unnd Wünschhütlin*, Frankfurt a.M.: Weigand Han, 1556, fol. 65r. See also *Fortunatus.* ed. Günther, pp.116–19.

73 Polydore Vergil, *Eigentlicher bericht der Erfinder aller ding*, Frankfurt a.M.: Weygand Han, *c.*1560, fol. 68v. The chapter is headed: 'Vom Ursprung der Necromantie auß der Todten Pyromantie auß der fewrs Eromantie auß des Lufffts Hydromantie auß des Wassers Geomantie auß der Erden und Chyromantie auß der Hände besichtigung' (book 1, ch. 23).

74 See also *Fortunatus*, ed. Günther, pp. 121–9.

75 *Fortunatus*, ed. Günther, p. 121.

76 *Fortunatus*, ed. Günther, p. 127.

77 The 1548 Augsburg edition by Zimmerman and the 1558 Strasbourg edition by Christian Müller also include faithful copies of the illustrations in the original 1509 Augsburg edition.

CHAPTER 7 REPORTING THE NEWS AND READING THE SIGNS

1 For the role of broadsheets and cheap print in the sixteenth century, see Scribner, *For the Sake of Simple Folk*; Watt, *Cheap Print and Popular Piety*; Kunzle, *History of the Comic Strip*; Walsham, *Providence in Early Modern England*; Schilling, *Bildpublizistik der frühen Neuzeit*; Sipek, '"Newe Zeitung"'.

2 For examples of an increasingly rich field, see Ferber, *Demonic Possession and Exorcism*; Midelfort, 'The Devil and the German People'; Roper, *Oedipus and the Devil*, pp. 171–98; Crouzet, 'A Woman and the Devil'.

3 A similar cut with only minor differences is held in the GNM and reproduced in Diederichs, *Deutsches Leben*, vol. 1, p. 123, fig. 410. A pen and coloured ink version also occurs in the Wickiana, F. 13, fol. 68.

4 Strauss, vol. 2, p. 737; vol. 3, p. 1293; Benzing, *Die Buchdrucker des 16. und 17. Jahrhunderts*, p. 360.

5 Derenburg was within the jurisdiction of the Count of Reinstein or Regenstein, which Strauss has read incorrectly as 'Remstein'. The unrelated story of the third witch, Sercksche, who was executed almost two weeks later, receives a brief notice in the text.

6 Baron, *Faustus on Trial*; Boerner and Johnson, *Faust through Four Centuries*.

7 Wickiana, PAS II, 12/16; also reproduced in Diederichs, *Deutsches Leben*, vol. 1, p. 121, fig. 408.

8 A pen and coloured ink version also occurs in the Wickiana, F. 13, fol. 66r. The woodcut was

also reproduced in Lycosthenes, *Prodigiorum ac ostentorum chronicon*, Basel: Adam Henric-petri, 1557, p. 550. For an account of these events, see *Zimmerische Chronik*, ed. Barack, vol. 3, p. 80. Strauss mistakenly refers to the place of execution in his caption as Schilta.

9 Strauss, vol. 1, pp. 391–405; Smith, *Nuremberg*, p. 265.
10 External evidence suggests that the two others may have been another son and a servant. For this and other aspects of the trial, see Haustein, *Martin Luthers Stellung*, pp. 141–2.
11 Wolfgang Behringer, *Witchcraft Persecutions*, pp. 104–76.
12 His name is also spelt Stump, Stumpe, Stube, Stubbe and Stub.
13 This account is based on information contained in the two broadsheets published in Nüremberg and Augsburg in 1589 (see below) and in the English pamphlet, *A True Discourse Declaring the Damnable Life and Death of One Stubbe Peeter, A Most Wicked Sorcerer...*, which was translated from a Cologne pamphlet and published in England in June 1590 (see Otten, *A Lycanthropy Reader*, pp. 69–76; Summers, *The Werewolf*, pp. 253–61). There are some discrepancies between these accounts and even between the two versions of the English pamphlet.
14 For the list of single-leaf woodcuts and broadsheets that Mayer produced between 1578 and 1605, most of them from 1589, see Strauss, vol. 2, p. 693. Of Negele's work only this single broadsheet seems to have survived; see Strauss, vol. 2, p. 795. A third image, a coloured etching with the same subject matter but different text, is held by the Hessian State and University Library in Darmstadt; see Harms, *Deutsche illustrierte Flugblätter*, vol. 4, pp. 412–13, no. 4, 301.
15 For the significant differences in the representation of the werewolf in the two broadsheets, see Michael Meurger, 'L'homme-loup et son témoin', p. 161.
16 A *True Discourse* also refers to Stumpf as a sorcerer, emphasizing the diabolic source of his lycanthropy and presenting the story as 'a warning to all sorcerers and witches' (Summers, *The Werewolf*, p. 259; Otten, *A Lycanthropy Reader*, p. 76). The accompanying woodcut, however, pays no attention to this, except for the inclusion of the werewolf's magic girdle (reproduced in Oates, 'Metamorphosis and Lycanthropy', p. 313; Otten, *A Lycanthropy Reader*, p. 75; Summers, *The Werewolf*, p. 255; but in the latter two cases, without the original captions). The girdle also features in the coloured etching reproduced in Harms, *Deutsche illustrierte Flugblätter*, vol. 4, pp. 412–13, no. 4, 301.
17 Strauss, vol. 2, p. 700.
18 See Behringer, *Witchcraft Persecutions*, pp. 119–20, where the titlepage is reproduced; Behringer, 'Hexenverfolgungen im Spiegel'.
19 Behringer, 'Hexenverfolgungen im Spiegel', pp. 348–9, n. 50.
20 In Dürer's famous woodcut from *The Apocalypse* series (TIB, vol. 61), St John is seated in a shallow cauldron, while an executioner and assistant adopt very similar positions to the two figures in this 1590 woodcut. In Hartmann Schedel's *Nuremberg Chronicle* (fol. 108ʳ) John is shown standing, hands joined in a gesture of prayer, in a cauldron with feet almost identical to those in this 1590 woodcut, and also with a second cauldron behind, but with only the one executioner.
21 *The Examination and Confession of certain witches at Chelmsford*, in Rosen, *Witchcraft*, p. 82. The woodcut is reproduced in Robbins, *Encyclopedia*, p. 89.
22 *A Detection of damnable driftes*. The woodcut is reproduced in Robbins, *Encyclopedia*, p. 91, and Rosen, *Witchcraft*, p. 93. It matches a devil in the shape of a white 'rugged' (shaggy) dog that appeared to Elizabeth Francis (fol. A 4ʳ).
23 *The Apprehension and Confession of Three Notorious Witches*, London: no publisher, 1589. The image is frequently reproduced, such as in Rosen, *Witchcraft*, p.183, where most of the pamphlet is also found (pp. 182–9).
24 Gibson, *Witchcraft and Society in England and America*, pp. 3–5; Sharpe, *Instruments of Darkness*, pp. 89–90; Macfarlane, *Witchcraft in Tudor and Stuart England*, pp. 14–15.
25 A number of illustrations of other 'familiars' or familiar spirits from these and other pamphlets are reproduced by Rosen, together with a useful list of the names they took (Rosen, *Witchcraft*, p. 396). For a discussion of their significance, see Holmes, 'Popular Culture?'; Sharpe, *Instruments of Darkness*, pp. 71–4.
26 *Warhaftigge Zeitung. Von den gottlosen Hexen*. See the list of works cited for the full title. I have identified two slightly different editions, which use the same block; however, the

version of the work published as part of the compilation *Theatrum de veneficis*, Frankfurt: Nicolaus Basseus, 1586, includes a quite different woodcut. For Lutz, see Midelfort, *Witch Hunting in Southwestern Germany*, p. 60.

27 *Von Hexen und Unholden*, Strasbourg: Christian Müller, 1575.

28 *Dess Teuffels Nebelkappen*, Frankfurt: Wendel Humm, 1583. For Frisius' pamphlet, see Zika, *Exorcising our Demons*, pp. 481–521.

29 There were two editions of 1566; see Zika, *Exorcising our Demons*, p. 505, n. 54.

30 The contents of the pamphlet have become widely known through their inclusion in the so-called 'Fugger Newsletters'. See *Fugger-Zeitungen*, ed. von Klarwill, pp. 103–10; *The Fugger News-Letters*, ed. von Klarwill, pp. 107–114; *The Fugger Newsletter*, ed. Matthews, pp. 137–43; Monter, *European Witchcraft*, pp. 75–81.

31 For Dillingen and its trials, see Behringer, *Witchcraft Persecutions*, pp. 123–6, 436–40.

32 In the Fugger newsletters he is named Bis im Pfarrhoff.

33 Roper, *Oedipus and the Devil*, pp. 155–6. For the literature on this important phenomenon, see Zika, *Exorcising our Demons*, pp. 501–3.

34 See fig. 8.13.

35 See Grimm, 'Die deutschen "Teufelbücher"', 536–37. The woodcut version in the Rheinhard Lutz news pamphlet was replaced when it was re-published in 1583 by the Frankfurt publisher Nicholas Bassé.

36 There were three printings of the work in the same year. The original Latin edition published in Trier in 1589 does not contain this woodcut, nor do the other four Latin editions that I have examined, nor the Trier German translation of 1590. See Franz, *Friedrich Spee*, pp. 65–7; Behringer, *Witchcraft Persecutions*, p. 141.

37 For this analysis of the political context, see Behringer, *Witchcraft Persecutions*, pp. 139–42, 201; and for the paradigmatic role of Binsfeld's work, especially for Catholic authorities, see Behringer, 'Das "Reichskhündig Exempel" von Trier', pp. 435–47.

38 For the following, see Senn, *Johann Jakob Wick*; *Die Wickiana*, ed. Senn, pp. 7–30; Weber, *Wunderzeichen und Winkeldrucker*, pp. 11–53.

39 Lycosthenes, *Prodigiorum ac ostentorum chronicon*; Lavater, *Von Gespänsten unghüren fäle*.

40 *Die Wickiana*, ed. Senn, pp. 15, 17.

41 For the following, see van Dülmen, *Theatre of Horror*, pp. 58–9, 81–7, 129–32; Stuart, *Defiled Trades and Social Outcasts*, pp. 121–48.

42 Van Dülmen, *Theatre of Horror*, pp. 88–92; Bader, *Die Hexenprozesse in der Schweiz*, p. 62.

43 Van Dülmen, *Theatre of Horror*, pp. 68–70.

44 As well as the various illustrations produced below, see also Wickiana F. 12, fol. 251v; F. 13, fol. 68; F. 19, 239v; F. 19, 249r; F. 22, fol. 50.

45 Wickiana F. 23, fol. 56; F. 23, 424; F. 25, 92r; F. 35, 338.

46 Wickiana F. 19, fol. 239v; F. 19, fol. 249; F. 22, fol. 50.

47 The woodcut appeared in *Histoire veritable et digne de memoire de quatre Jacopins de Bernes, heretiques et sorciers, qui y furent bruslez*, Geneva: Gustav Revilliod, 1549 (see the Geneva 1867 reprint, p. 33), which was a translation by François de Boniuard of book 13, chs 33–5 of Johann Stumpf's Swiss chronicle (*Gemeiner loblicher Eydgnoschafft Stetten Landen und Völckeren Chronick*), first published in 1547; and in the 1586 edition of Stumpf's chronicle at fol. 716. It is reproduced in Robbins, *Encyclopedia*, p. 518.

48 The image and text referred to below are reproduced in *Die Wickiana*, ed. Senn, pp. 208–10, 265.

49 Oath-taking is especially common in depictions of court scenes. See the illustrations from the Berne chronicle of Diepold Schilling, showing the noble women of Bubenberg swearing before the court in 1470, and the oath taken before Peter von Hagenbach in 1469, in which the men also hold their caps (Fehr, *Das Recht im Bilde*, figs 26, 190). The use of the left hand for swearing by one of the figures in fig. 7.10 would seem to be an attempt to display the hand gesture clearly.

50 van Dülmen, *Theatre of Horror*, pp. 32–4; and for its use in various witch trials in Zurich, see Bader, *Hexenprozesse*, pp. 81–4.

51 Bader, *Hexenprozesse*, p. 60.

52 Reproduced in Fehr, *Das Recht im Bilde*, fig. 112.

53 Reproduced in colour in Hinckeldey, *Pictures from the Crime Museum*, p. 71. The account of the 'grausame Historia' of these three women is found in the Wickiana, F. 23, fols 399–422.
54 Monter, *Witchcraft in France and Switzerland*, pp. 157–65.
55 F. 19, fol. 239ᵛ (Geneva, 1571); F. 19, fol. 249 (Schwyz, 1571); F. 21, 85ʳ (Colmar, 1572), which is fig. 7.9; F. 22, fol. 50 (Lausanne, 1573).
56 Bad Wurzach 1576 (Wickiana, F. 25, fol. 92ᵛ); Baden 1574 (fig. 7.11); Bremgarten 1574 (figs 7.12, 7.14).
57 van Dülmen, *Theatre of Horror*, p. 89.
58 F. 13, fols 90ᵛ-91ʳ; *Die Wickiana*, ed. Senn, pp. 78–9, 238.
59 Bader, *Hexenprozesse*, passim.
60 For the account of her witchcraft, see Wickiana F. 23, fols 424–35.
61 Roper, *Oedipus and the Devil*, pp. 203–6.
62 The image is reproduced with a commentary in Fehr, *Das Recht im Bilde*, p. 68, fig. 66.
63 Wickiana, F. 12, fol. 251ᵛ. A colour image is reproduced in Hinckeldey, *Pictures from the Crime Museum*, p. 64.
64 Wickiana, F.18, fols 145ʳ-146ᵛ; *Die Wickiana*, ed. Senn, pp. 161–2, 254. A colour image is also reproduced in Hinckeldey, *Criminal Justice*, p. 251.
65 Roper, *The Holy Household*, pp. 104–6, 115–17.
66 The account of the story in German beneath the drawing (Wickiana, F. 12, fol. 9ʳ) is virtually identical to the text in Hartmann Schedel's *Nuremberg Chronicle* (fol. 189ᵛ); the Latin version of the story (fol. 7ʳ) is taken from Conrad Lycosthenes, *Prodigiorum ac ostentorum Chronicon*, Basel: Adam Henricpetri, 1557, p. 378.
67 For references to beatings by the devil, see Wickiana, F. 23, fols 414, 419 (twice), 420.
68 On the significance of the timing at Candlemas (2 February), see Scribner, *Popular Culture and Popular Movements*, pp. 3–4.
69 The drawing and accompanying text are reproduced in *Die Wickiana*, ed. Senn, pp. 197–8. For a colour reproduction, see Hinckeldey, *Pictures from the Crime Museum*, p. 71.
70 The name Moreth is possibly a play on *Mor* or *More*, a middle high German word meaning a Moor or a devil.

CHAPTER 8 ON THE MARGINS OF CHRISTIAN EUROPE

1 For the series, see Veldman, 'De macht van de planeten', 21–53; and for a fuller account of the artist and print, as well as references to the literature, see Zika, *Exorcising our Demons*, pp. 411–17. Much of the following section on Saturn draws on parts of my earlier essays, published as chapters 10, 11 and 12 of *Exorcising our Demons*.
2 The third couplet reads: 'Possidet Phoebi decus Occidentis/ Omne terrarum; reperit sodinas./ Et magos implet genio sinistro,/ Ceu Deus artis.'
3 The first scholar to have drawn notice to the significance of Saturn for witchcraft iconography was Maxime Préaud. See Préaud, *Les sorcières*, pp.16–19, 60–61; Préaud, 'La sorcière de noël'.
4 Veldman relates it to the changing political situation in Antwerp in the 1580s; see Veldman, 'De macht van de planeten', 37, fig. 16; Hollstein, vol. 21, p. 521.
5 For a reproduction see Klibansky, Panofsky and Saxl, *Saturn and Melancholy*, pl. 53. The last section of the inscription differs from that in the de Passe: 'Occidentem possidet: Magis et sagis, fodinis et plumbo praeest.'
6 See Veldman, 'De macht van de planeten', for the whole series.
7 For these three motifs, see Zika, *Exorcising our Demons*, pp. 430–37.
8 The phrase is taken from the title of Hans Staden's work of 1557 — *Wahrhaftige Historia und beschreibung eyner Landtschafft der Wilden Nacketen Grimmigen Menschfresser Leuthen in der Newenwelt America gelegen* — which was immensely popular and ran through nine editions and translations in the sixteenth century. See Maack and Fouquet, *Hans Stadens Wahrhaftige Historia*, pp. 211–31; Alden and Landis, *European Americana*, vol. 1, p. 451. For other similarities between these prints and the contemporary depictions of the Americas, see Zika, *Exorcising our Demons*, p. 428.
9 The history of Saturn in European literature and iconography is immense. For the material

below, see especially Klibansky, Panofsky and Saxl, *Saturn and Melancholy*, pp. 67–214; Tinkle, 'Saturn of the Several Faces', 289–307; Préaud, 'Saturne, Satan, Wotan et Saint Antoine ermite', 81–102; Zafran, 'Saturn and the Jews', 16–27; Carr and Kremer, 'Child of Saturn', 401–34. I draw here on Zika, *Exorcising our Demons*, pp. 395–402, 417–25.

10 For further references, see Zika, *Exorcising our Demons*, p. 396, n. 36.

11 The Bodleian copy of *De la généalogie des dieux*, Paris: P. Le Noir, 1531, has been reprinted in facsimile as Giovanni Boccaccio, *Généalogie, Paris 1531*. For further references, see Zika, *Exorcising our Demons*, p. 398, n. 37.

12 Zika, *Exorcising our Demons*, pp. 398–401.

13 Zika, *Exorcising our Demons*, figs 64 and 83, for the engravings by Jacob Bink, after Rosso Fiorentino, and by Johann Ladenspelder.

14 Préaud, *Les sorcières*, pp. 49–50; Préaud, 'Saturne, Satan, Wotan et Saint Antoine ermite', 85–6.

15 See *Ein wunderlich gesprech von fünff unhulden* (1531) in *Hans Sachs*, ed. Keller, vol. 5, pp. 285–8; also reprinted in Kunstmann, *Zauberwahn und Hexenprozeß*, pp. 212–14.

16 Préaud, *Les sorcières*, pp. 60–61, fig. 90.

17 For further references, see Zika, *Exorcising our Demons*, p. 371, n. 72.

18 *Old Master Drawings from the Albertina*, p. 197; Marrow and Shestack, *Hans Baldung Grien*, p. 219; Bernhard, *Hans Baldung Grien*, p. 185.

19 Koepplin, *Cranachs Ehebildnis*, pp. 233, 238, fig. 18.

20 Koepplin and Falk, *Lukas Cranach*, vol. 1, p. 292; Klibansky, Panofsky and Saxl, *Saturn and Melancholy*, pp. 75–8, 110–11; Préaud, 'Saturne, Satan, Wotan et Saint Antoine ermite', pp. 87, 91–2.

21 See Zika, *Exorcising our Demons*, pp. 445–70. The first clear depiction of witches cooking human flesh seems to be in fig. 7.8, though there are intimations in fig. 3.2 (and in 7.4, if one includes werewolf-witches). A sharp increase occurs from the first decade of the seventeenth century.

22 Zika, *Exorcising our Demons*, pp. 459–62, 472–3.

23 For this literature, see Granlund, 'Introduction', in Magnus, *Historia*, ed. Granlund, pp. 26–9; Strauss, *Sixteenth-Century Germany*; Strauss, *Historian in an Age of Crisis*. And for the relationship between geography and patriotic sentiment, see Silver, 'Germanic Patriotism in the Age of Dürer'.

24 *Historia de Gentibus Septentrionalibus*, Rome: Johannes Maria de Viottis, 1555. The work appears in facsimile in Magnus, *Historia*, ed. Granlund; and in modern English translation in Magnus, *Historia*, ed. Foote. An English translation was published in the seventeenth century, as *A Compendious History*, London: J. Streater, 1658.

25 For an account of the work and its origins, see Foote, 'Introduction', in Magnus, *Historia*, ed. Foote, vol. 1, pp. vi–lxxii; Magnus, *Historia*, ed. Granlund, pp. 25–37; Johannesson, *The Renaissance of the Goths*, pp. 139–206. For its printing history, see Foote, 'Introduction', in Magnus, *Historia*, ed. Foote, pp. lxx–lxxii; Alden and Landis, *European Americana*, p. 421; and a Russian work by Saveleva, *Olaus Magnus*, p. 134.

26 For Olaus' life, see Magnus, *Historia*, ed. Foote, pp. xxvi–xxxvi; Magnus, *Historia*, ed. Granlund, pp. 5–25; Johannesson, *Renaissance*, passim.

27 See Knauer, *Die Carta Marina*.

28 There has been no detailed study of the woodcuts in Olaus' history. Some information is given in Magnus, *Historia*, ed. Granlund, pp. 31–3, and in Granlund's commentary to the the four-volume Swedish translation originally published between 1909 and 1925, *Historia om de nordiska Folken*. Granlund's commentary has been abridged and augmented in Magnus, *Historia*, ed. Foote, pp. xlii–xliii.

29 Magnus, *Historia*, ed. Granlund, pp. 29, 32.

30 See Johannesson, *Renaissance*, pp. 163–70, who argues that the rhetorical and pictorial image constitutes one of the fundamental frameworks through which the *History* needs to be understood.

31 For example, see *Historia*, book 3, chs 13, 15, 16.

32 The illustrations of the Rome 1555 edition were repeated in the Venice edition of 1565. The 1567 editions (*Historia de Gentium Septentrionalium variis conditionibus statibusque*, Basel: Adam Henricpetri, 1567; *Historien der Mittnächtigen Länder*, Basel: Johann Baptist Fickler,

1567) included a new set of woodcuts with substantially the same content. The Scribonius editions published in Antwerp in 1558, 1561 and 1562, and in Paris in 1561, all drastically reduced the number of woodcuts. Other editions, such as Venice 1561, included little more than a titlepage woodcut; while Amberg 1599 included no illustrations at all, as in the case of some seventeenth-century editions.

33 The 1658 English translation unfortunately translates most of these terms by the single word 'witchcraft' (or its derivatives), often quite unjustifiably.

34 The woodcuts of the 1567 edition are cruder than those in the original Rome edition of 1555, but often include more narrative detail. All the modern editions of the work include the same illustrations from the 1555 edition, except that the decorative borders differ in the Foote and Granlund editions.

35 *Historia*, book 3, ch. 13; 1555 ed., p. 114; 1567 Latin ed., p. 111. At the end of ch. 14, Olaus makes the general statement that the power of divination and the magical arts in their various forms depend on illusions produced by demons.

36 *Historia*, book 3, ch. 18; 1555 ed., p. 122; 1567 Latin ed., p. 116. The knight on the horse in the background would seem to be a reference to the story in the following chapter, of King Hadingus of Denmark, who was brought across the sea on his horse by the magician Odin. The puzzling scene in the top right corner may represent the cult of Holler as a god.

37 *Historia*, book 3, ch. 16; 1555 ed., p. 119; 1567 Latin ed., p. 114.

38 *Historia*, book 3, ch. 16; Magnus, *Historia*, ed. Foote, vol. 1, p. 173.

39 For examples of tying and untying from both ancient and medieval Christian magic, see Flint, *The Rise of Magic*, pp. 226–31, 286–9, 305.

40 *Historia*, book 3, ch. 20; 1555 ed., p. 124; 1567 Latin ed., p. 117.

41 See Flint, *The Rise of Magic*, pp. 219, 229, 289, 390; Kieckhefer, *Magic*, pp. 47–50.

42 Johannesson, *Renaissance*, p. 161.

43 *Historia*, book 3, ch. 15; 1555 ed., p. 117; 1567 Latin ed., p. 113.

44 This is largely based on Saxo Grammaticus, *The History of the Danes*. The use of such poles by armies marching into battle is described in *Historia*; see book 3, ch. 8; *Historia*, ed. Foote, p. 187, n. 3.

45 See, for instance, the crystal gazing of Anton Fugger, in Roper, *Oedipus and the Devil*, pp. 125–44.

46 Magnus, *Historia*, ed. Foote, book 3, ch. 17; 1555 ed., p. 121; 1567 Latin ed., p. 113.

47 A common and quite mistaken account of the woodcut refers to this figure as a victim of the witch. See Hults, 'Baldung's *Bewitched Groom* Revisited', 261–2; de Givry, *Witchcraft, Magic and Alchemy*, p. 133. Ginzburg, *Ecstasies*, p. 139, n. 112, fig.12, identifies the scene correctly as a Lapp shaman in ecstasy, although his more detailed description goes well beyond Olaus' text.

48 *Historia de gentibus septentrionalibus*, Antwerp: Johannes Bellerus, 1562, p. 39. This is clearly a copy of the woodcut in the 1555 edition, for the image is reversed.

49 *Historia*, 1555 ed., p. 126; 1567 Latin ed., p. 119.

50 See above, at fig. 2.20. Also fig. 7.18.

51 *Historia*, 1555 ed., p. 127; 1567 Latin ed., p. 120.

52 *Historia*, 1555 ed., p. 112; 1567 Latin ed., p. 107.

53 The text mistakenly refers to their further treatment in ch. 20 below, rather than in ch. 22.

54 As claimed by Davidson, *The Witch in Northern European Art*, p. 28.

55 As well as *Historia*, book 3, ch. 11, see also the list given at the beginning of ch. 12. While *striges* and *lamiae* are also listed, Olaus does not use these terms to refer to sorcerers or witches anywhere else.

56 Behringer, *Shaman of Oberstdorf.*

57 Hermann Witekind [pseud. August Lercheimer], *Christlich Bedenken und Erinnerung von Zauberey*, Basel: Sebastian Henricpetri, 1593. The titlepage is reproduced in Davidson, *The Witch in Northern European Art*, fig. 13.

58 Sebastian Münster, *Cosmographia oder Beschreibung der gantzen Welt*, Basel: Henricpetri, 1628, p. 1160. These woodcuts seem to have influenced later images, such as the woodcut of dancing in a 'fairy circle', found in Nathaniel Crouch, *The Kingdom of Darkness*, London: no publisher, 1688, p. 57, and reproduced in Robbins, *Encyclopedia*, p. 125.

59 *Theatrum Diabolorum*, Frankfurt: Peter Schmid, 1569; *Theatrum Diabolorum*, Frankfurt:

Peter Schmid, 1575. The engraver seems to have been Lucas Mayer (see fig. 7.5). The 1587 edition (which increases the number of devil books from 24 to 33) does not include this titlepage.

60 For below see Vignau-Wilberg, *Christoph Murer*, pp. 106–7, 218–21, figs 116–19; Vignau-Wilberg, 'Zur Entstehung zweier Emblemata', 85–94; Sperling, 'Christoph Murers Glasgemälde'.

61 For this image, see Zika, *Exorcising our Demons*, pp. 475–7. It has subsequently been published in Schild, 'Hexen-Bilder', fig. 42.

62 For Murer's works and also five later copies, see Vignau-Wilberg, *Christoph Murer*, pp. 271–2, figs 116–19. Sperling, 'Christoph Murers Glasgemälde', also includes an image not referred to by Vignau-Wilberg – a pen and ink drawing possibly from the 1590s and held in the Louvre. For Murer's work on the Edessa Christians, see Vignau-Wilberg, *Christoph Murer*, pp. 70–81.

63 Hsia, *Trent 1475*; Hsia, *The Myth of Ritual Murder*.

WORKS CITED

MANUSCRIPTS

Danse Macabre des Femmes, c. 1500, BN, MS fr. 995.

The Danse Macabre of Women: Ms. fr. 995 of the Bibliothèque Nationale, ed. Ann Tukey Harrison, Kent, Ohio, and London, 1994.

Deguileville, Guillaume de, *Pèlerinage de vie humaine*, second recension (1355), BN, MSS fr. 377; fr. 825; fr. 829.

——, *The Pilgrimage of the Life of Man*, second recension (1355), trans. John Lydgate, 1426, BL, MS Cotton Tiberius A.vii.

The Florentine Picture Chronicle, 1470s, British Museum, London [1889–5–27–46].

Le Franc, Martin, *Le Champion des Dames*, 1451, BN, MSS fr. 12476; fr. 841.

Schembartbücher, Stadtbibliothek, Nuremberg, MSS Nor. K. 444; Nor. K. 551; Amb. 54. 2°.

Schembartbuch, GNM, MS Gs.2196 Hs.–5664.

Schembartbuch, BSB, Munich, MS Cgm 2083.

Tinctor, Johannes, *Tractatus contra sectam Valdensium*, c. 1470, BN, MS fr. 961.

——, *Tractatus contra sectam Valdensium*, c. 1470, Bodleian Library, Oxford, MS Rawlinson D. 410.

——, *Tractatus contra sectam Valdensium*, c. 1467, Bibliothèque Royale de Belgique, Brussels, MS 11209.

Vintler, Hans, *Buch der Tugend*, c. 1400–50, Österreichische Nationalbibliothek, Vienna, MS Cod. 13.567.

——, *Buch der Tugend*, c. 1500, Forschungsbibliothek, Gotha, MS Cod. Chart. A 594.

[Wickiana] Wick, Johann Jakob, *Sammlung von Nachrichten zur Zeitgeschichte*, 1560–87, Zentralbibliothek, Zurich, F. 12–35 (24 vols).

PRINTED WORKS WRITTEN BEFORE 1800

Alciato, Andrea, *Omnia Emblemata*, Paris: Claude Minos, 1589.

——, *Andreas Alciatus*, ed. Peter M. Daly with Virginia W. Callahan, 2 vols, Toronto, 1985.

——, *Emblemata: Lyon, 1550*, trans. Betty Knott, with an introduction by John Manning, Aldershot, 1996.

The Apprehension and Confession of Three Notorious Witches. Arraigned and by Justice Condemned at Chelmes-forde, in the Countye of Essex, the Fifth Day of Julye, Last Past, London: no publisher, 1589.

Apuleius [Lucius Apuleius of Madauros], *Ain Schön Lieblich auch kurtzweylig gedichte Lucii Apuleii von ainem gulden Esel*, Augsburg: Alexander Weissenhorn, 1538.

——, *Metamorphoses*, ed. J.A. Hanson, 2 vols, Loeb Classical Library, 44, 453, London and Cambridge, Mass., 1989.

Apuleius, Lucius [Lucian of Samosata], *Asinus Aureus*, trans. Poggio Fiorentino, Augsburg: Ludwig Hohenwang, 1477.

——, *Eine hübsche Historie von Lucius Apuleius in Gestalt eines Esels verwandelt*, trans. Nicholas von Wyle, Augsburg: Ludwig Hohenwang, 1477.

——, *Eine hübsche Historie von Lucius Apuleius in Gestalt eines Esels verwandelt*, Strasbourg: Heinrich Eggestein, 1479.

——, *Ein hubsche history von Lucius apuleius in gestalt eins esels verwandelt*, Strasbourg: Bartholomeus Kistler, 1499.

——, *Ein hubsche history von Lucius apuleius in gestalt eins esels verwandelt*, Strasbourg: Johann Knoblauch, 1509.

——, *Von ainem gulden Esel*, Augsburg: Alexander Weißenhorn, 1538.

Augustine, Saint, *The City of God against the Pagans*, ed. and trans. R.W. Dyson, Cambridge and New York, 1998.

Beaujoyeulx, Balthazar de, *Balet Comique de la Royne, faict aux nopces de Monseiur le Duc de Joyeuse et madmoyselle de Vaudemont sa soeur*, Paris: Adrian le Roy, Robert Ballard and Mamert Patisson, 1582. (facsimile *Le Balet Comique 1581*, with an introduction by Margaret McGowan, Binghamton, N.Y., 1982).

Bible, *Die gantz Bibel Alt unnd Neüw Testament. ... Item auch mitt Zweyhundert Figuren*, Strasbourg: Wolfgang Köpfl, 1532.

——, *Biblia Das ist: die gantze heilige Schrifft Deudsch. D. Mart. Luth.*, Wittenberg: [Hans Krafft], 1572.

——, *Die Luther-Bibel von 1534. Vollständiger Nachdruck. Biblia das ist die gantze heilige Schrifft Deudsch Mart. Luther. Wittemberg. M.D.XXXIIII*, 2 vols, Cologne, 2003.

——, *Quadrins historiques de la Bible*, Lyon: Guillaume Roville, 1564.

Binsfeld, Peter, *Tractat Von Bekanntnuß der Zauberer und Hexen*, trans. Bernhard Vogel, Munich: Adam Berg, 1591.

Boccaccio, Giovanni, *Buch von den hochgerumten frowen*, Ulm: Johann Zainer, 1473.

——, *Liber de claris mulieribus*, Louvain: Aedigius van der Heerstraten, 1487.

——, *Ein Schöne Cronica oder Hystoribüch von den Fürnämlichsten Weybern*, Augsburg: Heinrich Steiner, 1541.

——, *Concerning Famous Women*, trans. and ed. Guido A. Guarino, London, 1964.

——, *De la généalogie des dieux*, Paris: Philippe Le Noir, 1531 (facsimile *Genealogie, Paris 1531*, New York, 1976).

Boguet, Henri, *Discours des Sorciers*, Lyon: Pierre Rigaud, 1608.

The Book of Hours of the Emperor Maximilian the First: decorated by Albrecht Dürer, Hans Baldung Grien, Hans Burgkmair the elder, Jorg Breu, Albrecht Altdorfer, and other artists. Printed in 1513 by Johannes Schoensperger at Augsburg, ed. Walter L. Strauss, New York, 1974.

Brant, Sebastian, *Navis Stultifera ... per Iac. Locher in Latinam traducta*, n.p.: Zachoni, 1498 (misprinted 1488).

——, *The Ship of Fools*, trans. William Gillis, London, 1971.

Braunschweig [Brunschwig], Hieronymus, *Das buch zu distillieren*, Strasbourg: Johann Grüninger, 1519.

——, *The vertuose boke of the distyllacyon of all maner of waters of the herbes ...* , trans. Laurence Andrew, London: no publisher, [1530] (facsimile *Book of Distillation*, with an introduction by Harold J. Abrahams, New York, 1971).

Corpus Iuris Canonici, ed. Aemilius Friedberg, 2 vols, Graz, 1955.

Crouch, Nathaniel, *The kingdom of darkness*, London: N. Crouch, 1688.

Deguileville, Guillaume de, *Le pèlerinage de l'homme*, Paris: A. Vérard, 1511.

——, The Pilgrimage of the Life of Man, *English by John Lydgate, A.D.1426, from the French by Guillaume de Deguileville, A.D. 1330, 1355*, with an introduction and notes by Katharine Locock, ed. F.J. Furnivall, London, 1904.

A Detection of damnable driftes, practized by three Witches arraigned at Chelmissforde in Essex ... ,
London: Edward White, 1579.

Ein erschroeckliche geschicht so zu Derneburg ... Im 1555. Jare ergangen ist, Nuremberg: Georg
Merkel, 1555.

*Ein erschröcklich geschicht Vom Tewfel und einer unhulden beschehen zu Schilta bey Rotweil in der
Karwochen. M.D.XXX Jar*, Nuremberg: Stefan Hamer, 1533.

Erastus, Thomas, *Deux dialogues touchant le pouvoir des sorciers*, Geneva: Jacques Chouet, 1579.

*Erschröckliche und zuvor nie erhörte newe Zeitung welcher massen im Landt zu Jülich uber drey
hundert Weibs personen mit dem Teuffel sich verbunden in Wolffs gestalt sich verwandlen könden
... auff den 6. tag May im Jar 1591*, Augsburg: Georg Kress, 1591.

Erweytterte Unholden Zeytung, Ulm, 1590.

*The Examination and Confession of certain witches at Chelmsford in the county of Essex before the
Queen's Majesty's judges, the 16th day of July, Anno 1566*, London: no publisher, 1566, in
Barbara Rosen, *Witchcraft*, London, 1969, 72–82.

Feyerabend, Sigmund (ed.), *Theatrum Diabolorum, Das ist: Ein sehr Nützliches verstenndiges Buch
...* , Frankfurt a.M.: Peter Schmid, 1569.

——, *Theatrum Diabolorum, Das ist Wahrhaffte eigentliche und kurze Beschreibung*, Frankfurt
a.M.: Peter Schmid, 1575.

Fortunatus, Augsburg: Hans Otmar, 1509.

Fortunatus. Vonn seinem Seckel unnd Wünschhütlin, Frankfurt a.M.: Hermann Gülfferich, 1554.

Fortunatus. Von seinem Seckel, unnd Wünschhütlin, Frankfurt a.M.: Weigand Han, 1556.

Fortunatus. Nach dem Augsburger Druck von 1509, ed. H. Günther, Halle, 1914.

Frisius, Paul [aus Nagold], *Dess Teuffels Nebelkappen. Das ist: Kurzer Begriff den gantzen Handel
von der Zauberey belangend zusammen gelesen*, Frankfurt a.M.: Wendel Humm, 1583.

The Fugger Newsletter, ed. George Matthews, New York, 1970.

The Fugger News-letters: first series, ed. Victor von Klarwill, New York, 1924.

Fugger-Zeitungen. Ungedruckter Briefe an das Haus Fugger aus den Jahren 1568–1605, ed. Victor
von Klarwill, Vienna, Leipzig and Munich, 1923.

*Das Gebetbuch Kaiser Maximilians. Der Münchner Teil mit den Randzeichnungen von Albrecht
Dürer und Lucas Cranach d. Ae.*, [Augsburg: Johann Schoensperger the Elder, 1515], ed.
Hinrich Sieveking, Munich, 1987.

Geiler of Kaysersberg, Johann, *Navicula sive speculum fatuorum*, Strasbourg: Matthias Schürer,
1510.

——, *Die Emeis. Dis ist das büch von der Omeissen unnd auch Herr der künnig ich diente gern. Und
sagt von Eigentschafft der Omeissen. Und gibt underweisung von den Unholden oder Hexen und
von gespenst der geist und von dem Wütenden heer wunderbarlich ...* , Strasbourg: Johann
Grüninger, 1516.

——, *Die Emeis. Dis ist das büch von der Omeissen ...* , Strasbourg: Johann Grüninger, 1517.

——, *[Die Emeis]* in August Stöber (ed.), *Zur Geschichte des Volks-Aberglaubens im Anfange des
XVI. Jahrhunderts. Aus Dr. Joh. Geilers von Kaisersberg Emeis*, Basel, 1856.

Gerson, Jean, *Oeuvres complètes*, vol. 10, Paris, 1973.

Grant danse macabre des femmes, Paris: Guy Marchant, 1491.

La grant danse macabre des femmes hystoiriée, Paris: Mathieu Husz, 1499.

Holtzwart, Matthias, *Emblematum Tyrocinia: Sive Picta Poesis Latinogermanica*, Strasbourg:
Bernhard Jobin, 1581.

L'imaginaire du sabbat. Edition critique des textes les plus anciens (c. 1430–c. 1440), eds Martine
Ostorero, Agostino Paravicini Bagliani and Kathrin Utz Tremp, Lausanne, 1999.

Jacobus de Voragine, *Legenda Aurea vulgo Historia Lombardia dicta*, 3rd edn, Leipzig, 1890
(reprint ed. Theodor Graesse, Osnabrück, 1969).

——, *Legenda Aurea*, 2 vols, ed. and trans. W.G. Ryan, Princeton, 1993.

Joris, David, *Twonderboeck*, Deventer: Dirk van Borne, 1542.

——, *Twonder-boeck*, n.p.: no publisher, 1551.

Keller, Adelbert von (ed.), *Hans Sachs*, 25 vols, Stuttgart, 1870–1908 (reprint, Hildesheim, 1964).

Kramer, Heinrich, *Der Hexenhammer, Malleus Maleficarum, Kommentierte Neübersetzung*, trans. Günter Jerouschek, Wolfgang Behringer and Werner Tschacher, Berlin, 2001.

——, *Malleus Maleficarum von Heinrich Institoris (alias Kramer) unter Mithilfe Jakob Sprengers aufgrund der dämonologischen Tradition zusammengestellt. Kommentar zur Wiedergabe des Erstdrucks von 1487 (Hain 9238)*, ed. André Schnyder, Göppingen, 1993.

Lancre, Pierre de, *Tableau de l'inconstance des mauvais anges*, Paris: Nicolas Buon, 1613.

La Tour Landry, Geoffroy de, *Der Ritter vom Turn*, Basel: Michael Furter for Johann Bergmann von Olpe, 1493.

Lavater, Ludwig, *Von Gespänsten unghüren fäle und anderen wunderbare dingen* … , Zurich: Christoph Froschauer, 1569.

——, *Von Gespänsten unghüren fälen un anderen wunderbare dingen* … , Zurich: Christoph Froschauer, 1578.

The Laws of the Salian Franks, trans. and with an introduction by Katherine Fischer Drew, Philadelphia, 1991.

Le Franc, Martin, *Le Champion des Dames*, ed. A. Piaget, Lausanne, 1968.

——, *Le Champion des Dames*, ed. Robert Deschaux, 4 vols, Paris, 1999.

Leonrod, Hans von, *Hymmelwagen auff dem, wer wol lebt un wol stirbt, fert in das reich der himel. Hellwag auff dem, wer Übel lebt, un übel stirbt fert in die ewigen verdamnuß*, Augsburg: Sylvan Otmar, 1517.

Lercheimer, August [Hermann Witekind], *Christlich Bedenken und Erinnerung von Zauberey*, Basel: Sebastian Henricpetri, 1593.

[Lucian of Samosata], *Lucian of Samosata*, ed. M.D. Macleod, Loeb Classical Library, 432, London and Cambridge, Mass., 1979.

Lutz, Reinhard, *Warhaftigge Zeitung. Von den gottlosen Hexen, auch ketzerischen und Teufels Weibern, die zu des heyligen römischen Reichstatt Schletstat im Elsass, auff den zwey und zwentzigsten Herbstmonats des verlauffenen siebentzigsten Jars, von wegen ihrer schentlicher Teuffels Verpflichtung verbrent worden* … , n.p.: no publisher, 1571.

Lycosthenes, Conrad, *Prodigiorum ac ostentorum Chronicon*, Basel: Adam Henricpetri, 1557.

Magnus, Olaus, *Historia de Gentibus Septentrionalibus*, Rome: Johannes Maria de Viottis, 1555 (facsimile *Historia de Gentibus Septentrionalibus: Rome, 1555*, ed. John Granlund, Copenhagen, 1972).

——, *Historia de gentibus septentrionalibus*, Antwerp: Johannes Bellerus, 1562.

——, *Historia de Gentium Septentrionalium variis conditionibus statibusque*, Basel: Adam Henricpetri, 1567.

——, *Historien der Mittnächtigen Länder*, Basel: Johann Baptist Fickler, 1567.

——, *A Compendious History of the Goths, Swedes and Vandals and Other Northern Nations*, London: J. Streater, 1658.

——, *Historia om de nordiska Folken*, with commentary by John Granlund, 4 vols, 1951 (reprint Ostervåla, 1976).

——, *Historia de Gentibus Septentrionalibus: Romae 1555/ Description of the Northern Peoples: Rome 1555*, trans. Peter Fisher and Humphrey Higgens, ed. Peter Foote, 3 vols, London, 1996–8.

Mayer, Asmus, *Ein newer spruch von der Zauberey und dem unglauben*, Nuremberg: Hans Guldenmundt, [after 1526?].

Milich, Ludwig, *Der Zauber Teuffel. Das ist Von Zauberei, Warsagung, Beschwehren, Segen, Aberglauben, Hexerey, und mancherley Wercken des Teufels … Bericht* … , Frankfurt a.M.: Sigmund Feyerabend and Simon Hüter, 1564.

Molitor, Ulrich, *Von den Unholden oder Hexen*, Ulm: Johann Zainer, [1490?].

——, *Von den Unholden oder Hexen*, Strasbourg: Johann Prüss, [*c.* 1493].

——, *De lanijs et phithonicis mulieribus*, Speyer: Konrad Hist, [*c.* 1494].

Molitor, Ulrich, *De lamiis et pythonicis mulieribus*, 2nd edn, Basel: Johann Amerbach, [*c*. 1495].

——, *De laniis et Phitonicis Mulieribus*, Cologne: Cornelius von Ziericksee, [*c*. 1496–1500].

——, *Hexen Meysterei ... ein schön Gesprech von den Onholden*, Strasbourg: Jakob Cammerlander, 1544.

——, *Von Hexen und Unholden. Ein Christlicher nutzlicher unnd zu disen unsern gefährlichen zeiten notwendiger Bericht auß Gottes wort ... und jetz newlich auffs trewlichst verteutscht. Durch Conradum Lautenbach Pfarharrn zu Hunaweyler*, Strasbourg: Christian Müller, 1575.

——, *Schriften*, ed. J. Mausz, Constance, 1997.

Münster, Sebastian, *Cosmographia oder Beschreibung der gantzen Welt*, Basel: Henricpetri, 1628.

Murner, Thomas, *Tractatus perutilis de phitonico contractu*, Strasbourg: Matthias Hupfuff, 1499.

——, *Schelmenzunft*, Strasbourg: Beatus Murner, 1512.

——, *Narrenbeschweerung*, Strasbourg: Johannes Knobloch, 1518.

——, *Narrenbeschwörung*, ed. M. Spanier, Berlin, 1926.

Nider, Johannes. *Formicarius*, ed. and with an introduction by Hans Biedermann, Graz, 1971.

Ovid, *Metamorphoseos*, Milan: Giovanni Angelo Scinzenzeler, 1517.

——, *Metamorphoseos*, Lyon: Jacobus Huguetan, 1518.

——, *La Métamorphose d'Ovide figurée*, Lyon: Jean de Tournes, 1557.

——, *Metamorphoses*, Augsburg: Johann Sprenger, 1563.

——, *Metamorphoseos*, Frankfurt a.M.: Jeremiah Reusner, 1563.

——, *Metamorphoseos*, Venice: Nicolaus Moretus, 1586.

——, *The* Metamorphoses *of Ovid*, trans. Mary M. Innes, Harmondsworth, 1955.

Pairis, Gunther von, *De gestis Imperatoris Caesaris Friderici primi*, Augsburg: Erhard Oeglin, 1507.

Palingh, Abraham, *'t afgerukt Mom-Aansight Der Tooverye*, Amsterdam: Jan Rieuwertz, 1659.

Paracelsus, Theophrastus, 'De Sagis', in *Werke*, ed. Will-Erich Peuckert, vol. 3, Basel and Stuttgart, 1967.

Pauli, Johann, *Das Buch Schimpf und Ernst*, Strasbourg: Bartholomäus Grüninger, 1533.

——, *Schimpf und Ernst durch alle Welthändel*, Strasbourg: Bartholomäus Grüninger for Christian Egenolph, 1538.

——, *Schimpff unnd Ernst*, Augsburg: Heinrich Steiner, 1542.

——, *Schimpf und Ernst durch alle Welthändel*, Berne: Matthias Apiarius, 1542, 1543.

Paul zun Rom. XIII. Die Gewaltigen oder Oberkeiten sind nich den die gutes sunder den die böses thun zufürchten, [Wittenberg, 1540?].

Petrarca, Francesco [Petrarch], *Von der Artzney bayder Glück des güten und wider wertigen*, Augsburg: Heinrich Steiner, 1532.

——, *De rebus memorandis*, Augsburg, Heinrich Steiner, 1541.

——, *Von der Artzney bayder Glück des guten und widerwertigen*, ed. Manfred Lemmer, Leipzig, 1984.

[Robert of Brunne], *Robert of Brunne's* Handlyng Synne, *A.D. 1303*, ed. Frederick J. Furnivall, London, 1901.

[Sachs, Hans], *Hans Sachs*, ed. Adelbert von Keller, 25 vols, Stuttgart, 1870–1908 (reprint, Hildesheim, 1964).

Saur, Abraham, *Ein kurtze treuwe Warnung Anzeige und Underricht, ob auch zu dieser unser Zeit unter uns Christen, Hexen, Zauberer und Unholden vorhanden, und was sie ausrichten können*, Frankfurt a.M.: Christoph Rab, 1582.

Schedel, Hartmann, *Liber Chronicarum*, Nuremberg: Anton Koberger, 1493.

——, *Liber Chronicarum*, Augsburg: Johann Schönsperger, 1496.

Schwarzenberg, Johann von, *Das Büchle Memorial das ist ein angedänckung der Tugent von herren Joannsen vonn Schwartzenberg yetz säliger gedächtnuß etwo mit figuren und rümen gemacht*, Augsburg: Heinrich Steiner, 1534, 1535.

Scot, Reginald, *The Discoverie of Witchcraft*, ed. Montague Summers, New York, 1972.

Sigfridus, Thomas, *Richtige Antwort auff die Frage: Ob die Zeuberer und Zeuberin mit ihrem Zauberpulfer Krankheiten oder den Todt selber beybringen können*, Erfurt: Jakob Singen, 1593.

Staden, Hans, *Wahrhaftige Historia und beschreibung eyner Landtschafft der Wilden Nacketen Grimmigen Menschfresser Leuthen in der Newenwelt America gelegen*, Marburg: Andres Kolben, 1557.

——, *Hans Stadens Wahrhaftige Historia*, ed. Rheinhard Maack and Karl Fouquet, Marburg, 1964.

Stambaugh, Ria (ed.), *Teufelbücher in Auswahl*, 5 vols, Berlin, 1970.

Stumpf, Johann, *Gemeiner loblicher Eydgnoschafft Stetten Landen und Völckeren Chronick wirdiger thaaten beschreybung*, Zurich: Christoph Froschauer, 1547.

——, *Gemeiner Loblicher Eydgnoschaft Stetten Landen vnd Völckern Chronicwirdiger thaaten beschreibung*, Zurich: Froschauer, 1586.

——, *Histoire veritable et digne de memoire de quatre Jacopins de Bernes, heretiques et sorciers, qui y furent bruslez*, trans. François de Boniuard, Geneva: Gustav Revilliod, 1549 (reprint Geneva, 1867).

Tengler, Ulrich, *Der neü Layenspiegel*, Augsburg: Hans Otmar, 1511.

Theatrum de veneficis. Das ist: Von Teufelsgespenst … , Frankfurt a.M.: Nicolaus Basse, 1586.

Tractat Von Bekanntnuß der Zauberer und Hexen, Munich: Adam Berg, 1591, 1592.

Treitzsaurwein, Marx, *Der Weiß Kunig. Eine Erzehlung von den Thaten Kaiser Maximilian des Ersten*, Vienna: Kurzböck, 1775 (reprint, ed. Christa-Maria Dreissiger, Weinheim, 1985).

A True Discourse Declaring the Damnable Life and Death of One Stubbe Peeter, A Most Wicked Sorcerer … , [England]: no publisher, June 1590, in Charlotte F. Otten (ed.), *A Lycanthropy Reader: werewolves in western culture*, Syracuse, N.Y., 1986, 69–76.

Urgicht und verzaichnuß so Walpurga Haußmännen zu Dillingen inn ihrer peinlichen Marter bekandt hatt … , n.p.: no publisher, 1588.

Vergil, Polydore, *De inventionibus rerum*, Augsburg: Heinrich Steiner, 1537, 1544.

——, *Von den erfyndern der dingen*, Augsburg: Heinrich Steiner, 1537, 1544.

——, *Eigentlicher bericht der Erfinder aller ding*, Frankfurt a.M.: Weygand Han, [*c.*1560].

Vintler, Hans, *Buch der Tugend*, Augsburg: Johann Blaubirer, 1486.

——, *Die Pluemen der Tugent*, ed. Ignaz von Zingerle, Innsbruck, 1874.

Virgilius Maro, Publius [Virgil], *Opera cum quinque vulgatis commentariis: expolitissimisque figuris atque imaginibus nuper per Sebastianum Brant superadditis*, Strasbourg: Johann Grüninger, 1502.

——, *Omnia Opera*, Venice: Bartolomeus de Zannis de Portesio, 1508.

——, *Dryzehen Aeneadische Bücher von Troianischer zerstörung … durch doctor Murner vertütst*, Strasbourg: Johann Grüninger, 1515.

——, *Opera Virgiliana cum decem commentis*, Lyon: J. Crespin, 1529.

——, *Opera … in pristinam formam restituta*, Venice: L.A. Giunta, 1533.

——, *Dreyzehen Aeneadische bücher von Troianischer zerstörung und auffgange des Römischen Reichs*, Worms: Gregorius Hofmann, 1543.

——, *Opera Omnia*, Venice: L.A. Giunta, 1552.

——, *Dreyzehen Bücher von dem tewren Helden Enea*, Frankfurt a.M.: David Zöpffeln, 1559.

——, *Opera Omnia … edita studio et opera Gregor Bersmani Annaebergensis*, Leipzig: Johann Steinmann, 1581.

——, *Dreyzehen Bücher von dem tewren Helden Enea*, Zurich: Christoph Froschauer, 1587.

——, *Opera Bucolicon Georgicon Aeneis argumentis et scholiis virorum doctissimorum illustrata …* , Leipzig: Johann Steinmann, 1588.

Warhafftige und Wunderbarlich Newe zeitung von einen pauren der sich durch Zauberey des tags siben stund zu ainen wolff verwandelt hat und wie er darnach gericht ist worden durch den Colnischen Nachrichter den letzten October Im 1589 Jar, Nuremberg: Lucas Mayer, 1589.

Weyer, Johann, *De Praestigiis. Der Erste Theil. Von den Teuffeln Zaubrern Schwartzkünstlern*

Teuffelsbeschwerern Hexen oder Unholden und Gifftbereitern … , Frankfurt a.M.: Peter Schmidt and Sigmund Feyerabend, 1566.

Weyer, Johann, *De Praestigiis. Von den Teuffeln Zauberrn Schwartkünstlern Teuffels beschweren Hexen oder Unholden und Gifftbereitern* … , Frankfurt a.M.: Nicolaus Basse, 1575.

——, *De Praestigiis Daemonvm. Von Teuffelsgespenst Zauberern vnd Gifftbereytern Schwartzkünstlern Hexen und Unholden* … , Frankfurt a.M.: Nicolaus Basse, 1586.

——, *Witches, Devils and Doctors in the Renaissance: Johann Weyer, De praestigiis daemonum*, ed. George Mora, Binghamton, N.Y., 1991.

Whitney, Geoffrey, *A Choice of Emblemes*, Leiden: Christopher Plantin, 1586.

Wick, Johann Jakob, *Die Wickiana. Johann Jakob Wicks Nachrichtensammlung aus dem 16. Jahrhundert. Texte und Bilder zu den Jahren 1560 bis 1571*, ed. Matthias Senn, Küsnacht-Zurich, 1975.

Wyle, Nicholas *Etlicher bücher Enee silvij*, Straßburg: Johann Prüss, 1510.

——, *Translation, oder Deütschungen des hochgeachten Nicolai von Weil*, Augsburg: Heinrich Steiner, 1536.

Zimmerische Chronik, ed. K.A. Barack, 4 vols, Tübingen, 1869.

WORKS WRITTEN AFTER 1800

Accati, Luisa, 'The spirit of fornication: virtue of the soul and virtue of the body in Friuli, 1600–1800', in Edwin Muir and Guido Ruggiero (eds), *Sex and Gender in Historical Perspective*, trans. Margaret A. Galluci, with Mary A. Galluci and Carole C. Galluci, Baltimore and London, 1990, pp. 110–40.

Albrecht Dürer, 1471–1971, exh. cat., GNM, Nuremberg; Munich, 1971.

Albricci, Gioconda, '*Lo Stregozzo* di Agostino Veneziano', *Arte Veneta*, 36, 1982, 55–61.

Alden, John with Dennis Landis (eds), *European Americana: a chronological guide to works printed in Europe relating to the Americas, 1493–1776*, vol. 1, *1493–1600*, New York, 1980.

Ammann, Hartmann, 'Der Innsbrucker Hexenprozess von 1485', *Zeitschrift des Ferdinandeums für Tirol und Voralberg*, 34, 1890, 3–87.

Andenmatten, Bernard and Kathrin Utz Tremp, 'De l'hérésie à la sorcellerie: l'inquisiteur Ulric de Torrenté OP (vers 1420–1445) et l'affermissement de l'inquisition en Suisse romande', *Zeitschrift für Schweizerische Kirchengeschichte*, 86, 1992, 69–119.

Andersson, Christiane, 'Hans Baldung Grien: Zwei Wetterhexen', in Günther Pflug (ed.), *Preziosen. Sammlungsstücke und Dokumente selbständiger Kulturinstitute der Bundesrepublik Deutschland*, Bonn, 1986, pp. 13–16.

Ankarloo, Bengt and Stuart Clark (eds), *Witchcraft and Magic in Europe*, 6 vols, London, 1999–2002.

Bader, Guido, *Die Hexenprozesse in der Schweiz*, Affoltern, 1945.

Bailey, Michael, 'The Medieval Concept of the Witches' Sabbath', *Exemplaria*, 8, 1996, 419–39.

——, *Battling Demons: witchcraft, heresy and reform in the late Middle Ages*, University Park, Pa., 2003.

Bailey, Michael and Edward Peters, 'A Sabbat of Demonologists: Basel, 1431–1440', *The Historian*, 65, 2003, 1375–95.

Balberghe, E. van and J.-F. Gilmont, 'Les théologiens et la *vauderie* au XVe siècle', in Pierre Cockshaw, Monique-Cecile Garand and Pierre Jodogne (eds), *Miscellanea codicologica F. Masai dicata MCMLXXIX*, 2 vols, Ghent, 1979, pp. 393–411.

Balmas, E., 'Il "Traité de Vauderie" di Johannes Tinctor', *Protestantismo*, 34, 1979, 1–26.

Baltrusaitis, Jurgis, *Anamorphic Art*, trans. W.J. Strachan, Cambridge, 1977.

Bandmann, Günter, *Melancholie und Musik. Ikonographische Studien*, Cologne and Opladen, 1960.

Baroja, Julio Caro, *The World of Witches*, trans. O.N.V. Glendinning, Chicago and London, 1964.

Baron, Frank, *Faustus on Trial: the origins of Johann Spies's* Historia *in an age of witch hunting*, Tübingen, 1992.

Barto, Philip, *Tannhäuser and the Mountain of Venus: a study in the legend of the Germanic paradise*, New York, 1916.

Bastelaer, René van, *The Prints of Peter Bruegel the Elder: catalogue raisonné*, trans. and revised by S. Gilchrist, San Francisco, 1992.

Bartrum, Giulia, *German Renaissance Prints 1490–1550*, exh. cat., British Museum, London, 1995.

Bax, Dirk, *Hieronymus Bosch: his picture-writing deciphered*, trans. M.A. Bax-Botha, Rotterdam, 1979.

Becker, Hanna, *Die Handzeichnungen Albrecht Altdorfers*, Munich, 1938.

Bedaux, Jan Baptist, *The Reality of Symbols: studies in the iconography of Netherlandish art, 1400–1800*, 's-Gravenhage, 1990.

Behringer, Wolfgang, 'Hexenverfolgungen im Spiegel zeitgenössischer Publizistik. "Die Erweytterte Unholden Zeyttung" von 1590', *Oberbayerische Archiv*, 109, 1984, 339–60.

—— (ed.), *Hexen und Hexenprozesse in Deutschland*, Munich, 1988.

——, 'Das "Reichskhündig Exempel" von Trier. Zur paradigmatischen Rolle einer Hexenverfolgung in Deutschland', in Gunther Franz and Franz Irsigler (eds), *Trierer Hexenprozesse. Quellen und Darstellungen*, vol. 1, *Hexenglaube und Hexenprozesse im Raum Rhein-Mosel-Saar*, ed. Elisabeth Biesel, Trier, 1995, pp. 435–47.

——, *Witchcraft Persecutions in Bavaria: popular magic, religious zealotry, and reason of state in early modern Europe*, trans. J.C. Grayson and David Lederer, Cambridge, 1997.

——, *Shaman of Oberstdorf: Chonrad Stoeckhlin and the phantoms of the night*, trans. H.C. Erik Midelfort, Charlottesville, 1998.

——, *Witches and Witch-hunts: a global history*, Cambridge, 2004.

——, 'How Waldensians Became Witches: heretics and their journey to the other world', in Gábor Klaniczay and Éva Pócs (eds), *Communicating with the Spirits*, Budapest and New York, 2005, pp. 155–85.

Benzing, Josef, *Die Buchdrucker des 16. und 17. Jahrhunderts im deutschen Sprachgebiet*, Wiesbaden, 1982.

Bernhard, Marianne, *Hans Baldung Grien: Handzeichnungen, Druckgraphik*, Munich, 1978.

Biedermann, Rolf (ed.), *Hans Burgkmair: 1473–1973. Das graphische Werk*, exh. cat., Städtische Kunstsammlungen, Augsburg, 1973.

Blauert, Andreas, *Frühe Hexenverfolgungen. Ketzer-, Zauberei- und Hexenprozesse des 15. Jahrhunderts*, Hamburg, 1989.

Blok, Anton, 'Rams and Billy-Goats: a key to the Mediterranean code of honour', *Man*, 16, 1981, 427–40.

Bock, Elfried, 'The engravings of Ludwig Krug of Nuremberg', *Print Collector's Quarterly*, 20, 1933, 87–115.

Boerner, Peter and Sidney Johnson, *Faust through Four Centuries: retrospect and analysis*, Tübingen, 1989.

Bonomo, Giuseppe, *Caccia alle streghe*, Palermo, 1959.

Boon, Karel, *Netherlandish Drawings of the Fifteenth and Sixteenth Centuries in the Rijksmuseum*, vol. 2, The Hague, 1978.

Boon, Karel, J. Bruyn, G. Lemmens and E. Taverne (eds), *Jheronimus Bosch*, exh. cat., Nordbrabants Museum, s'-Hertogenbosch, 1967.

Borst, Arno, *Medieval Worlds: barbarians, heretics, and artists in the Middle Ages*, trans. Eric Hansen, Chicago, 1992.

Borst, Arno et al., *Tod im Mittelalter*, Constance, 1993.

Bossy, John, 'Moral Arithmetic: seven sins into ten commandments', in Edmund Leites (ed), *Conscience and Casuistry in Early Modern Europe*, Cambridge and Paris, 1988, pp. 214–34.

Bottigheimer, Ruth, 'Publishing, Print, and Change in the Image of Eve and the Apple 1470–1570', *Archiv für Reformationsgeschichte*, 86, 1995, 199–235.

Brady, Thomas A., Jr., 'The Social Place of a German Renaissance Artist: Hans Baldung Grien (1484/85–1545) at Strasbourg', *Central European History*, 8, 1975, 295–315.

Briggs, Robin, *Witches and Neighbours: the social and cultural context of European witchcraft*, 2nd edn, Oxford and Malden, Mass., 2002.

Broedel, Hans Peter, *The* Malleus Maleficarum *and the Construction of Witchcraft: theology and popular belief*, Manchester and New York, 2003.

Brooks, Jerry Carroll, 'La filiation des manuscrits du *Champion des Dames* de Martin Le Franc', Ph.D. thesis, Florida State University, 1976.

Brugerolles, Emmanuelle and David Guillet, *The Renaissance in France: drawings from the École des Beaux-Arts, Paris*, trans. Judith Schub, exh. cat., École nationale supérieure des beaux-arts, Paris; Cambridge, Mass. and Seattle, 1995.

Bryson, Norman, 'Semiology and Visual Interpretation', in Norman Bryson, Michael Holly and Keith Moxey (eds), *Visual Theory*, Cambridge, 1989, pp. 61–73.

Bryson, Norman, Michael Holly and Keith Moxey (eds), *Visual Culture: images and interpretations*, Hanover, N.H., 1994.

Burke, Peter, *Popular Culture in Early Modern Europe*, London, 1979.

——, 'Witchcraft and Magic in Renaissance Italy: Gianfrancesco Pico and his *Strix*', in Sydney Anglo (ed.), *The Damned Art: essays in the literature of witchcraft*, London, 1977, pp. 32–52.

Butsch, A.E., *Handbook of Renaissance Ornament*, New York, 1969.

Callois, Roger, *Au coeur du fantastique*, Paris, 1965.

Camille, Michael, 'The Illustrated Manuscripts of Guillaume de Deguileville's *Pèlerinages*, 1330–1426', Ph.D. thesis, University of Cambridge, 1984.

——, 'Reading the Printed Image: illuminations and woodcuts of the *Pèlerinage de la vie humaine* in the fifteenth century', in Sandra Hindman (ed.), *Printing the Written Word: the social history of books, circa 1450–1520*, Ithaca and London, 1991, pp. 259–91.

Carr, Amelia and Richard Kremer, 'Child of Saturn: the Renaissance church tower at Niederaltaich', *Sixteenth Century Journal*, 17, 1986, 401–34.

Carroll, Eugene, *Rosso Fiorentino: drawings, prints, and decorative arts*, exh. cat, National Gallery of Art, Washington, 1987.

Carroll, Jane, 'The Paintings of Jacob Cornelisz. van Oostsanen, 1472?–1533', Ph.D. thesis, University of North Carolina, 1987.

——, 'Cornelisz. van Oostsanen [von Amsterdam], Jacob', in Jane Turner (ed.), *The Dictionary of Art*, vol. 7, London, 1996, pp. 868–70.

Chartier, Roger, *The Cultural Uses of Print in Early Modern France*, trans. Lydia G. Cochrane, Princeton, 1987.

Clark, Stuart, *Thinking with Demons: the idea of witchcraft in early modern Europe*, Oxford, 1997.

—— (ed.), *Languages of Witchcraft: narrative, ideology and meaning in early modern culture*, London and New York, 2001.

Clayson, Hollis, 'Materialist Art History and its Points of Difficulty', *Art Bulletin*, 77, 1995, 367–71.

Clifton-Everest, John M., *The Tragedy of Knighthood: origins of the Tannhäuser-legend*, Oxford, 1979.

Cohn, Norman, *Europe's Inner Demons*, St Albans, 1976.

Colvin, Sidney, *A Florentine Picture-chronicle*, London, 1898.

Conway, William Martin, *The Woodcutters of the Netherlands in the Fifteenth Century*, Hildesheim, 1961.

Courcelle, Pierre, *La consolation de philosophie dans la tradition littéraire. Antécédents et postérité de Boèce*, Paris, 1967.

Crouzet, Denis, 'A Woman and the Devil: posssession and exorcism in sixteenth-century France',

in Michael Wolfe (ed.), *Changing Identities in Early Modern France*, Durham, N.C., 1997, pp. 191–215.

Cummins, John, *The Hound and the Hawk: the art of medieval hunting*, London, 1988.

Cust, L. and H. Horne, 'Notes on Pictures in the Royal Collections. Article VIII – the story of Simon Magus, part of a predella painting by Benozzo Gozzoli', *Burlington Magazine*, 7, 1905, 377–82.

D'Arcais, Francesca, 'La decorazione della cappella di San Giacomo', in Camillo Semenzato (ed.), *Le pitture del Santo di Padova*, Vicenza, 1984, pp. 15–42.

Davidson, Jane, *The Witch in Northern European Art, 1470–1750*, Freren, 1987.

Degenhart, Bernhard and Annegrit Schmitt, *Corpus der italienischen Zeichnungen 1300–1450*, 4 vols, Berlin, 1968.

De Tolnay, Charles, *Hieronymus Bosch*, New York, 1966.

D'Evelyn, Charlotte (ed.), *Peter Idley's Instructions to his Son*, Boston and London, 1935.

Diederichs, Eugen, *Deutsches Leben der Vergangenheit in Bildern*, vol. 1, Jena, 1908.

Duerr, Hans Peter, *Dreamtime: concerning the boundary between wilderness and civilization*, trans. Felicitas Goodman, London, 1985.

Dülmen, Richard van (ed.), *Hexenwelten. Magie und Imagination, vom 16.–20. Jahrhundert*, Frankfurt a.M., 1987.

——, *Theatre of Horror: crime and punishment in early modern Germany*, trans. Elisabeth Neu, Cambridge, 1990.

Dunand, Louis and Philippe Lemarchand, *Les compositions de Jules Romain intitulées les amours des dieux. Gravées par Marc-Antoine Raimondi*, Lausanne, 1977.

Durian-Ress, Saskia, *Hans Balding Grien in Freiburg*, Freiburg, 2001.

Dwyer, Richard A., *Boethian Fictions: narratives in the medieval French versions of the* Consolatio Philosophiae, Cambridge, Mass., 1976.

Ebermann, Oskar and Max Bartels, 'Zur Aberglaubensliste in Vintlers Plumen der Tugent (V. 7694–7997)', *Zeitschrift des Vereins für Volkskunde*, 23, 1913, 1–18, 113–36.

Edgerton, Samuel Y., *Pictures and Punishment: art and criminal prosecution during the Florentine Renaissance*, Ithaca, 1985.

Eichberger, Dagmar and Charles Zika (eds), *Dürer and his Culture*, Cambridge, 1998.

Eisenstein, Elizabeth L., *The Printing Press as an Agent of Change: communications and cultural transformations in early modern Europe*, Cambridge and New York, 1979.

——, *The Printing Revolution in Early Modern Europe*, Cambridge and New York, 1983.

Emiliani, Andrea (ed.), *Bologna 1584. Gli esordi dei Carracci e gli affreschi di Palazzo Fava*, Bologna, 1984.

Emison, Patricia, 'Truth and *bizzarria* in an Engraving of Lo stregozzo', *Art Bulletin*, 81, 1999, 623–36.

Emmerson, Richard, *Antichrist in the Middle Ages: a study of medieval apocalypticism, art and literature*, Seattle, 1981.

Emmerson, Richard and Ronald Herzman, 'Antichrist, Simon Magus, and Dante's "Inferno" XIX', *Traditio*, 36, 1980, 373–98.

Endres, Rudolf, 'Heinrich Institoris, sein Hexenhammer und der Nürnberger Rat', in Peter Segl (ed.), *Der Hexenhammer. Enstehung und Umfeld des Malleus Maleficarum von 1487*, Cologne and Vienna, 1988, pp. 195–216.

Fahy, Everett, 'The Kimbell Fra Angelico', *Apollo*, 125, 1987, 178–83.

Falk, Tilman, *Hans Burgkmair. Studien zu Leben und Werk des Augsburger Malers*, Munich, 1968.

Faral, Edmond, 'Guillaume de Digulleville, Jean Gallopes et Pierre Virgin', in *Études Romanes dediées à Mario Roques*, Paris, 1946, pp. 89–102.

——, *Guillaume de Digulleville: moine de Chaolis*, Paris, 1952.

Fehr, Hans, *Das Recht im Bilde*, Zurich, 1923.

Ferber, Sarah, *Demonic Possession and Exorcism in Early Modern France*, London and New York, 2004.

Ferreiro, Alberto, 'Simon Magus: the patristic-medieval traditions and historiography', *Apocrypha*, 7, 1996, 147–65.

Filedt Kok, Jan Piet (ed.), *The Master of the Amsterdam Cabinet, or the Housebook Master, ca. 1470–1500*, exh. cat., Rijksprentenkabinet, Amsterdam; Amsterdam and Princeton, 1985.

Filedt Kok, Jan Piet, W. Halsema-Kubes and W.Th. Kloek (eds), *Kunst voor de beeldenstorm: Noordnederlanse kunst: Catalogus*, exh. cat., Rijksmuseum, Amsterdam; s'Gravenhage, 1986.

Fischer, Don, 'Edition and Study of Martin Le Franc's *Le Champion des Dames*', Ph.D. thesis, Florida State University, 1981.

Flint, Valerie, *The Rise of Magic in Early Medieval Europe*, Oxford, 1991.

Fraenger, Wilhelm, *Hans Weiditz und Sebastian Brant*, Leipzig, 1930.

Franits, Wayne E., *Paragons of Virtue: women and domesticity in seventeenth-century Dutch art*, Cambridge and New York, 1993.

Franz, Gunther, *Friedrich Spee: Dichter, Seelsorger, Bekämpfer des Hexenwahns. Kaiserswerth 1591–Trier 1635*, exh. cat., Heinrich-Heine-Instituts Düsseldorf; Trier, 1991.

Freedberg, David, *The Power of Images: studies in the history and theory of response*, Chicago, 1989.

Friedländer, Max J. and Jakob Rosenberg, *Die Gemälde von Lukas Cranach*, Berlin, 1932 (reprint Basel, 1979).

——, *The Paintings of Lucas Cranach*, Secaucus, N.J., 1978.

Füssel, Stephan, *Gutenberg and the Impact of Printing*, trans. Douglas Martin, Aldershot, 2005.

Gamboso,Virgilio, *La Basilica del Santo di Padova*, 2nd rev. edn, Padua, 1991.

Geisberg, Max (ed.), *Die deutsche Buchillustration in der ersten Hälfte des XVI. Jahrhunderts*, 9 vols, Munich, 1930–32 (reprint Doornspijk, 1987).

[Geisberg/Strauss] Geisberg, Max, *The German Single-leaf Woodcut: 1500–1550*, edited and revised by Walter Strauss, 4 vols, New York, 1974.

Gibbons, Felton, *Dosso and Battista Dossi: court painters at Ferrara*, Princeton, 1968.

Gibson, Marion (ed.), *Witchcraft and Society in England and America, 1550–1750*, Ithaca, 2003.

Gibson, W., *Bruegel*, London, 1977.

Ginzburg, Carlo, *The Night Battles: witchcraft and agrarian cults in the sixteenth and seventeenth centuries*, trans. John Tedeschi and Anne Tedeschi, Baltimore and London, 1983.

——, *Ecstasies: deciphering the witches' sabbath*, trans. Raymond Rosenthal and Gregory Elliott, London, 1990.

Gitlitz, David, 'The Iconography of St. James in the Indianapolis Museum's Fifteenth-century Altarpiece', in Maryjane Dunn and Linda Key Davidson (eds), *The Pilgrimage to Compostella in the Middle Ages*, New York and London, 1996, pp. 113–30.

Givry, Grillot de, *Witchcraft, Magic and Alchemy*, trans. J. Courtenay Locke, New York, 1931.

Goddard, Stephen H. (ed.), *The World in Miniature: engravings by the German Little Masters 1500–1550*, exh. cat., Spenser Museum of Art, Lawrence, Kan., 1988.

Goldberg, Gisela, *Albrecht Altdorfer: Meister von Landschaft, Raum und Licht*, Munich and Zurich, 1988.

Golden, Richard M. (ed.), *Encyclopaedia of Witchcraft: the western tradition*, 4 vols, Santa Barbara, Calif., 2006.

Gose, Walther (ed.), *Reformationsdrucke. Von den Anfängen Luthers bis zum Ende des 16. Jahrhunderts*, Nuremberg, 1972.

Gottlieb, Carla, 'The Brussels' version of the Mérode *Annunciation*', *Art Bulletin*, 39, 1957, 53–64.

Gramaccini, Norberto, 'La Médée d'Annibale Carracci au Palais Fava', in *Les Carrache et les décors profanes. Actes du colloque organisé par l'École Française de Rome, 2–4 Octobre 1986*, Rome, 1998, pp. 491–519.

Grimm, Heinrich, 'Die deutschen "Teufelbücher" des 16. Jahrhunderts. Ihre Rolle im Buchwesen und ihre Bedeutung', *Archiv für Geschichte des Buchwesens*, 16, 1959, 513–70.

Grimm, Jacob, *Deutsche Mythologie*, 3 vols, Berlin, 1875–8.

Grimm, Claus, Johannes Erichsen and Evamaria Brockhoff (eds), *Lucas Cranach. Ein Maler-Unternehmer aus Franken*, Augsburg, 1994.

Grünwald, Michel, 'Die Beziehungen des Jungen Hans Weiditz zu Hans Frank', *Jahrbuch der Preussischen Kunstsammlungen*, 44, 1923, 26–36.

Gunnoe, Charles D., Jr, 'The Debate between Johann Weyer and Thomas Erastus on the Punishment of Witches', in James Van Horn Melton (ed.), *Cultures of Communication from Reformation to Enlightenment: constructing publics in the early modern German lands*, Aldershot, 2003, pp. 257–85.

Hamburger, Jeffrey F., 'A *Liber Precum* in Sélestat and the Development of the Illustrated Prayer Book in Germany', *Art Bulletin*, 73, 1991, 209–36.

Hansen, Joseph, *Quellen und Untersuchungen zur Geschichte des Hexenwahns*, Bonn, 1901 (reprint Hildesheim, 1963).

Harms, Wolfgang (ed.), *Deutsche illustrierte Flugblätter des 16. und 17. Jahrhunderts*, vol. 1, *Die Sammlung der Herzog August Bibliothek in Wolfenbüttel*, Tübingen, 1985; vol. 4, *Die Sammlungen der Hessischen Landes- und Hochschulbibliothek in Darmstadt*, ed. Wolfgang Harms and Cornelia Kemp, Tübingen, 1987.

Hartlaub, G.F., 'Der Todestraum des Hans Baldung Grien', *Antaios*, 2, 1961, 13–25.

——, *Hans Baldung Grien: Hexenbilder*, Stuttgart, 1961.

Hauber, Anton, *Planetenkinderbilder und Sternbilder. Zur Geschichte des menschlichen Glaubens und Irrens*, Strasbourg, 1917.

Haustein, Jörg, *Martin Luthers Stellung zum Zauber- und Hexenwesen*, Stuttgart, Berlin and Cologne, 1990.

[HDA] Hoffmann-Krayer, Eduard, with Bächtold-Stäubli, Hanns (eds), *Handwörterbuch des deutschen Aberglaubens*, 10 vols, Berlin and Leipzig, 1927–42.

Heck, Christian, 'Entre humanisme et réforme, la *Mélancholie* de Lucas Cranach l'Ancien', *Revue du Louvre et des Musées de France*, 36, 1986, 257–64.

Hell, Vera and Hellmut Hell, *The Great Pilgrimage of the Middle Ages: the road to St James of Compostella*, trans. Elisa Jaffa, London, 1964.

Henkel, Arthur and Albrecht Schöne, *Emblemata. Handbuch zur Sinnbildkunst des XVI. und XVII. Jahrhunderts*, Stuttgart, 1967.

Herkommer, Hubert and Carl Ludwig Lang (eds), *Deutsches Literatur-Lexikon, biographisch-bibliographisches Handbuch*, vol. 5, Berne and Munich, 1978.

Herzig, Tamar, 'The Demons' Reaction to Sodomy: witchcraft and homosexuality in Gianfrancesco Pico della Mirandola's *Strix*', *The Sixteenth Century Journal*, 34, 2003, 53–72.

Herzman, Ronald and William Cook, 'Simon the Magician and the Medieval Tradition', *Journal of Magic History*, 2, 1980, 29–43.

Hinckeldey, Christoph, *Pictures from the Crime Museum*, Rothenburg o.d. Tauber, Heilsbronn, 1985.

——, *Criminal Justice through the Ages*, trans. John Fosberry, Rothenburg o.d. Tauber, 1981.

Hind, A.M, *Early Italian Engraving*, London, 7 vols, 1938–48.

Hoak, Dale, 'Art, Culture and Mentality in Renaissance Society: the meaning of Hans Baldung Grien's *Bewitched Groom* (1544)', *Renaissance Quarterly*, 38, 1985, 488–510.

Hoffmann, Konrad, 'Cranachs Zeichnungen "Frauen Überfallen Geistliche"', *Zeitschrift des deutschen Vereins für Kunstwissenschaft*, 26, 1972, 3–14.

Hofmann, Werner, *Luther und die Folgen für die Kunst*, Munich, 1983.

——, *Zauber der Medusa: Europäische Manierismen*, Vienna, 1987.

Hollstein, F.W.H., *Dutch and Flemish Etchings, Engravings and Woodcuts c. 1450–1700*, vol. 21, *Aegidius Sadeler to Raphael Sadeler II*, compiled by Dieuwke de Hoop Scheffer, ed. K.G. Boon, Amsterdam, 1980.

[Hollstein] F.W.H. Hollstein, *German Engravings, Etchings and Woodcuts c. 1400–1700*, Amsterdam, 1954.

Holmes, Clive, 'Popular Culture? Witches, magistrates and divines in early modern England', in Steven L. Kaplan (ed.), *Understanding Popular Culture: Europe from the Middle Ages to the 19th century*, Berlin, 1984, pp. 85–111.

Hope, Charles (ed.), *The Autobiography of Benvenuto Cellini*, Oxford, 1983.

Hsia, Ronald Po-Chia, *The Myth of Ritual Murder: Jews and magic in Reformation Germany*, New Haven and London, 1988.

——, *Trent 1475: stories of a ritual murder trial*, New Haven and London, 1992.

Hughes, Merritt, 'Spenser's Acrasia and the Circe of the Renaissance', *Journal of the History of Ideas*, 6, 1943, 381–99.

Hults, Linda C., 'Hans Baldung Grien's *Weather Witches* in Frankfurt', *Pantheon*, 40, 1982, 124–30.

——, 'Baldung's *Bewitched Groom* Revisited: artistic temperament, fantasy and the *Dream of Reason*', *Sixteenth Century Journal*, 15, 1984, 259–79.

——, 'Baldung and the Witches of Freiburg: the evidence of images', *Journal of Interdisciplinary History*, 18, 1987, 249–76.

——, *The Witch as Muse: art, gender and power in early modern Europe*, Philadelphia, 2005.

Humfrey, Peter, 'Two Moments in Dosso's Career as a Landscape Painter', in Luisa Ciammitti, Steven Ostrow and Salvatore Settis (eds), *Dosso's Fate: painting and court culture in Renaissance Italy*, Los Angeles, 1998, pp. 201–18.

Humfrey, Peter and Mauro Lucco, *Dosso Dossi: court painter in Renaissance Ferrara*, ed. Andrea Bayer, exh. cat., Pinacoteca nazionale, Ferrara, Metropolitan Museum of Art, New York, J. Paul Getty Museum, Los Angeles; New York, 1998.

Johannesson, Kurt, *The Renaissance of the Goths in Sixteenth-century Sweden*, Berkeley and Los Angeles, 1991.

Johansen, Jens Christian, 'Hexen auf mittelalterlichen Wandmalereien. Zur Genese der Hexenprozesse in Dänemark', in Andreas Blauert (ed.), *Ketzer, Zauberer, Hexen: Die Anfänge der europäischen Hexenverfolgungen*, Frankfurt a.M., 1990.

Jones, Ann and Peter Stallybrass (eds), *Renaissance Clothing and the Materials of Memory*, Cambridge, 2000.

Jones Hellerstedt, Kahren, 'Hurdy-gurdies from Hieronymus Bosch to Rembrandt', Ph.D. thesis, University of Pittsburgh, 1980.

Jurina, Kitti, *Vom Quacksalber zum Doctor Medecinae*, Vienna, 1985.

Kanter, Laurence B. et al., *Painting and Illumination in Early Renaissance Florence 1300–1450*, exh. cat., Metropolitan Museum of Art, New York, 1994.

Katzenellenbogen, A., *Allegories of Vices and Virtues in Medieval Art*, New York, 1964.

Kautzsch, R., *Die Holzschnitte zum Ritter vom Turn*, Strasbourg, 1903.

Kieckhefer, Richard, *European Witch Trials: their foundations in popular and learned culture, 1300–1500*, London, 1976.

——, *Magic in the Middle Ages*, Cambridge, 1989.

——, 'Avenging the Blood of Children: anxiety over child victims and the origins of the European witch trials', in Alberto Ferreiro (ed.), *The Devil, Heresy and Witchcraft in the Middle Ages: essays in honour of Jeffrey B. Russell*, Leiden, 1998, pp. 91–109.

——, *Forbidden Rites: a necromancer's manual of the fifteenth century*, University Park, Pa., 1998.

Killy, Walther (ed.), *Literatur Lexikon. Autoren und Werke deutscher Sprache*, vol. 3, Gütersloh, 1989.

Kimpel, S., 'Jakobus der Ältere', LCI, vol. 7, col. 24–40.

King, Francis X., *Witchcraft and Demonology*, New York, 1991.

Kinser, Samuel, 'Presentation and Representation: carnival at Nuremberg, 1450–1550', *Representations*, 13, 1986, 1–41.

Klein, H. Arthur, *Graphic Worlds of Peter Bruegel the Elder*, New York, 1963.

Klibansky, Raymond, Erwin Panofsky and Fritz Saxl, *Saturn and Melancholy: studies in the history of natural philosophy, religion and art*, London, 1964.

——, *Saturn und Melancholie: Studien zur Geschichte der Naturphilosophie und Medizin, der Religion und Kunst*, trans. Christa Buschendorf, Frankfurt a.M., 1990.

Kloek, W.Th., W. Halsema-Kubes and R.J. Baarsen, *Art Before the Iconoclasm: Northern Netherlandish Art, 1525–1580*, exh. cat., Rijksmuseum, Amsterdam, 1986.

Knape, Joachim, *Die ältesten deutschen Übersetzungen von Petrarcas Glücksbuch*, Bamberg, 1986.

Knapp, Karl-Adolf, *Dürer: the complete engravings, etchings and woodcuts*, London, 1965.

Knauer, Elfriede Regina, *Die Carta Marina des Olaus Magnus von 1539. Ein kartographisches Meisterwerk und seine Wirkung*, Göttingen, 1981.

Koch, Carl, *Die Zeichnungen Hans Baldung Griens*, Berlin, 1941.

Koepf, Hans, *Das Ulmer Rathaus*, Ulm, 1981.

Koepplin, Dieter, *Cranachs Ehebildnis des Johannes Cuspinian von 1502. Seine christlich-humanistische Bedeutung*, Basel, 1973.

Koepplin, Dieter and Tilman Falk, *Lukas Cranach. Gemälde, Zeichnungen, Druckgraphik*, vol. 1, 2nd edn, Basel and Stuttgart, 1974.

Koerner, Joseph Leo, *The Moment of Self-portraiture in German Renaissance Art*, Chicago, 1993.

Könneker, Barbara, *Satire im 16. Jahrhundert: Epoche, Werke, Wirkung*, Munich, 1991.

Kors, Alan C. and Edward Peters (eds), *Witchcraft in Europe, 400–1700*, 2nd edn, Philadelphia, 2001.

Kotalík J. et al., *Staré ceské umení. Sbírky národní galerie v Praze Jirsky kláster*, exh. cat., National Gallery, Prague, 1988.

Kratz, Henry, 'Über den Wortschatz der Erotik im Spätmittelhochdeutschen und Frühneuhochdeutschen', Ph.D. thesis, Ohio State University, 1949.

Kristeller, Paul (ed.), *Holzschnitte im königlichen Kupferstichkabinett zu Berlin*, series 2, Berlin, 1915.

Kühnel, Harry (ed.), *Alltag im Spätmittelalter*, Graz, 1984.

Kunstmann, Hartmut, *Zauberwahn und Hexenprozeß in der Reichsstadt Nürnberg*, Nuremberg, 1970.

Kunzle, David, *History of the Comic Strip: the early comic strip, narrative strips and picture stories in the European broadsheet from c. 1450 to 1825*, vol. 1, Berkeley, 1973.

Kuster, Jürgen, *Spectaculum vitiorum. Studien zur Intentionalität und Geschichte des Nürnberger Schembartlaufs*, Remscheid, 1983.

Labouvie, Eva, 'Perspektivenwechsel. Magische Domänen von Frauen und Männern in Volksmagie und Hexerei aus der Sicht der Geschlechtergeschichte', in Ingrid Ahrendt-Schulter et al. (eds), *Geschlecht, Magie und Hexenverfolgung*, Bielefeld, 2002, pp. 39–56

——, 'Men in Witchcraft Trials: towards a social anthropology of "male" understandings of magic and witchcraft', in Ulinka Rublack (ed.), *Gender in Early Modern History*, Cambridge, 2002, pp. 49–68.

Landau, David and Peter Parshall, *The Renaissance Print, 1470–1550*, New Haven and London, 1994.

Lauts, Jan (ed.), *Hans Baldung Grien: Ausstellung unter dem Protektorat des I.C.O.M., 4 Juli–27 September 1959*, exh. cat., Staatliche Kunsthalle, Karlsruhe, 1959.

[LCI] Engelbert Kirschbaum with Günter Bandmann et al. (eds), *Lexikon der christlichen Ikonographie*, 8 vols, Rome, 1968–76.

Leeman, Fred, *Hidden Images: games of perception, anamorphic art, illusion: from the Renaissance to the present*, New York, 1976.

Lemarchand, Philippe and Louis Dunand, *Les compositions de Jules Romain, intitulée Les Amours des Dieux, Gravées par Marc-Antoine Raimondi*, Lausanne, 1977.

Lesourd, Dominique, 'Diane et les sorcières, étude sur les survivances de Diana dans les langues romanes', *Anagrom*, 1, 1972, 55–74.

Leutenbauer, Siegfried, *Hexerei- und Zaubereidelikt in der Literatur von 1450 bis 1550*, Berlin, 1972.

Leutrat, Paul, 'Les medaillons de saint Jean', *Vie Lyonnaise*, vol. 1, no. 11, 1969 to vol. 15, no. 1, 1970.

Levack, Brian P., *The Witch-hunt in Early Modern Europe*, 3rd edn, Harlow and New York, 2006.

Levy, Janey, 'The Erotic Engravings of Sebald and Barthel Beham: a German interpretation of a Renaissance subject', in Stephen H. Goddard (ed.), *The World in Miniature: engravings by the*

German Little Masters 1500–1550, exh. cat., Spencer Museum of Art, Lawrence, Kan., 1988, pp. 40–53.

List, Edgar, 'Holda and the *Venusberg*', *Journal of American Folklore*, 73, 1960, 307–11.

Maas, Herbert, 'Schembart und Fastnacht. Eine Rückkehr zu alten Deutungen', *Mitteilungen des Vereins für Geschichte der Stadt Nürnberg*, 80, 1993, 147–59.

Macfarlane, Alan, *Witchcraft in Tudor and Stuart England: a regional and comparative study*, 2nd edn, London, 1999.

McGinn, Bernard, *Antichrist: two thousand years of the human fascination with evil*, San Francisco, 1994.

Mâle, Emile, *The Gothic Image: religious art in France of the thirteenth century*, trans. Dora Nussey, New York, 1972.

——, *Religious Art in France: the late Middle Ages: a study of medieval iconography and its sources*, ed. Harry Bober, trans. Marthiel Mathews, rev. edn, Princeton, 1986.

Manhes-Deremble, Colette with J-P. Deremble, *Les vitraux narratifs de la cathédrale de Chartres. Étude iconographique*, Paris, 1993.

Manning, Bertina Suida, 'The Transformation of Circe: the significance of the sorceress subject in seventeenth-century Genoese painting', in *Scritti di storia dell'arte in onore di Federico Zeri*, vol. 2, Los Angeles, 1984.

Marijnissen, R.H. and M. Seidel, *Bruegel*, New York, 1987.

Marijnissen, R.H., *Bruegel. Tout l'oeuvre peint et dessiné*, Anvers and Paris, 1988.

Marrow, James and Alan Shestack, *Hans Baldung Grien: prints and drawings*, exh. cat., Yale University Art Gallery, New Haven, 1981.

Matthews Grieco, Sara F., *Ange ou Diablesse. La répresentation de la femme au XVIe siècle*, Paris, 1991.

Maxwell-Stuart, P.G., *Witchcraft in Europe and the New World, 1400–1800*, New York, 2001.

Meier, Gabriel, 'Der Rosenkrantz in der Reformationszeit', *Zeitschrift für Schweizerische Kirchengeschichte*, 8, 1913, 296–303.

Mende, Matthias, *Hans Baldung Grien: das graphische Werk. Vollständiger Bildkatalog der Einzelholzschnitte, Buchillustrationen und Kupferstiche*, Unterschneidheim, 1978.

Menz, Cäsar and Hugo Wagner (eds), *Niklaus Manuel Deutsch: Maler/ Dichter/ Staatsman*, exh. cat., Kunstmuseum Bern, Berne, 1975.

Merback, Mitchell, *The Thief, the Cross and the Wheel: pain and the spectacle of punishment in medieval and Renaissance Europe*, London, 1999.

Mercier, Franck, *La Vauderie d'Arras: une chasse aux sorcières à l'automne du Moyen-Âge*, Rennes, 2006.

Mesenzeva, Charmian A., '*Der behexte Stallknecht* des Hans Baldung Grien', *Zeitschrift für Kunstgeschichte*, 44, 1981, 57–61.

——, 'Zum Problem: Dürer und die Antike. Albrecht Dürer's Kupferstich "Die Hexe"', *Zeitschrift für Kunstgeschichte*, 46, 1983, 187–202.

Meurger, Michael, 'L'homme-loup et son témoin. Construction d'une factualité lycanthropique', in Jean de Nynauld (ed.), *De la lycanthropie, transformation et extase des sorciers 1615*, Paris, 1990, pp. 143–79.

Michalon, Antoine, *La cathedrale de Lyon*, Colmar-Ingersheim, 1974.

Midelfort, H.C. Erik, *Witch Hunting in Southwestern Germany, 1562–1684: the social and intellectual foundations*, Stanford, 1972.

——, 'The Devil and the German People: reflections on the popularity of demon possession in sixteenth-century Germany', in Brian P. Levack (ed.), *Articles on Witchcraft, Magic and Demonology: a twelve volume anthology of scholarly articles*, vol. 9, *Possession and Exorcism*, New York and London, 1992, pp. 113–33.

Mielke, Hans, *Albrecht Altdorfer: Zeichnungen, Deckfarbenmalerei, Druckgraphik*, Berlin, 1988.

——, *Pieter Bruegel. Die Zeichnungen*, Brepols, 1996.

Milne, Louise, 'Dreams and Popular Beliefs in the Imagery of Pieter Bruegel the Elder, *c.* 1528–1569', Ph.D. thesis, Boston University, 1990.

Mitchell, W.J.T., *Picture Theory: essays on verbal and visual representation*, Chicago, 1994.

Modestin, Georg, *Le diable chez l'évêque. Chasse aux sorciers dans le diocèse de Lausanne (vers 1460)*. Lausanne, 1999.

Moncrieff, Elspeth, 'The Royal Collection: utility and delight', *Apollo*, 356, 1991, 228–33.

Monter, William E., *European Witchcraft*, New York, 1970.

——, William E., *Witchcraft in France and Switzerland: the borderlands during the Reformation*, Ithaca, 1976.

Morse, Ruth, *The Medieval Medea*, Cambridge, 1996.

Moxey, Keith, *Peasants, Warriors and Wives: popular imagery in the Reformation*, Chicago and London, 1989.

——, *The Practice of Theory: poststructuralism, cultural politics, and art history*, Ithaca, 1994.

Muchembled, Robert, *La sorcière au village (XVe-XVIIIe siècle)*, Paris, 1979.

Müller, Christian (ed.), *Das Amerbach-Kabinett. Zeichnungen Alter Meister*, Basel, 1991.

Müller, Johannes, *Schwert und Scheide: der sexuelle und skatalogische Wortschatz im Nürnberger Fastnachtspiel des 15. Jahrhunderts*, Berne and New York, 1988.

Müntz, Eugène, 'Études iconographiques. La légende du sorcier Vérgile dans l'art des XIVe, XVe, et XVIe siècles', *Monatsberichte über Kunstwissenschaft und Kunsthandel*, 2, 1902, 85–91.

Musper, Theodor, *Die deutsche Bücherillustration der Gothik und Frührenaissance (1460–1530)*, 2 vols, Munich and Leipzig, 1874.

——, *Die Holzschnitte des Petrarca-Meisters. Ein kritisches Verzeichnis mit Einleitung und 28 Abbildungen*, Munich, 1927.

Nahl, Rudolf van, *Zauberglaube und Hexenwahn in Gebiet von Rhein und Maas: spätmittelalterlicher Volksglaube im Werk Johan Weyers, 1515–1588*, Bonn, 1983.

Nyborg, Ebbe, *Fanden på væggen*, Århus, 1978.

Oates, Caroline, "Metamorphosis and Lycanthropy in Franche-Comté, 1521–1643", in Michel Feher, Ramona Naddaff and Nadia Tazi (eds), *Fragments for a History of the Human Body*, vol. 1, New York, 1989, pp. 304–63.

Oberhuber, Konrad, 'Baccio Baldini', in Jay Levenson, Konrad Oberhuber and J. Sheehan (eds), *Early Italian Engravings from the National Gallery of Art*, Washington, 1973, pp. 13–21.

Oberman, Heiko, *Luther: man between God and the devil*, trans. Eileen Walliser-Schwarzbart, New Haven and London, 1989.

Ohly, Kurt, 'Ein unbeachteter illustrierter Druck Eggesteins', *Gutenberg Jahrbuch*, 28, 1953, 50–61.

Old Master Drawings from the Albertina, exh. cat., National Gallery of Art, Washington, 1985.

O'Neil, Mary, 'Magical Healing, Love Magic and the Inquisition in Late Sixteenth-century Modena', in Stephen Haliczer (ed.), *Inquisition and Society in Early Modern Europe*, Totowa, N.J., 1987, pp. 88–114.

Orenstein, Nadine, *Pieter Bruegel the Elder: drawings and prints*, exh. cat., Museum Boijmans Van Beuningen, Rotterdam and Metropolitan Museum of Art, New York; New York, 2001.

Os, Henk van den et al. (ed.), *Netherlandish Art in the Rijksmuseum*, vol. 1, Amsterdam, 2000.

Osten, Gert von der, *Hans Baldung Grien: Gemälde und Dokumente*, Berlin, 1983.

Oursel, Raymond, 'La Primatiale Saint-Jean de Lyon', *Archeologia*, 36, 1970, 18–25.

Ozment, Steven, *When Fathers Ruled: family life in Reformation Europe*, Cambridge, Mass., 1983.

Panofsky, Erwin and Dora Panofsky, *Pandora's Box: the changing aspects of a mythical symbol*, New York, 1956.

Paravicini Bagliani, Agostino, Kathrin Utz Tremp and Martine Ostorero, 'Le sabbat dans les Alpes. Les prémices médiévales de la chasse aux sorcières', in *Sciences: raison et déraisons*, Lausanne, 1994, pp. 67–89.

Paravy, Pierrette, 'Zur Genesis der Hexenverfolgungen im Mittelalter: der Traktat des Claude

Tholosan, Richter in der Dauphiné', in Andreas Blauert (ed.), *Ketzer, Zauber, Hexen. Die Anfänge der europäischen Hexenverfolgungen*, Frankfurt a.M., 1990, pp. 118–59.

Paravy, Pierrette, *De la chrétienté romaine à la reforme en Dauphiné: évêques, fidèles et deviants (vers 1340–vers 1530)*, vol. 2, Rome, 1993.

Paris, Katherine, *The Frederick W. Schuhmacher Collection, Columbus Gallery of Fine Arts*, Columbus, Ohio, 1976.

Parshall, Peter and Rainer Schoch, *Origins of European Printmaking: fifteenth-century woodcuts and their public*, exh.cat., National Gallery of Art, Washington, and GNM, Nuremberg; New Haven, 2005.

Paster, Gail Kern, *The Body Embarrassed*, Ithaca, 1993.

Peltzer, A., 'Nordische und italienische Teufels- und Hexenwelt', in E. Castelli (ed.), *Christianesimo e ragion di stato. L'umanesimo e il demoniaco nell'arte*, Rome, 1953, pp. 275–8.

Peters, Edward, *The Magician, the Witch, and the Law*, Philadelphia, 1978.

Philip, L. Brand, '*The Peddler* by Hieronymus Bosch: a study in detection', *Nederlands Kunsthistorisch Jaarboek*, 9, 1958, 1–81.

Piaget, Arthur, *Martin Le Franc, Prévot de Lausanne*, Lausanne, 1888.

Pigeaud, Renée, 'Woman as Temptress: urban morality in the 15th century', in Lène Dresen-Coenders (ed.), *Saints and She-devils: images of women in the 15th and 16th centuries*, London, 1987, pp. 39–58.

Pinson, Yona, 'The Water Mill in Brueghel's *Witch of Malleghem* (1559); or Incurable Folly', *Source. Notes in the History of Art*, 12, 1993, 30–33.

Pompen, Aurelius, *The English Versions of* The Ship of Fools*: a contribution to the history of the early French Renaissance in England*, Shannon, 1925.

Porter, Roy, 'Seeing the Past', *Past and Present*, 118, 1988, 186–205.

Préaud, Maxime, *Les sorcières*, exh. cat., Bibliothèque Nationale, Paris, 1973.

——, 'La sorcière de Noël', *Hamsa*, 7, 1977 (special issue: *L'esoterisme d'Albrecht Dürer*), 47–51.

——, 'Saturne, Satan, Wotan et Saint Antoine ermite', in *Alchimie mystique et traditions populaires*, ed. Maxime Préaud, *Cahiers de Fontenay*, 33, 1983, 81–102.

Purkiss, Diane, *The Witch in History: early modern and twentieth-century representations*, New York, 1996.

Radbruch, Gustav (ed.), *Elegantiae Juris Criminalis. Vierzehn Studien zur Geschichte des Strafrechts*, 2nd edn, Basel, 1950.

Réau, Louis, *L'iconographie de l'art chrétien*, 3 vols, Paris, 1955–9.

Reid, Jane Davidson, *The Oxford Guide to Classical Mythology in the Arts, 1300–1990s*, vol. 2, New York and Oxford, 1993.

Reinitzer, Heimo, *Biblia deutsch. Luthers Bibelübersetzung und ihre Tradition*, Wolfenbüttel, 1983.

Robbins, Rossell Hope, *The Encyclopedia of Witchcraft and Demonology*, London, 1959.

Rode, Herbert, *Die mittelalterlichen Glasmalereien des Kölner Domes*, Berlin, 1974.

Roettig, Petra, *Reformation als Apokalypse. Die Holzschnitte von Matthias Gerung im Codex germanicus 6592 der Bayerischen Staatsbibliothek in München*, Berne, 1991.

Roller, Hans-Ulrich, *Der Nürnberger Schembartlauf: Studien zum Fest- und Maskenwesen des späten Mittelalters*, Tübingen, 1965.

Roos, Keith, *The Devil in Sixteenth-century German Literature: the Teufelsbücher*, Berne, 1972.

Roper, Lyndal, 'Mothers of Debauchery: procuresses in Reformation Augsburg', *German History*, 6, 1988, 1–19.

——, *The Holy Household: women and morals in Reformation Augsburg*, Oxford, 1989.

——, *Oedipus and the Devil: witchcraft, sexuality and religion in early modern Europe*, London, 1994.

——, 'Tokens of Affection: the meaning of love in sixteenth-century Germany', in Eichberger, Dagmar and Charles Zika (eds), *Dürer and his Culture*, Cambridge, 1998, pp.143–63.

——, *Witch Craze: terror and fantasy in baroque Germany*, New Haven and London, 2004.

Roques, Marguerite, *Les peinture murales du sud-est de la France, XIIIe-XVIe siècle*, Paris, 1961.

Rosenberg, Jakob, *Die Zeichnungen Lucas Cranachs d.Ä*, Berlin, 1960.

Röttinger, Heinrich, *Hans Weiditz der Petrarkameister*, Strasbourg, 1904 (reprint, Nendeln, 1975).

——, *Dürers Doppelgänger*, Strasbourg, 1926.

Rücker, Elisabeth, *Hartmann Schedels Weltchronik: Das größte Buchunternehmen der Dürer-Zeit. Mit einem Katalog der Städteansichten*, Munich, 1988.

Ruggiero, Guido, *Binding Passions: tales of magic, marriage and power at the end of the Renaissance*, New York, 1993.

Rumpf, Marianne, *Perchten. Populäre Glaubensgestalten zwischen Mythos und Katechese*, Würzburg, 1991.

Russell, Diane H. with Bernadine Barnes, *Eva/Ave: woman in Renaissance and baroque prints*, exh. cat., National Gallery of Art, Washington; Washington and New York, 1990.

Russell, Jeffrey Burton, *Witchcraft in the Middle Ages*, Ithaca, 1972.

Sanchez Ortega, Maria Helena, 'Sorcery and Eroticism as Love Magic', in Mary Elizabeth Perry and Anne J. Cruz (eds), *Cultural Encounters: the impact of the inquisition in Spain and the New World*, Berkeley, 1991.

Saveleva, E., *Olaus Magnus i ego Istoriya severnykh narodov/ Olaus Magnus and the* History of the Northern Peoples, Leningrad, 1983.

Sawicka, S., *Jan Ziarnko, peintre-graveur polonais et son activité à Paris au premier quart du XVIIe siècle*, Paris, 1938.

Schade, Sigrid, *Schadenzauber und die Magie des Körpers. Hexenbilder der frühen Neuzeit*, Worms, 1983.

——, 'Kunsthexen – Hexenkünste', in Richard van Dülmen (ed.), *Hexenwelten. Magie und Imagination vom 16.–20. Jahrhundert*, Frankfurt a.M., 1987, pp. 170–218.

Schade, Werner, *Cranach: a family of master painters*, trans. Helen Sebba, New York, 1980.

Schama, Simon, *The Embarrassment of Riches: an interpretation of Dutch culture in the Golden Age*, Berkeley and Los Angeles, 1988.

Scheidig, Walther, *Die Holzschnitte des Petrarca-Meisters zu Petrarcas Werk Von der Artzney bayder Glück des guten und widerwärtigen, Augsburg 1532*, Berlin, 1955.

Schild, Wolfgang, *Die Maleficia der Hexenleut'*, Rothenburg o.d. Tauber, 1997.

——, 'Hexen-Bilder', in Gunther Franz and Franz Irsigler (eds), *Methoden und Konzepte der historischen Hexenforschung*, Trier, 1998, pp. 329–413.

——, 'Die zwei Schleswiger Hexlein: einige Seufzer zu Lust und Last mit der Ikonologie', in Helfried Valentinitsch and Markus Steppan (eds), *Festschrift für Gernot Kocher zum 60. Geburtstag*, Graz, 2002, pp. 249–71.

Schilling, Michael, *Bildpublizistik der frühen Neuzeit. Aufgaben und Leistung des illustrierten Flugblatts in Deutschland bis um 1700*, Tübingen, 1990.

Schmidt, Jürgen Michael, *Glaube und Skepsis. Die Kurpfalz and die abendländische Hexenverfolgung 1446–1685*, Bielefeld, 2000.

——, 'Das Hexereidelikt in den kursächsischen Konstitutionen von 1572', in Günter Jerouschek, Wolfgang Schild and Walter Gropp (eds), *Benedict Carpzov. Neue Perspektiven zu einem umstrittenen sächsischen Juristen*, Tübingen, 2000, pp. 111–35.

Schmidt, Philip, *Die Illustration der Lutherbibel 1522–1700*, Basel, 1962.

Schmitt, Jean-Claude, 'Le spectre de Samuel et la sorcière d'en dor. Avatars historiques d'un récit biblique: I Rois 28', *Études rurales*, 105–6, 1987, 37–54.

——, *Ghosts in the Middle Ages: the living and the dead in medieval society*, trans. Teresa Lavender Fagain, Chicago, 1994.

Schneider, Bernd, *Vergil. Handschriften und Drucke der Herzog August Bibliothek*, exh. cat., HAB, Wolfenbüttel, 1982.

Schnittger-Schleswig, Doris, 'Vom Dom zu Schleswig', *Repertorium für Kunstwissenschaft*, 14, 1891, 472–90.

Schoch, Rainer, Matthias Mende and Anna Scherbaum, *Albrecht Dürer. Das druckgraphische Werk*, Munich, 2001.

Schouten, Jan, *The Pentagram as a Medical Symbol: an iconological study*, Nieuwkoop, 1968.

[Schramm] Schramm, Albert, *Der Bilderschmuck der Frühdrucke*, 23 vols, Leipzig, 1920–43.

Schreiber, Wilhelm Ludwig, *Handbuch der Holz- und Metallschnitte des XV. Jahrhunderts*, vol. 4, *Holzschnitte Nr. 1783–2047*, Leipzig, 1927 (reprint Stuttgart, 1969); vol. 11, *Der Einblattholzschnitt und die Blockbücher des XV. Jahrhunderts*, ed. H.Th. Musper, Stuttgart, 1976.

——, *Manuel de l'Amateur de la Gravure sur Bois et sur Metal au XVe Siècle*, vol. 2, Berlin and Leipzig, 1892; vol. 5, Berlin and Leipzig, 1911.

Schreyl, Karl-Heinz, *Hans Schäufelein. Das druckgraphische Werk*, 2 vols, Nördlingen, 1990.

Schuster, Peter-Klaus, *Melencolia I. Dürers Denkbild*, 2 vols, Berlin, 1991.

Schwarzwälder, Herbert, 'Die Geschichte des Zauber- und Hexenglaubens in Bremen', *Bremisches Jahrbuch*, 46, 1959, 156–233; 47, 1961, 99–142.

Schweitzer, Franz-Josef, *Tugend und Laster in illustrierten didaktischen Dichtungen des späten Mittelalters. Studien zu Hans Vintlers* Blumen der Tugend *und zu* Des Teufels Netz, Hildesheim, 1993.

Scribner, Robert, *Popular Culture and Popular Movements in Reformation Germany*, London, 1987.

——, *For the Sake of Simple Folk: popular propaganda for the German Reformation*, rev. edn, Oxford and New York, 1994.

——, 'Ways of Seeing in the Age of Dürer', in Eichberger, Dagmar and Charles Zika (eds), *Dürer and his Culture*, Cambridge, 1998, pp. 93–117.

——, *Religion and Culture in Germany (1400–1800)*, ed. Lyndal Roper, Leiden, 2001.

Senn, Matthias, *Johann Jakob Wick (1522–1588) und seine Sammlung von Nachrichten zur Zeitgeschichte*, Zurich, 1974.

Shachar, Isaiah, *The Judensau: a medieval anti-Jewish motif and its history*, London, 1974.

Sharpe, James, *Instruments of Darkness: witchcraft in England, 1550–1750*, London, 1996.

Silver, Larry, 'Forest Primeval: Albrecht Altdorfer and the German wilderness landscape', *Simiolus*, 13, 1983, 4–43.

——, 'Germanic Patriotism in the Age of Dürer' in Eichberger, Dagmar and Charles Zika (eds), *Dürer and his Culture*, Cambridge, 1998, pp. 38–68.

——, 'Nature and Nature's God: Immanence in the Landscape Cosmos of Albrecht Altdorfer', *Art Bulletin*, 91, 1999, 124–214.

Singer, G., '*La Vauderie d'Arras*, 1459–91: an episode of witchcraft in later medieval France', Ph.D. thesis, University of Maryland, 1974.

Sipek, H., '"Newe Zeitung". Marginalien zur Flugblatt und Flugschriftenpublizistik', in S. Lorenz (ed.), *Hexen und Hexenverfolgung im deutschen Südwesten*, Karlsruhe, 1994, pp. 85–92.

Smith, Jeffrey Chipps, *Nuremberg: a Renaissance city, 1500–1618*, exh. cat., Archer M. Huntington Art Gallery, University of Texas at Austin, 1983.

Smith, Susan Louise, *The Power of Women: a topos in medieval art and literature*, Philadelphia, 1995.

Spargo, John Webster, *Virgil the Necromancer: studies in virgilian legends*, Cambridge, 1934.

Sperling, Katja, 'Christoph Murers Glasgemälde für den Rat und für Patrizierfamilien der Stadt Nürnberg', M.A. thesis, University of Erlangen-Nürnberg, 1991.

Spinks, Jennifer, 'Monstrous Births and Visual Culture in German-speaking Europe, *c.* 1490–1570', Ph.D. thesis, The University of Melbourne, 2006.

Stafford, Barbara Maria, *Body Criticism: imaging the unseen in Enlightenment art and medicine*, Cambridge, Mass. and London, 1991.

——, *Artful Science: enlightenment, entertainment, and the eclipse of visual education*, Cambridge, Mass., 1994.

Steinberg, Leo, 'Michelangelo's Florentine *Pietà*: the missing leg', *Art Bulletin*, 50, 1968, 343–53.

Stephens, Walter, *Demon Lovers: witchcraft, sex and the crisis of belief*, Chicago and London, 2002.

Stintzing, Roderich, *Geschichte der populären Literatur des römisch-kanonischen Rechts in Deutschland am Ende des fünfzehnten und im Anfang des sechzehnten Jahrhunderts*, Leipzig, 1867.

Stöber, August (ed.), *Zur Geschichte des Volks-Aberglaubens im Anfange des XVI. Jahrhunderts. Aus Dr. Joh. Geilers von Kaisersberg Emeis*, Basel, 1856.

Strauss, Gerald, *Sixteenth-century Germany: its topography and topographers*, Madison, 1959.

——, *Historian in an Age of Crisis: the life and work of Johannes Aventinus*, Cambridge, Mass., 1963.

—— (ed.), *Manifestations of Discontent in Germany on the Eve of the Reformation*, Bloomington, Ind., 1971.

Strauss, Walter L. (ed.), *The Complete Drawings of Albrecht Dürer*, 6 vols, New York, 1974.

——, *Albrecht Dürer: woodcuts and woodblocks*, New York, 1980.

[Strauss] ——, *The German Single-leaf Woodcut: 1500–1600*, 3 vols, New York, 1975.

Strieder, Peter et al., *Dürer*, Augsburg, 1996.

Stuart, Kathy, *Defiled Trades and Social Outcasts: honor and ritual pollution in early modern Germany*, Cambridge, 1999.

Sullivan, Margaret A., 'The Witches of Dürer and Hans Baldung Grien', *Renaissance Quarterly*, 53, 2000, 332–401.

Sumberg, Samuel, *The Nuremberg Schembart Carnival*, New York, 1941.

Summers, Montague, *The Werewolf*, New Hyde Park, N.Y., 1966.

Swan, Claudia, *Art, Science and Witchcraft in Early Modern Holland: Jacques de Gheyn II (1565–1629)*, Cambridge, 2005.

Talvacchia, Bette, *Taking Positions: on the erotic in Renaissance culture*, Princeton, 1999.

Tavel, Hans Christoph von, 'Dürers *Nemesis* und Manuels *Frau Venus*', *Zeitschrift für Schweizerische Archäologie und Kunstgeschichte*, 33, 1976, 285–95.

Térey, Gabriel von, *Die Handzeichnungen des Hans Baldung gen. Grien*, vol. 1, Strasbourg, 1894.

Thomas, Keith, *Religion and the Decline of Magic: studies in popular beliefs in sixteenth and seventeenth century England*, London, 1971.

[TIB] Strauss, Walter L. (ed.), *The Illlustrated Bartsch*, New York, 1978-.

Tietze-Conrat, Erika, 'Der "Stregozzo" (Ein Deutungsversuch)', *Die graphischen Künste*, 1, 1936, 57–9.

——, *Mantegna*, London, 1955.

Tinkle, Theresa, 'Saturn of the Several Faces: a survey of the medieval mythographic traditions', *Viator*, 18, 1987, 289–307.

Trebbin, Heinrich, *David Teniers und Sankt Antonius*, Frankfurt a.M., 1994.

Trevor-Roper, H.R., *The European Witch-craze of the Sixteenth and Seventeenth Centuries, and Other Essays*, New York, 1969.

Unverfehrt, Gerd, *Hieronymus Bosch. Die Rezeption seiner Kunst im frühen 16. Jahrhundert*, Berlin, 1980.

Valentinitsch, Helfried and Ileane Schwarzkogler, *Hexen und Zauberer*, exh. cat., Steirische Landesaustellung 1987, Riegersburg/Oststeiermark; Graz and Vienna, 1987.

Van Gennep, Arnold, *Manuel de folklore contemporain*, vol. 1, part 6, *Les cérémonies périodiques cycliques et saisonnières*, Paris, 1953.

[VD16] Bayerische Staatsbibliothek, Munich and HAB, *Verzeichnis der im deutschen Sprachbereich erschienenen Drucke des XVI. Jarhhunderts*, ed. Irmgard Bezzel, 25 vols, Stuttgart, 1983–2000.

Veldman, Ilya M., 'De macht van de planeten over het mensdom in prenten naar Maarten de Vos', *Bulletin van het Rijksmuseum*, 31, 1983, 21–53.

Vignau-Wilberg, Thea, 'Zur Entstehung zweier Emblemata von Christoph Murer', *Anzeiger des Germanischen Nationalmuseums*, 1977, 85–94.

——, *Christoph Murer und die 'XL. Emblemata Miscella Nova'*, Berne, 1982.

Vignau Wilberg-Schuurman, Thea with Renée Pigeaud, *Hoofse minne en burgerlijke liefde in de prentkunst rond 1500*, Leiden, 1983.

Vogel, Gerhard, *Der Mythos von Pandora. Die Rezeption eines griechischen Sinnbildes in der deutschen Literatur*, Hamburg, 1972.

Volkmann, Kurt, *Das Becherspiel des Zaubers in der bildenden Kunst. Das 15. und 16. Jahrhundert*, Düsseldorf, 1954.

——, *The Oldest Deception: cups and balls in the art of the 15th and 16th centuries*, trans. Barrows Mussey, Minneapolis, Minn., 1956.

Voltmer, Rita, *Wie der Wächter auf dem Turm – ein Prediger und seine Stadt. Johannes Geiler von Kaysersberg (1445–1510) und Straßburg*, 2 vols, Trier, 2004.

Waite, Gary K., 'Talking Animals, Preserved Corpses and *Venusberg*: the sixteenth-century magical worldview and popular conceptions of the spiritualist David Joris (*c.* 1501–56)', *Social History*, 20, 1995, 137–56.

——, *Heresy, Magic, and Witchcraft in Early Modern Europe*, Houndmills, Hampshire and New York, 2003.

Waldburg Wolfegg, Christoph, Graf zu, *Venus und Mars. Das Mittelalterliche Hausbuch aus der Sammlung der Fürsten zu Waldburg Wolfegg*, exh. cat., Haus der Kunst, Munich, 1997.

Wall, Jan, *Tjuvmjölkande väsen*, vol. 1, *Äldre nordisk tradition*, Uppsala, 1977.

Walker, John, *National Gallery of Art, Washington*, rev. edn, New York, 1984.

Walsham, Alexandra, *Providence in Early Modern England*, Oxford, 1999.

Warner, Marina, *From the Beast to the Blonde: on fairytales and their tellers*, London, 1994.

Watt, Tessa, *Cheap Print and Popular Piety, 1550–1640*, Cambridge, 1994.

Weber, Bruno (ed.), *Wunderzeichen und Winkeldrucker 1543–1586. Einblattdrucke aus der Sammlung Wikiana in der Zentralbibliothek Zurich*, Dietikon and Zurich, 1972.

Welt im Umbruch. Augsburg zwischen Renaissance und Barock, 2 vols, exh. cat., Rathaus und Zeughaus, Augsburg, 1980.

Whitaker, Lucy, 'Maso Finiguerra, Baccio Baldini and *The Florentine Picture Chronicle*', in Elizabeth Cropper (ed.), *Florentine Drawing at the Time of Lorenzo the Magnificent*, Bologna, 1994, 181–96.

——, 'Maso Finiguerra, and Early Florentine Printmaking', in Stuart Currie (ed.), *Drawing 1400–1600: invention and innovation*, London, 1998, pp. 181–96.

Wilson, Adrian and Joyce Lancaster Wilson, *The Making of the Nuremberg Chronicle*, Amsterdam, 1976.

Wilson, Eric, 'Institoris at Innsbruck: Heinrich Institoris, the *Summis Desiderantes* and the Brixen witch trial of 1485', in Bob Scribner and Trevor Johnson (eds), *Popular Religion in Germany and Central Europe 1400–1800*, New York, 1986, pp. 87–100.

Wirth, Jean, *La jeune fille et la mort: recherches sur les thèmes macabres dans l'art germanique de la Renaissance*, Geneva, 1979.

Wolfram, Richard, (ed.), *Studien zur älteren Schweizer Volkskultur. Mythos, Sozialordnung, Brauchbewußtsein*, Vienna, 1980.

Wood, Christopher S., *Albrecht Altdorfer and the Origins of Landscape*, London, 1993.

Wuttke, Adolf, *Der deutsche Volksaberglaube der Gegenwart*, ed. Elard Hugo Meyer, 4th ed., Leipzig, 1925.

Yarnall, Judith. *Transformations of Circe: the history of an enchantress*, Urbana and Chicago, 1994.

Zafran, Eric, 'Saturn and the Jews', *Journal of the Warburg and Courtauld Institutes*, 42, 1979, 16–27.

Zapalac, Kristin Eldyss Sorensen, *'In His Image and Likeness': political iconography and religious change in Regensburg, 1500–1600*, Ithaca, 1990.

Zeri, F., 'Investigations into the Early Period of Lorenzo Monaco I', *Burlington Magazine*, 106, 1964, 554–58.

Zerner, Henri, 'L'estampe érotique au temps de Titien', in *Tiziano e Venezia, Convegno Internationale di Studi*, Venice, 1980.

Ziegeler, Wolfgang, *Möglichkeiten der Kritik am Hexen- und Zauberwesen im ausgehenden Mittelalter: Zeitgenössische Stimmen und ihre soziale Zugehörigkeit*, Cologne and Vienna, 1973.

Zika, Charles, '"Magie" – "Zauberei" – Hexerei"', in Bernhard Jussen and Craig Koslofsky (eds), *Kulturelle Reformation: Sinnformationen im Umbruch, 1400–1600*, Göttingen, 1999, pp. 317–82.

——, 'Images of Circe and Discourses of Witchcraft, 1480–1580', *Zeitenblicke: Online-Journal für die Geschichtswissenschaften*, 1, 2002 [http://www.zeitenblicke. historicum.net/2002/01/zika/zika.html].

——, *Exorcising our Demons: magic, witchcraft and visual culture in early modern Europe*, Leiden and Boston, 2003.

——, 'Reformation, Scriptural Precedent and Witchcraft: Johann Teufel's woodcut of the *Witch of Endor*', in Ian Breward (ed.), *Reforming the Reformation: essays in honour of Peter Matheson*, Melbourne, 2004, pp. 148–66.

——, 'The Witch of Endor: transformations of a biblical necromancer in early modern Europe', in Charles Zika and F.W. Kent (eds), *Rituals, Images, and Words: varieties of cultural expression in late medieval and early modern Europe*, Turnhout, 2005, pp. 235–59.

——, 'Art and Visual Images', in Golden, Richard M. (ed.), *Encyclopaedia of Witchcraft: the western tradition*, 4 vols, Santa Barbara, Calif., 2006, pp. 59–63.

Zingerle, Ignatz von, 'Beiträge zur älteren tirolischen Literatur', Sitzungsberichte der Kaiserlichen Akademie der Wissenschaften. Philosophisch-historische Classe 66, 1, 1870, 279–351.

INDEX

Italic page numbers indicate illustrations not included in the text page range.